AN ARTISAN ELITE IN VICTORIAN SOCIETY

AN ARTISAN ELITE IN VICTORIAN SOCIETY

KENTISH LONDON 1840-1880

GEOFFREY CROSSICK

CROOM HELM LONDON

ROWMAN AND LITTLEFIELD TOTOWA N.J.

© 1978 Geoffrey Crossick
Croom Helm Ltd, 2-10 St John's Road, London SW11

British Library Cataloguing in Publication Data

Crossick, Geoffrey
 An artisan elite in Victorian society.
 – (Croom Helm social history series).
 1. Skilled labor – England – Greenwich
 (London Borough) – History 2. Skilled labor
 – England – Deptford, London – History
 3. Skilled labor – England – History – 19th
 century 4. Elite (social sciences) – England
 I. Title
 301.44'92 HD8400.L/

 ISBN 0-85664-797-7

First Published in the United States 1978 by
Rowman and Littlefield
81 Adams Drive, Totowa, New Jersey

ISBN 0-8476-6098-2

FOR MY PARENTS

Printed in Great Britain by
Biddles Ltd, Guildford, Surrey

CONTENTS

LIST OF TABLES

ACKNOWLEDGEMENTS

My first and most important academic debt is to Eric Hobsbawm for his active help and encouragement throughout the development of this research. Two colleagues and friends must also be thanked. Robbie Gray has over many years discussed with me both the ideas and the material in this book, while Roderick Floud has given advice and encouragement in many areas, but especially in the use of the computer and other quantitative aspects of the work. Many research seminars round the country have listened patiently and argued constructively about some of these ideas, and to them all I am grateful. Finally, my thanks are due to the Master and Fellows of Emmanuel College, Cambridge, for electing me to a Research Fellowship during which I was able to continue this work.

The officials and staff of research offices and libraries have helped in innumerable ways by providing facilities and access to records. The staff of the local history libraries at Woolwich and Lee, and those of the excellent Greenwich Local History Centre, have always been generous with their assistance. I must thank especially the staff of the Greater London Record Office, the Public Record Office, the British Museum Reading Room and the Newspaper Library at Colindale, the Bishopsgate Institute Library, and the Brynmor Jones Library at the University of Hull. Miss M.W.H. Schreuder of the Amsterdam International Institute of Social History made available xerox copies of some important letters. The Superintendent Registrars at the Woolwich and Lewisham Register Offices were both exceptionally helpful in giving me extended access to their marriage registers. The staff of the Cambridge University Computer Laboratory eased me through the difficulties of first using a computer. Many officials of local organisations gave freely of their time to help me find material, amongst them H.C. Tarr of the Provident Reliance Friendly Society; A.G. Morgan of the Independent Order of Oddfellows, South London District; H.A. Wright of the Ancient Order of Foresters, South London District; M.J. Cox of the Royal Arsenal Co-operative Society; G.V. Brown of the Greenwich Building Society; and the officials of many organisations, trade unions and churches recorded in the list of sources. A number of people have generously answered requests for assistance over specific problems, among them the late Henry Collins, Philip Bagwell, Sheila Cross, J.S. Binnie, and

Brigadier O.F.G. Hogg. I am grateful to Hilary Newton for typing the manuscript of this book with such efficiency.

My final acknowledgements are more personal. Rita Vaudrey read these chapters in many drafts, criticised and encouraged, and above all gave support. She knows the extent of my debt to her. The longest standing debt of all is acknowledged with gratitude in the dedication.

The jacket illustration shows a view of Messrs Penn and Son's Works, Greenwich and Deptford. (By courtesy of the Greenwich Local History Library.)

The Position of Kentish London within the Metropolis

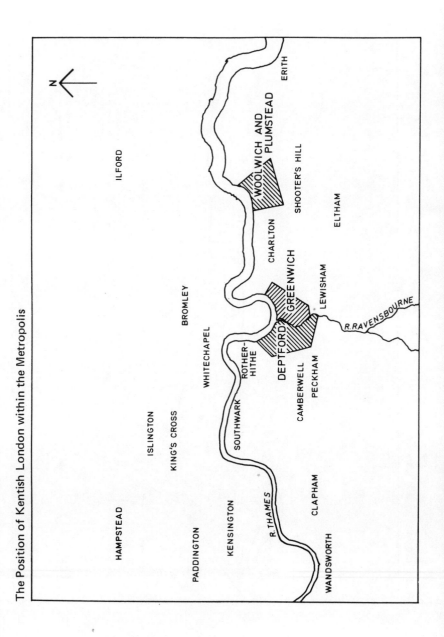

Mid-Victorian Kentish London

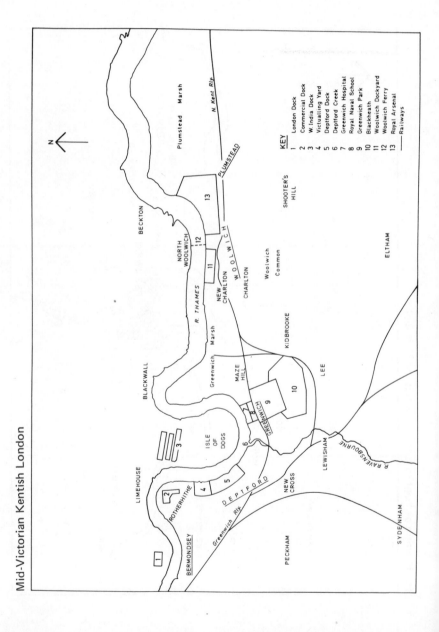

KEY

1 London Dock
2 Commercial Dock
3 W. India Dock
4 Victualling Yard
5 Deptford Dock
6 Deptford Creek
7 Greenwich Hospital
8 Royal Naval School
9 Greenwich Park
10 Blackheath
11 Woolwich Dockyard
12 Woolwich Ferry
13 Royal Arsenal
—— Railways

1 INTRODUCTION

This book is an argument about the nature and the origins of an artisan elite and its ideology in the mid-Victorian period. At the level of discrete chapters, many can be read as separate studies of aspects of artisan life in a particular set of mid-Victorian communities. This is especially true of the latter part of the book, where individual artisan-dominated institutions and the nature of working-class politics are examined at length. Friendly societies, where a substantial quantity of pliable data has been uncovered of a kind little explored by historians previously, building societies, co-operatives, political organisation and ideas, religious participation, marriage patterns, and occupational mobility between generations — all these areas are covered in a way which it is hoped will be helpful to historians interested in those specific topics. Yet it must be emphasised here in the introduction that more is intended than that. The book is offered as an argument whose chapters tie closely together as a contribution to the debate on specific historical problems concerning the Victorian period.

These problems coalesce around the place of a labour aristocracy, an elite of the skilled working class, within the political economy of mid-Victorian Britain. At one level the existence of that elite is in dispute, but beyond that problems appear that I consider more complicated and interesting, involving questions about the content of value systems, and their changing functions within specific social situations. They demand an examination of the relationship between those values and the society in which they develop. These are the issues with which this book concerns itself, as it focuses upon the formation of an artisan elite in a set of mid-Victorian communities, its composition, institutions and ideology.

Between the 1850s and the 1880s, the temper of working-class political and social organisations began to change in ways that have appeared striking to both contemporaries and historians. The emergence of an elite of relatively well-paid and secure skilled workers has been seen as a central element in explaining that change. Gillespie's pioneering and still unsurpassed survey[1] of working-class politics in the period lays out the territory most fully, but Royden Harrison's more recent exploration of the theme has presented the emergence of a labour aristocracy as the key setting for his essays on mid-Victorian

working-class politics.[2] This theme has also been explored in relation to specific institutions, in which a dramatic change of ideals is often presented. Pollard's essay on co-operation is a good example.[3] Biographers of leading figures in the labour movement have pursued this apparently clear transformation of mood, though Leventhal's characterisation of George Howell's political and social views as typical of mid-Victorian labour aristocrats is excessive.[4] Howell became far too isolated from his working-class past as he aspired to a thoroughly bourgeois respectability, and the way in which this differed from the aspirations of most labour aristocrats is a central argument of this study. Other political historians have correctly stressed the importance of the labour aristocracy for an understanding of mid-Victorian politics. F.B. Smith in fact sees its visibility to middle- and upper-class eyes as a prime condition for the making of the Second Reform Bill and, if the evidence of Kentish London is anything to go by, his argument on this point is correct.[5] The apparent slackening of class tensions and the growing quiescence of working-class organisations have thus been recurring themes in the historiography of this period, and the growing importance of a labour aristocracy has been a central feature of such studies.

Until the last two or three years, however, only Hobsbawm's pioneering article[6] has sought to offer a concrete examination of that labour aristocracy in Britain. A number of studies have recently appeared, though, that focus more centrally on the labour aristocracy and its ideology than those works referred to above which tended to assume rather than examine it. Tholfsen's study[7] of the origins of mid-Victorian working-class radicalism locates it within a developing radical tradition that derived from the relationship between eighteenth-century rationalism and the British intellectual and social experience of the intervening years. The broad outlines of his depiction of mid-Victorian artisan ideology are convincing, and represent a substantial alteration of his earlier position,[8] but his mode of argument and explanation are far less persuasive than his conclusions. The book is fundamentally idealist in its analysis of ideology and consciousness, explaining them in terms of the interplay of ideas. The essential relationship of ideological formation and transmission to economic and social structures and experience is neglected.

Foster's discussion of the labour aristocracy[9] is anything but idealist, for he presents its creation as the conscious and manipulative work of Oldham's bourgeoisie in order to achieve control of working-class institutions and defuse working-class consciousness. It was not just the creation of the stratum which was the work of the ruling class, but also

the instilling within it of what was in effect bourgeois ideology and values. My disagreements with Foster on these matters will emerge clearly in the argument of this book. His interpretation of the way in which the labour aristocracy came to 'collaborate', the extent and nature of that collaboration, the definition of labour aristocratic ideology, and the way in which a version of bourgeois ideology was diffused more widely, are all areas where this study of Kentish London diverges fundamentally from Foster; not just in its conclusions, but in its mode of argument and presentation of the processes involved. Foster's rigid economic determinism, positing a far too direct relationship between economic and ideological change, and the Leninist structure of his argument, require the simplistic version of the mid-Victorian period that emerges.

I shall argue, on the contrary, that the relative mid-Victorian stability was not simply the outcome of one class's victory over another, but the result of a process of continuing struggle, in which the features of a class society determined the outcome in only the most generalised sense. Whatever the consequences of that class domination, the specific process was in no way the result of one-way imposition. The labour aristocracy achieved its position through struggle and conflict, not capitulation.

Gray's study of the labour aristocracy in Edinburgh[10] implicitly rejects many of Foster's key propositions, and interprets the formulation of a labour aristocracy and the construction of its ideology in a way far more sympathetic to the arguments that will be presented in this book. In particular, his insistence that culture and values do not passively reflect economic structures, and that 'the key question is that of the cultural mediation of different economic experiences',[11] stresses the ideological complexities of the mid-Victorian stability and of the process of change that produced it. Gray joins Foster, however, in seeing the formation of a labour aristocracy as the primary explanation for the specific direction of working-class activity and consciousness in Britain between the decline of Chartism and the First World War. The main concern of this study of mid-Victorian Kentish London is not to offer a reinterpretation of the whole of British working-class history during those years, but to study the specific local formation of a labour aristocracy, its institutions and its place within its own communities; to examine closely the sources and nature of its ideology, and to refine our definitions, explanations and understanding of that elite and its place in the social formation. All this must contribute to such an interpretation of the working class in the Victorian period as a whole, but I

would not argue that the emergence of a labour aristocracy is the key component of an explanation of the stabilisation of Victorian society. Stabilisation is itself a complex notion, assuming a relationship to the classic period of industrialisation and the social instabilities that went with it. It refers not to some absolute social calm, but to the way in which the areas of conflict between *all* classes, and their ideological scope, were narrowing during these years.

The relationship between any two groups, especially if that relationship is presented simply as one of domination, cannot adequately explain the way in which the exercise of power shifts during these years from coercion to a deepening dependence on cultural and ideological forces. The development of the whole of the working class, as well as of class relationships outside the working class, must be analysed if the overall stabilisation of the period is to be understood. If the existence of a fragmented working class, with a labour aristocratic elite, is one component of that explanation (and my case in this book clearly points that way), it must remain only that. A satisfactory explanation must draw in economic and cultural developments that cover a much wider area than could be encompassed in the study of an artisan elite.

At the base of all this analysis is the expansion of the British economy during the quarter century from 1848 to 1873. To Ashworth it was a period of 'striking economic growth'. Whatever the problems and the fluctuations, 'it is its astonishingly dynamic quality that is the outstanding economic characteristic of the mid-Victorian period'.[12] This view has been echoed elsewhere. Economic historians may develop it with their own, often major, qualifications, yet for Hobsbawm, Checkland and Hughes the dynamic expansion of the British economy during these years is undisputed.[13] A recent survey has qualified this picture more precisely. Church points out that although the secular rate of growth did reach its peak in this period, the difference in the rate achieved was relatively modest.[14] Yet one must turn to quality not just quantity of growth. Accelerating demand abroad, free trade, the fruition of cost-reducing developments of earlier decades, and the major expansion of the capital goods industries, produced a broadening and deepening of industrialisation. Whether or not 'the British economy had reached maturity',[15] it had certainly achieved a restructuring and a stabilising of capitalist industrialism to the extent that the new political economy took on a sense of permanence. The pricking of the over-excited investment bubble in 1857 provoked a financial crisis, but one from which the economy emerged reasonably quickly and with astonishingly few distortions.[16]

Exports rose at an unprecedented rate in what seems to have been a demand-inspired expansion, for with other European countries beginning their own industrial revolutions, Britain's growth occurred with no adverse movement in the terms of trade. The declared value of exports rose from £53m in 1848 to £122m in 1857, and after faltering through the 1857-8 crisis, doubled again in the next decade.[17] When terms of trade calculations are taken into account, Britain's export gain from trade, which had risen by 130 per cent between 1821-5 and 1846-50, rose by 229 per cent between the latter quinquennium and 1871-5.[18] This was the period when trade's share of national income reached its peak.[19] Growth abroad, free trade and international developments in railways and shipping provided the basis for this success.

The broad pattern is clear, certainly up to the commercial crisis of 1866, from which recovery was much slower than in 1857. There was in 1866 a more pervasive sense of depression and uncertainty than at any time in the preceding two decades. It is those twenty years, most of all, that laid the foundations for the developments that this book explores. The real development, which is of particular importance for this study, was the new significance of the heavy industries. Output of coal, iron and steel rose with the expansion of both workforce and productivity. With them, and with the wider extension of mechanisation and steam-power, came the heavy assembly industries of metal-working, engineering and shipbuilding. The doubling of the number of employees in these last two industries between 1851 and 1881 had two effects that will be developed in the chapters that follow. The first was the substantial increase in numbers and importance of the labour aristocracy, the second was the expansion of just those industries that were dominant in Kentish London. At a national level employment continuity improved, though unemployment levels did not change much between then and the years of the Great Depression, and there was also a transfer of labour from worse to better paid jobs. This was part of the broadening of the industrial base with the extension of capital goods industries that were as yet facing little serious competition from other countries.

Church's 'qualified affirmative' to the notion of a mid-Victorian boom[20] derives from his precise probing of trends in prices, growth rates, investment and trade patterns and so on. At the level of restructuring of the British industrial economy, however, he is in no doubt. This was the period when manufacturing, mining and building increased markedly their share of the national product. It represents 'the emergence of an urban industrial economy and society'.[21] It is that solidifying and

deepening of British industrial capitalism that is the key to the develop-
ments studied here. The late nineteenth-century problem of the narrow-
ness of the British industrial base was yet to come. Major diversification
of employment of both labour and capital was still under way in the
mid-Victorian period, and it underpinned the economic expansion of
those decades. In terms of economic expansion, if not of income distri-
bution, and with whatever qualifications as to fluctuations, over-invest-
ment, periodicity and the like, the mid-Victorian period represented a
major advance for the British economy.

Explanations of the relative quietening of class tension in these
years have tended to centre on a fairly straightforward link between
relative economic prosperity and the political and social climate. These
economic developments, however, were a *necessary* but not a *sufficient*
condition for the formation of the labour aristocracy. An analysis that
centred exclusively, or even predominantly, upon this economic expan-
sion, or even the economic restructuring that went with it, would
dangerously elevate an economic basis for other structural and ideo-
logical developments into a sole determining cause. Economic progress
alone leads to no particular ideological or behavioural consequences.
The effects of the mid-Victorian expansion can only be interpreted
within the wider framework of social relationships and ideological
forces; these determined the consequences of the economic develop-
ments, in specific places, at specific points in time.

That is the focus of this study, which examines a major element in
the lessening of social tensions, the emergence of a labour aristocracy
taking up a particular stance in relation to the society in which it lived.
It is concerned with the formation, ideology and significance of that
labour aristocracy in particular mid-Victorian communities. National
studies have of necessity been limited to a generalised characterisation
of labour aristocracy activities and values, as well as a very generalised
explanation of these developments. By examining the three towns on
the edge of south-east London, Deptford, Greenwich and Woolwich, I
hope to study these themes within a local setting. The intention is not
to argue that what happened in Kentish London also occurred else-
where, that Kentish London was in some ways 'typical' — though the
study will shed light on processes elsewhere. People lived and exper-
ienced their lives as individuals within families, communities, work-
places. All of these were subject to fundamental national forces. Never-
theless, attempts to penetrate the meaning of values and ideologies, and
to penetrate them within a social environment, must at some stage seek
an analysis that takes account of one irreducible fact — that if we wish

to study and explain human behaviour, we must at some point attend
to the level at which people experience their lives.

One aim of the book is to demonstrate the existence of an elite of
skilled, relatively well paid, and relatively secure workers who came to
dominate so much of the politics and the organised social life of
working-class Kentish London. One approach might be to accumulate
earnings information, but the absence of wages data beyond the gener-
alised material presented in chapters 4 and 6 renders this impossible. In
any case, there is more to a labour aristocracy than high earnings. There
is no necessary reason why high wage-earners should form an exclusive
social group with aspirations and values distinct from others. If this
happened, then it must be demonstrated. In other words, we have to
look for the formation of a social stratum, not just an economic elite,
for evidence that this elite of skilled men actually took on exclusive
values, patterns of behaviour and social aspirations that effectively dis-
tinguished it from other sections of society.

The second aim is to examine the ideology of that labour aristocracy,
and the nature of the institutions that it created or developed. There
was certainly a middle-class view of the labour aristocracy, one that was
central to the debate around the Second Reform Bill. At its best it was
seen, in the words of F.B. Smith, as 'the living proof that, while the
improvident masses might be irredeemably dangerous and depraved, the
artisan class was capable of aspiring to middle-class standards of
Christian observance, sobriety, thrift, orderliness and cleanliness'.[22]
Middle-class reformers and liberal politicians pressed upon the working
class a particular set of values that we recognise today as peculiarly
Victorian – domesticity, industry, thrift and respectability were their
catchwords. Attempts to reach and reform the working class seemed, in
the post-Chartist period, to be bearing fruit. In many ways this was true,
though any easy equation between what reformers thrust upon them
and what the labour aristocrats took would be dangerous. Words have
meanings, and meanings can change. More important, words take on
meanings in social situations, and those situations were different for the
various strata of mid-Victorian Britain. For that reason, I have sought
to establish and then to interpret the values of labour aristocrats in
Kentish London through their own institutions and words in as far as
that is possible. This is not due to any purist belief that only working-
class sources hold the truth about working-class history,[23] but because
ideas and values are illusory things, whose content can change subtly
but meaningfully between actor and observer. What did artisans mean
by self-help? What were these values? In what ways did the value system

espoused by labour aristocrats in this period constitute a process of 'embourgeoisement', instilling bourgeois ideology and bourgeois aspirations into the elite of working men? These questions will be tackled in the latter part of the book. It will be argued that the differences of meaning and of situation were such as to conflict with the idea of embourgeoisement. Yet, objectively, much of the ideology developed by these workers demonstrated an acceptance of the broad contours of the political economy in which they lived. In consequence, the book implicitly examines the way in which a degree of ideological hegemony was established by the ruling classes of Victorian England. What is fascinating about that process is that so much of it proceeded not through indoctrination, not through capitulation to middle-class ideals, but through the development, out of working-class traditions and the labour aristocrat's social and economic experience, of a set of values which represented historically a new degree of integration into the existing social and economic system. The development of these values, and the examination of their content, will be one aspect of the latter part of the book, which will at the same time look at the membership and functions of those institutions of artisan life which expressed these values.

This study goes further than this, and while establishing artisan ideology and activities, labour aristocracy formation, and differentiation within the working class, it also tries to locate them within a firm explanatory framework. This context is the particular focus of the early chapters. The activities and values of the labour aristocracy in Kentish London derived from the perceived experience that they drew from their own lives and traditions, and from the forces operating upon and around them. It is the reconstruction of the dominant features of that situation which is the continuing context of this whole study. It is based on that explicit argument, that the ideology and behaviour of the skilled elite derive from particular forces, of which the crucial ones were those in their own workplace, their own employment situation, their own community and their own institutions. The economic and social system of industrialising Britain was not seen by the workers within it as a totality, but only as they themselves experienced it. This is especially true with reference to the London working class in the mid-nineteenth century, for we are dealing with people who are still learning to live in an industrial society. Their history, their families, their culture and their ideology are only beginning to embody an assumed understanding of industrialisation and of industrial capitalism. In that situation, especially, local social structure and local situations are crucial to any attempt to understand working-class behaviour. This should not be

read as the elimination of the national economy and national society, merely an assertion that we must examine the way in which national and international developments were transmitted to the working class by local circumstances.

The early chapters are concerned with establishing the basic relevant features of the economic and social structure of the area, while the later chapters examine the main artisan institutions, working-class politics, and the nature of artisan ideology. Chapter 2 describes the area of study, its physical development and relationship to London, while also sketching some of the broad features of the process of residential segregation that took place during the period. The next chapter examines the employment structure and the principal industries in Kentish London. The character of that industry is emphasised, particularly the nature of the workforce it employed and the structure of firms within it. The purpose is to see how far industrial capitalism appeared from the local economic structure to be a permanent phenomenon that effectively shut off economic opportunity for various sections of the working class. From that basis, chapter 4 focuses upon the specific relationships within the workforce, as dictated by the industry and job structure and the trade unionism that went with it, and the extent to which these industries encouraged differentiation and fragmentation within the working class. The other side of this picture is to establish whether the social structure of the community itself was such as to encourage this fragmentation or to discourage it. A situation where the local social structure did not mirror the local economic structure, that is where local status, power and wealth were not seen to derive from the work of the town's working class and its industry, was one which increased the logic of social stratification within the working class. In the same way, a community where wealth and power lay in the hands of big permanent employers might encourage perception not of the group but the class position. This is the subject of chapter 5.

The rest of the book is concerned with some of the results of this situation. A number of working-class institutions are examined, first to see the extent to which they reveal the separation from the rest of the working class of a status-conscious elite of stable skilled workers, with its own life style and aspirations. Secondly, to deepen our understanding of the activities and ideology of that labour aristocracy. Finally, a lengthy examination of working-class political activity is undertaken to see the way in which the specific elitism, and the ideology and traditions which it embodied, can explain the nature of working-class politics in the area. In addition, the absence of a politically conscious and ideo-

logically aggressive middle class distinguishes Kentish London from certain other towns in this period, and has a particular and continuing effect on the style and the ideological position of popular politics in the area. Chapter 6 draws together the threads of the argument in the early chapters, and presents additional analyses of differentiation within the working class on the basis of a variety of material such as a social survey from the 1880s, and an extensive analysis of marriage registers. It discusses the whole concept of a labour aristocracy and its relationship to other social strata. Chapter 7 outlines the main threads of the artisan value system that emerges from subsequent chapters, incorporating additional evidence on aspects such as mechanics' institutes and religious participation.

The unskilled section of the working class, especially numerous in a riverside area such as Kentish London, are not the primary focus of this book, concerned as it is with the labour aristocracy. Yet any analysis of one social stratum and its ideology must of necessity relate it to others. It is thus that unskilled workers appear, in terms of their relationship with skilled workers in the workplace, in marriage and in institutions. The position of unskilled workers was not static. The book notes the improving opportunities enjoyed by them at various points – their growing membership of friendly societies is one example, but chapter 9 demonstrates the way in which this was carefully circumscribed to protect the labour aristocrats' superiority. Their prospects for marriage contacts outside the unskilled stratum also improve. In other words their position was not static, though the interesting changes were in a context that did not effectively damage the elitism of the labour aristocracy. No claims are made, however, to examine fully what unskilled workers were specifically doing in terms of activities, life style, culture, values and so on. That would be a valuable project – we know all too little about the situation of such workers in Victorian society.[24] Yet it is a task of great difficulty. Establishing the characteristics, situation and values of the organised and collectively articulate artisans has proved difficult enough. Problems of studying the unskilled must be far greater. No wonder that so many historians have been deterred, at least until unskilled unionisation presented the labour historian with a wealth of accessible sources.

Trade unionism was for skilled workers the basis of so much of their strength that emerges through this study. Two basic aspects of this will be examined, and they will be divided between two chapters. In chapter 4 the size and scope of trade unionism in Kentish London will be examined in the course of looking at differentiation within the work-

place. The role of trade unionism in artisan life will be analysed in chapter 7, its functions in bargaining and craft defence, the way in which its conflict situations could have been incorporated within the broader artisan ideology. It might have been worth presenting a fuller analysis of trade unionism, but source limitations have made it impossible systematically to uncover evidence about the questions that relate to this study. The problems would have been less in a town with its own trade union structure and, more important, its own surviving records. For Kentish London, however, I have been unable to find any local records, any information as to local experience. One is left with the entries in national union reports, which tend to be brief, limited and bureaucratic in content; and newspaper reports, which rarely go beyond an intermittent coverage of strikes and occasional local celebrations. The continuing questions of local trade unionism cannot be answered from the sources available, beyond the degree presented here. The existence of local and metropolitan unions that have left no records at all, and which proliferated in the London area even into the period of amalgamations, only made the sources problem more serious.

With these points out of the way, we shall turn to examine the geographical area that is the focus of attention, mid-Victorian Kentish London.

2 THE GROWTH OF KENTISH LONDON

The segregation of social classes on a large geographical scale was a matter of social concern to many residents of mid- and late-Victorian London, and has been of analytical concern to later historians. This process was not segregation into separate parts of a still cohesive town, for this was evidently proceeding elsewhere, but into what might almost be described as separate towns. London became fragmented in the second half of the nineteenth century by a multiplication of local communities that were increasingly unbalanced in their internal social composition. This phenomenon has come to be well understood, and no attempt can be made to wrestle with the difficulties with which the metropolis confronts the modern historian that does not allocate a central role to the problems of social relationships that it creates. Edward Denison and the Charity Organisation Society each recognised that problem as early as the 1860s, and sought to create either a surrogate or a real 'resident gentry' to fill the void.[1] The danger in giving excessive weight to such analyses, however, is that the characteristics that are most important in studying major areas of London come to be transferred as a generalisation to the whole of the metropolis. The riverside area that stretched from Deptford to Plumstead, an area that was principally composed of the three towns of Deptford, Greenwich and Woolwich, was one exception to the general social developments of London as a whole in this period, and it is likely that areas of southwest London were similarly distinctive.[2]

The towns of Kentish London were separate and identifiable communities, more self-sufficient in their social relationships and more complete in their social composition than most other parts of London. Only at the very end of our period can we detect the beginnings of a mass exodus of the more prosperous strata of local society, although from the 1850s the towns were very slowly losing some of their 'old and respected inhabitants'.[3] This argument of relative completeness is not meant to deny a process of residential segregation within the towns, but to suggest that what was taking place was more an internal reorganisation involving the development of new residential areas within the existing districts, rather than the movement of certain strata away from the towns altogether. Deptford, Greenwich and Woolwich grew as real communities with their own middle class, their own industries, their

24

own internal social relationships. This 'completeness' of the area had caused confusions in the debate on whether to enfranchise Greenwich in the First Reform Bill. Peel's opposition was on predictable criteria. He could see no peculiarity in its trade, population or commerce especially entitling it to that prestige. Other speakers feared that the voters of the new borough would return 'low' men, while Hodges disagreed, convinced that the large number of respectable citizens, including many wealthy merchants, would make it 'a most unobjectionable constituency'.[4] The peculiarity of Kentish London was thus already creating confusion. It had a substantial working class, much of it dependent on government works in shipbuilding, munitions and engineering. It had a substantial bourgeoisie and professional elite. Yet what often united them was not an economic relationship based on employment but a social relationship based on community.

There had long been significant settlements at these locations along the south bank of the Thames, and by the beginning of the nineteenth century the only places around London that were larger than villages were Greenwich, Woolwich and Croydon. Deptford and Greenwich, separated by the River Ravensbourne, had long been an important shipbuilding centre, probably from the late Middle Ages.[5] Historical as well as economic reasons can thus explain why the shipbuilding works were the traditional focal point of Deptford. Local legend held that Alexander the Great worked in the town as a common shipwright, but there is more authenticity in the story that Peter the Great was a ships' carpenter in the Dockyard.[6] Shipbuilding can also help to explain the growth and permanence of Woolwich as a population centre. With the river deeper there than at Deptford, Woolwich Dockyard was constructed in the sixteenth century.[7] The expansion of the town was assured with its choice as a location for the national munition works and for permanent army barracks. When Daniel Defoe visited Woolwich in the 1720s he found it 'wholly taken up by, and in a manner rais'd from, the Yards and publick works, erected there for the publick service'.[8]

Fashion rather than industry was the main support of Greenwich until the nineteenth century. To Defoe it was 'the most delightful spot of ground in Great Britain'.[9] Its great natural beauty, its location on the river and the absence of heavy industry brought it royal patronage from the sixteenth century, and the Palace, Hospital, Park and Observatory assured it visitors and fame. If the town could attract visitors, it could also offer much to wealthy inhabitants, and Defoe felt that the residence there of gentlemen, businessmen and naval gentlemen had resulted in the fact that even in the early eighteenth century 'the Town

of Greenwich begins to outswell its bounds'.[10] Greenwich was thus well established before its industrial development.

Long before our period, then, Deptford, Greenwich and Woolwich had taken on separate existences. They were not part of London, and through much of the Victorian period they resisted absorption. That resistance could be local and self-conscious, and literary sources for such detachment must be treated with the scepticism that local chauvinism must always arouse. There will always be local people eager to claim the distinctiveness of their own patch of a town, especially in the context of Victorian civic consciousness. Nevertheless, the same picture emerges from more reliable evidence on the extent to which the towns of Kentish London were integrated into the London labour market. The degree of daily movement between the area and inner south-east London seems small, and it was not common for workers who had their employment in London itself to choose to live in Deptford or Greenwich, certainly not in Woolwich. Transport deficiencies and the powerful forces for inertia in inner-city living that so resisted decentralisation of working-class residence clearly prevented that. The most straightforward indicator of labour markets is to be found in trade union branch and district organisation,[11] and the clear distinctiveness of Woolwich in this respect, and the more ambiguous distinctiveness of Deptford and Greenwich, emerge from examining the extent to which Kentish London branches were within the London districts of their union, the involvement of those branches in London trade disputes, and local wage rates and hours of work. Woolwich branches of major unions (especially in the building trades, a sensitive indicator of this) were generally outside the London district, and in both pay and hours of work the town constantly lagged behind London as a whole. The same type of evidence points to Deptford existing firmly within the orbit of Greenwich in terms of branch organisation and consequently conditions of work. Greenwich's own separation from London was more ambiguous than that of Woolwich, but the branch evidence that does exist, the tendency of wage rates and hours to lag behind those of London, and an only hesitant involvement in London trade movements, suggest that it was very much on the margins of metropolitan influence.[12]

Identifiably separate from the metropolis, Kentish London was also clearly internally divided between the three towns. Deptford was cut off from London by the broad, undeveloped land of the docks, railways and market gardens, and as late as the 1880s Ellen Chase found it to be a self-contained area. 'Deptford', she wrote, 'was uncommonly like a small country community in some ways.'[13] Frederick Willis's memory

of the turn of the century is in accord with that. 'Despite its trim neighbours,' he claimed, 'Deptford made no attempt to become suburban. It was a town in its own right.'[14] Throughout the period of this study the town had considerable farmland on its highly fertile borders. This was mainly market gardens and nurseries, but there was also some intensive farming, with mixed arable to the south. That farmland, together with the flood plain, Hatcham Park and the slopes of Telegraph Hill, enclosed the town and gave it a tightness that it only slowly lost.[15]

The River Ravensbourne separated Deptford from Greenwich, and the penny toll on each crossing of the bridge at Deptford Creek provided a surprisingly strong barrier to the mixing of the two towns. When men crossed the bridge for work their wives would bring lunch to the bridge and pass it across, thus saving twopence on midday tolls.[16] The local press repeatedly affirmed that the toll was a serious obstacle to social intercourse between Deptford and Greenwich,[17] but it was not removed until 1880.

Finally, the Greenwich Marshes and Woolwich Common meant that Woolwich and Plumstead formed a town by themselves. In 1840 the Woolwich vestry petition against the extension of the Metropolitan Police to the town stressed how isolated it was, miles from Greenwich and Blackheath.[18] This was true, for though an occasional chemical or rope works made use of the open land and cheap rents between Greenwich and Woolwich, there was little else there. In the 1840s the area had been little more than meadow and pastureland. Of 600 acres, only 56 were developed, even as market gardens.[19] In Alfred Bennett's youth in the 1860s 'the path along the river to Charlton and Woolwich . . . was . . . a desolate embankment overgrown with wild vegetation'.[20] The riparian settlement at Woolwich, founded entirely on isolated chalk bluffs, thus grew alone.

This broad division within the area, and separation from London, were characteristics of which the local press and middle-class political leaders were very conscious. It was not only an identifiable sub-area of London, it was a somewhat isolated sub-area, and one which was itself divided. There is no single explanation of Kentish London's development in relative isolation from the rest of the metropolis. During the mid-Victorian decades the area failed to fill up as a dense and expanding part of London, in contrast to central south London which responded to the pull exerted by Croydon and the south coast. This neglect of development towards Woolwich is all the more unexpected when it is remembered that the town shared with Croydon a uniqueness of size and proximity to the metropolis. Yet it was the Surrey town which saw

London reaching out to meet it, through ribbon development along lateral roads followed by the even more important railway link to Croydon itself and beyond to Brighton and the south coast. These transport developments made the intervening land ripe for the construction of residential housing. The Thameside location of Woolwich, on the other hand, meant that a road or rail link with it opened up no fresh territory but merely passed through the marshes and claylands which had long resisted settlement. In fact, it was not until the twentieth century that the substantial area between Greenwich and Woolwich was filled by the major expansion of Charlton and Kidbrooke. One consequence was the failure of the region to the south of riverside Kentish London to develop extensively.

Communications were partially a response to demand, but studies of the growth of London stress how the supply of transport facilities was itself a spur to the creation of residential areas and peripheral centres.[21] Coaching roads were of great importance at first, with new estates filling in the gaps between the roads, and this lateral form of development was emphasised by the increasingly important role of trams and omnibuses. The actual direction of the growth south of the Thames is therefore initially explicable in terms of road development. Until the early nineteenth century the Thames had proved a strong barrier to the southward expansion of London beyond the ancient settlement at Southwark. The construction of new bridges at Vauxhall, Waterloo and Southwark changed all this, and were followed by new turnpike roads to Kennington, Newington Butts and Camberwell and new coaching routes to the coast. These stimulated prosperous middle-class property development beyond the older areas. By the 1820s, many short-stage coach routes were running to Clapham and Camberwell.[22] For these reasons, both south-west London and the central southern areas formed an increasingly solid block adjoining the central areas north and south of the river, and neither followed the pattern of development that characterised Kentish London. The neglect of Kentish London in transport services may be seen as the major reason for the slow suburban build-up of the area.[23] The great attraction of the principal areas of Kentish London was the river, and although it was undoubtedly put to great use for transport, it was an unreliable means of regular communication. Problems were repeatedly caused by uncertain weather conditions and accidents on the river, not to mention more bizarre hazards such as the whale sighted off Deptford in 1842.[24] The Thames came to be limited to holiday traffic, as Greenwich reached its heyday as an excursion centre. Water transport was nevertheless Kentish London's only advan-

tage. In other spheres of communications the area lagged, being poorly provided with omnibus and coach services. Woolwich was especially isolated. In 1870 there was just one service to Deptford and Greenwich from Gracechurch Street, while Lewisham enjoyed only one coach a day.[25] Trams served the area well, but developed only at the very end of our period, and they tended to cover short journeys.[26]

If roads and omnibuses provided the initial impetus, it was the railway that was the major force in extending the metropolis. This was especially true to the south, where railways, with little lucrative freight and long-distance traffic, encouraged residential settlement to a greater degree than their counterparts on the other side of the river. Here again Kentish London was neglected, in spite of the fact that the first passenger railway in the London area was that from London Bridge to Deptford, which was opened in 1836 and extended to Greenwich in 1838.[27] If we look to the south of the three riverside towns, the area whose slow development we are trying to explain, we find a relative neglect by railway companies in terms of both services and lines. In 1849 the North Kent Line was opened, running to New Cross, Lewisham, Blackheath and Woolwich. No further major line into Kentish London was constructed during our period. This stands out in comparison with the very extensive network of lines and services that was built in other parts of London, notably in the 1860s.[28] Furthermore, in spite of the lack of heavy industry, mineral traffic and provincial cities in its region, the South Eastern Railway Company was slow to develop its passenger traffic,[29] and its lines were always expensive ones on which to travel. The *Deptford and Greenwich Chronicle* saw this as a major reason for the lack of demand for better-class housing in Deptford around 1870.[30]

This case must not be overstated. There certainly was development in the area to the south of Deptford, Greenwich and Woolwich. As the traditional suburbs came to be threatened by the growth of estates on the outskirts of inner London, Blackheath, Lee and Brockley became increasingly popular for suburban residence, but to a lesser extent than other suburban areas. The main areas of growth in Kentish London remained the old riparian industrial zone until the 1860s. Then only Deptford continued to grow and the main increases now occurred in the peripheral areas to the south. By now, however, the development of that area lagged behind other parts of London. The transport deficiency and the consequently slow pace of suburbanisation must have been an important factor in reinforcing the sense of isolation that pervaded Kentish London during the nineteenth century.

This study is thus concerned with a riparian development building up around three existing town nuclei and retaining, during that development, the structure of three separate communities. It is in this context of developing heterogeneous social communities that working-class development during the period must be understood, rather than that of the overwhelmingly working-class districts that characterised inner south London. The details of population growth illustrate this picture. Table 2.1 shows the population for both the main core of Kentish

Table 2.1: Population of the Principal Districts of Kentish London, 1801-81

	1801	1841	1851	1861	1871	1881
Core areas						
Deptford	18,282	25,617	31,970	45,973	60,188	84,653
Greenwich	14,339	29,595	35,028	40,002	40,412	46,580
Woolwich*	9,826	25,875	32,367	41,695	35,557	36,665
Plumstead*	1,166	2,816	8,373	24,502	28,259	33,250
Charlton*	747	2,655	4,818	8,472	7,699	8,764
Peripheral areas						
Lee	376	2,360	3,552	6,162	10,493	14,435
Kidbrooke	58	597	460	804	1,865	2,166
Lewisham	4,007	9,361	10,560	12,213	17,460	26,989
Eltham	1,627	2,186	2,437	2,867	4,064	5,048

*Woolwich, Plumstead and Charlton must be seen basically as one town.
Source: Printed Census Tables.

London and the peripheral areas. The expansion of the three main foci took place as accretions to an existing core. This is not a quirk of the registrar-general's divisions, for the peripheral areas existed as separate communities and developed as such. There were, of course, close relationships in terms of work, labour markets and other forms of contact between the areas, but the main centres appear through the literary and newspaper evidence as separate towns that were experienced as such.[31] One example was in 1859 when the *Kentish Mercury*'s Deptford reporter bid farewell to Mr T. Veness who was leaving the area, and leaving the local community affairs in which he had been prominent. He was going to live in Lee.[32]

A brief description of these peripheral areas will give a picture of the geographical and residential context into which the specific growth of the three towns has to be set. In the early nineteenth century the scattering of small settlements from Lee to Eltham was composed of

small indigenous village populations together with wealthy residents, notably gentry, nobility and very prosperous merchants. From the 1840s professional and business middle-class families began to move in,[33] a process increased in the 1850s by the opening of the North Kent Railway. These were the dormitory areas that grew from the middle decades of the century, often grouped around the only relevant railway line. Such were the expanding settlements at Lewisham, Lee Green, Catford and Kidbrooke. The social character of the area is further demonstrated by the large number of private and endowed schools, especially boarding schools, at Lee, Lewisham, Sydenham and Blackheath.

In the 1840s Lewisham village was largely a rural area, with a number of middle-class residences, while Sydenham was growing with spacious brick villas. Kidbrooke was composed of little more than a manor farmhouse and labourers' cottages. Then the real growth took place. The wealthy merchants and gentry began to leave Lewisham, and it came to be dominated by the solid middle class in the late 1860s, together with some lower-middle class, clerks and skilled workmen.[34] By the 1880s skilled workers were an important part of the Lewisham population, and the local Charity Organisation Society secretary could deny the existence of any slums in the area, on neatly expressed grounds that 'the population comes up to us'.[35] The other districts, however, did not even change this far until the turn of the century. The relative social decline of Lewisham from the 1880s was abrupt, for as late as 1867 it could be said of Lee, Lewisham and Kidbrooke that they 'are wealthy parishes, the bulk of their ratepayers being well-to-do merchants holding their houses as country residences'.[36] Even in 1896 Westcombe Park, Lee, Blackheath and Lewisham were described as prosperous residential localities.[37] Of all the growing villages, Kidbrooke was the most exclusive. In the 1850s slow development began on the land owned by Lord St Germains, who allowed no development below a certain value.[38] Kidbrooke and the southern parts of Charlton Village came to be inhabited by 'city gentlemen and others who generally occupied villa residences in good neighbourhoods'.[39]

This was the basic pattern of residential development to the south of the riverside towns. All else was villages, hamlets, market gardens, farmland, parks and heath. This was of course its great residential attraction. The social exclusiveness of these districts in 1867 is confirmed by Table 2.2, which shows the rateable value per head of population in the Lewisham and Greenwich Unions for 1867.

The first purpose of this chapter has been to establish the atypicality

Table 2.2: Rateable Value per Head of Population: Kentish London, 1867*

	Rateable Value 1867 (£)	Population 1861	R.V. per head of population (£)
Deptford	140,743	45,000	3.1
Greenwich	136,032	34,801	3.9
Woolwich	79,913	41,693	1.9
Plumstead	57,346	24,379	2.4
Charlton	45,377	8,164	5.6
Lee	55,290	4,750	11.6
Kidbrooke	13,604	460	29.6
Lewisham	200,595	17,240	11.6
Eltham	21,680	3,044	7.1

*Some discrepancies in population figures between this table and Table 2.1 are due to boundary differences.
Source: Calculated from data in *Kentish Mercury,* 7 December 1867.

of Kentish London within the metropolis as a whole, and to emphasise and explain its separate development for much of the century. The other main task is to examine briefly the way in which the towns grew, and to observe within them the segregation of broadly different social status groups.

Deptford was always the poorest of the three towns, and this relative poverty was made especially apparent by the fast decline of the riverside parts of the original settlement. The town grew around two points, the Thameside and High Street area, and Deptford Bridge. Under various pressures, not the least of which was the growth of some unpleasantly pungent small factories, this central core became a working-class area fairly early in the period. The greatest decline was in the riverside area, the small parish of St Nicholas, which stagnated in its persistent poverty.

The parish officers complained in 1866 that the high turnover of weekly tenants in the parish made the collection of rates impossible.[40] No other part of Deptford declined to this level during our period, but the rest of the core of the old town became principally working class at quite an early stage. The comfortable business and tradesman class had once lived there in large numbers, for they had left behind them the large three-storey family residences which were converted to tenements.[41] The total exodus of the indigenous middle class was slow. Initially, and for much of the period, they moved to developing areas around the core, notably to the west and to the south. The district to the south of the New Cross Road was ideal for middle-class estates.

Hilly and attractive, it compared favourably with the flat and dull area northwards to the Thames. However, the first major developments from the old core were the artisan housing that established the New Town and Hatcham. Deptford New Town, between the railway and the New Cross Road, took in the Drake Property, which was from the 1850s specifically developed for the better artisan and lower middle-class strata.[42] A similar demand stimulated growth at Hatcham during the 1850s and 1860s. This character was maintained in the 1880s, for Booth found it to be occupied mainly by well-to-do working class and clerks, 'many of whom have probably bought the leases of their houses'. The streets were wide, and the houses had gardens, and there was 'a general aspect of comfort and respectability'.[43]

The principal middle-class expansion took place to the south of the Broadway and the New Cross Road, which was extensively settled from the 1860s. Residents of the Wickham Road, Brockley Road and Malpas Road area demanded a railway station there in 1870, on account of the fast development of houses 'occupied principally by gentlemen who were employed in town'.[44] It was to such estates that the indigenous middle class of the town began to move, and they were still there at the turn of the century.[45] Here one found many residents who travelled each day to work in London, one of whom felt it was more befitting his dignity to say that he lived in New Cross, though he recognised that it was really Deptford.[46] The most important feature of the growth of Deptford was thus the clear separation that Booth found[47] but which had been proceeding throughout the period, of artisan and lower middle-class strata to the south-west and of a middle-class population to the south, leaving the mass of the working class in the centres of old Deptford and round the railway at Hatcham.

The Hospital, Naval School, Park and Blackheath divided Greenwich in two. While both Deptford's street markets were centrally located in the High Street and Broadway, Greenwich had two markets to the west of the Park and one to the east. This division might explain why residential segregation on a social basis was never as decisive in Greenwich as in other parts of Kentish London. It took place, none the less. The poorest part of the town was always St Peter's parish, a fairly isolated area that stretched from the Creek to the Hospital, hugging the river all the way. Away from the river lay the major core of the town, the area north of the railway, between the Creek and the Park. This was socially mixed from the beginning of the period, and in many ways it remained so.[48] Even when Booth was examining the area he judged the population to be fairly evenly divided between three groups. These were gentry and

shopkeepers, artisans and labourers.[49] To the south lay the comfortable middle-class developments that stretched towards Blackheath. The central area of Greenwich did not decline during these decades in the way that old Deptford did, principally because the centre of new working-class settlement was focused elsewhere, to the east, where the major industrial growth took place from the 1850s.

East Greenwich was from the beginning divided into fairly clear residential areas. The unskilled and poor lived to the north, with an area settled by clerks, travellers and regular skilled workers to the south around Maze Hill and Greenwich Park. Comfortable middle-class development took place towards Kidbrooke and Westcombe Park. In general terms, then, the expansion of Greenwich was southwards towards Blackheath Road, and to the east. Overall, the residential segregation was less marked than Deptford in the western parts. This must be related to the nature of the town's growth, with the development of two separate centres, and to the fact that the industrial area did not grow within the old residential district. The social effects of the halt to the economic expansion of Greenwich in the 1860s meant that the western part of the town was able to sustain the existing residential structure without undue strain.[50]

On the southern border of Greenwich was Blackheath, many of whose residents were active in Greenwich political and social affairs; yet Blackheath, more than any other part of the area, was an important place for wealthy London businessmen, professional men and merchants to live. Samuel Smiles chose to live there when he was appointed secretary of the South Eastern Railway Company in 1854.[51] Spasmodic building of Regency and early Victorian houses around Blackheath Park and St Germain's Place characterised the first half of the century, but the real impetus for growth in the area to the north, more adjacent to Greenwich, came after the opening of Blackheath Railway Station in July 1849. This development was in the area around Eliot Vale, Dartmouth Row and Morden Hill, with large and expensive houses, whose attractions with those of Blackheath as a whole are still in evidence. John Stuart Mill and Harriet Taylor moved there in 1851, and Charles Eliot Norton's description of their house shows both the appeal of the area and the nature of the villa residences that it offered.

> A square, plain, brick mansion in a little plot of ground . . . but with a characteristically English air and look in its seclusion behind a wall, and trim thick shrubbery, and the ivy covering one side and affording a shelter for innumerable twittering shadows. Over the way is a wide

open space of rolling meadow bounded far off by a blue outline of distant hills.[52]

Woolwich itself grew little during the period. Even by 1851 it was capable of no further expansion, with its 'thickly inhabited streets being hemmed in betwixt the river, the Dockyards, the Arsenal, and the military establishments on the Common'.[53] The town that developed was a larger one than Woolwich itself, and we must really consider a single social and geographical entity that embraced both Plumstead and Charlton, for it is in these areas that extensive building took place. The core of Woolwich, St Mary's parish, always had a limited middle-class population. Woolwich grew from its early years as a garrison as well as an arsenal town, and if the large working-class population had not deterred non-indigenous middle-class settlement in the early history of the town, the large military presence would certainly have done so. A local observer declared that one could draw a line around the main part of old Woolwich — 'dirt and squalid misery reign supreme' in a densely crowded neighbourhood.[54] When Booth examined the central area of Woolwich, he found large tradesmen still living in the main streets, but apart from skilled workers to the south the rest of the population was poor.[55]

This central area was surrounded by 'suburbs of Woolwich'[56] that were really part of Woolwich's natural growth. They looked to Woolwich as their centre, and were clearly accretions to the old town. The Charlton Road and Shooter's Hill area was increasingly inhabited by tradesmen and prosperous army people, together with London merchants. Growth here was early; by 1854 it was 'this now fashionable locality'.[57] There was no difficulty in selling the 'genteel villa residences' that sprang up on the Herbert Estate on the eastern side of Woolwich Common in the 1860s.[58] Charlton Village attracted new residents of a similar standing. The most important new developments, however, were working-class housing that created New Charlton and Plumstead New Town. W.T. Vincent, the chronicler of the Woolwich district, remembered Plumstead before the development as 'a small village, a mile away from Woolwich, down a long country lane with hedges and ditches, and only a few houses scattered|along the wayside'.[59] The growth of Plumstead New Town and Burrage Town alongside it during the 1850s was phenomenal, achieving the largest inter-censal growth (293 per cent) of all London parishes during that decade. 'The once rural parish of Plumstead [is] suddenly rising into the importance of a populous town', declared the impressed *Kentish Mercury*.[60] The

impetus behind this dramatic building activity was the demand for housing created by the huge expansion of the Arsenal for the Crimean War. The Burrage Estate and New Plumstead were principally developed for, and inhabited by, skilled artisans and supervisory grades from the Arsenal.

On the other side of Woolwich, the development of New Charlton followed at a somewhat later date, spurred by the arrival of some important new industries near the river and by the general pressure for housing in Woolwich. New Charlton and, until the latter part of the period, the Dockyard area, together with New Plumstead, were principally inhabited by skilled workers, often those in regular government employment. The district between them was always a poorer and more volatile one. The overall pattern for Woolwich was thus closer to the Deptford model than to that of Greenwich, with a central working-class area increasingly dominated by the poor and unskilled, and the steady growth of middle-class areas to the south, and the segregation of fairly clear artisan housing.

These patterns of development, the social segregation, the self-contained nature of the towns, their relative isolation from London, and their degree of detachment from each other, are the essential background to the analyses in the chapters that follow.

3 OCCUPATIONS AND INDUSTRY

This chapter will outline the structure of employment and the industrial base of mid-Victorian Kentish London. The first section will provide a schematic picture of the ways in which the inhabitants of the area earned their living, and will also reconstitute the occupational information in such a way as to suggest key features of the social structure. The second and more substantial section will be more concerned with the main sectors of working-class employment, the size of the firms involved and their longevity. Together, the two themes will provide an essential empirical basis for the analysis of work relationships and social elites in the chapters that follow.

Occupational Structure

The principal source for any brief examination of occupational structure must be the printed census tables. It is important to remember the inadequacies of this source, for no matter how sophisticated the techniques of analysis employed, faulty data will remain faulty. Among the analyses that cannot be made from the printed tables is a breakdown of social structure. The classification used in the tables is an industrial one, which may, where sufficient detail is given, be manipulated into an occupational classification. It is not a sociological classification, for it in no way distinguishes social strata except where they can be confidently said to coincide with occupational groups.[1] In particular, it is difficult and often impossible to separate employer from worker, clerk from professional, and skilled from semi-skilled and unskilled within a given trade or industry.

Additional problems are posed by the inadequacies of the tabular presentations in 1871 and 1881. The 1841 census tables give an occupational breakdown for Deptford Town, Greenwich Town and Woolwich Town, the three constituent parts of the Borough of Greenwich. The subsequent two censuses give this breakdown for the Borough of Greenwich as a whole and for the Borough of Lewisham, classifying the occupations fairly crudely but giving sufficient information for reallocation to a different system of classification. The 1871 census only presents the totals for each of seventeen broad and unhelpful industrial classes, and it gives this information for districts different from those used in previous censuses. More occupational detail is given

in 1881, but only for a large area called Intra-Metropolitan Kent. For these reasons, the census tables for 1841, 1851 and 1861 are the only ones that can be satisfactorily used in this analysis of occupational structure.

The census districts divide between Greenwich and Lewisham, both referring to the boroughs of those names rather than to the specific localities. While a more precise town by town presentation would have been useful, the division is an acceptable one, for the Borough of Greenwich encompassed in essence the riverside core area, while the Borough of Lewisham covered the peripheral area to the south. An awkward exception is Plumstead (also Charlton, though this is less important), which fell in the Borough of Lewisham. In 1861 this anomaly seriously distorts the industrial content of the peripheral areas while under-representing that of riverside Kentish London.

The data in this section will concentrate on adult male civilians. This matters in Kentish London, for the army and navy barracks in the Borough of Greenwich,[2] particularly at Woolwich, accounted for a high proportion of the resident adult males. In 1841 there were 3,145 army and navy personnel over the age of twenty in the Borough, equivalent to 17.4 per cent of all occupied adult males. In 1851 the total was 8,374 (29.3 per cent), and in 1861 it was 7,591 (21.1 per cent). They were important for the social life of the area, in that both active and retired officers would often participate in local society. The army could also be useful for law and order. Woolwich Vestry argued in 1840 that the soldiers were there should disorder occur,[3] and although they intervened only rarely the troops did parade through Woolwich during the Murphy riots of April 1870.[4] In the occupational analysis, however, armed personnel have been excluded, and they do not appear in the figures for the total occupied population.

The concentration of the occupational analysis was described as being upon adult male civilians, and that is because of the absence of serious employment for either women or children in the area. A major theme of this book argues that the dominant industries of the area were characterised by employment structures that separated a skilled elite from the mass of the workforce. If employment for women and children existed, and if it went to the families of unskilled or semi-skilled workers, then it could be one factor in closing the distance in life experience between labourers' and artisans' families. In fact, Kentish London was particularly devoid of any special sources of female or child work. None of the major industries were those which employed substantial numbers of children, except for some work of uncertain

availability filling cartridges and rockets in the Royal Laboratory Department at the Arsenal. Adult female employment is shown in Table 3.1, and it can be seen to have hardly existed outside clothing, personal service and laundry work. There was certainly no industry playing the

Table 3.1: Female Employment in the Borough of Greenwich, 1841-61

	1841		1851		1861	
	no.	%	no.	%	no.	%
Personal service	2,566	54.2	3,811	38.5	4,748	41.1
Laundry	473	10.0	1,158	11.7	1,430	12.4
Clothing, textiles	837	17.7	2,320	23.4	2,661	23.0
Shoemaking	61	1.3	472	4.8	603	5.2
Food manuf. and distribution	137	2.9	393	4.0	399	3.5
Distribution (excl. food)	123	2.6	264	2.7	304	2.6
Inns, pubs, lodging houses	61	1.3	351	3.5	366	3.2
Teaching	208	4.4	446	4.5	460	4.0
Agriculture	76	1.6	192	1.9	206	1.8
Miscellaneous	188	4.0	487	4.9	379	3.3
Total occupied females over 20 yrs	4,730		9,894		11,556	
Total females over 20 yrs	23,700		28,519		35,593	
% adult females occupied		20.0		34.7		32.5

Source: Printed Census Tables 1841, 1851, 1861.

role that the cotton industry had in Lancashire, where the whole family employment structure was distorted by the degree of dependence on female and child labour. There was no substantial industrial or even regular employment, other than domestic service which bore little relevance to family income. The clothing workers, for example, were almost all intermittent outworkers, principally milliners, dressmakers and makers of fancy items. Female occupations of an extremely irregular kind would still be entered on the census form, and thus appear in the final tables. There were some exceptions, such as the shirt factory in Creek Road, Deptford, that employed almost entirely women in the 1850s.[5] In addition there was the military clothing store in Woolwich, employing 350 women indoors as well as outworkers until its closure in 1868. This, and the women's employment on powder bags in the Arsenal, generally went to the widows of soldiers.[6] Firewood chopping at Wells' wood merchants in Deptford seems, in fact, to have been the most substantial firm oriented to female labour, employing some 300 women and girls in 1858.[7] This is the extent of the large employment available for women and children outside domestic service and irregular

outwork in clothing. There were no industries that could fundamentally alter the family income structure in such a way as materially to affect social distance within the working class.

Although social structure cannot be reconstructed from the printed census tables, this does not preclude an analysis which retains the basic industrial occupational data but still indicates some of the broader social characteristics of the area. The occupied adult male population may be divided into three main categories. First, professional, administrative and commercial occupations; second, retailing; third, industrial and transport. Table 3.2 shows for Greenwich, Lewisham and the metropolitan area as a whole the proportion of the adult male occupied population in each of these categories.

The first group represents the non-industrial and non-tradesman middle class, encompassing gentlemen and those of independent means; those in the professions (including teachers[8]); and all commercial and financial occupations other than retailing, including of necessity all commercial and banking employees, merchants, brokers, accountants and commercial clerks. Greenwich proves to have a lower proportion in these occupations than London as a whole,[9] while the proportion for Lewisham is higher, reflecting the area's reputation as a residential suburb for the metropolis's business and professional middle classes.

The analysis of those involved in retailing (which includes assistants as well as proprietors, and excludes trades that combined retail with manufacturing operations) reveals a lower proportion in that sector in Lewisham, and to a lesser extent in Greenwich, than in London as a whole. Lewisham residents obviously supplemented local shops with visits to the larger establishments in the three towns — Woolwich certainly functioned in the 1840s as the market centre for most of West Kent's towns and villages[10] — while the Greenwich figures show the importance of central London to the middle classes of all towns within travelling distance.

The third main section of this classification is that of the staple working-class industries, although it unavoidably includes all in those industries and not just manual workers. The industrial category takes in all those in manufacturing and processing trades. If it includes some manufacturing/retailing trades, reflecting the character of the mid-nineteenth-century London economy,[11] it will still serve to estimate those involved in essentially manufacturing or processing industries, as distinct from those solely concerned with retailing. The transport category contains those in railways, docks, and river and road transport. General labour simply covers those described as such in the census tables.

Table 3.2: Occupational Structure of Greenwich, Lewisham and London, 1841-61 (as percentage of adult occupied males)

			GREENWICH	LEWISHAM	LONDON
1	Professional, administrative	1841	3.0		
		1851	4.0	6.2	5.9
		1861	4.5	5.8	5.9
2	Commerce, finance	1841	2.8		
		1851	2.5	4.5	3.9
		1861	2.8	5.9	5.2
3	Gentlemen, independent	1841	(5.0)*		
		1851	1.3	2.3	1.3
		1861	0.9	1.4	1.3
1-3	Total professional/commercial	1851	7.8	13.0	11.1
		1861	8.2	13.1	12.4
4	Retailing occupations	1841	8.9		
		1851	10.3	9.0	12.8
		1861	9.9	7.1	12.6
5	Industrial	1841	43.7		
		1851	47.8	39.3	46.4
		1861	47.2	51.6	47.3
6	Transport	1841	9.8		
		1851	12.2	5.2	10.3
		1861	13.1	6.8	12.2
7	General labour	1841	17.6		
		1851	12.6	8.7	7.3
		1861	11.8	6.5	6.3
5-7	Total industrial, etc.	1851	72.6	53.2	64.0
		1861	72.1	64.9	65.8
8	Agriculture	1841	4.2		
		1851	4.9	15.7	2.5
		1861	3.1	9.1	2.0
9	Miscellaneous	1841	5.0		
		1851	4.4	9.1	9.6
		1861	6.7	5.8	7.2
TOTAL ADULT MALE OCCUPIED POPULATION		1841	14,909		
		1851	20,182	7,601	597,702
		1861	28,302	15,575	671,052

*There is no explanation for this apparently freak figure.
Source: Printed Census Tables 1841, 1851 and 1861.

Almost half of Greenwich's adult males were involved in manufacturing or processing in 1851 and 1861, a similar proportion to London as a whole, while Lewisham in 1851 remained in that sense a distinctly

non-industrial area. If we remember that the fast-expanding Plumstead was enumerated in the Borough of Lewisham rather than Greenwich, these figures draw even further apart, for that fact seriously lowers the Greenwich figure for industrial workers and overstates that for Lewisham.

Greenwich's substantial number of transport workers reflects the general growth of London's transport facilities at the time, and Greenwich's own importance as a centre for docks and other riverside trades helps to explain the extremely high proportion of general labourers in the borough. This declines over the period as a whole, partly due to improved methods of classification, but also to a secular trend towards more identifiable trades and away from purely casual labour.

Greenwich thus had a heavier concentration of industrial and other manual workers than did London and a far greater concentration than Lewisham, whether before or after the growth of Plumstead. Middle-class non-industrial occupations were below average in Greenwich but over-represented in Lewisham with its regular commuters into London and the City. On the other hand, a greater part of Greenwich's middle class saw the town as their social base than did those in Lewisham, whose districts displayed an increasingly suburban character.

The more detailed structure of employment in Kentish London as shown in Table 3.3 points to the atypicality of the area within the metropolis as a whole. London was in mid-century the country's largest manufacturing centre though this has been obscured by the absence of either a predominant industry or large capital intensive operations. Most London workers in 1851 participated in small indus- tries, that were typically artisan and dispersed, often domestic. The major industries – clothing, shoemaking, timber and furniture, metal work and building – accounted for over 70 per cent of all London industrial workers in 1851. Bédarida rightly concluded that London was dominated by small units of production.[12] London was the greatest consumer market in the country, and that is one explanation of its industrial character. The distant location of coal and raw materials discouraged heavy industry, while ample credit facilities and ease of access to warehouses encouraged small enterprises. In fact, London's economy in the mid-nineteenth century was still predominantly small- scale, oriented towards artisans, small masters and outworkers.

All this applies to the old inner-industrial ring, not the more outlying areas along the Thames where land was cheaper and more readily avail- able and where the river could provide transport. Wandsworth was one

Table 3.3: Employment Structure: Borough of Greenwich, 1841-61
(occupied males over 20 years)

	TOTAL			PERCENTAGE		
	1841	1851	1861	1841	1851	1861
Agriculture and fishing	631	990	886	4.2	4.9	3.1
Engineering, founding, etc.*	1,146	1,523	3,051	7.7	7.5	10.8
Others in metal	212	303	399	1.4	1.5	1.4
Vehicle manufacture	124	214	263	0.8	1.1	0.9
Shipbuilding, dockyards*	833	1,799	2,986	5.6	8.9	10.6
Building	1,571	2,104	2,970	10.5	10.4	10.5
Shoemaking	682	848	942	4.6	4.2	3.3
Clothing, textiles	512	688	801	3.4	3.4	2.8
Furniture	80	138	166	0.5	0.7	0.6
Wood (exc. building, furn.)	463	581	688	3.1	2.9	2.4
Printing	35	107	164	0.2	0.5	0.6
Other manufactures	422	687	828	2.8	3.4	2.9
Docks and water	738	1,065	1,487	5.0	5.3	5.3
Seamen	507	634	1,108	3.4	3.1	3.9
Road transport	97	347	502	0.7	1.7	1.8
Railways	7	299	415	0.0	1.5	1.5
Labourer (undefined)	2,630	2,534	3,339	17.6	12.6	11.8
Food (manuf. and distrib.)	1,002	1,511	1,849	6.7	7.5	6.5
Innkeeper, publican	232	471	446	1.6	2.3	1.6
Other retail and distrib.	533	810	1,035	3.6	4.0	3.7
Finance, commerce	298	269	477	2.0	1.3	1.7
Government	87	234	700	0.6	1.2	2.5
Professions	216	450	584	1.4	2.3	2.1
Schoolteachers	132	170	176	0.9	0.8	0.6
'Gentlemen'	741†	260	254	5.0†	1.3	0.9
Police	105	230	247	0.7	1.1	0.9
Porters, messengers	42	81	130	0.3	0.4	0.5
Personal service	727	623	670	4.9	3.1	2.4
Other occupations	104	212	739	0.7	1.1	2.6
TOTAL	14,909	20,182	28,303	100	100	100

*The exclusion of Plumstead from the Borough of Greenwich particularly understates the presence of these industries.

†There is no explanation for this apparently freak figure.

Source: Printed Census Tables 1841, 1851 and 1861.

such district. Another was Kentish London, whose industrial structure
was quite distinct from that of early and mid-Victorian London. The
dominant trades of Kentish London were not those of the old skilled
artisan elite, whose economic and status problems underlie the history
of London radicalism in the first half of the century, and the attacks on
whose skills opened the gulf between the honourable and dishonour-
able sections of the trade that Mayhew observed in 1851.[13] The
typical older crafts and skills of London, whether those under strain
during the first half of the century or those maintaining their position
in the context of a luxury consumer market, are all under strength in
the area. Hall's site quotients relating the strength of a trade in a given
area to its presence in London as a whole shows this clearly. (A site
quotient of 1.0 indicates a presence in the area in the same proportion
as in London as a whole.) Clothing at 0.66 and shoemaking at 0.72 are
both substantially under-represented, but the really low readings are
for printing and bookbinding (0.15), cabinet making and upholstery
(0.27), fur and primary leather (0.17), saddlery and harness (0.46) and
watches and precious metals (0.26).[14]

The industrial structure of the three towns can now be seen as
breaking down into three important groupings. The first of these is
engineering and shipbuilding.[15] These were large-scale industries
developing new skilled elites, whose strength and status grew with the
older-established general crafts in these industries during the earlier
part of the century, and through the middle decades as far as London
was concerned. Machine making, marine engineering, armaments
manufacture and shipbuilding were all industries characterised by a high
proportion of skilled labour, where many different crafts worked in
many separate departments. This development was not typical of the
London metal-working industry as a whole in this period, which tended
to be dominated by small jobbing workshops. The categories of
engineering, heavy metal trades, shipbuilding and dockyards account for
13.3 per cent of the adult male occupied population in 1841, and 21.4
per cent twenty years later. These figures underestimate the position —
for they do not include a large proportion of the sawyers and wheel-
wrights who were also in these industries. More important, a very large
number of Arsenal workers living in Plumstead in 1861 and some from
Woolwich Dockyard are totally absent from this calculation.

Building, whose workers accounted for around 10 per cent of
occupied adult males in each census year, was the principal traditional
craft industry in the area. Organised fundamentally as small-scale pro-
duction, although large-scale contractors were important in the

government works, its character in terms of skill and artisan status changed little during the period.

The large proportion of 'general labourers' in Greenwich compared with London as a whole reveals the third major industrial grouping. It indicates the strong presence, particularly in Deptford, of apparently unskilled labour in docks, riverside employment, railways and road transport. The characteristics of riverside and docks labour will be discussed later, but it ought not to be described merely as unskilled. Absence of skill was no clear-cut characteristic in nineteenth-century Britain, but a relative assessment, and seemingly unskilled and casual labour could contain within it a multiplicity of trade divisions and status sub-groups.

These are the main sources of employment, the principal industries of Kentish London. The mid-Victorian years are dominated by the growth of the engineering, metal and shipbuilding industries, and a decline in traditional crafts such as tailors, shoemakers, leather and woodworkers, as geographical specialisation increased in the London economy. The decline in general labour reflects the expansion of unskilled and semi-skilled trades in the growth industries themselves, as well as the more prosaic improvements in census classification. In general, the strongest characteristics of the dominant and growth industries is that they are those whose skilled elite formed the backbone of mid-Victorian unionisation and, it has been argued, aristocracy of labour.[16]

Industrial Structure

When the *Kentish Mercury* cried that 'Greenwich has fallen asleep', and argued that 'the place has become a complete cul-de-sac, cut off from all its old connections, and leading to nowhere',[17] it was acknowledging the fact that, unlike Deptford and Woolwich, the prosperity of Greenwich did not totally depend upon industry. It was the recession in non-industrial wealth during the 1850s that produced that apparent crisis, in effect falling property values and rents, that gave so much anxiety to the town's social elite.

An article in the *Kentish Mercury* in 1858 gave a fairly accurate if caricatured picture of the sources of wealth for each of the three towns.[18] Woolwich rested on the Dockyard, Arsenal and army barracks. Deptford had its dockyard, victualling yard, the General Steam Navigation Company's works, and various manufacturing industries. The wealth of Greenwich, however, came from its importance as a place of residence for wealthy families and as a place of resort for day's outings.

The importance of holiday traffic to Greenwich was immense. Boats alone brought 10,000 visitors to Greenwich on the first August Sunday in 1840.[19]

During the 1850s a combination of railway travel and the rise of other attractions around London drew pleasure-seekers away from the town. 'Gardens' sprang up, those formal organised pleasure centres which proved such a magnet to working-class and lower middle-class families on their days off. So it was that Greenwich yielded to the Rosherville Gardens, the Erith pleasure gardens, the gardens at Cremorne, Crystal Palace and the Surrey Gardens, and ultimately to seaside holiday excursions. Yet Greenwich did develop over time a considerable base of manufacturing industry, although the larger establishments only arrived with the industrial development of the Marshes and East Greenwich after 1860. The more varied industries found here the open sites and cheap rents that they sought – cable and cement works, soap and chemical manufactories, ammunition manufactures, and ship and barge building. Engineering and building formed the staple of Greenwich industry, with this diversification taking place in the latter decades.

Deptford could always boast of both a greater and a more diverse industrial orientation. While the Greenwich middle class was somewhat falsely bewailing an economic disaster, one Deptford resident claimed that his town was economically booming. He pointed to the engineering works, dockyard, shipyards, the victualling yard, Steam Navigation Company, 'and numberless other factories, all teeming with industrious workmen'.[20] There were on the one hand heavy industries employing a large proportion of skilled men, and on the other a large number of miscellaneous factories attracted by the cheap rents and riverside location and often dominated by unskilled and semi-skilled work. The first type of industry was principally made up of engineering, marine engineering, boiler works, shipbuilding and locomotive building. The latter group contained the works that rendered the Creek area 'one great stinking abomination',[21] chemical works, breweries, bleach and dye works, firewood yards, floorcloth manufactories, glue works, tar distilleries and manure manufactories.

Woolwich only developed a more diverse industrial structure towards the end of the century. The town was dominated by the Arsenal, building, and until 1869 the Dockyard. For the *Kentish Independent* in these years 'every throb of the nation's existence has its corresponding pulsation in the national workshop'.[22] Siemens' cable works opened in 1863 and was the first major manufacturing establish-

ment to offer any alternative employment. They took advantage of the open land in New Charlton to the west of the town, and other firms followed. By the 1880s it was 'a growing locality, and one not wholly dependent on the Royal Arsenal, but possessing many industries of a diversified kind'.[23] Such expansion could, however, only partially diminish the hold that the Arsenal exercised over Woolwich.

The structure of these principal industries was clearly a major factor in determining working-class perceptions of the economic and social system. The rest of this chapter must thus be seen as dovetailing with the two chapters that follow, for a central argument of this study is that working-class values and behaviour which are generally only observed by historians can be demonstrated to have been feasible and relevant to those involved when set within the context of their experience of the community, economy and workplaces that shaped their views of society. The structure of the major industries will be established through newspaper and other unsystematic evidence, because virtually no industrial, wage or employment records have been unearthed; and more systematically through local street and trade directories. In terms of capitalisation and employment opportunities, the main local industries were dominated by a number of very large firms. The directories can help to establish the extent to which these industries also contain a large number of very small firms, often just shops with few employees, and having only a temporary existence.

The relevance of this lies not just in the direct experience it created of the permanence of industrial wealth, but also because it affected the related perception of the opportunity for skilled artisans to leave dependence on employment and to work on their own account. A high turnover of firms, such as occurred in building and in small metal work, encourages a view of the openness of economic opportunity, however much actual mobility may in practice deny it for the overwhelming majority of even the skilled working class. The social distinction between artisans and small masters was often a flimsy one, if it existed at all. Movement in and out of the ranks of employees must have closed even further the distinction that did exist. What we are observing, however, is not a perception of social opportunity, but of work opportunity fairly narrowly defined; that is to say, the opportunity to cease being an employee following the instructions of an employer, depending on his work regulations and his economic success, while remaining at one's craft and maintaining a traditional pride in it.

The conclusions about industrial longevity are based on an analysis of directory entries for seven specific years: 1840, 1846 (or 1847),

1851 (or 1853), 1858, 1865, 1870 and 1878.[24] The absence of a firm
from a specific directory does not necessarily mean that it was no
longer in existence, but cross-checking suggests that these discrepancies
occurred only rarely. Nevertheless, the results must be used to illustrate
general trends rather than to supply precise detail. References to the
length of a firm's existence in terms of directory entries are to be
understood simply in terms of the directory dates themselves. A firm
whose life is given as 1846-1865 could, given the directories used, have
existed from 1841 to 1869. Table 3.4 shows the persistence rate for
firms in the main local industries.

Table 3.4: Survival of Firms in Principal Industries of Kentish London

	number of directory entries				
	1	2	3	4	open*
SHIPBUILDING					
Deptford	4	5	2	1	2
Greenwich	9	2	2	3	6
Woolwich	9	2	—	—	1
Kentish London total	22	9	4	4	9
Kentish London %	45.8	18.8	8.3	8.3	18.8
ENGINEERING, HEAVY METAL					
Deptford	22	11	—	8	7
Greenwich	47	—	5	3	4
Woolwich	16	2	2	—	2
Kentish London total	85	13	7	11	13
Kentish London %	65.9	10.1	5.4	8.5	10.1
OTHER METAL TRADES					
Deptford	48	16	12	20	19
Greenwich	45	21	12	10	19
Woolwich	49	24	10	10	22
Kentish London total	182	61	34	40	60
Kentish London %	48.3	16.2	9.0	10.6	15.9
BUILDING					
Deptford	105	45	31	31	60
Greenwich	132	48	18	38	30
Woolwich	109	38	22	22	48
Kentish London total	346	131	71	91	138
Kentish London %	44.5	16.9	9.1	11.7	17.8

*'open' refers to firms which first appeared in the final two directories and which
had not disappeared by the last.

Source: Local, trade and London directories listed in note 24.

The *private ship and boat building* industry of the area presents a
picture of fluctuations and variety, reflecting that basic insecurity of

the Thames shipbuilding industry which came to a head in the dramatic collapse during the financial crisis of 1866 to 1867. Victorian London was not a good site for a shipbuilding centre. There was little space for expansion, and the strong trade unions and rigid system of wage contracts were not compensated for by advantageous proximity to iron and coal deposits. The iron shipbuilding industry on the Thames was decidedly unhealthy even before its crisis.[25] The smaller firms often survived better than the large, for they found their contracts not in the competitive world of large-scale shipbuilding, but in the more gentle realm of boats and barges, where entry was easier and organisation less harassing. The permanent firms of the area were not Charles Lungley or Maudsley, Son and Field, but George Barnett, a Deptford boatbuilder throughout the period, and Richard Harding and James Corbett, whose boatbuilding yards were a part of the Greenwich riverside scene for over twenty-five years. In contrast to other industries, however, we must not assume a fairly direct correlation between size and longevity. The largest firms were often relatively short-lived, and most of the firms that remained were small, often concentrating on boats and barges. Woolwich had only jobbing shipwrights and a couple of barge-builders but Deptford and Greenwich could boast famous names. Pride of place goes to Charles Lungley's yard at Deptford Green, if only because Patrick Barry's eulogy to private enterprise was based upon it. He considered it the most complete yard on the Thames,[26] and before its demise in 1867 it employed some 800 men.[27] Rennie's were victims of the scattering of sites that the Thameside crowding forced upon a number of firms, and established their Greenwich yard at Thames Street to cope with the expansion from their Southwark base. There were 700 men employed at Rennie's Greenwich works as late as 1875.[28] In 1856 William Joyce was launching one steamer or gun boat every month from his Greenwich yard and employed some 200 men.[29] Maudsley, Son and Field's shipyard on Greenwich Marshes was one of a number of substantial yards to set up in the 1860s, and they used it for what for them was a surprising purpose, and built some famous iron sailing clippers.[30] Many of these firms survived the 1866-7 crisis and so did the General Steam Navigation Company's yard at the Stowage, Deptford. In 1825 the shipping company had opened its major repairing yard there on the site of the old East India warehouses, and it was greatly enlarged in 1837 to cope with a fleet of forty ships.[31] The works were a large and permanent source of shipbuilding employment in Deptford. While Thames shipbuilding never really recovered from the collapse of the 1860s, that decade did not mark the end of the industry.

If no recovery took place on the north bank, there was certainly a revival in Deptford and Greenwich, for not only did old firms survive, but new names appeared, including Lewis and Stockwell in East Greenwich, who in 1873 were building six steamers for Brazilian purchasers,[32] and William Walker, a Limehouse shipbuilder who took over Lungley's yard and in 1875 was employing 700 men.[33] Thames shipbuilding had suffered a major setback to which it eventually succumbed, but one must be careful not to imagine in the 1870s a river bank strewn with ghost yards.

Until their controversial and unexpected closure in 1869, the long-established *government dockyards* at Deptford and Woolwich offered the most substantial and sustained shipbuilding employment in the area. They shared with the Royal Arsenal the peculiar employment situation of government establishments, and also the fact that their fluctuations were determined not by the trade cycle but by foreign affairs and the vagaries of British politics.

Deptford Dockyard had been closed as a building yard in 1833, but the distress this brought to the town ended in 1843 with the decision to build the steam frigate 'The Terrible' there. The yard expanded fast and by April 1846 naval rearmament boosted employment to over 2,000,[34] though this soon settled and the general level of employment stood at around 1,000 for most of the period. While Woolwich Dockyard suffered no decline in the 1830s it too expanded in the following decade with the building of two modern dry docks and the steam engine factory, whose construction began in 1842. Except for periods of major foreign crisis and naval rearmament, the Woolwich employment figures fluctuated between 1,500 and 2,000,[35] though the engineering workers at the steam engine factory must be added to that figure. This factory, modelled on the great London marine engineering establishments such as Maudsley and Penn,[36] was equipped for erecting, building and repairing marine engines, but the Admiralty's ideological preference for private enterprise prevented it from doing any building.[37] It could employ 1,450 workmen in its fifteen specialist engineering and metal-working shops, but it rarely exceeded 600 before its closure in 1869.

The *Royal Arsenal* experienced fluctuations in activity in a similar fashion to the dockyards, and a perennial local complaint was that these were not so much short-term, from month to month, as over periods of years. Thus a war, a colonial dispute, or a rearmament programme could lead to a three- or four-year boom at the Arsenal. The subsequent reduction would undermine the whole prosperity of the

town. In 1814, at the end of the Napoleonic Wars, there were 5,000 at work in the Arsenal, but this soon declined and stood at around 1,000 during the 1840s. A new arms programme and the Crimean War then produced a sharp rise in employment – 2,500 in 1854, 8,000 in 1855 and 9,000 the following year. A peak of over 10,000 was reached in 1861, but this was then reduced to around 5,000 during the 1870s (precise figures are 7,088 in 1862, 4,959 in 1870 and 5,153 in 1880).[38]

The Arsenal contained three major and distinct departments, the Royal Carriage Department, the Royal Gun Factory and the Royal Laboratory. According to one local observer, they 'are utterly dissimilar, and consequently can never be reduced to the same organisation'.[39] Stores, clerical and official administration, wages and hours were all separately controlled by each of the three departments,[40] and this was reflected in workers' organisations and social institutions. The Amalgamated Society of Engineers' branches appear to have covered separate departments, and friendly and benefit societies were similarly based. The Royal Gun Factory was the smallest of the three, concerned with gun and mortar boring, turning, planing, and the moulding and modelling of guns. The Royal Carriage Department – 'the great manufacturing department of the Ordnance'[41] – made gun carriages, carts, ambulances, trucks and wagons, while the largest department, the Laboratory, was dominated by unskilled and boy labour, and concerned with ammunition, shells, and tube and rocket filling.

The roots of the London *engineering and metal trades* lay in the all-round skill of the independent millwright, and London's domination of the early engineering industry rested on lightly-capitalised jobbing shops whose skilled workforce undertook slow and methodical craft work. In 1825 Galloway claimed that there were 400 different firms with no more than 10,000 men making machinery in and around London.[42] This old craft tradition particularly characterised firms north of the Thames, but the diffusion of machine tools threatened their position. The centre of the industry shifted to south Lancashire, while there grew up in London at the same time a number of larger and more heavily capitalised engineering firms.[43] In Kentish London, the old structure took second place to these new developments, for if large shipbuilding was one characteristic industry of the area, large-scale engineering and metal establishments was the other. The low-rental site on the river made Kentish London together with Battersea and Lambeth the centre of London's heavy metal trades. It was the centre of the new elite of artisan skills, in the same way that the North London metal trades represented the old elite of craft workers.

It was in Deptford and Greenwich that these large and often long-established metal and engineering firms expanded during the middle years of the period. The principal firms were the boiler and marine engineering works of Penn, Rennie, and Maudsley, Son and Field. John Penn was the largest, and at his Greenwich works the oscillating engine was substantially improved. Penn built engines for both the navy and private shipowners, fitting them at the riverside yard in Deptford.[44] The labour force grew from 700 in 1846 to 1,500 in 1862, while in 1873, 1,300 were employed at the Greenwich works and 500 more at Deptford.[45] The other major marine engineering firm was Humphrey, Tennant and Dyke, founded in Deptford in 1852. Edward Humphrey had worked with both Penn and Rennie, and had also been chief engineer at Woolwich Dockyard. The firm concentrated on engines for screw sloops, and soon started a long-lasting link with the navy. By 1853 they employed over 800 men.[46] Another man who learned his engineering skills with Penn's was George England who in 1845 opened his locomotive building works in the unlikely location of Hatcham — finished products had to be carted by road from Hatcham to Bricklayers Arms or New Cross.[47] The railway companies themselves engaged in substantial engineering activity at New Cross. The South Eastern Railway employed 334 men there in 1846, mostly skilled engineering and metal workers. It closed the following year, to be reopened in the late 1860s by the London, Brighton and South Coast Railway which employed 496 men, again mostly skilled, in 1871.[48]

Examples of the numerous medium-sized firms are Bunnett and Forbes of Deptford, with 200 men making metal shutters in 1860,[49] Frederick Braby's galvanised iron tanks factory, opened in Deptford in 1867,[50] and Josaiah Stone, the brassfounder and engineer. Stone was the son of a dockyard shipwright, and worked for a private shipbuilder until 1831, when he started making copper nails and fastenings for ship work with the assistance of two employees. The firm expanded in the 1840s and made pumps, marine fittings and ships' propellers throughout the period.[51] Further east at Greenwich stood the dominant Penn's yard, but also Joshua Beale, who made rotary engines through much of the period, and Joyce and Company, ironfounders, engineers and iron boatbuilders until their 1855 bankruptcy.[52]

These were the principal large-scale engineering and metal firms of the area. Yet this is not the complete picture, for as Table 3.4 shows, both Deptford and Greenwich had a great number of short-lived firms, mostly described as just engineers, millwrights or brassfounders. Both towns were dominated by large and highly capitalised firms, but

beneath them was a mass of small craft engineering and general jobbing shops. Here it was that the two faces of the London metal trades co-existed.

This layer of unstable small shops can be seen most clearly in the other metal trades in Table 3.4, the smiths, zinc workers, tin workers, wire workers, locksmiths and bellsmiths, tool makers, cutlers and so on, where the traditional jobbing structure dominated. While there was a great variety of such establishments in Deptford and Greenwich, the equally large number of firms at Woolwich were mostly smiths, tinmen and ironmongers, that is the most general of metal trades and the ones most prominent in jobbing work. The ironmonger, exclusively a retailer in the city centres by mid-century,[53] still clung elsewhere to his older function as both producer and retailer. Change was slow in the smaller metal trades of Kentish London.

The overall pattern of the metal and engineering industries in the three towns was determined by the 1850s, and underwent no major structural changes during the period. The large establishments domin-ated employment, but below them was a base of small metal and engineering shops, similar to those in the traditional sectors of the London industry. The distinction between one smith working on his own or with a couple of journeymen, and another doing jobbing work while out of employ or when in need of extra money, is an imprecise one, compounded by the relative ease of entry into small-scale inde-pendent work. Yet what is important is that, notwithstanding develop-ments in the highly capitalised world of the Penns and the Rennies, there was still an opportunity for a skilled workman in these trades to escape wage employment and set up on his own account. Sometimes he survived, often not. He might even emulate Josiah Stone and permanently escape. Whatever the reality for the mass of skilled workers, the feasibility was maintained of a genuine mobility that was economic, even if it was rarely social.

The most substantial employer in *docks and river work* was the Grand Surrey and Commercial Dock Company, which brought together the docks that lay in the sweep of the river between Rotherhithe and Deptford – the Grand Surrey, Commercial, Baltic and East Country docks. Employment was highly localised, for dock work was both seasonal and casual; it was also highly specialised, as a result of the concentration on grain and timber. As these trades grew from the 1850s, so did the Surrey Commercial Docks, and by the end of the century they were the most prosperous in the port, for their trade was less affected by the new ships whose size threatened the supremacy of the

older docks across the river.[54] Gangs were directly employed by the dock companies, though lumpers — timber unloaders — worked for contractors, whose profit came from the drink that the workers purchased in their public houses or in those with which they were connected.[55] It is in the nature of such casual work that employment figures cannot be accurately assessed, but by 1891-2, when mechanisation had already reduced the labour required, they ranged from 1,800 men in July to 620 in March.[56]

Other river trades were more scattered but still substantial. There was a considerable number of coal-heavers, often employed by large coal merchants like Cory of Charlton. The other main group was the elitist licensed lightermen and rafters, whose security was threatened by the attempts by lightering and trading firms to put unlicensed men on the river. Watermen looked to their ancient rights from the Watermen's Company as protection against such competition, and in spite of an 1864 Act aimed at weakening the Company's monopoly of employment, the watermen and lightermen preserved their exclusiveness.[57] Licensed lightermen could often set up on their own; capital could be economised upon by acquiring a second-hand or even a hired barge.

The highly localised London *building industry* was organised on craft lines of production, for technical changes altered the structure of neither the industry nor the job.[58] The sizes of building firms are not easy to ascertain, though it is useful to know that when the committee of Woolwich building workers moved in 1866 for the one o'clock Saturday, they thought it worth calling on 32 local builders, and struck against 25 of them, bringing out 563 skilled men in all. The largest of these firms by far were Tongue with 152 skilled men, and Kirk with 169. A great gulf separated these firms from the more typical Vaughan with 34, Johnson 27 and Howard 20. The other firms all employed fewer than twenty skilled men, some just two or three.[59] Here we glimpse the small scale of the local building industry, for the two exceptions were firms that did considerable work for the government. Most government building in Woolwich was carried out by London contractors who brought a good deal of their labour with them. During the Crimean War five London firms had 1,772 men at work in the Arsenal.[60]

The district surveyors' returns provide a greater insight into the strictly local building industry. Under the Metropolitan Building Act of 1844,[61] notice had to be given to the appointed district surveyor 48 hours before any building operation commenced. The district surveyor was paid solely by the fees he charged for registering and inspecting

work. So aggressive were some that the Lewisham surveyor, called Badger, was subjected to 'rough music' in Deptford as late as 1861. A fair degree of accuracy can thus be expected from the returns, which were analysed for two periods, from 1850 to 1852 and from 1877 to 1879, for districts in and adjoining Kentish London.[62]

Housebuilding in Kentish London, and almost certainly elsewhere as well, was a locally based industry. In 1852, 80 per cent of all builders constructing houses in Deptford were from that town; 70 per cent of Greenwich housebuilders were locally based, and a remarkable 97 per cent in Woolwich. By 1878, with a larger degree of economic integration over the metropolis, the proportion of local builders was still high — 70 per cent in Deptford, 73 per cent in Greenwich (though outside builders were penetrating more substantially here in 1877 and 1879), and 81 per cent in Woolwich. Table 3.5 indicates the contribution of local and non-local builders to new housebuilding. It shows that distance from the metropolis was related to the degree of penetration by London-based builders — mainly the large speculative builders, who entered the area during years of peak activity. Woolwich remained resolutely self-contained.

Table 3.5: Housebuilding in Kentish London: Relative Contribution of Local and Non-local Builders

| | Housebuilding in each town | | |
Origin of Builder	Deptford (%)	Greenwich (%)	Woolwich* (%)
1850-1852			
Same town	65.4	65.2	94.0
Other Kentish London	4.4	14.6	0.5
Elsewhere	30.2	20.2	5.5
Total houses built (= 100%)	494	485	621
1877-1879			
Same town	57.1	64.3	86.8
Other Kentish London	6.9	17.5	2.8
Elsewhere	36.0	18.2	10.4
Total houses built (= 100%)	767	443	479

*Woolwich includes Plumstead and Charlton.

Source: District Surveyors' Returns. See note 62.

These local builders constituted the core of the building industry in the area. How large were they? Table 3.6 takes account of all houses

Table 3.6: Size of Kentish London Housebuilders

Column (1) = number of firms
Column (2) = number of houses built by each size of firm expressed as a percentage of all houses built by local builders

	no. houses built	1850 (1)	1850 (2)	1851 (1)	1851 (2)	1852 (1)	1852 (2)	1877 (1)	1877 (2)	1878 (1)	1878 (2)	1879 (1)	1879 (2)
Deptford builders	1-3	16	27.7	15	31.4	14	16.6	11	12.3	15	12.2	17	14.4
	4-6	8	34.7	7	36.0	13	45.9	15	39.1	13	25.0	10	25.1
	7-9	4	26.8	2	18.0	3	14.6	4	19.0	7	23.6	5	18.6
	10-19	1	10.8	1	14.6	3	22.9	4	29.6	7	39.2	7	41.9
	20+	–	–	–	–	–	–	–	–	–	–	–	–
	Total	29	100	25	100	33	100	34	100	42	100	39	100
Greenwich builders	1-3	16	18.8	15	34.6	13	22.6	4	15.8	4	4.0	4	3.8
	4-6	7	23.6	5	32.0	5	15.4	3	42.1	5	20.1	5	14.1
	7-9	5	26.4	2	18.7	1	5.0	–	–	1	6.5	2	9.8
	10-19	3	31.2	1	14.7	4	42.4	1	42.1	1	14.5	7	56.0
	20+	–	–	–	–	1	14.6	–	–	3	54.9	1	16.3
	Total	31	100	23	100	24	100	8	100	14	100	19	100
Woolwich builders	1-3	11	10.9	19	17.4	18	14.9	14	25.1	18	30.4	32	32.9
	4-6	19	33.5	15	29.5	13	29.3	5	23.9	8	35.6	10	22.8
	7-9	2	5.7	–	–	3	10.6	1	8.3	1	6.3	4	15.8
	10-19	8	42.8	3	16.6	5	22.6	3	42.7	2	27.7	3	18.3
	20+	1	7.1	3	36.5	2	22.6	–	–	–	–	1	10.2
	Total	41	100	40	100	41	100	23	100	29	100	50	100

Source: District Surveyors' Returns. See note 62.

built by builders from the three towns in a wide area of south-east London. Very small firms, which built no more than six houses in a year, were overwhelmingly predominant in the earlier period, and they were responsible for a high proportion of houses built by local builders. Medium-sized builders were more evident in Woolwich, mainly at work in the fast-growing Plumstead and New Charlton. The figures for the later period reveal a move towards medium-sized builders in Greenwich in 1879, when there was a good deal of activity. Deptford, on the other hand, was still dominated by very small builders, although these accounted for a lower proportion of houses built. Woolwich was characterised by a quite remarkable predominance of small builders. Most of these builders, in all three towns, were speculative, that is to say that they were building in anticipation of sales, rather than on contract. In the earlier period, 78 per cent of all houses built by the Deptford building industry were built on speculation, and the figures for Greenwich and Woolwich were similar (82 per cent and 76 per cent respectively). While Woolwich builders built an identical proportion on speculation in the later period, the degree of speculative building activity increased in Deptford and Greenwich to 94 per cent in each case. Woolwich's exception to this trend must be the result of the industry's exceptionally small scale there.

This analysis has shown on just how small a scale was the structure of the housebuilding industry in Kentish London, and how little that structure changed over the period. This confirms more general conclusions made by Dyos for the whole of London, that 'the most impressive feature of the industry . . . was not that the few were so large, but that the many were so small'.[63] This wide general base, including both small housebuilders and the even smaller jobbing builders,[64] was in terms of units the major part of the local industry. It was partly made up of small but established firms, either building or specialising in some specific building craft, yet only about one-third even surfaced in a trade directory.[65] The proportions of work in building a house were 40 per cent brickwork and 30 per cent carpentry and joinery, with 7 per cent each for the other main trades, so it was not difficult for a bricklayer or a carpenter to build a house by hiring other trades, forming partnerships and so on, to do the other parts of the work.[66] Of 51 'builders' in the directories who had previously appeared under more specific trades, it is instructive that 22 had been bricklayers and 27 carpenters and joiners. The general base to the industry contained men normally engaged in sub-contracting or wage employment but who would venture into housebuilding or jobbing

work from time to time. Samuel Clemmison was one such person, involved in small-scale building work in Deptford in 1850 and 1851, but who reappears as an employee in the Greenwich Hospital works a year or two later.[67] Small jobbing tradesmen could break into house-building without undue difficulty for by mid-century a technical press supplied complete kits of designs, bills of quantities and so on. Nor was finance too great a problem. The landowner himself would often provide development loans, and other sources would have included loans within the building trade and from building societies and solicitors.[68] John Green claimed in 1887 that 'there are 5 or 6 building societies in Woolwich which would be only too glad to advance money to any jerry builder. They have such a large amount of surplus capital that they are glad to get rid of it.'[69]

Interest in the rise of the large master builders[70] should not be allowed to hide the extraordinarily small scale of the industry as a whole throughout the century. The overall picture of a local building industry on a very small scale in Kentish London confirms in consider-able detail previous characterisations of the London industry.[71] A specific point of additional relevance here is the fluid movement in and out of independent work at the bottom of the structure, for this is relevant to the issues of industrial size and opportunity that were raised in an earlier part of this chapter. For many skilled building craftsmen, the industry did not appear as one in which they were permanently tied to being employees with no chance of taking on work of their own and perhaps setting up in business. This could be made easier by combining an uncertain and seasonal independence as a builder with the greater security afforded by an additional income from small shopkeeping. Combinations of building trade and retailing were frequent, amongst them William Took, a Greenwich carpenter in 1845, who also ran a beer shop, John Edgley of Woolwich who was both bricklayer and greengrocer in 1850, and Joseph Palfreman who was in 1864 both a carpenter in Woolwich and the owner of a general shop. A steady income from a small shop or a market stall could supplement an un-certain income from independent building work.[72]

The second part of this chapter has served two purposes. It has first presented a detailed picture of the industrial structure of Kentish London during these years. In addition to this, however, this structure has been shown to have had two layers in the dominant industries of engineering, metal work and shipbuilding. The first layer was made up of large-scale establishments, unusually large in comparison with the

rest of London. At the lower level, however, was a base with a high turnover of small unstable firms. Shipbuilding was completely dominated by large establishments, both private and government. Building, on the other hand, with very few exceptions, was on an extremely small scale. The large scale of much engineering, metal work and shipbuilding is of central importance, but equally fundamental to this analysis is the existence of a volatile small-scale base to the engineering, metal work and building industries. For this points to a situation that was raised earlier in this chapter, where in none of these industries did the path out of a dependence on wage employment appear totally closed. The recruitment of small masters out of the ranks of the employed was clearly common. This means that with the exception of the Josaiah Stones of Kentish London, too firm a line must not be drawn between small masters and the elite of skilled workers from which they often came. Nevertheless, the distinction is relevant, not for the reality it portrays — that reality offered little escape for most skilled workers — but because it allowed the view of economic opportunity to remain a partially open one.

4 THE IMPACT OF THE WORKPLACE

The workplace and its relationships were central to the process of stratification within the working class. The stratification with which this book is concerned describes a situation where the primary concern of certain workers was not a generalised class position, though that inevitably underpinned much of their experience, but their position within a certain elite of the working class, and the status, aspirations and expectations that went with it. The contrast between class consciousness and sub-grouping used by John Foster to compare Oldham, Northampton and South Shields[1] is too emphatic in anything but ideal terms. His only partial investigation of local ideologies in the three towns over time permits the shading and the complexities of these contrasting ideas to be overlooked. The notion of a working-class elite regarding its own relative status as more significant than its class position is concerned with tendencies rather than absolutes. The direction of the later ideological chapters of this study points precisely that way. Yet however more complex that stratification might have been, particularly in its consequences, if it was to be embedded within the working-class community it had to start at work; for there is a sense in which relations at work and those derived from the industrial situation were the most fundamental for the Victorian craftsman. His status group was defined in relation to others by wages, skill, work situation, economic opportunity, prestige, craft control, education and so on. A central argument of this study is that the logic of such stratification is particularly convincing in the economic and social situation of mid-Victorian Kentish London, characterised by the specific skill differentiation in its industry, the absence of a wealthy industrial bourgeoisie, the importance of government employment, and a local social elite whose members the next chapter will show behaving in a way that set themselves and their values less in opposition to the dominant upper stratum of the working class.

The resulting artisan elite was separated from lower strata by a complex of social, economic and cultural characteristics, and to some extent divided internally amongst precisely demarcated crafts. This aristocracy of labour, and the skilled workers who shared its aspirations if not its achievements, was defined by more than income alone. Social status, opportunity and behaviour reinforced the elitist potential

offered by a stable and relatively adequate income. These artisans were conscious of their superiority over other sections of the working class, especially their labourers and the 'dishonourable' sections of their own trades, and they held an ambiguous position at the very time when they were the only organised section of the working class, organised within trade unions and, with those white-collar and petit-bourgeois groups with which they were seen by contemporaries to merge, dominating the benefit societies, building societies, co-operatives and working men's clubs.

Their superiority rested partly on earnings and job security. The earnings differential between skilled workers and labourers widened as much as did social distance during the mid-Victorian years, as was observed at a public meeting in Greenwich in 1876.[2] It has proved impossible to obtain systematic local wages and earnings data, and a key economic dimension of labour aristocracy formation is therefore not susceptible to examination on a local level.[3] We need to know not simply about rates, but about variation in earning consistency between skilled and unskilled, between one skilled trade and another, and perhaps most interesting of all, between individual men in the same skilled trade. We must, however, depend upon London or national wages information of the kind used in the rest of this chapter. The widening of the differential referred to above was based upon the expansion of those industries based upon skilled labour and a new readiness of artisans to discover what the market would bear.[4] Seasonality in employment could influence the effect of pay rates on status, especially important in building and, to a lesser degree, shipbuilding. Workers in the better crafts were paid enough to enable them to live through periods of seasonal slackness; the best of them would maintain full employment, but the position was very different for unskilled and semi-skilled workers, who could only survive with any ease if they were able to dovetail one seasonal occupation with another.[5]

Earnings were not the only factor in operation; others included treatment at work, control over the pace of production and the type of work done. All of these developed and strengthened an occupational culture which could reinforce initially economic differentials. As a working man observed in 1879, 'according to workshop etiquette – and nowhere is professional etiquette more sternly insisted upon than among the handicrafts – all who are not mechanics are labourers'.[6] Apprenticeship, whether formal or informal, had a double function, providing a means of restricting the supply of skilled labour, while also serving to teach customs as well as techniques.

The survival of traditional trade values was in some ways an
anachronism in Kentish London where the basis of industry and
employment was not the traditional and vulnerable London petty-craft
structure, but the very centre of the expanding industries of post-
industrial revolution England. These engineering, shipbuilding and
metal industries, together with building, were those specified by
Hobsbawm as forming the centre of gravity of the English aristocracy of
labour during these years.[7] The artisan elite of Kentish London was
not one built around an old-established craft culture threatened by
technological change or bureaucratised modes of production. Building
changed little in job structure over the period. In metals, the traditional
craft system was not destroyed by repeated encroachment and attack;
rather, it was rapidly swamped by the new skills and methods of
organisation that arose in the second quarter of the century. In
engineering and metal work bureaucratised modes of production were
advancing only slowly, for the constant need for individual hand skills
was sustained throughout the period, and the use of sub-contracting,
gang work and other forms of decentralised organisation maintained
many of the features of craft control.[8] Shipbuilding did see the attack
on the traditional shipwrights' craft, though the attack was in many
ways unsuccessful until the industry itself declined. As with metals, we
are here dealing with an industry whose technological and organisa-
tional advances created new skills and specialisms, rather than one
replacing the old skills by a degraded form of labour, as happened in
other traditional London crafts.

This chapter will not argue that the dominant trades in the Kentish
London skilled elite were under no strain during the period – an
essential feature of a social elite is its constant need for definition
against potential or felt challenge – but that the attack was not of the
same dimension or character as that experienced by other London
crafts. The building craftsmen certainly had to fight to preserve their
position against encroachment, and nowhere more so than in London,
with its increasing specialisation and the decline of the all-round
craftsman. This stress was less strong in the metal trades, though it was
always present as semi-skilled machine men grew in importance, most
notably in the Arsenal. In shipbuilding, the change of materials from
wood to iron created a whole range of new skills, rather than subjecting
the craftsmen to dilution of their existing skill. The elite of the river
workers – lightermen and watermen – had their exclusiveness chal-
lenged not by any technological or organisational change, but by the
attempts of masters and merchants to break their licensing and

apprenticeship system. These industries were not unchanging; what is important is the position within them of the different grades of workers.

Docks and River Workers

The most striking characteristic of riverside labour was the interminable division of its workforce. It spilled over into a complex status system which provided for many the only possibility of respectability and pride in a degraded and humiliating labour market. This was not true for all river workers, especially the lightermen and watermen of the Thames. Licensed lightermen were jealous of their status, and, if Harry Gosling's father was at all typical, strove to better it, for he 'always lived in the best house he could afford, and perhaps it was larger than he could well manage to keep up'. This did not imply extravagance, for like any respectable working man, he would 'never buy anything unless he could pay ready money for it'.[9] The only watermen living in a poor unskilled area of Deptford were those 'fallen upon evil days'.[10]

The watermen and lightermen of the Thames were exclusive trades, the only ones in the port, restricting entry by a meticulously enforced system of apprenticeship and licensing. With the widespread ability of lightermen to become masters as late as the 1860s,[11] they were generally regarded as the elite among workers on the river. The size of firms grew as ships increasingly discharged overside to lighters in the river in order to avoid port dues, and both watermen and lightermen had to struggle to keep unlicensed men off the river. The short-lived society of 1866 and the more lasting Amalgamated Society of Watermen and Lightermen of 1872 aimed more at obtaining representation on the Watermen's Court and parliamentary legislation to confirm their privileges than at bargaining with employers.[12] The consequently weak identity of interest with other port workers prevented them joining even the loose 1872 federation of dock workers. They campaigned alone but in strength in both Deptford and Greenwich.[13] They were conservative and exclusive occupations, especially the watermen who were organised occupationally and socially into close Turnway Societies which arranged the distribution of work as well as operating benefit societies.[14] The United Greenwich Watermen's Floating Accomodation Society restricted itself to men who had served their time at Greenwich.[15] This tightly-knit occupational culture and the rigid enforcement of regulations surfaced in Woolwich in 1870 when local watermen paraded through the town carrying the effigy of one of their number who had been fined by the magistrate for conveying more people than he was licensed to carry. The procession, accompanied by a

rough music band, ended with the effigy being placed on a barge and burned.[16]

In numerical terms, riverside labour in Kentish London was dominated by the labourers at the Surrey Commercial Docks. A complex system of sub-grouping pervaded the whole of London docks labour, and was a function of the overall low status of occupations which attracted the most casual and destitute of workers.[17] The movement of labour around the docks was severely restricted by both specialisation and the casual nature of employment, which served to reinforce occupational distinctions. The small area within which job opportunities would be known, and the need to be recognised at the source of employment, inhibited mobility even further, and employers encouraged this by distributing the work around as many men as possible in order to maintain a permanent surplus.

The Surrey Commercial Docks specialised in grain and timber and were regarded as superior docks in which to be employed, for they did not require the movement from cargo to cargo that rendered the company labourers on the north bank so low in status. The greater technical and physical ability required was perhaps more important. The Surrey docks were regularly presented as an exception in London. 'Strong in physique, with more regular employment, these men are very far from the type of labourers usually thought of as "dockers", and there was plenty of evidence during the strike [of 1889] that they themselves were fully conscious of the distinction.'[18] They were themselves extremely fragmented in a fashion that owed much but not everything to tradition.[19] Grain handlers would rarely work with timber, which was discharged by gangs of lumpers, under subcontracting masters. In spite of the notorious drunkenness of lumpers produced by their conditions of payment and employment,[20] their dexterity and strength raised their status above that of truckers, warehouse labourers or ordinary quay workers. Corn, on the other hand, was discharged by the overside corn porters, a highly specialised branch of workers employed in gangs of seven men. Their position was threatened only when corn unloading began to be mechanised in the 1880s. By the standards of the docks, they enjoyed relatively high status and wages for as long as their strength remained and, together with the stevedores across the river, they were the only section of dock labour to keep a trade union branch in existence from 1872 to 1889. The most exclusive branch of the South Side Labour Protection League in the 1890s was that of the overside corn porters.[21] With the sole exception of the timber docks, shipworkers enjoyed a higher status than

shoreworkers,[22] partly based on the skill required in handling ropes and winches, but also on that reliance of gang members on each other for their safety which bound ship gangs together.

Shoreworkers were generally of a lower status in the London docks, but this was not true on the south side. The less skilled shore corn porters were certainly placed below the overside corn porters, but they formed a distinctive, highly specialised and localised group whose work demanded a degree more technique than did ordinary quay work. They were mostly pre-Famine Irish immigrants who had taken up the increased work in the aftermath of the repeal of the Corn Laws, and kept it within their families from that time.[23] Timber shorework was the most demanding in technique of all the dock trades. The deal porters who carried and stacked the deals performed an arduous and dangerous job. They worked in gangs employed by contractors, and as with lumpers, their close identity was increased by the small-scale employment structure.

These were only the main groups amongst many in the Surrey Commercial Docks. If some may be called superior in terms of technique and income, this only makes sense in the degraded world of docks employment. These men could not stand alongside the elite craftsmen. However one estimates the skill and pay in the corn and timber trades, the casual nature of the work and the seasonality of employment seriously diminished income and security. It must also be noted how seriously this riverside labour was fragmented. Every one of these trades was organised into a separate occupational branch in the 1889 unionisation, each with its own sectional interests. The structure of the south side trades was 'far too complex to be fully grasped by the stevedores who formed the nucleus of the committee at Wade's Arms'.[24] The events of 1872 were repeated in 1889, and an organisation of virtually autonomous branches was established. These were the only terms on which many of the sectional groups would have joined.

Shipbuilding

If a shipbuilding industry in Deptford and Greenwich did survive the catastrophe of the late 1860s, a profound upheaval in work routine and security was experienced by many London shipbuilding workers. The industry on the Thames came gradually to be concerned with repairing and refitting, and by the last decade of the century all work other than boatbuilding and bargebuilding was casual.[25] The cultural impact of this decline was of great long-term importance, but it was not sudden,

and its greatest effects on Kentish London were delayed beyond the 1870s. Shipbuilding labour was characterised by a fragmented labour force dominated by exclusive craftsmen. Shipbuilding had a very high proportion of skilled labour, with a large wage differential over the unskilled, and a highly paid elite which maintained its privileged position by strong craft unionism and a long apprenticeship. Craftsmen employed by the General Steam Navigation Company in the ten years from 1877 could by craft and union controls enforce uniform rates within each trade. The proportion receiving the mode rate for each trade was 100 per cent of shipwrights and caulkers, 97 per cent of ships' joiners, 93 per cent of riveters and 92 per cent of sailmakers.[26]

Skilled workers in wooden shipbuilding were numerically dominant, and the gulf that separated them from their labourers was wide in pay, privileges, craft control and status. Shipbuilding crafts were amongst the best organised, but each was exclusive, and in our period the Thameside unions were generally local rather than national. For each trade there was a union, sometimes, as amongst sailmakers, more than one. For each union there was a pride, one of whose main supports was the fact that most wooden shipbuilding craftsmen owned their own tools.[27] Dominant were the shipwrights, the aristocrats of the yard, and one of the best organised trades in London. Shipwrights were traditionally exclusive,[28] and none were more so than those on the Thames. The Shipwrights' Provident Union of the Port of London grew out of the long-established St Helena Benefit Society, and in 1873 it still imposed a heavy entrance fee on those who had not served their time on the Thames.[29] Shipwrights shut themselves off from the general labour movement, joining neither the London Trades' Council nor the later Federation of Riverside Trades Unions.[30] Shipwrights in outports built barges, boats and ships, and did caulking and mast making, but the fragmentation of the Thameside crafts generated three separate shipwrights' trades — shipwrights whose status was the highest, boatbuilders, and bargebuilders, with a traditionally based demarcation that was jealously preserved. Blanchard, asked to explain the line drawn between a ship and a barge, replied, 'That question would take three hours to answer.'[31] The United Kingdom Amalgamated Society of Shipwrights joined together a host of local societies, and by 1870 claimed London as its second strongest port, but the largest union in the port was based at Deptford. This was the Shipwrights' Provident Union of the Port of London, established in 1824, and by 1867 boasting 1,700 members.[32] Both societies rigidly enforced a seven-year apprenticeship. Deptford was the centre of shipyard unionism for the main caulkers' union, the

United Society of River Thames Caulkers, was also based there.[33]

It was not only the divisions among shipwrights that were unique to London, for the other trades were also unusually specific.[34] Most trades in other ports were organised in the shipwrights' unions, but the Thames had distinct unions for shipwrights, boat and bargebuilders, sailmakers, mast and block makers, caulkers and ship joiners. Many of these, like the caulkers and sailmakers, were old and well-founded craft societies, whose activities led to repeated demarcation conflicts,[35] such as the prolonged and violent dispute in 1868 between shipwrights and caulkers at Harrington's near the Commercial Dock.[36]

The problem deepened with the challenge of iron shipbuilding. The most basic conflict was between shipwrights and boilermakers, with the former initially refusing to tackle iron work, but belatedly acquiescing. That clash over craft territory served only to intensify the defensive demarcation of skill that technological change brought to the London shipbuilding trades. The boilermakers formed the elite of a new structure of trade and status differentials that transposed the craft complexity of the old technology on to the new. 'The angle-iron smiths, plater, and riveter', observed Booth, 'regarded themselves as *the* skilled men, and the rest as rather an inferior class of workmen "to be kept in their proper places".'[37] Wage rates in 1877 indicate this hierarchy, with Greenwich angle-iron smiths and platers receiving 42s per week, and below them a second layer of skilled men, the riveters and caulkers, on 36s.[38] The necessity of defending their craft exclusiveness provided the tension that encouraged a complacent pride amongst boilermakers which can be observed when the secretary of the Deptford branch of the union left for Turkey in 1869, to work for the government of that country. At a farewell meeting, the branch president declared that he would be 'an ornament to England as a nation, and a credit to English employers of labour, who have become the wealthiest employers in the known world'.[39]

The proportion of skilled workers in iron yards, some 50 to 60 per cent, was probably lower than that in the old wooden establishments,[40] but the pay differentials between skilled and unskilled workers now responded to economic demands with greater sensitivity than had the more customary rates in wooden shipbuilding. Bowley and Wood's calculation of the 1886 differential, based on the labourer's rate as 100, show an elite of shipbuilding (184), platers and angle-smiths (both 178); there followed a layer of ship painters (170), ship joiners (168) and riveters (167); finally amongst the crafts were caulkers, sailmakers and riggers (all 157). Only the holder-up (133) stood between the

labourer and the craftsman.[41]

The majority of the trades in iron shipbuilding were highly skilled, for it was not until the twentieth century that automatic machines seriously weakened the position of the skilled craftsmen.[42] Those with a craft position to protect did so as vigorously as had the wooden craftsmen. Delegates of the London District Boilermakers were apprehensive about the signs of encroachment, and in 1873 earnestly appealed to their platers 'to keep their helpers in their proper place, and not to let them help and plate too'.[43] There were frequent disputes between chippers and drillers, and between fitters and both shipwrights and boilermakers.[44] Samuda told a Royal Commission that 'they are totally distinct trades, and have nothing whatever to do with one another, all working under different foremen'.[45]

The craft and income differences between skilled and unskilled workers were accentuated by work relationships in both wooden and iron yards, such as when skilled men on piecework employed their labourers on time rates. The craftsman who thus employed his own assistants was not only conscious of his superiority, but there were now conflicting responses to the pressures of the work, with the skilled man dictating both speed and the number of days worked.

The gang-contract system in the wooden yards established this exploitative relationship, and that indirect structure of employment continued into iron work. One shipwright would contract for a job as a spokesman for his fellow craftsmen (not as a sub-contractor)[46] and together they would employ their own assistants and labourers. In the early days of large yards this system was the only means by which such establishments could expand without massive management problems. A favourite system at Rennie's[47] saw the intervention of a master ship-wright, who would act as a middleman between the builder and the leading hand of a gang of up to thirty shipwrights, all of whom would own their tools. No matter which out of a complex range of sub-contracting or piecework methods was used, skilled workers had a far greater degree of independence and bargaining power than men directly employed by the shipbuilder; their freedom of action and their sense of craft control were maintained, and they were less likely to feel conscious of direct employment by the owner of a vast and capitalised establishment. They were furthermore in a situation far more conducive to relationships of exploitation with their labourers. It is significant that shipbuilding was a prime example of an industry where, in the 1890s, general labour unions of the apparently unskilled were formed to fight the skilled men as much as the masters.[48]

Government Dockyards

The Dockyards at Woolwich and Deptford were no different from private shipyards in terms of the predominance of skilled workers and the distinctions between trades. At Woolwich in 1859 skilled workers and apprentices made up 70 per cent of all workers; they comprised 73 per cent at Deptford.[49] The actual composition of dockyard trades is less easily demonstrated, and the presence of convict labour until 1856 and the distinction between established (that is, permanent) and hired men only adds further complexity. The Steam Engine Factory at Woolwich Dockyard will be discussed not here but under engineering.

Table 4.1 presents the data which exist. In 1848 there were 837 established men in Woolwich Dockyard, augmented by 319 convicts housed in the prison hulks on the river. These convicts did heavy labour and rarely actually worked with skilled men. A large number of hired men are excluded from these figures, as is shown by the 1863 data which suggest that, in comparison with the establishment, the balance between craftsmen and labourers amongst hired men tilted more towards the latter. The 367 shipwrights dominated the Yard, overshadowing the 62 joiners, 58 smiths, 37 riggers, 24 sawyers and 24 caulkers.[50]

Table 4.1: Dockyard Employment

	Woolwich (Establishment only) 1848		Deptford 1863		Woolwich 1863	
	No.	%	No.	%	No.	%
Skilled shipbuilding	510	60.9	504*	60.8*	843*	55.9*
Skilled metal	68	8.1	35*	4.2*	89*	5.9*
Other skilled trades	64	7.6	54*	6.5*	102*	6.8*
Apprentices	106	12.7				
Total skilled and apps.	748	89.3	593	71.5	1034	68.6
Semi- and unskilled	89	10.7	236	28.5	474	31.4
Total	837	100	829	100	1508	100

*including apprentices.
Sources: 1848: Miscellaneous papers on establishments. PRO, ADM 7/596.
　　　　　1863: *Parliamentary Papers*, 1863, XXXV, p. 163.

The 1863 figures pose even greater difficulties. Apprentices are not distinguished from craftsmen, hammermen are grouped with smiths, and although hired labourers are listed separately there is an additional

total for 'hired artificers and labourers attached to the shipwrights' department'. This group has been divided between shipwrights and labourers in the ratio of three to one.[51] Hammermen are taken as one-quarter of the total given for smiths and allocated to semi-skilled.[52] The results in Table 4.1, together with the 1848 analysis, confirm the domination of skilled workers, and their even clearer predominance among the elite established men. Most semi-skilled men and labourers were hired.

Shipwrights in the dockyards agreed to do iron work, and thus maintained their elitist position. The draughtsmen felt themselves superior, for at one time they complained of the lack of recognition for their skill and self-esteem, claiming that they were unjustifiably 'both for rating and pay, scarcely one whit above the joiner or blacksmith and had to go in and out of the yard with mechanics and labourers'.[53] The tension surfaces here between those escaping manual labour and those they left behind. More significant were the divisions amongst skilled workers, such as that between shipwrights and boilermakers. A local paper felt it necessary to answer the *Morning Herald*'s accusation that boilermakers had been involved in a crowd attacking an unpopular officer — they were, it seems, all shipwrights.[54] Such distinctions were only reinforced by the organisation of work and employment. Each yard was divided into departments, dominated by a single trade and under its own foreman and officers. Communications were channelled to the Admiralty through the officers of each department, a severe inhibition to common movements and struggles. This can be seen in the separate pay deputations to the Admiralty in 1865 from shipwrights, smiths, joiners, sawyers, plumbers, hosemakers, painters and labourers.[55] It remains unclear how far this imposed sectionalism increased divisions amongst craftsmen. Most apparent of all was the exclusiveness of the shipwrights. Even in the dockyard schools the ship-wright apprentices were regarded as the cream,[56] and the sense of superiority inculcated with the customs of the craft was reflected in the way in which the joint committee of Woolwich and Deptford ship-wrights chose to fight alone in their 1854 pay movement, rejecting the engineers, caulkers, sawyers and labourers who sought to join them.[57]

Wages in the dockyards (other than the Steam Engine Factory) were always below the general London rates, but these must not be confused with earnings. Steady employment, at least for permanent men, meant that the earnings of skilled workers compared well with those in private yards. Jane Connolly remembered this security in the Woolwich of the 1850s. 'Poverty was not known; poor sailors' and mariners' wives might

be in straits if allotment papers failed to come, but the wives of men in steady work in the Yard knew none of these vicissitudes.'[58] The rate of pay of labourers was always appallingly low, fluctuating between twelve and fourteen shillings a week, and although their bargaining position was made even worse by the extensive use of convict labour until 1856, the situation did not really improve subsequently. The small number of established labourers might look forward to superannuation, but as a prominent Deptford businessman forcefully argued, 'when men were compelled to exist year after year with empty bellies, they could scarcely with any confidence expect to live long enough to require superannuation'.[59] The quality of labourers recruited was consequently low, emphasising the superiority of the skilled workers. The gulf was deepened on the frequent occasions on which the skilled men were put on piecework, while the labourers stayed on time rates. The extra shilling the labourers then received was inadequate compensation for the speeding up of work.

The great attraction of work at the dockyards was the establishment, for it was amongst the hired men that fluctuations occurred. The mean weekly total of employees at Woolwich Dockyard between November 1860 and April 1861 was 2,069 but only 1,322 places had been authorised on the establishment. The figures for Deptford were 1,032 and 680.[60] At slack times the workforce would reduce to few more than the establishment but during high activity hired men could be in the majority. The most important benefit for established workers was security, for they were the very last to be dismissed, and on the rare occasions when this happened the Admiralty was required to pay them a pension. Those employed for ten years would receive one on retirement, generally £24 a year[61] for artisans until a new scale increased the amount in 1859.[62] In December of that year six shipwrights were each superannuated at £46 16s a year.[63] Relative security of employment, and some assured income in old age, were major attractions. This security allowed many established workers to improve their position in relation to other workers by running shops and small manufacturing establishments outside their working hours.[64] There were other benefits – pay was not stopped for holidays, medical attendance was organised, half pay was given to a man hurt on duty, and widows of men killed in service received a pension.

Opportunities for promotion allowed confirmation of that element in artisan ideology which trusted in the possibility of progress for the disciplined and hard-working. Such a ladder was set up in the smith's department in 1846 'to reward meritorious artificers'.[65] The system

throughout the yard involved an annual examination in arithmetic and skill which a man might apply to take after three years on the establishment.[66] In 1848, 6.4 per cent of skilled workers were leading men, and 7.4 per cent first-class workers.[67] Above this level was the possibility of promotion to writer, foreman, inspector, converter, measurer and very rarely master. William Sharp was apprentice and working shipwright in Woolwich Dockyard between 1807 and 1843, when he became inspector of shipwrights at Deptford Dockyard until his retirement in 1855.[68] Promotion on this scale was rare, but the numbers who rose to lower positions, or even just improved their class within a trade, cannot be estimated. It must have been considerable, judging from the great concern of workers about methods of promotion. The final advantage that the establishment offered was apprenticeship for a worker's son and this was commonly used.[69] Dockyard apprenticeships were keenly sought — until 1861 they even guaranteed a place on the establishment. Hundreds of applications would follow an announcement of vacancies.[70]

Established workers could thus feel some real degree of security, and this inhibited trade union organisation in dockyards.[71] Hired workers would be attracted by the prospect of being taken on to the establishment. For these reasons, once a worker had entered the dockyard there was a tendency not to leave voluntarily. The emigration movements amongst top-class workers that accompanied the rare massive reductions confirmed this feeling — workers used to cyclical or other fluctuations in work would not react as if the withdrawal of employment was so final and permanent, unless its presence had been similarly viewed.

These established skilled men were among the real working-class elite of their town, and might be described as an institutionalised aristocracy of labour. 'The Dockyard workmen', wrote Jane Connolly, 'were a fine, respectable set of men . . . There were fluctuations in the number of unskilled labourers, but these did not touch the good, established workmen.'[72] The relative security of established men and the fact that all workers were employed by the government, rather than by a private employer, led to an ambiguous situation. Not only was there less short-term insecurity than among workers in private industry, who were more susceptible to movements of the trade cycle; but their employer was a vague non-profitmaking body confused with concepts of Britain's power, and with the working-class patriotism that manifested itself during the Crimean War. Dockyard workers dealt only with their officers, and saw the Lords of the Admiralty as they passed through the yards once a year and awarded a half-day paid holiday. When a deputa-

tion went from the town of Woolwich to the Admiralty in 1869, Eveling addressed the First Lord of the Admiralty, Childers, 'Will you permit me, as a working man of the Factory . . . ' Childers interrupted him. 'Did you say "a working man of the Factory"? I had no idea I was receiving a deputation so composed. Speak to me, Sir, through your officers.'[73]

There was little trade union organisation in the Dockyards, outside the Steam Engine Factory. The rarity of strikes is reflected in the severity of the Admiralty response. In 1859 they dismissed all 100 striking sawyers at Woolwich within a day of the strike beginning and with no attempt at conciliation.[74] The shipwright chairman of an 1853 pay meeting at Woolwich argued that if the Admiralty did not agree to an advance, they had no choice 'but to go to private yards or to emigrate'.[75] Industrial action was neither considered nor used. In 1866 the Woolwich Dockyard engineers decided not to take up the London agitation for a wage increase − they said that they got less pay than in private firms, but had more holidays, prospects of a pension and other advantages.[76]

The rigid discipline of the Dockyards was coupled with paternalism, and Barry, admittedly no friend of government enterprise, attacked both aspects fiercely. He believed of superintendents that 'if some of them had their will it is well known that the Articles of War would be read to the "employés" every morning beside a triangle and a cat-o'-nine-tails".[77] No attempts were made to conciliate labour, and the commodore of the Dockyard did not hesitate to use his magisterial authority.[78] Paternalism and discipline together with relative security deformed the already peculiar elitism of shipyard labour.

Building

The building industry allowed a more open view of the possibility of escaping pure dependence on wage labour, and also a less closed view of the social structure as a whole than might develop in heavily capitalised industries. The high proportion of craftsmen in the building industry was the other important factor in developing the attitudes of its workers, though there were great varieties of skill amongst these. According to one estimate, artisans made up 64 per cent of all adult workers in the building industry of the 1860s.[79] With technological change limited to minor improvements in materials, craft organisation and traditions prevailed. The rise of small speculative builders, the influx of provincial labour, the decline of apprenticeship and the signs of casualisation that characterised the London building industry when

Dearle studied it[80] were making an impact in the early Victorian years, though their effects were less serious in Kentish London. Greenwich Hospital, which may not have been a typical case, had virtually no un-apprenticed building craftsmen between 1848 and 1855. A substantial 37 per cent had been apprenticed in Kentish London, and a further 19 per cent elsewhere in the metropolis. Some trades were more local in their origins than others — 56 per cent of bricklayers were apprenticed in Kentish London, but only 17 per cent of masons.[81]

The term aristocrat cannot be applied to all building craftsmen for their quality ranged from a craft-conscious and highly-skilled elite to unapprenticed men who had casually picked up the trade. A higher proportion of building artisans were not obtaining the going rate than other skilled crafts.[82] A hierarchy existed, and the top of it coincided with the trade unionists. The size of that elite in each craft would depend on its vulnerability to dilution. Even with this variation, however, the gap between labourers and most craftsmen was wide. W. Stevenson, secretary of the United Builders' Labourers' Union, when a young man courted a bricklayer's daughter 'who rejected him with scorn when she found out that he was only a labourer'.[83] A man who worked as a labourer in 1866 recalled that 'the bricklayers appeared to me, at that time, almost as demi-gods, the way they shouted for mortar and bricks, and the difference between their treatment and ours by the boss'.[84] The pay differential widened during the period, with the ratio of craftsmen's rates to labourers' rates in London advancing steadily from 1.50 in 1850 to 1.85 in 1877,[85] but it must be especially noted in this industry that this differential only refers to the better craftsmen able to command that rate. Apart from the short-lived General Amalgamated Labourers' Union of 1872, which had branches in Deptford and Woolwich, there was no trade union organisation for labourers.[86] The distinctions in the job encouraged a social differential. Labourers had to start work early to prepare for the artisans and were expected to work overtime without pay on occasions. The leader of the 1872 union, Patrick Kenney, explained that the labourers always suffered when the skilled men went on strike. 'It did not matter who began the struggle, they were between the hammer and the anvil, and had to suffer the concussion whoever struck the blow.'[87] In 1876 building labourers confirmed this during a skilled workers' strike in Woolwich when they met and complained of 'the class distinction which . . . has hitherto existed among the working classes'.[88] Kentish London branches of the carpenters could vote overwhelmingly for a levy to help the agricultural labourers,[89] but would not carry their sympathy into active assistance

to the unskilled on their own sites. Victorian artisans found it easier to support the advance of those unskilled who did not affect their own status at work. This was especially true of the bricklayers who in the 1850s sought to raise the status of an easily diluted trade by actively destroying the previous close relationship between the brickie and his labourer.[90] Only the bricklayers had to do this. The other London building trades (excluding painters) were certain of their own superiority, and displayed it by oppression or paternalism in their relations with their labourers.[91]

Seasonality was one factor determining the success of a building craft in maintaining a level of relative security and respectability. Others were the ease with which the skill could be picked up, and the strength of trade organisation. Labourers and painters were by far the greatest sufferers from seasonal unemployment, leading to partial casualisation, but the problems were far less serious amongst the other trades, even in Dearle's time.[92] After the initial shocks of dilution in the 1820s and 1830s, the other sections of London building recovered and substantially advanced their position in the boom of the 1850s. Unlike the other traditional London crafts, the honourable sector of building survived the pressures of the early Victorian period well.[93] With growing local and then amalgamated organisations, steadily increasing money wages and a widening differential, the better craftsmen could thus widen the gap between themselves and their labourers. It is not these factors alone, but all the other advantages that fairly high pay for the better craftsmen, craft status and aspirations made possible and desirable, that identifies their importance as an elite trade. A London mason who had his box robbed in a lodge house lost from it 'half a sovereign, a black frock coat, 2 waistcoats, a shirt, a pair of stockings, a silk pocket handkerchief, a neck handkerchief, a pair of boots marked "R. Dyke, stonemason", a tool box with about 30 tools, and a hammer'.[94] The tools were an important distinction both of independence and achievement. Most building craftsmen had their own, and in 1867 their cost ranged from about £1 for a bricklayer's set to £20 for a joiner's.[95]

Building trades unionism consisted of separate craft organisations from the days of the earliest local societies, and local organisations survived the amalgamation period of the 1860s to emphasise the extreme specialisation among the building crafts in London. Booth felt that 'the lines of demarcation between trade and trade are much too sharply drawn' in the metropolis, and he compared the situation with that of a small provincial town, where 'every builder's operative tends

to be an all-round man'.[96] Harnott of the Stonemasons when asked, 'Do the various building trades ever act together?' replied, 'No, not at all.'[97] An exaggeration, but none the less revealing. In the Woolwich movement of 1866 each trade organised the strike separately, with its own committee and its own funds,[98] and this was repeated in many disputes.

A status consciousness accompanied this sectionalism. Masons and plumbers were regarded as the elite, followed by bricklayers and carpenters and joiners. Most foremen were recruited from carpenters and joiners who 'have long been recognised as embracing a large proportion of the elite among operative builders'.[99] The resistance of many local carpenters' societies in London to joining the amalgamation was in part a function of this. The maintenance of local plumbers' societies with little co-ordination also derived from their exclusiveness in relations with other trades.[100] The most exclusive branch of all was the masons. Always reserved and secret, they were loyal to trade regulations even if not in the society.[101] Their union organisation was probably the best of all, though the shifting nature of masons' work tended to mean that individual lodges might be unstable. The Operative Stonemasons were particularly strong in Kentish London, with a lodge at Woolwich almost throughout the period, and others in Deptford (1836), Greenwich (1850) and Plumstead (1863).[102] Good organisation and a high level of skill meant that masons were always most successful in preventing labourers from advancing to journeymen,[103] but their exclusiveness was as notorious amongst the other crafts as it was resented by the labourers. According to the bricklayers, masons had 'a great deal of bombast and self-importance', which they were always 'parading . . . before those trades whom they are in the habit of working with'.[104] The masons agreed that they transacted their affairs in the lock-out and strike of 1859 and 1861 'aloof from the general conference of trades'.[105] They were careful to dissociate themselves from the meeting of Woolwich building workers to discuss the nine-hour movement in 1860,[106] and settled alone in 1872.[107]

The masons' exclusiveness was only one characteristic of a broadly-based sectionalism in the London building trades. A labourer remembered how 'during the meal hours the best fun was to hear the masons telling tales at the expense of the joiners. Those in their turn would have a go at the bricklayers and plasterers, whilst all hands relished a poke at the plumbers.'[108] Each trade had its own pride and its own status, of the kind reflected in the views of the Woolwich bricklayer, John Jeffery, that 'masons and carpenters could be replaced by workmen from the continent, but . . . the English bricklayer was

unrivalled'.[109] As a result, building trade unionism was characterised by small, local and sectional organisations of which the historian can usually obtain only glimpses. The carpenters and joiners in particular boasted a network of small, parochial local clubs that long resisted amalgamation, and organised only the elite of the trade.[110] Building was probably the least well organised of the main Kentish London industries. The masons were the best organised, as we have seen, but the Operative Bricklayers' Society seems to have been a small and somewhat hesitant presence in Kentish London from the 1860s. The Woolwich members claimed lodges well before the first recorded one in 1862: local clubs clearly preceded amalgamations.[111] In the mid-1860s the National Association of Operative Plasterers and the Amalgamated Society of Carpenters and Joiners opened their first branches in Kentish London.[112] It must be assumed that some rudimentary, perhaps well-organised unionisation existed before these dates at the local level, and that it persisted to a greater or lesser extent into the amalgamated period. The Amalgamated Painters were not represented in the area in the 1870s, yet even they had been sufficiently well organised at a local level to pursue successful wage movements.[113] There was certainly a Woolwich Society of House Painters as late as 1877.[114] Building trade unions in Kentish London, as in the metropolis as a whole, reflected the confusions of the building craftsmen — sectional, differentially threatened by dilution, only partially organised and struggling to re-establish their craft position, with a degree of success for the better craftsmen in the more favourably placed trades. It was these men, in local or amalgamated societies, who formed a fragmented but significant section of the Kentish London artisan elite, and they displayed many of the fundamental characteristics of that stratum. A major objection to the hour system in 1861 was its effect on the craftsmen's position vis-à-vis other occupational groups. They claimed that it was undignified to work on an hourly basis, and that the system reduced skilled building workers to the level of day labourers.[115] The interesting point is not their predictable objection to the hour system, but that their objection was located within the context of a status hierarchy that related directly to dignity and pride.

Engineering

In the first half of the nineteenth century, the capital-intensive development of the engineering industry introduced major changes in machine making and metal work. The introduction of the power-driven lathe, planers, slotters, and self-acting drills, at the same time as a vast increase

in demand for engineering and metal products, led to a shortage of the old, exclusive millwrights at the very time when their replacement was becoming possible. The introduction of machine tools opened a period of intense specialisation and division of labour within the industry. The need to work expensive machine tools extensively at establishments such as Penn's in Greenwich explains the rise of systematic overtime and piecework, and the union struggles against them.[116] The new techniques and machines could be operated by men without the all-round experience of the millwright, and a new range of metal trades grew up in the middle decades of the century. They may have lacked the range of the millwrights, but the new craft required a high level of hand and technical skill that was not challenged until the rise of self-acting machine tools towards the end of the century.[117] In place of millwrights, carpenters and smiths, there grew up patternmakers, brass founders, iron founders, smiths, moulders of all kinds, firemen, vicemen, fitters, planers, filers, erectors, turners and many more.[118]

In the larger engineering works, men were divided into different shops by trades — such as turnery, fitting and erecting shops, patternmakers' shops, smithery, press shops. Specialisation within each trade became important. By mid-century there were five types of lathe, which meant that each turner had very specific experience. As the century progressed, employers tended to seek men of increasingly precise skill. The steam engine makers complained that 'there are members in our own trade who know little of the relative parts of an engine, only what they read of or are told by others'.[119] This all occurred within a more general specialisation into marine, locomotive and stationary engine work. The 'general workman' who could operate with ease in all three fields was the exception.[120]

These new craftsmen dominated their industry. Jefferys estimated that skilled workers constituted around 75 per cent of the workforce,[121] probably even more in the marine engineering works that dominated Deptford and Greenwich. Maudsley's and Penn's were in fact cited by William Allen as works with an unusually small number of machines being operated by semi-skilled workers.[122] Engineering craftsmen were among the best-paid industrial workers of the mid-Victorian period, although they suffered in the 1860s a higher level of unemployment than in other skilled trades.[123] The best of these highly paid workers were those in marine engineering, according to an ASE survey in 1861.[124] The field was specialised. When the Steam Engine Factory at Woolwich Dockyard sought quality specialist workers in 1854, a local union secretary informed members elsewhere that 'good fitters and

erectors are required still, but must be accustomed to marine engines'.[125] That particular factory, employing around one thousand men at the time, was specially selective and demanded character references from applicants for employment.[126] The dominant firms in the Kentish London engineering industry were thus in the sector with the most skilled and best-paid craftsmen. Penn's marine engineers were renowned in the area. 'An inquirer in Greenwich or Deptford will find that Penn's "men" are a class known to and esteemed by the whole community, chiefly because of the respect they manifest for themselves and of the esteem in which they hold the members of the firm.'[127]

These craftsmen were not homogeneous however, for sectional differences between trades were superimposed on the hierarchy within each. As a result, an increasing differentiation in both rates and job produced a partial return to union sectionalism in the 1870s.[128] The rates paid to workers in the Steam Engine Factory in mid-century indicate these variations. Turners, millwrights, patternmakers and smiths formed the elite, with a mode rate of six shillings per day. On five shillings and eight pence were fitters, moulders and coppersmiths, while boilermakers received five shillings. As interesting as this division was the pay scale within each trade, up which a worker could climb. Above them stood the leading hands who generally received eight shillings and sixpence and were recruited from craftsmen.[129] The Steam Engine Factory was modelled on the major London marine engineering works, and followed general rates. The pay gap between the various engineering trades in London seems to have narrowed by 1886.[130]

This division between trades was reflected in the patterns of unionisation. London engineering had been renowned for its competing sectional societies,[131] though this was in part a reflection of the geographical fragmentation of the metropolis. Of the numerous unlinked smiths' societies of the 1840s and 1850s, we can pinpoint only the Old Smiths' Society, which opened a branch in Greenwich in 1848;[132] the others have disappeared from view. Local societies have left little trace of themselves, but industrial conflicts in the area in the 1840s very clearly rested on trade union organisation, in the larger works at least. A non-unionist who crossed the Thames to work at Penn's in 1846 was told that 'he had no business there, as he did not belong to the club, and he had come there to take the bread out of the mouths of those who did belong to it'.[133] Sectional development followed the amalgamation into the Amalgamated Society of Engineers, revealing the status distinctions amongst skilled workers in the industry, but this was more

marked north of the Thames and the ASE made good headway in the large-scale industry across the river. Branches at Greenwich and Woolwich were established immediately and by 1855 they had 350 members. Ten years later, with a Deptford branch added, there were over 1,000 ASE members in four Kentish London branches. This total was generally maintained through the rest of the period, except for a decline in the late 1860s depression.[134] They were active branches. At one presentation to the Woolwich branch secretary, over 500 members were present.[135]

The other national trades were well organised locally. The ironfounders had substantial branches at Greenwich and Woolwich, the former having 120 members through the 1870s.[136] Boilermakers' branches at Woolwich and Greenwich dated from the early 1840s, and in 1877 Kentish London contained 340 members, of whom 210 belonged to the Deptford branch.[137] In the 1860s a breakaway boilermakers' union was set up in Deptford, the High Order of Friendly Boilermakers of the London Unity; there was a persistent localisation in London metal-working unions.[138] The Steam Engine Makers' Society was never strong in the area, and their branches at Greenwich (established 1844) and Woolwich (1842) rarely went beyond 60 members. They organised widely, covering as extensive a range of skilled engineering trades as the ASE, but were always a secondary if elitist organisation, taking care about admissions and concentrating upon skill, health and character rather than enrolling all in the trade.[139] Life could still be uncomfortable and their Greenwich secretary complained about his members being swamped by the ASE.[140]

Patternmakers also considered that their higher skill and different materials elevated them above other skilled engineering workers.[141] The society that broke from the ASE in 1872 proclaimed their sense of identity to London patternmakers. 'As patternmakers we claim that no other section of mechanics understands our affairs as well as we do ourselves, we therefore claim a right to have a separate existence to other Trade Unions.'[142] In the 1860s there was an even more exclusive society of patternmakers for the Greenwich and Deptford area, a conservative and very exclusive body, priding itself upon organising the cream of the trade.[143] It was based on Penn's, Maudsley's and Humphrey and Tennant. Their ownership of their own tools enhanced their sense of distinctive pride; this was equally true of millwrights and machine joiners. Aspirations such as these indicate the importance of status in the London metal trades, and craft walls reinforced the status differences. Examples could proliferate. Fyrth and Collins have shown

the exclusiveness of the moulders, and the rigid craft barriers that separated brass moulders from those who worked in iron.[144] Wages in the Steam Engine Factory show that this exclusiveness was not based on pay. Foremen were often recruited from these men and, even more important in the context of the argument in the preceding chapter, there was the opportunity for a moulder to set up as a small master. In the first half of 1852, of the twenty-eight London members excluded for non-payment of contributions, at least three had 'turned master',[145] while others would not have let their membership lapse.

The rates for unskilled workers in these trades were far behind those of skilled. In 1884 labourers' rates in engineering ran at about 50 per cent of skilled rates, while semi-skilled assistants received about 65 per cent.[146] The mode rate of pay at the Steam Engine Factory in 1848 was, at two shillings and eight pence, lower than these estimates, if anything.[147] Engineering was an industry where the differential between the rates of skilled men and labourers, less hindered by old craft traditions, rested increasingly upon the exploitation of the market by trade union activity. The differential apparently widened during the period. Between 1856 and 1870 the index of the standard rate for patternmakers and fitters rose by six points, that for engineering labourers by four points.[148] As in shipbuilding, divisions based on differentials and status might be reinforced by exploitative relationships between the skilled man on piece rates and his labourer paid by the hour.[149]

Nevertheless, engineering workers' skills were not totally secure in the 1860s. Improvements in machines gave rise to a semi-skilled stratum of machinists, who began to threaten the position of some skilled trades, although only marginally during our period.[150] The problem was less serious in the marine engine shops of Kentish London, where a greater reliance upon hand skill was maintained, and where repetitive work was rare.

Royal Arsenal

John Anderson had transformed the Royal Arsenal by 1854. In his own words, 'there is hardly any comparison between the way in which it used to be done, and that in which it is done now'.[151] Changes in both machinery and organisation put the establishment on the advanced footing which it maintained for the rest of the period. According to one observer, 'the introduction of machinery on a large scale put to flight the old traditions of the Arsenal, and the manufacturing spirit had to be substituted for the military organisation under which the establishment

had been conducted before'.[152]

Anderson was no military man, and that was a vital qualification. He was trained in Manchester, and came to the Arsenal via Napiers in London.[153] He found the Carriage Department in a reasonable condition which he could develop. Bramah and Maudsley had supplied it with machinery in the first decade of the century, and extensive use of Nasmyth's steam hammer maintained its forward-looking stance.[154] Sir Richard Vivian claimed that most work in the other departments was done 'in a primitive manner by manual labour'.[155] From 1842, Anderson improved both the machinery and the organisation. He turned the Brass Foundry (later incorporated in the Gun Factory) into an engineering workshop producing machinery for the whole of the Arsenal.[156] The Laboratory, traditionally tied to hand methods, was equipped with machines and engines largely from Nasmyth.

If the broad lines of the changes are clear, their effects on the labour force are obscured by the absence of employment records.[157] Processes that could be conducted by unskilled labourers substantially increased only in the Laboratory. Anderson's faith in machine tools and steam power led him to exaggerate their impact,[158] but he could also be more sober in his appraisal of the changes, comparing the quantities that could be produced with unskilled labour in the Laboratory with the other 'iron foundry for general work, [where] frequent use is made of ordinary patterns which require another class of workmen earning high wages and performing in appearance much less work'.[159]

The rough and possibly inconsistent breakdown in Table 4.2 shows that the Gun Factory manufacturing machinery, guns and mortar increased its proportion of skilled workers over the period, as it settled as an engineering and metal-working factory whose labour force resembled that discussed in the last section. The Carriage Department was extensively mechanised but remained dominated by skilled workers throughout the period. The breakdown for the middle period, showing an increase in the proportion of labourers, is less easily explained. There was certainly a disproportionate intake of labourers in 1857,[160] and we are probably seeing the effects of a specially large intake of labourers for some specific need that did not relate to the long-term structure of the department. The change from wood to metal in the 1850s and 1860s was carried out by retraining wheelers as smiths.[161] The principal trades in the Carriage Department were wheelers, smiths, carpenters, joiners, sawyers, and harness and collar makers.

The Laboratory fulfilled Anderson's hopes, dominated as it was by

Table 4.2: Employment at the Royal Arsenal

	Gun Factory no.	per cent	Carriage dept. no.	per cent	Laboratory no.	per cent	All depts. no.	per cent
1848*								
Foremen, leading men	8	3.8	17	2.9	26	9.5	51	4.8
Artificers	99	46.7	476	81.9	99	35.9	674	63.3
Labourers	105	49.5	88	15.2	148	54.6	341	31.9
Total	212	100.0	581	100.0	273	100.0	1,066	100.0
1861-2								
Officers, clerks, foremen	67	1.7	90	3.9	57	1.7	214	2.4
Artificers	2,099	62.9	1,232	53.3	512	15.4	3,843	42.8
Labourers	1,172	35.4	990	42.8	2,767	82.9	4,829	54.6
Total	3,338	100.0	2,312	100.0	3,336	100.0	8,986	100.0
1886								
Officers, clerks, foremen	110	5.7	162	7.5	137	2.3	409	4.0
Artificers	1,115	58.0	1,526	66.8	1,109	18.7	3,750	37.0
Labourers	698	36.3	596	25.7	4,678	79.0	5,972	59.0
Total	1,923	100.0	2,284	100.0	5,924	100.0	10,131	100.0

*The Gun Factory was at this time known as the Brass Foundry and the Inspector of Artillery's Department.
Sources: 1848: PRO, WO44/523; 1861-2: *Parliamentary Papers*, 1863,XXXIII, p. 531; 1886: *Parliamentary Papers*, 1886,XL, p. 879.

labourers and boys making ammunition and shells, and filling rockets and tubes. The Arsenal was not dominated by unskilled labour, as the total statistics and Anderson's extravagant claims would suggest, but by three departments, of which one went over wholesale to cheap unskilled labour, while the other two changed from old wood and metal crafts to the new metal skills that have been already examined. Craftsmen and labourers were far apart. It was argued in 1854 that strikes would be avoided in the Arsenal compared with private industry, on the grounds that the skilled workers were well paid while the unskilled were of an inferior sort.[162] Captain Denison's evidence to the General Board of Health contrasted the security and moderate to high pay of skilled ordnance workers with the large numbers of unskilled labourers in the town, many of whom included irregularly hired labourers at the Arsenal.[163]

Arsenal artisans were often of a very high standard. There was certainly a great demand by engineers for jobs there, and men were so willing to give up good positions elsewhere to go to the Arsenal that the ASE had to warn against overstocking the labour supply available to the Board of Ordnance.[164] The officers could be very selective about which workers they employed, even at times of great activity such as the Franco-Prussian War.[165] Those taken on at the Gun Factory had to have unexceptionable testimonies of skill and industry,[166] to be under forty, to pass a medical and have good references from a former employer.[167]

If the standard of the skilled workers was high – and to achieve that was one of the main objects of Anderson's reforms – that of the labourers was very low. They were appallingly paid, even for unskilled labour, hovering around 14s a week for much of the period, and switched around from job to job[168] in a fashion injurious to labourers' dignity, while skilled men were on a scale ranging from 24s 6d to 36s and above. In 1851, engineering workers in the Arsenal enjoyed the lowest hours in the country.[169] The prospects of promotion available to skilled men and clerks widened the perceived gap. A regular system of promotion from one pay rate to another operated for good workmen, based on ability and length of service.[170] The 1852 pay structure had three levels, 24s 6d, 27s and 36s, and this pattern was to change little.[171] This ladder of opportunity was rarely available to the unskilled, but for those craftsmen who aspired to such mobility it could even stretch out of manual labour. Writers, a minor clerical grade, were recruited from amongst skilled workers. The same hierarchy existed in the clerical grades, from a rate in 1857 of £90 a year for the bottom of the third

class to £280 a year for the top of the first class.[172] F.J. Fullom made the full journey, from a third class clerk in the Carriage Department in 1847 to Principal Clerk, and his death in 1868 led to a major process of promotion.[173]

There were more substantial advantages to be gained from work at the Arsenal for skilled workers, especially those on the establishment. The security was even an attraction for labourers, a minority of whom could look forward to a fair degree of stability of employment, something that was not general for those without a trade. Ellen Chase tells of a man who was taken on at the Arsenal. 'It was practically a permanent position to a man of his steady habits, and guaranteed a larger measure of comfort to the family than they had enjoyed since I had known them.'[174] Letters from army pensioners, old Arsenal workers, and people with even more tenuous links with the Ordnance works, in search of places for their sons or themselves, testify to the appeal of employment there. In the 1840s, though apparently not subsequently, employment at the Arsenal was to some extent tied in with the whole structure of political constituency patronage.[175]

The security was especially strong for the men on the establishment, which existed in much the same fashion as at the Dockyards. The pensionable establishment was discontinued in 1861, although men already on it retained their rights. They constituted 10 per cent of all Arsenal workers as late as 1886, an indication of the long service of the more permanent workers.[176] Superannuation was cited by one Arsenal worker as a reason for staying there,[177] while another said that Arsenal workers would be unwilling to leave their employment even for improved pay.[178] The distinction between established and hired survived the 1861 reforms. The other benefits continued, including non-contributory sick pay after three years' employment,[179] libraries, schools, medical treatment, an infirmary and a number of paid holidays.[180] The hired men shared some of these lesser privileges.

The combination of a general elitism of skill and these benefits that naturally impinged more upon the artisans who formed the more stable part of the workforce and who were more likely to remain in work to enjoy them, led to an institutional security that manifested itself in a number of ways. The artisan consciousness that prevented skilled men doing inferior duties in the Carriage Department in the 1850s, and led to the employment of 50 extra labourers to do the work, is an example paralleled elsewhere.[181] More specific to the Arsenal are the social customs that developed amongst craftsmen. The blacksmiths celebrated 'Old Clem' every November, with a degree of disturbance to the town

of Woolwich that depended on the amount of money they could persuade the townspeople to contribute for drinks.[182] The 'engineers' had a dinner each year, though there is no evidence as to how exclusive that body was.[183] 'Junior artisans' held supper meetings.[184] In addition to specifically trade occasions, there were the benefit societies, such as the Royal Laboratory Burial Society,[185] co-operative societies, reading rooms and so on. These institutions were dominated by artisans, and the more stable among them, for they declined only marginally during major reductions of the workforce.

It seems clear that a pattern of tradition, custom and social life built up amongst the more stable workers in the Arsenal, which gave some cultural reinforcement to the various economic differentiations. They were deeply rooted. The annual bean feasts could not be interfered with by the authorities even at times of the most urgent activity.[186]

This security and elitism, together with the traditional disciplined structure, help to explain the infrequency of industrial disputes at the Arsenal. As with the Dockyards, the response of the authorities to strikes was generally extreme. They usually led to all the men involved being dismissed, as with those who struck in the rocket factory in 1855,[187] or all the moulders involved in a strike the following year. Workers were unwilling to jeopardise a secure position except in the occasional short actions in defence of craft privileges that were common during the high activity of the Crimean War. The Arsenal engineers in 1866 decided not to respond to the London union leaders' call for wage agitation, replying that they were content with their added benefits of buildings, pensions and other advantages.[188] Even high feeling was not generally transmitted into a strike, as when Thomas Driver was fined double time in 1872 for absence from work. A mass meeting on Plumstead Common supported by Charles Jolly and other local notables was emphatic about its views, but when the War Department refused to act, the matter was dropped.[189] Similarly, a meeting in support of the nine-hour movement in 1872 specifically ruled out the idea of a strike, and articulated widespread fears of loss of privilege.[190]

'What about the poor labourer?' demanded a voice from the floor at that meeting. He was told that 'the labourers always improved their position in a ratio the same as the mechanic, who had to fight the battle alone'.[191] This was simply not true, but it reflects the distance that was felt to divide them by both labourers and artisans in the Arsenal. As in the Dockyards, the Arsenal elevated a heterogeneous skilled elite, part of the major well-paid trades of the mid-Victorian period, above a low and badly-paid labourers' section, and a smaller body of less secure,

hired craftsmen. It gave them relative security and benefits, a social life and a fear of dismissal. Both Dockyards and Arsenal also created specific problems for class attitudes by their structure of government employment, and the deformation of attitudes that went with it. Issues of that kind lead us into the question of the shape of the local community, and that is the subject of the next chapter.

5 ELITES AND THE COMMUNITY

However great or small was the impact of a town's principal clergyman
on its inhabitants while he was alive, his death was always a major event.
The death of Rev. W. Soames of Greenwich in 1866 was no exception,
and a committee was soon established to organise a memorial in his
honour.[1] If we are searching for the social leaders of Greenwich it
would be difficult to find a better place to start than with the members
of this committee. It was set up to raise money, and had few organisa-
tional responsibilities. Those invited to join were sought for their
names rather than their talents, and both its honorary character and its
importance in the community suggest that this committee would have
been composed of those regarded as the social elite of the town. An
analysis of its membership can be found in Table 5.1, but it is worth
taking a closer look at the fifty members of this committee.

The presence of six local clergymen should cause little surprise, but
more notable is the large number of professional men. The three
doctors were all men of moderate or high status in their profession, a
matter of importance with a medical profession which, however far it
had progressed from the world of *Middlemarch*, was still precisely
stratified with regard to qualifications and status. Gay Shute 'was
locally regarded as the Father of the Profession',[2] and was a Fellow of
the Royal College of Surgeons, as were both the other doctors,
indicating a teaching hospital training and examinations as a minimum.
The ten lawyers included such important figures in the community as
John Pontifex, Edgar Sydney and Joseph Smith, and indicate the local
importance of a layer of professional men, businessmen and merchants,
many of them based in London. This is emphasised by three City
merchants, the silk mercer Thomas Cabban, the sugar merchant
Thomas Fry, and F.O. Smithers, a City chemical merchant and agent.
These men were not as deeply involved in parochial offices as were the
tradesmen and local businessmen on the Soames Committee, but they
were men whose names recur on the honorary committees of the town.
The four retired naval men — Admirals Hamilton and Scott, and
Captains Lane and Routh — indicate a further peculiarity of Greenwich
society.

Local social standing often accompanied particular offices, and for
this reason the Astronomer Royal, G.B. Airy, the local MP, William

Angerstein, and the chief clerk to the Greenwich Hospital, J.I. Langley, all served on the committee. So did John Penn, the only major local employer represented, but, resident at Lee, he was the only one close at hand. The other manufacturers were economically lesser men who were, on the other hand, far more prominent in the social life of the town. James Soames was a soap manufacturer who served intermittently for thirty years as poor law guardian and churchwarden. The shoemaker Joseph Mead was also active for many years, on the Board of Works and as a vestryman and poor law guardian. Here the committee firmly interlocks with those prominent in local government and church office, for although professional men and merchants did hold these offices, as we shall see, they were far more strongly represented on such honorary committees as this. Of the eleven tradesmen, virtually all either held or went on to hold some important local office. These tradesmen were men of substance, active in parochial affairs. T.R. Huntley was a prosperous coal merchant; Henry Hatfield, plumber and ironmonger, lived in the Blackheath Hill area; another ironmonger, G. Oliver, was no minor shopkeeper, for in 1871 he kept four servants at his Blackheath Hill home. These were all tradesmen of wealth and standing. Thomas Burton, the grocer, held local office for twenty years; so did Henry Morley, piano and music seller, who resided in the fashionable Croom Hill area, and held practically every local elected office of importance.

The remaining members of the Soames Committee show the more miscellaneous side of local elites. Only the builder William Holding could be described as involved in local industry. Samuel Noble and R.P. Brown were both architects while G. Gordon Scott was an Admiralty clerk, and William Sherman a merchant's clerk, but the portmanteau role of the designation 'clerk' is indicated by the fact that both appeared in the 'Gentry' section of the local directories. Guilford Barker Richardson was a stockbroker and East India agent, prominent in the vestry and on the Board of Works, and the list is completed by a shipowner, James Roberts, and the High Constable, George Reeve. Only a limited amount of flesh has been added to the bare bones of the names in this long list, yet the task has been important, for these were the men who formed the social elite of Greenwich in 1866. Their occupations are perhaps those that might have been expected from the earlier discussion of the social structure of the area. A major part of this chapter will examine how far evidence for the whole of Kentish London confirms the picture suggested by this one committee.

Earlier examination of industrial structure and work situation stressed the importance of immediate relations within the community

or groups in which workers were involved, and argued that those relations were fundamental to the formation of working-class attitudes and behaviour. A key variable that dictates the way in which these other factors operate is the character of the local community, particularly its relationship to the economic structure of the town, and the types of people who stand out as its social elite. The completeness of the community is the foremost concern, the extent to which it reflected within itself its own economic and social structure. The notion of a resident bourgeoisie in particular describes a situation where those who owned the capital, made the profits and controlled employment were a visible part of the local community. It will clearly influence working-class perceptions of social and economic control, and the ideological formulations by which people make sense of what they perceive. If the local community shows that both wealth and social prestige derive from long-standing permanent industrial establishments, that is from the labour of the community's working class, then the image of the economic and social system which the working class receives from its immediate environment will more probably take on a class character. Whether or not that picture does in fact emerge depends upon a range of further variables, some of which are examined elsewhere in this study. If an ideological framework is to develop and persist amongst a group of people, then it must in some way make sense of that group's experience. For the skilled workers whose value system and behaviour are the concern of the rest of this book, that experience included images they derived from their own local community. One important theme of this chapter is the way in which social prestige and respectability related to economic power.

The real wealth in Kentish London was generally extraneous to its economic structure, and the social elite of the towns was constructed around a non-industrial middle class. The most prosperous inhabitants were those such as merchants, lawyers and businessmen who lived in the area but derived their wealth from activities outside it. Real wealth in Woolwich lay with families like the Maingays of Shooter's Hill, who were Russian merchants,[3] or old landowning families such as the Wilsons of Charlton and the Angersteins. Richard Wallington and William White, solicitor and accountant respectively in the City, were men whose wealth was worthy of local comment, as were the City lime merchant, Richard Wrighton, and the general manager of the National Bank of India, Robert Orr Saunders. Locally derived industrial wealth was scarce, visible in Deptford alone. The large-scale establishments of the area were part of the towns' economic structures only in so far as

they gave employment to their workers; they did not grow out of the towns' economies, nor did their profits increase the wealth of locally based employers. This was true of Greenwich and Woolwich, although in Deptford some of the main employers lived in or near the town. Astride the whole area, however, stood the government establishments, where neither capital nor profit seemed relevant and where there were no visible employers. This was especially marked in Woolwich, distorting the way in which industrial capitalism appeared in the town, and affecting the character of working-class behaviour there.

If social success depended upon prestige, talent and respectability rather than on capital and the work of the community's labour force, an ideological framework among aspirant workers that made apparent sense of that situation is more readily explicable. This chapter will seek to establish those who appeared successful in Kentish London society. Ought we to define social leaders by activity or attribution? Are we looking for men with a long record of activity in local social direction, or those deemed part of the elite by reputation?[4] This distinction in sociological research was to a large degree unreal in Victorian communities, and we ought to seek those who took the lead in community affairs, where values dominated, and who were regarded as the established and successful men in the town, for it is the men who *seemed* to have social prestige and social influence who are the elite sought in this chapter. Unlike the realities of community power that have absorbed American sociologists,[5] we are concerned above all with appearances. The starting point will be those local bodies concerned with the economic and social functioning of the towns; amongst them poor law guardians, Board of Works, Local Board of Health, Select Vestry, churchwardens. Their functions were real but not excessive, and election to them depended upon local standing. It is more relevant to see members of such bodies as part of the towns' elites than would be the case for the councils of Birmingham and Leeds investigated by Hennock.[6] Mr Tuffield of Woolwich thought so, for he said of the local Board of Health that 'there were men entitled by their *position, influence* and *past services,* to the *honour* of a seat at the board'.[7] The declining quality of town councillors observed in those two incorporated industrial towns must be placed in the very different context of a preceding struggle for community power between competing elites, the cosmopolitan and externally oriented nature of the towns and the politicisation of council politics. The histories of smaller developing nineteenth-century towns, on the other hand, indicate just how important in their social lives were the people who went on to bodies such as

those listed above.[8] In Middlemarch society, after all, those on the local committees were the social leaders, and George Eliot depicts the elite of the town as men of the stamp of banker, merchant, ironmonger, doctor, rich tanner and lawyer.

A more purely reputational source was suggested at the opening of this chapter. Committees were formed throughout the period to head appeals or give respectability to an institution. Memorials to vicars, committees for raising relief funds, deputations to royalty, church-building committees and so on. The men who did the work were rarely those on the committee — secretaries or treasurers were appointed for that purpose. The names were required to establish the body's credentials and to give it respectability. Here is where social activity ought to reflect reputation as directly as can be expected. The composition of twelve such committees is analysed in Table 5.1.[9] The three church-building committees and the four relief committees were all fund-raising bodies whose real work was carried out by treasurers and collectors. Those on the committee lent their name to persuade others of its security and respectability. The same is true of the leading honorary officials of the Deptford Savings Bank. The president, vice-presidents, and trustees were a layer above the 51 managers — mainly small tradesmen — who actually organised the Bank and collected savings. The leading officials had to provide an appearance of trustworthiness, especially important because of memories of insecurity in such institutions, including the occasion 25 years earlier when the secretary of the Woolwich and Plumstead Savings Bank had defaulted with the funds.[10] In such organisations trust was not automatic, but had to be created. Men had to be chosen who would encourage working-class confidence, which makes those selected especially significant — even more so because they were all men whose names recur on other local bodies.[11] Of the other committees, one was to raise money for the Royal Kent Dispensary, a long-established local medical institution. The other three were all honorary committees formed to give respect to local residents — the deceased vicar, the retired bank manager and the sickly Prince Arthur on his twenty-first birthday.

There are problems with this approach. Confirmation must be obtained from the recurrence of individuals in the reported social life of Kentish London, that the men we are locating are those who dominated local society. Newton has correctly urged the use of the local press in this respect.[12] There still remains the possibility that the picture of local society received by the working class might not have coincided with the apparently objective outline presented here. After all,

Table 5.1: Kentish London Social Elites: Honorary Committees

Committee	Professional, clergy, gentlemen	Military, naval	Dockyard, Arsenal officers	Finance, commerce	Manufacture – substantial local	Manufacture – non-local	Manufacture – builders	Manufacture – others	Tradesmen	Miscellaneous	Unidentified	Total cases
Christchurch building (Greenwich 1847-52)	8	–	–	3	–	1	–	–	2	–	–	14
Savings Bank Trustees (Deptford 1860)	5	–	1	1	–	–	1	2	6	–	–	16
Relief Association (Greenwich 1861)	8	3	–	5	–	–	3	3	16	–	–	38
Soames memorial (Greenwich 1866)	26	4	–	6	1	–	1	1	11	–	–	50
St Paul's Building (Greenwich 1866)	13	3	–	1	–	–	–	3	3	–	–	21
Relief Association (Greenwich 1867)	21	3	–	7	–	–	5	4	14	–	–	54
Relief Association (Woolwich and P. 1868)	34	9	4	–	–	1	4	1	13	5	3	74
All Saints Building (Plumstead 1870)	3	1	1	–	–	–	1	1	3	–	3	13
Charitable Relief (Greenwich 1871)	3	3	–	1	1	–	3	2	9	–	2	24
Prince Arthur Deputation (Greenwich 1871)	5	2	–	1	1	–	2	–	3	–	–	14
Royal Kent Dispensary (Kentish London 1873)	29	3	–	11	1	2	1	4	5	1	1	58
T.W. Day Testimonial* (Deptford 1876)	5	–	–	4	–	3	1	6	15	4	3	41

*T.W. Day was a highly respected local bank manager, treasurer to many local committees.

Source: see note 9.

reputation amongst the workers of the area was not what mattered most to social leaders. Yet the elite analysed here was so dominant that there appears no alternative repository of local social prestige. In Kentish London there were no competing elites such as those in the larger expanding cities, which often led to working-class support for traditional against new elites in the context of rapid and disruptive change. The West Riding woollen towns in the 1830s and 1840s provide a good example of this. Later evidence will reinforce this argument, showing that when friendly societies sought social approval and recognition of respectability within the town, the men whom they invited to their gatherings and whom they elected to honorary membership were the men whose names recur on these committees and local bodies.

There was no closely knit county and gentry society and the closest approximation was in Woolwich, where respectable society was separated in the 1850s into two merging layers. Jane Connolly's clergyman family moved in the upper stratum of senior army and navy officers, the Dockyard Commodore's family, the wives of generals and so on. This layer made only limited contact with the town, but individual military figures participated in elite activity, suggesting a degree of involvement and a definite visibility. The other stratum was a 'worthy class' of tradespeople and professional people,[13] and this was closer to the visible elites in Greenwich and Deptford. A contemporary observer of Woolwich society in the 1860s confirmed this when he wrote of the inhabitants of Bowling Green Row and George Street as 'the elite of Woolwich, not only officials in the Government service, but private families of independent means'.[14]

A more specific examination of elite composition must rest on the data in Tables 5.1 and 5.2, the second of which analyses the holders of parish offices.[15] In spite of fluctuations, a picture does emerge for the period as a whole. The two separate sources of elite composition share a large proportion of members, but do not produce identical results. The principal difference lies in the heavier concentration of men in the professional/clergy category on elite committees, and the lower representation of small manufacturers, when compared with parish office-holding. This plausibly suggests that the committee evidence creams the elite more effectively than does that for parish officers. A closer examination of the tradesman component of these bodies supports this conclusion, for the elite committees show a higher proportion of what are regarded as the superior Victorian retail trades — wine and spirit merchants (8.5 per cent, compared with 3.2 per cent on parish committees), chemists (5.6 per cent and 2.5 per cent), auctioneers (7.0 per

Table 5.2: Kentish London Social Elites: Office-holders (percentages)

Town/Period	Professional, clergy, gentlemen	Military, naval	Dockyard, Arsenal officers	Finance, commerce	Manufacture — substantial local	Manufacture — non-local	Manufacture — builders	Manufacture — others	Tradesmen	Miscellaneous	Unidentified	Total cases
Deptford												
1840-44	8.2	—	—	1.4	—	—	5.5	8.2	67.1	1.4	8.2	73
1855-59	7.9	—	—	7.9	3.3	—	4.6	9.9	52.6	8.6	5.3	152
1870-74	5.3	0.8	—	10.5	0.8	0.8	3.8	14.3	45.9	10.5	7.5	133
Greenwich												
1840-44	15.0	—	—	12.5	—	—	6.3	10.0	50.0	1.3	5.0	80
1855-59	9.6	1.2	—	13.4	—	1.2	7.3	12.2	51.2	2.4	1.2	82
1870-74	16.4	—	—	7.1	1.2	—	7.1	20.0	43.5	1.2	3.5	85
Woolwich and Plumstead												
1840-44	13.3	3.6	9.6	6.0	—	—	10.8	3.6	47.0	2.4	3.6	83
1855-59	16.4	2.6	1.7	6.9	—	0.9	12.1	6.0	33.6	7.8	12.1	116
1870-74	19.4	5.4	3.1	4.7	—	0.8	9.3	4.7	41.1	10.1	1.5	129

Source: see notes 9 and 15.

cent and 2.3 per cent) and stationers (5.6 per cent and 1.8 per cent) –
and a lower proportion of licensed victuallers (9.9 per cent and 17.5 per
cent) and bakers (4.2 per cent and 10.2 per cent).

The single most prominent group is not unexpectedly the trades-
men, an ambiguous title that covered a social spectrum 'from the
smartest Bond Street furriers down to the worst-shod street salesmen,
from Dombey and Son down below Silas Wegg and Pleasant Rider-
hood'.[16] It is with the superior layer of retailers that we are concerned.
Furthermore, the dominant trades are those traditionally regarded as
superior, on grounds that included capital requirements and customer
relations.[17] The distribution amongst various types of retailer is consider-
able, but certain groupings stand out.[18] Most prominent were the food
retailers,[19] notably grocers and cheesemongers, but also bakers and
butchers. Drink retailers also were important,[20] both licensed victuallers
and wine and spirit merchants. The most notable amongst the other
trades were a range of those requiring at least a moderate amount of
capital tied up in stock – ironmongers, chemists, booksellers, drapers
and clothiers, and coal and timber merchants.

The principal food retailers were the grocer-cheesemonger and the
baker. The former served a mainly middle-class clientele, for working-
class purchasing centred on markets and general dealers, and in most
Victorian towns the substantial grocers joined the drapers near the head
of the hierarchy of tradesmen. They were men like G. Wade, a leading
local Liberal dissenter, with a grocer's shop in Deptford High Street,
who was prominent in parish affairs in the 1840s. The most important
of these grocers was Thomas Burton of Greenwich. His status was not
only assured by living away from the premises of his shop,[21] a good
rule-of-thumb means of distinguishing between different shopkeeping
strata, but he lived in the fashionable Devonshire Road. For over
fifteen years he held office on the Board of Works, as a governor and
director, and on the vestry, and he was an automatic member of the
local relief committees and the Soames Committee as well as being an
honorary steward of the Royal Kent Dispensary. Although butchers and
bakers are generally seen as retailer-producers, those prominent in
Kentish London were of not inconsiderable means. The baker Thomas
Tame, who held local office in Woolwich in the 1840s and 1850s, left
£1,000 to found a new Congregational church on his death in 1858,
while another Woolwich baker of local standing, George Starling, was a
wealthy man when he committed suicide in 1875. Leading butchers in
the elite were Thomas Veness, who held almost every local office while
he lived in Deptford, and James Bassett of Woolwich, who had held the

offices of poor law guardian, churchwarden and town commissioner by the time of his death in 1853.

The importance of the drink trade is not unexpected, for its interest in local government was notorious. Nevertheless licensed victuallers were less prominent on elite committees than in parish office-holding, while the more elevated and established wine and spirit merchants, such as John Lovibond, founder of the retail chain, show the contrary pattern. If one section of a town's licensed victuallers were socially closer to their working-class clientele than to any other stratum, there was a layer of greater respectability and prosperity, and such men appeared on Kentish London elite bodies. The most prominent licensed victuallers in Kentish London were the landlords of public houses, often with restaurants attached, in central positions in their towns, men with a long-established and prosperous trade — George Parsons of the Crown and Cushions, Woolwich, one of the most active local social leaders in the 1840s, George Bratt of the New Cross Inn on a main coaching route, George Lyons of The Crown in Trafalgar Road, Greenwich, who held most local offices during the 1870s.

The draper was generally a prosperous and respected member of any local community, so the prominence of men like John Wade and George Whale was to be expected. Wade lived in Evelyn Street, Deptford, and had his shop in the High Street. Throughout the 1840s and the 1850s he was on bodies such as the Poor Law Guardians, the vestry, and the Court of Requests, as well as being a vice-president of Deptford Savings Bank in 1860. Whale's activities were in Woolwich, where his drapery and tailoring shop stood in a prime High Street position. This list of tradesmen could continue, through the chemists, auctioneers, stationers and others who formed such a major part of the social leadership of each town. W.T. Vincent noted with pleasure how old tradesman families persisted amongst Woolwich's most well-established families.[22] These most prominent tradesmen were in those branches of retailing regarded as the most respectable and remunerative: grocers and cheesemongers, drapers and clothiers, wine and spirit merchants, coal merchants, stationers and booksellers. There are no trades, other than the ambiguous licensed victuallers, that one would not expect to find represented among the leading tradesmen of a town. Many involved considerable capital outlay, and most had a largely middle-class clientele.

The other elite groups in Tables 5.1 and 5.2 need more explanation. What type of professional men were active in local society? Who were the City businessmen, and those in commerce and finance? And who

were the manufacturers? Once again, some illustration might help. If
the prominence of local clergymen is predictable, the large proportion
of professional men is of more interest. They were mainly doctors and
solicitors, either travelling into central London, or attracted to the outer
area by its wealthy residents. Solicitors were as important on parish
bodies as they were on elite committees, with some people especially
prominent — David Wire, Alfred Bristow (later to become Member of
Parliament for Kidderminster), Richard Pidcock and Edwin Hughes (MP
for Woolwich at the end of the century). The doctors were men of
relatively high standing in their profession. All the twenty-one identi-
fied were at least hospital trained. Thirteen were members of the Royal
College of Surgeons, while as many as five were Fellows of that College.
Even the one medical practitioner who was only a Licentiate of the
Society of Apothecaries, Duncan Lewes of Plumstead, was an excep-
tional member of that body, having been educated at Guy's Hospital
and St Thomas' Hospital Schools, and having many published articles to
his name, including some in *The Lancet*.[23]

Major Mercer in Deptford, and Admiral Hamilton and Captain Routh
in Greenwich, were prominent both in office-holding and committee
membership, but it is indisputably in Woolwich and Plumstead that
such men made their mark. The military tradition of the area made it a
natural place for officers to settle on retirement, and many of them
found the elite of professional men and Arsenal and Dockyard officers
sufficiently compatible to draw them into the town's social life and
affairs. From Captain Fead in 1841 through to the retired Paymaster in
Chief to the Royal Navy, Captain Dutton, in the 1870s, a long line of
army and navy figures feature prominently. They must have felt
particular affinity with the senior officers in the government establish-
ments, for not a few of those officers themselves had a military
background, and were often involved in local affairs — Captain Denison
of the Dockyard and Lieutenant Harrison of the Arsenal are the most
notable examples. Most of these officers were not military men, how-
ever, especially after John Anderson's reforms. All who appeared on
local committees and boards held high office. Mr Eccles was Modeller in
the Arsenal; Adam Grinton was Chief Clerk in the Royal Carriage
Department. They were both town commissioners, as was the Store-
keeper in the Dockyard, Joseph Pinhorn.

These professional and military men are examples of social leaders
for whom Kentish London was a residential rather than an economic
base. A similar group contained those in finance and commerce, for
whom the residential attraction of Greenwich, Blackheath, New Cross

and southern Woolwich explains their presence in the locality. They
were not merely resident, but closely involved in community affairs. A
clerk could range from a man who marked off bags of coal entering a
railway yard, to William Dawson, a banker's clerk, living with his family
and servants in Ashburnham Road, Greenwich, and a churchwarden in
1874. It is with clerks of Dawson's status that we are dealing when we
consider those who figured amongst the social elite of Kentish London.
Edwin Allpike of Deptford was chief clerk to the Canada Land Com-
pany, while in the same area lived J.H. Stone, an Inland Revenue officer
in the City, and Thomas Varley, a merchant's clerk. Civil servants were
prominent in Woolwich, amongst them T.E. de la Mare, a clerk in the
Bank of England. Such men held numerous local offices during the
period, and doubts as to their status are removed by noting the areas of
their residence — districts such as Amersham Park, Ashburnham Road,
Fox Hill and Upper Park Place.

The City merchants and businessmen were a more varied collection.
Mr Debac, a Deptford vestryman, was a wholesale grocer whose firm
had nationwide branches by 1873. William David Barnett, living in
Vanburgh Park, Greenwich, and holding countless local positions,
described himself simply as a 'City merchant'. Other City men included
Newton Crosland of Greenwich, a wine and spirit importer, Thomas
Purvis, a tea dealer, and Joseph Manwaring, an iron merchant. Some
were based in inner south London, like W.J. Burdett, a partner in the
Staffordshire warehouse firm of Bacon and Burdett at Bermondsey. In
the financial sphere, the most prominent local men were mainly in
stockbroking and insurance. The most notable example was Blacknell
Carter of Greenwich who, during the 1840s and 1850s, served as poor
law guardian, commissioner of the Court of Requests, vestryman and
governor and director, as well as serving on various honorary committees.
Other important men in insurance were Henry Jeula of Wickham Road,
a City insurance broker and underwriter, and the stockbroker Guilford
Barker Richardson, who throughout the last thirty years of our period
served in local government and joined honorary committees,
withdrawing only when elected chairman of the Metropolitan Board of
Works.

The social elite of Kentish London was clearly dominated by
established tradesmen and men of externally derived wealth, but with
the manufacturing categories we enter more closely into the economic
life of the locality. Even amongst them, however, we find wealthy and
prominent residents who conducted their businesses elsewhere. Such
men as the iron manufacturer, Crowley Millington, the silk manufac-

turer, Richard Edmunds, and George Lockyer, a chemicals manufac-
turer with offices in the City and a factory in Bristol. It was rare to find
equally substantial residents whose businesses were conducted in the
locality, and the reasons for this have already been examined. Only in
Deptford were large local employers part of the visible elite. John Penn,
George England, Charles Lungley and James Dyke were not especially
active in local affairs, but their election as vestrymen indicates a degree
of participation and visibility. It would be naive to link this directly to
the fact that Deptford was more radical than Greenwich and Woolwich
in its working-class politics, for that related to other more important
factors. In any case it was a traditional liberal radicalism that rarely
encompassed a critique of employers. Nevertheless, in Deptford, and
there alone, local social success could visibly relate to the control of
employment and the ownership of capital, and even in that town these
employers were strikingly uninvolved in directing social affairs. They
neither dominated nor directed it in the way that can be seen amongst
the industrialists in many industrial towns of the north of England and
south Wales.

The manufacturers who were active in elite positions in Kentish
London were those involved in traditional small-scale production. The
most numerous were metal workers and engineers, wheelwrights and
coopers, shoemakers, tailors and soap and tar manufacturers.[24] The
metalworkers were principally men like John Cavell, file cutter, William
Marshall, blacksmith, and Cornelius Moriarty, a long-established maker
of wire blinds. The other fields are almost all those dominated locally
by small firms. The largest employers were the brewers — Edward
Lambert employed forty-nine men,[25] Thomas Norfolk twenty.[26] The
others were generally the owners of well-established firms in those areas
of profitable small-scale production which retained in Kentish London
their traditional structure and craft basis: wheelwrights like James
Baker who was Woolwich churchwarden in 1855, cabinet makers like
Henry Major who was on the Greenwich Poor Law Guardians and lived
in the fashionable South Street area, or a saddler such as William
Bampton, Town Commissioner for Woolwich in the 1840s. None of the
shoemakers or tailors was large, for it was after all the wholesale not the
manufacturing unit that grew in London at this time, but most were
well-established small manufacturers like William Bevan or W.C. Taylor,
who died at his home in Bowater Crescent, Woolwich, leaving 'a moder-
ate fortune'. Finally, in this small manufacturer category are the
builders, identifiably the long-established firms in an unstable small-
scale industry. In the context of the insecure mass of small building

firms in the area, it is interesting that the builders or building tradesmen who were members of elite committees or held parish office between 1855 and 1865 had an unusual rate of survival. Of twenty-five firms traced, and following the procedure adopted in chapter 3, we find that two firms appear in only one directory, one firm appears in two directories, four appear in three directories, and the remaining eighteen all appear in at least four directories. This longevity often encompassed successive generations in the same firm, as with the Simmonds family in Greenwich or the important Jolly family in Woolwich.

This chapter has argued that in the absence of a strong employing class such as sought to direct the social life of many industrial towns, it is important to establish the kind of people who appeared as social leaders, who were most active in community affairs, and who were characterised in the local press as carrying a high degree of social prestige. Three main groups constituted these elites in Kentish London. The first comprised men tied to the area residentially but not economically, mainly lawyers and other professions but especially the merchants and City businessmen who inhabited the southern reaches of the towns. This group must include the military and naval personnel. Local tradesmen, often wealthy and generally from the higher status trades, formed the second group. Finally, manufacturers were divided between the owners of small firms, often in traditional craft production, and the handful of important local employers who appear tentatively in the social life of Deptford.

There were fluctuations in the relative importance of different categories analysed in Table 5.2, but these variations from period to period do not materially alter the basic argument in this chapter. It was, after all, not occupation alone that gave a man a certain prestige in the local community, but a range of other criteria which, however much they might have been ideologically related to the source of income, were not occupation specific. In any case this chapter is not concerned with certain occupational qualifications for elite membership, but with the type of people who actually formed that elite, with the way in which social prestige appeared to the community as a whole. In that search, the fluctuations seem less important than the overall conclusions.[27] Given these conclusions, and their potential consequence for the structuring of the working-class views of society and social prestige, it is necessary to ask how that social elite actually made contact with sections of the local working class. There are two principal issues here. The first is the impact of government employment on the relationship between social leaders and local labour, and the other is the way in

which certain working-class institutions sought approval from local notables. Before turning to these, however, the Plumstead Common Riots of 1876 are worth noting, for the response of sections of the local elite to predominantly working-class disturbances suggests a degree of social harmony in the district. These were, in fact, a series of fairly orderly demonstrations on Plumstead Common during which crowds, at times 2,000 strong, were present at the removal of fences erected by two local businessmen whose property adjoined the Common and which were allegedly enclosing common land. Summonses were taken out against those who were supposed to have removed the fences, but prominent local leaders became involved in support of the working men who had been arrested. As further demonstrations took place, it was repeatedly claimed that many of the most respectable men of the town had participated, and at the actual court hearings three of the most prominent local social leaders gave evidence for the defence – John Cook of Plumstead, John French, a glass merchant, and Robert Lonergan, a well-established local builder. It is clear that the relationship between local social leaders and the working class of Plumstead was not such as to bring the former out in firm opposition to large-scale unlawful activity in the town.[28]

The apparent identity of interest in towns of government employment between the workers and social elite over economic matters is a wider manifestation of this. In Woolwich, and to a lesser extent Deptford, reductions in employment and low wages were not in the interests of the town's middle class. In fact, we find the local social elite actually petitioning and using its influence to obtain higher wages for a large number of the workers in their towns. Increases for labourers in the government establishments were partly sought because the government made no contribution to the poor rates in the area, and the very low pay of labourers meant that these rates were high. There was also the broader interest that wage increases for government employees in no way affected the profits, wealth and competitiveness of a local bourgeois elite but, on the contrary, increased purchasing power. We can thus find support from local newspapers of all opinions for almost every pay movement in the Dockyards or the Arsenal. The shipwrights' pay movement in Woolwich and Deptford in 1853 was supported by public meetings, with local social leaders on the platform, including Montague Chambers, Member of Parliament for Greenwich, who promised to fight for their claim.[29] In the same year the Woolwich Board of Health memorialised the Admiralty for an increase in pay for Dockyard labourers,[30] and a similar movement in Deptford was

launched in 1866 by local social leaders and clergymen, at what the
Kentish Mercury described as 'a highly influential meeting'. Rev. C.F.
Money was in the chair, and the proprietor of a leading building firm,
William Maslen, was the main speaker.[31] Other cases abound — in 1858
Robert Jolly, a leading Woolwich builder and businessman, led the
agitation for higher pensions for Arsenal workers. In addition, workers
at the government establishments actively used local Members of
Parliament for pressing their wage claims and grievances. This could
have been simply because they were government employees, and need
reflect no attitude towards their view of the interest of the Members of
Parliament in them, but the two arguments were probably mutually
reinforcing.

These conclusions only concern government employment, and there
is of course no evidence of similar activity in support of private wage
movements. Nevertheless, the level of government employment and the
place of those employees within the local working class suggest that the
repercussions were felt beyond the walls of the government establish-
ments. There was little immediate *economic* hostility between the social
leaders and the workers of Kentish London. This lack of continuing
class tension, however, must not be confused with a more vigorous
support for working-class activity on the part of an anti-capitalist local
elite resisting the disruption of industrial outsiders.[32] The situation in
Kentish London was blander and less coherent than that. Working-class
efforts to obtain approval from local notables, and involvement of
these social leaders in working-class activity, simply confirm the
relationship that existed. Many cases could be cited from savings banks,
building societies and mechanics' institutes — but these institutions
were often launched by the local middle class and therefore of only
limited relevance. More significant is the evidence from friendly
societies which were in origin and to their very roots working-class
organisations. Considerable importance was attached to obtaining active
support for them from local social leaders. Court after court of these
basically artisan institutions gave honorary membership to local
notables and invited them to dinners and meetings as part of a search
for social approval. The *Oddfellows Magazine* argued that the main
reason for electing honorary members was that it signified recognition
by other classes of the good of friendly societies.[33] It is therefore rele-
vant that when societies elected such members the men they turned to
were those discussed in the earlier part of this chapter, members of the
social leadership of the area. The *Kentish Mercury* in 1858 noted the
prominent place of the local courts and lodges of friendly societies in

the life of Kentish London, and indicated as evidence the large number of prominent personalities who attended the anniversary dinners of these courts.[34] In June 1852 the Court of Promise, Ancient Order of Foresters, met at the Windsor Castle Inn, Plumstead, and enrolled as honorary members Alderman Salamons, the Liberal candidate at the forthcoming election; Richard Pidcock, solicitor, who was a church-warden, poor law guardian and member of the Board of Health; and H.B. Roff, a steam packet wharf owner and coal merchant, who was a poor law guardian and town commissioner.[35] The annual fete of the Wool-wich district of the Ancient Order of Foresters was held in 1852 at the Reynolah Gardens, and amongst the 2,000 persons present were the leading gentlemen of the town.[36] A similar grand occasion at the other end of Kentish London, the grand ball at Hatcham of the Blossom of Kent Court, AOF, was held under the patronage of Peter Rolt, a wealthy local property owner and engineer.[37] Nelson's Pride Court of the same order, with many leading townsmen already members, in 1857 elected new honorary members — Sir William Codrington MP, James Dyke of Humphrey, Tennant and Dyke, engineers, and Thomas Norfolk, the principal local brewer.[38] Francis Keddell, solicitor, was invited to take the chair at the annual dinner of the Foresters' Delight Court of the AOF, of which he was an honorary member,[39] and the court was still continuing the practice fifteen years later, when many 'gentlemen and leading tradesmen' were guests at its annual dinner.[40] The list could continue, taking in other orders,[41] but the evidence would merely accumulate. The main point is clear — that social approval, for those whose ideals dominated the friendly societies of Kentish London, was approval by just the social elite that we have identified. For an upper stratum of the local working class, at least, the specific economic and social structure of mid-Victorian Kentish London helped create a situ-ation where in addition to being *not* antagonistic to the social leaders of the area, they outwardly shared or thought that they shared enough of their values to seek their applause and approval. The first part of this study thus concludes with a pointer towards the discussion in the chapters that remain, an attempt to understand the values and behaviour of an artisan elite in the specific context of the society whose broad economic and social features have here been reconstructed.

6 THE ARTISAN ELITE: I STRATIFICATION

> He of the better type is a man of provident inclinings, a man who, according to his lights, attempts to provide against the proverbial rainy day. He is usually a much-clubbed man, a member of a trade, a benefit, a yard and a slate club, having thus a fourfold provision against the hour of sickness, while more likely than not he has a few pounds invested in the Post Office Savings Bank or in some building society.[1]

With these words a London working man of the 1870s pointed out the principal characteristics of the elite amongst London workers. Such institutions were vital, for they helped define the life chances of the artisan. They all contributed to a necessary broadening from craft exclusiveness into a wider social stratification through organised and informal activities. The chapters that follow will examine such institutions, but will go further, seeking to penetrate the meaning of the other phrases in the quotation. In what ways was such a man 'better', and in whose eyes? How far were these 'provident inclinings' exclusive to the stratum, or could it alone afford to indulge them? The relationship between capacity and aspirations was of course more dialectical than such a question would allow. Most difficult of all, what were these 'lights' in accordance with which such norms took shape?

The remaining chapters will focus upon the values and behaviour of the artisan elite in mid-Victorian Kentish London. They will concentrate upon three themes. The first seeks to establish the social composition of the leaders and members of the various organisations and activities upon which attention will be focused. The second examines the purpose of the institutions and movements, and the values that developed within them. The final theme argues that this value system and the behaviour that went with it derived from the social experience of those whom we are examining. Further, it suggests that the membership of the organisations, and the accompanying rewards and satisfactions, served to reinforce the participants' interpretations of their world. The ideology and the pattern of behaviour that went with it were not some superstructural error, nor some ill-conceived and passing eccentricity exploited by capitalists and politicians, but a response to the world in which these workers lived that was pervasive precisely because it made

apparent sense of their experience.

The argument of the preceding chapter might usefully be recapitulated. The three towns were genuine heterogeneous communities, developing their own social relationships and their own industrial structure. Residential segregation, which we shall see to be of normative importance, was more a localised one than a disintegration into suburban fragments. The towns kept an unexpected social coherence and this sense of completeness was the setting for the experiences of the towns' workers. Yet this did not include an economic completeness. The industrial structure of the towns was characterised on the one hand by large works owned either by the government or by mostly non-resident capitalists, and on the other by a myriad of small and often short-lived firms. One result was to suggest a degree of openness in the local economic structure. Another was a probable deformation in the way in which artisans would see the relationship between economic control over labour and prestige in the community.

Furthermore, the main industries were those that led the mid-Victorian boom. Multiplying a relatively well-paid skilled elite amongst their workforces, they provided within the work situation pressures towards stratification inside the working class. There was a gulf between themselves and their own unskilled workers, but an even greater divide separated them from Kentish London's insecure and low-paid riverside labour. Here was the division at its most explicit. The further distinctions that grew from the hierarchy of skilled trades, and the differentiation *within* skilled trades, accentuated the potential fragmentation. It was these distinctions of life experience, deriving in part from economic and workplace divisions, that lay behind the view of the social system and more particularly the status system that will be presented in these chapters. The economic structure of the towns was given only a distorted reflection in their social structure, as emerged from an examination of the local social elites and their relationship to the skilled artisans of the towns. The purpose was to develop further the picture of the local social and economic system which the working class might have derived from its immediate environment, and to clarify the ideological formulations that grew from that perception in order to understand it.

It was argued that these factors created a situation where the working class of the area was more likely to be fragmented than united in its self-perception. Furthermore, the structure of opportunity was unlikely to appear to an upper stratum of the working class as closed and based on illegitimate wealth and capital, but as in some respects

open, and one in which the aspirations of that stratum were relevant, even if not always fulfilled. These aspirations were especially feasible if mediated through lesser aspirations of respectability, and this is one of the fundamental dimensions of the argument. The following chapters will show behavioural and ideological factors giving unity to an emerging elite of skilled workers. This unity was shaped by ambitions that were defined by status, values and a striving for political equality and political justice. This elite stratum was called, both by contemporaries and historians, an aristocracy of labour. Through the relationship between its traditions and its experience, this elite developed a range of institutions and a set of values that intensified its position within the mid-Victorian working class, and which for a period at least made sense of the Kentish London world in which it worked and lived.

Differences of life experience, some primarily economic but others less precisely so, lay at the roots of this process of stratification. Many have already been indicated: amongst them were the protection afforded by trade unions, the relationship with less skilled and unskilled workers, treatment by the employer or manager, and the ability to control the pace and the regularity of work. Underlying them all, however, were wages and income. The other differences stemmed from decisions that were based as much upon a particular set of values as they were upon a particular economic position. This is hardly surprising, for the attachment of status distinctions to different sources of income was a central feature of Victorian England. The most entrenched distinctions separated business from land, and manual work from non-manual. If the former receded slowly in importance, the latter became more acute, and we have seen a multitude of such status distinctions within the working class itself. Similarly in the field of expenditure, the important issue was less how much was spent and more what it was spent upon. From the number of horses that drew a merchant's carriage, through the categories of servants a draper could afford, to the types of bread a casual labourer would eat, Victorian England was obsessed with types and not just quantities of expenditure. At the level of the mid-Victorian working class it stemmed from the need to cope with inequality, hardship and insecurity in an economic and social system that increasingly seemed permanent. Status consciousness, as much as class consciousness, is about economic inequality. Its growth amongst skilled workers in Kentish London was an attempt to come to terms with the wider economic inequalities of mid-Victorian capitalism, by magnifying those dimensions of status and respectability that related to income differentials within the working class.

The differences in life style that distinguished the skilled elite en-
compassed many spheres — levels of crowding in accommodation, the
ability to move to more prestigious housing, recourse to the Poor Law,
the ability to join provident institutions, the chances of passing on a
superior economic position to children and the availability of time and
income to select appropriate leisure pursuits. Income levels and job
security dictated not so much this choice or that choice, but the very
ability to choose. If the options were limited in comparison with those
of the wealthier classes, the ability to make some choices was basic to
much that distinguished this skilled elite.

The elitist position of the aristocracy of labour rested upon earnings
differentials and relative job security, although, in the absence of wage
series, chapter 4 could suggest this only through less systematic data.
The widening of the pay differential between skilled and unskilled
during this period partly depended upon a greater willingness by
artisans in the growth industries to advance from customary wage rates
to a clearer determination of what the market would take.[2] Trade
unions played a key role in thus exploiting market conditions, especially
the new amalgamated unions in Kentish London. It was argued in
Greenwich in the 1870s that artisan wages had advanced substantially
in recent years through trade union action, but labourers had been left
even worse off, for their wages had risen by far less while the costs of
necessities had advanced.[3] Labourers and other unorganised workers
suffered from a classic inability to increase rates in booms or maintain
them in depressions to the same extent as skilled men. Unskilled wages
depended on a generally overstocked market, and were far more volatile
even in the government establishments.

It was essential to maintain stability of wage rates as well as their
level, and avoid the violent fluctuations in weekly earnings that dictated
not only patterns of expenditure but the ability to plan it. A widening
of differentials is not essential for the creation of an artisan elite, for
relative movements of real wages might have been less important than
absolute levels. Even if the differential had not widened, a hypothetical
slow growth of real income throughout the working class during the
mid-Victorian decades might have taken an upper layer of workers over
some threshold in the balance between necessities and disposable
income that would allow for choices of expenditure and providential
investment. A substantial section of skilled workers might have passed
over that threshold during the mid-Victorian period and determined the
differences in life experience. It is, in any case, the general opinion of
historians that actual differentials did widen during the period.[4] By

1880 an unskilled wage in building stood at 64 per cent of that of a craftsman, while the figure was 60 per cent in engineering and 54 per cent in shipbuilding.[5] The differential between the unskilled and the *elite* of skilled men in each trade must have been wider still.

Distinctions within a trade cannot be established without detailed wage series. They were widespread, as in the government establishments, but must have been most acute in trades such as shoemaking where changes in technology or the market were affecting the structure of the workforce. A social survey conducted for the government in 1887 provides the only wage evidence beyond that outlined in chapter 4. The survey of working men was uneven and crude, but one of its districts included parts of St Nicholas and St Paul's, Deptford, and the results are useful notwithstanding their limitations.[6] The findings on earnings are presented in Table 6.1, and although the lateness of the year and the fact that the area was closest to inner south London might have affected the results (particularly for shoemakers), the general findings do confirm these differences of income within and between trades. The elitist economic position of shipwrights, and engineering and building craftsmen, is marked. The table does not reveal a hierarchy of mean earnings, but something potentially more interesting. It shows the proportion of each trade earning high wages, and the length of the tail behind it. The artisan elite of this book was an elite amongst skilled workers, not one embracing all of them. The survey indicates the potential contribution of different trades to that elite, and the emphatic position within it of the artisans in the area's principal industries. The gap separating them from the unskilled looks vast.

It was in the fields of housing and poverty that these had the greatest effect on working-class families. They expressed both financial capabilities and the variety of everyday experiences that stemmed from those capabilities. This fine distinction is important. Living in the poorer areas of the towns was distasteful to many artisans for normative as well as practical reasons. The newly built houses to which they moved might have been badly built, but they were in socially superior areas and boasted flourishes of architectural respectability. This can be seen in the response of the more successful of Ellen Chase's respectable unskilled families to the street of model housing which she 'visited'. She could not understand their desire to escape unacceptable neighbours and middle-class patronage, by fleeing from this well-maintained Deptford street to jerry-built 'artisan cottages'.[7] The value of respectability was most accepted amongst the artisan elite, but there is no doubt that it penetrated further. An issue as basic as housing involved values

Table 6.1: Weekly Earnings in Specific Occupations, Deptford, 1887

Occupation	Cases	% earning over 30s	% earning under 21s
Shipwrights and boatbuilders	102	81.4	7.9
Skilled engineering and metal	248	80.2	8.8
Building crafts*	242	77.7	7.1
Carpenters, joiners, sawyers	368	70.4	13.2
Furniture makers	38	68.4	23.8
Commercial clerks	151	64.2	17.9
Printers	67	62.7	12.0
Smiths and tinworkers	526	62.4	14.4
Painters, plumbers	278	56.8	15.6
Tailors	32	40.6	40.6
Dock labourers	290	26.9	40.0
Bakers	46	23.9	28.3
Shoemakers	82	14.6	66.9
Labourers	2,257	7.7	54.1
Carmen, carters	274	6.9	41.6

*excluding carpenters, joiners, painters.

NB 16.5 per cent of those interviewed refused to answer this question. The question asked was, 'If in work at present, weekly wages or earnings. If out of work at present, ordinary weekly wages when in work.'

Source: Calculated from Conditions of the Working Classes, *Parliamentary Papers*, 1887, LXXI.

relating to neighbours, status identification and the powerful attractions of house ownership. These points will be developed in the next chapter. The 1887 survey findings on housing and crowding in Table 6.2 are less clear-cut than the earnings data, especially when the two are brought together. The similarity of crowding experience of carmen and some building craftsmen might be due to the survey's concentration on old inner Deptford, thus excluding those skilled workers whose response to economic security had been to move to the outer artisan districts in the town. A similar point might be made about shoemakers. Table 6.2 is nevertheless instructive. First, it records a clear variation in housing experience between the skilled workers surveyed and the mass of general and dock labourers; second, it shows a hierarchy amongst skilled trades that placed engineers, shipbuilding workers, and carpenters and joiners in a high position. It is unfortunate that the boundaries of the survey did not include the whole of a working-class district.[8]

Housing patterns were complicated by their dependence upon both economic and normative pressures. The poor law ought to offer few such difficulties, for resort to the workhouse was the most fundamental social fear of all Victorian workers and their families. The protective

Table 6.2: Number of Rooms Occupied by Workers in Specific
Occupations, Deptford, 1887

Occupation	Cases	% occupying 1 room or less	% occupying 2 rooms or less	% occupying 3 rooms or more	% not married
Skilled engineering and metal	301	12.3	26.9	73.1	9.3
Wheelwrights	37	13.5	28.2	71.8	12.9
Carpenters, joiners, sawyers	411	14.3	26.3	73.7	8.3
Shipwrights and boatbuilders	139	14.4	22.3	77.7	6.5
Tailors	39	15.4	41.0	59.0	12.9
Printers	77	15.6	26.0	74.0	11.3
Commercial clerks	218	16.1	26.2	73.8	13.9
Coopers	42	16.7	26.2	73.8	7.0
Carmen and carters	306	21.0	40.6	59.4	11.9
Bakers	51	21.6	37.3	62.7	13.5
Smiths and tin workers	624	21.8	40.4	59.6	11.9
Building crafts*	278	22.0	38.9	61.1	8.1
Painters, plumbers	331	22.1	42.0	58.0	14.2
Furniture makers	45	22.3	31.2	68.8	22.5
Shoemakers	97	28.9	48.5	51.5	13.6
Labourers	2,536	41.2	61.2	38.8	22.5
Dock labourers	318	44.4	68.3	31.7	21.0

*excluding carpenters, joiners and painters.
NB 2.0 per cent of those interviewed refused to answer this question.
Source: Calculated from Conditions of the Working Classes, *Parliamentary Papers,*
1887, LXXI.

barriers of provident institutions were sought by many workers, pre-
dominantly artisans, to remove precisely that fear, as we shall see in
chapter 9. The security and level of income that reduced for the artisan
the dangers of intensive poverty were the same characteristics which
enabled him through provident institutions to protect himself further.
The life situations of Victorian workers thus became reinforcing, and
from that source the moral commitment to prudence and saving could
flow.

The admissions register to Greenwich Workhouse records the occupa-
tion of all males over the age of twenty who were admitted for reasons
of poverty or sickness,[9] inseparable factors for many Victorian workers.
The differential threat of the workhouse can thus be examined. The

choice of years analysed was largely determined by the quality of the sources, but the periods cover a variety of conditions, including the huge slump in engineering and shipbuilding in 1867-8, and the subsequent poor years to 1870. Table 6.3 confirms that the fear and experience of the workhouse was a threat of far greater seriousness to the

Table 6.3: Admissions to Greenwich Workhouse: Occupations

	1854-6* %		1864 %		1867-70 %		1871-2 %	
Professional	—		0.5		0.1		—	
Retail, tradesmen	1.5		0.7		2.1		4.0	
Clerks, etc.	0.2		1.4		0.7		1.5	
Skilled workers	24.5		27.4		24.1		20.8	
Engineering, metal		3.7		4.0		3.8		2.0
Shipbuilding		1.5		0.7		0.4		0.3
Boilermakers		0.2		0.7		0.6		0.3
Building		5.4		4.7		5.9		6.0
Shoemakers		3.7		4.9		3.8		2.7
Tailors		2.0		3.3		1.8		1.2
Bakers		1.0		0.9		1.1		1.1
Watermen, lightermen		1.2		4.0		1.4		2.2
Cooper, wheelwright, coachbuilder		0.5		0.2		0.8		1.2
Others		5.2		4.0		4.5		3.8
Unskilled, semi-skilled	73.8		70.0		73.0		73.8	
Total cases (= 100%)	404		425		2,409		1,164	

*August to July.
Source: Greenwich Workhouse Admissions Registers 1854-6, 1864, 1867-72.

unskilled and semi-skilled than to the skilled worker. It was an omnipresent fear for all, but might only be the result of unexpected catastrophe for the engineer or shipwright, delayed by the institutions of thrift that cushioned his fall. For the largely unprotected unskilled worker, the experience was far closer to home. The Poor Law Guardians might have had more faith in the ability of artisans to get back on their feet, and been more willing to grant them out-relief. Middle-class views of respectability thus erected yet another barrier between the artisan and the workhouse.

The distribution of occupations within the population was not of course equal, but the imprecision of the census tables means that an index relating the incidence of an occupation in the population at large to that in admissions to Greenwich Workhouse can be constructed for only a handful of occupations, mainly skilled. An index of 100 would

mean that the observed frequency exactly coincided with what the size of an occupation in the workforce at large would lead one to expect, though the observed frequencies will have been inflated in significance by the fact that a large section of the population would never be at risk of having to enter the workhouse. The figures show the difference in the realities of skilled and unskilled fears of the workhouse — and remember that it is almost certainly the lesser men in the trades who were most at risk. The index[10] for 'labourers', the only unskilled category named in the census and hence having to represent here all unskilled workers, was 549. The highest craftsmen index was the 103 for shoemakers,[11] followed by tailors (80), masons (75), coopers and wheelwrights (both 67), bakers (65), sawyers (60), all building craftsmen and carpenters (both 59), bricklayers (44) and engineering craftsmen (27).

From those sinking to those rising. The question of social mobility in the Victorian period has been more often referred to than analysed by historians. It is important for two reasons. The ability to rise or fall in some social scale on the basis of apparent qualities or achievements must have a significant impact on working men's expectations, and on their view of their life prospects. The second consideration refers more to inter-generational mobility. Victorian society was highly stratified, yet discussions of stratification make the implicit assumption that each generation does not begin the process anew; that class or status position is tied to some cluster of factors that derive from the parental economic and social position. The issue is important precisely because the meaning of social inequality depends upon the extent to which it is structured and permanent.[12] Before offering some evidence on this second type of social mobility it is worth reflecting briefly upon the first, which includes mobility within the working class, and that which removed men from it. The data available for Britain make systematic studies of such career mobility virtually impossible.

It was in the nature of the main artisan trades that entry was difficult without apprenticeship. Impossible in some, notably the shipbuilding crafts and amongst watermen and lightermen, and difficult in others, such as the engineering and metal trades. During the period, the apprenticeship system was weakening in the London building trades,[13] although this was slower to penetrate the somewhat distinct Kentish London labour market. An influx of informally trained young men must explain the fact that the variations of ability and wages were more marked amongst building craftsmen than the other main trades of the area. On the whole, however, the apprenticeship system acted as a

strong barrier to the upward mobility of semi-skilled and unskilled workers, and skilled unions vigorously resisted encroachment of un-apprenticed workers on to skilled work. It was easier for an unskilled worker to attain a crisis-ridden insecurity, but apparent independence, as a small dealer or shopkeeper, than to enter the main crafts of Kentish London. Costermongers, butchers, and greengrocers required little initial capital, and they predominated amongst the retailers who entered Greenwich Workhouse during the years examined above. Their independence was often illusory.

The prospects of skilled workers obtaining some mobility within the working class was examined in chapter 4. Within the main engineering and shipbuilding crafts the clear rankings identified by different rates of pay provided one possible area of progress for the individual. This was more firmly structured in government works, with the possibility of moving on to supervisory positions. The imprecise nature of these distinctions, however, means not only that they are less amenable to analysis, but also that they were less socially meaningful.[14]

The ability of skilled workers to leave the working class is a very different issue. Apart from rare exceptions like Josaiah Stone, progress into the small master category probably transformed neither life style nor social milieu. Some educated working men became white-collar workers, though the massive demand for clerical labour was more of a late Victorian phenomenon. The benefits of being a small master were not the abandonment of manual work or of the artisan social world, but freedom from the vagaries and indignities of wage employment. The achievement might have been less secure than was hoped, but the aspirations and the possibilities for such advance were a reality. The mobility sought in this way was often small, but it was the principal type for skilled artisans whose intense pride and satisfaction in their craft seems incompatible with a fervent desire to escape it. Small masters would often keep their trade union membership, and this shows more than an awareness of the insecurities of their new position, but also a continuing identification with their craft milieu.[15]

Mobility between generations can be analysed more precisely by the use of occupational information on marriage certificates. All marriages in Kentish London were examined for two periods of three years each, and the procedure is explained in the Appendix to this chapter. A very small proportion of grooms were below twenty-one years of age, so it is less likely that we are examining the son's occupation at too early a point in his career.

The results are set out in Tables 6.4 and 6.5. Grooms' occupations

Table 6.4: Inter-generational Occupational Change, 1851-3

Groom	Total cases	Percentage whose fathers were:														
		Gentlemen, professions, finance	Retail	Farmer	White-collar	Craft engineering, metal, shipbuilding	Craft building	Wheelwrights, etc.*	Shoemakers, tailors	Misc. skilled†	Total skilled	Labourer	Misc. unskilled	Gardener	Army, navy, police	Others††
Clerical	63	12.7	6.4	6.3	20.7	3.2	7.9	–	4.8	20.6	36.5	1.6	–	–	11.2	4.8
Shop assistants	15	26.7	13.4	20.0	–	–	6.7	–	6.7	6.7	20.1	6.7	13.4	–	–	–
Engineering crafts	250	4.8	12.8	2.0	1.2	41.2	5.6	2.4	2.4	7.2	58.8	8.0	2.4	3.2	2.4	4.4
Shipbuilding crafts	91	–	4.4	1.1	–	64.8	3.3	4.4	8.8	5.5	86.8	3.3	–	1.1	–	3.3
Boilermakers	28	–	7.1	–	–	46.5	–	–	–	14.2	60.7	17.9	7.1	–	–	7.1
Building crafts	342	0.6	8.2	3.5	1.8	4.7	57.9	0.9	6.2	1.5	71.2	5.6	3.0	2.9	–	3.5
Wheelwrights	27	–	–	7.4	–	18.5	11.1	22.2	14.8	7.4	74.0	11.1	7.4	–	–	–
Furniture makers	26	3.8	3.8	–	–	11.5	3.8	–	15.4	50.0	80.7	–	–	11.5	–	–
Sawyers	24	–	–	4.2	–	4.2	16.7	41.7	–	4.2	66.8	8.3	4.2	16.7	–	–
Small metal crafts	20	5.0	15.0	5.0	5.0	25.0	15.0	–	5.0	15.0	60.0	–	5.0	–	–	5.0
Printers	29	6.9	24.1	–	3.4	–	3.4	–	3.4	31.0	37.8	–	3.4	–	20.7	3.4
Shoemakers	80	–	3.8	2.5	3.8	7.5	5.0	3.8	37.6	10.1	64.0	6.3	7.5	5.0	3.8	3.8
Tailors	64	–	12.6	4.7	–	9.5	3.1	1.6	45.3	12.6	72.1	1.6	1.6	3.1	1.6	3.1
Watermen	81	1.2	9.9	1.2	–	3.7	4.9	–	3.7	64.2	76.5	3.7	3.7	1.2	–	2.5
Labourers	780	0.3	3.3	0.9	1.0	3.3	3.8	2.1	3.8	1.9	14.9	67.8	6.1	1.5	1.6	2.8
Carmen	22	–	18.1	–	4.5	–	–	9.1	4.5	4.5	18.1	36.4	22.7	–	–	–

*includes coopers, sawyers, coachbuilders
†includes watermen, lightermen, saddlers, printers, furniture makers, foremen.
††mainly mariners, fishermen, pensioners.
Source: Marriage certificates; see Appendix to this chapter.

Table 6.5: Inter-generational Occupational Change, 1873-5

Groom	Total cases	Percentage whose fathers were:														
		Gentlemen, professions, finance	Retail	Farmer	White-collar	Craft engineering, metal, shipbuilding	Craft building	Wheelwrights, etc.*	Shoemakers, tailors	Misc. skilled †	Total skilled	Labourer	Misc. unskilled	Gardener	Army, navy, police	Others††
Clerical	179	13.4	17.9	3.4	24.1	6.2	3.9	0.6	4.5	9.6	24.8	1.1	3.4	1.1	7.2	4.0
Shop assistants	47	4.3	19.2	6.4	14.9	6.4	8.6	–	6.4	6.4	27.8	8.6	10.7	2.2	4.3	2.2
Engineering crafts	365	2.2	7.0	3.0	5.2	42.7	6.8	3.6	4.1	6.8	64.0	5.5	3.5	1.6	4.1	3.5
Shipbuilding crafts	55	3.6	1.8	1.8	–	63.6	3.6	1.8	7.3	–	76.3	1.8	3.6	–	1.8	9.1
Boilermakers	83	1.2	8.4	2.4	3.6	45.8	3.6	2.4	2.4	7.2	61.4	12.0	3.6	–	1.2	6.0
Building crafts	351	2.0	8.6	2.0	2.9	9.1	45.6	3.8	5.2	4.9	68.6	6.8	4.3	2.6	1.2	1.5
Wheelwrights	20	–	–	10.0	10.0	10.0	5.0	25.0	5.0	5.0	50.0	20.0	10.0	–	–	–
Furniture makers	34	–	8.7	–	8.8	17.6	17.6	–	8.8	26.4	70.4	–	5.9	2.9	–	2.9
Sawyers	21	–	4.8	–	–	9.6	9.6	52.4	–	4.8	76.3	14.3	4.8	2.9	–	–
Small metal crafts	43	2.3	11.7	–	4.7	21.0	7.0	4.6	9.4	16.4	58.4	4.7	11.7	2.3	–	4.6
Printers	25	4.0	16.0	4.0	4.0	8.0	12.0	–	16.0	20.0	56.0	4.0	4.0	–	4.0	4.0
Shoemakers	55	1.8	3.6	–	3.6	5.4	9.1	–	49.1	3.6	67.2	9.1	10.9	1.8	1.8	–
Tailors	42	–	4.8	4.8	4.8	7.2	–	–	50.0	7.1	64.3	7.1	2.4	–	4.8	7.2
Watermen	77	1.3	6.5	–	2.6	6.5	2.6	1.3	1.3	64.9	76.6	6.5	1.3	–	1.3	3.9
Labourers	705	0.3	4.4	2.0	1.6	8.1	5.7	2.0	3.7	3.5	23.0	54.3	7.8	2.1	2.0	2.6
Carmen	59	1.7	15.3	3.4	5.1	10.2	5.1	1.7	3.4	3.4	23.8	20.3	20.4	5.1	3.4	–

*includes coopers, sawyers, coachbuilders.
†includes watermen, lightermen, saddlers, printers, furniture makers, foremen.
††mainly mariners, fishermen, pensioners.
Source: Marriage certificates; see Appendix to this chapter.

were selected which were of reasonable size, significance for the study and precision of description. They were then compared with the occupations of their fathers. As a result, it is only the rows in the tables that count, giving a clear picture of patterns of occupational recruitment.

The outstanding conclusion is a marked degree of stratified recruitment. The chance of a son obtaining an occupation that was superior in terms of income, security and status clearly rested upon the occupation of his father. The most explicit element in this stratified recruitment lies in the proportion of labourers whose fathers were also labourers. In certain skilled occupations there was also a marked occupational continuity, most notably those with a closed and traditional character — shipbuilding craftsmen, and watermen and lightermen. The number of skilled shipbuilding workers who were themselves sons of skilled shipbuilding workers was 64.8 per cent in 1851 to 1853 and 63.6 per cent in 1873 to 1875. The figures for shipwrights alone were even more emphatic, 72.0 per cent and 69.7 per cent. Continuity amongst watermen and lightermen was 60.5 per cent and 63.6 per cent for each period.[16] That pattern of industrial continuity is weaker elsewhere though still substantial amongst skilled engineering and metal workers (41.2 per cent and 42.7 per cent), building craftsmen (57.9 per cent and 45.6 per cent), tailors (37.5 per cent and 50.0 per cent), sawyers and boilermakers. More important, however, is the broad picture of recruitment from the ranks of skilled and non-manual grades. It is clear that the chances of a son obtaining a skilled or non-manual job were massively increased by being born into a family already in those social strata. A proportion of unskilled workers' sons did become skilled workers, as the tables indicate, but one of the clearest of all occupational continuities is that from labourer to labourer, and this was in spite of a decline in the number of undifferentiated unskilled men known simply as labourers. While the general pattern of stratified recruitment seems to have persisted, the tables show amongst the unskilled a decline in self-recruitment.

Few trades appear to have been closed autonomous crafts whose very isolation might hinder the development of a wider cultural unity amongst artisans. Nevertheless, there is some evidence of sons entering the same industries as their father, reminding us of the ability of a trade unionist to obtain an apprenticeship for his son or generally obtain a place for him within the industry. The immense improvement in a son's life opportunities if his father was more generally in skilled or non-manual employment was dependent upon social and work contacts,

attitudes to education, and the willingness and financial ability of parents to delay their son's earnings while he trained for a skilled trade. The London casual labour market thrived on the long-term personal disadvantages caused by boys being placed in jobs that paid far more than apprentices or improvers received, but left them unwanted and untrained by the end of their teens.[17]

Unskilled fathers were particularly rare amongst shipbuilders, tailors, watermen and printers, followed by engineering workers, furniture workers and building craftsmen. The trends over time are not striking. The problem is that the overall impact of the father's occupation upon that that of the son can be shown, but the data will not distinguish the varieties of ability, security and income within each trade to see how this related to the father's occupation. They will not reveal which factors, in terms of life experience and opportunities, distinguished those skilled engineering workers whose fathers were retailers, itself an especially imprecise category, of course, from those whose fathers were unskilled workers, nor either of these groups from the majority whose fathers were skilled workers.

A labour aristocracy is a stratum within society, and as such must be defined in terms of its behaviour, relationships and prospects vis-à-vis other strata. This is recognised, for example, in Hobsbawm's criteria for defining a labour aristocracy in his pioneering essay on the subject, yet he proceeds to use earnings as the determining issue.[18] This opens up a central purpose of this book, which is not just to indicate an economic elite within the working class, but to show that during these decades it emerged as an identifiable stratum, with a range of distinct social relationships, material and status aspirations, values and patterns of behaviour. The economic basis of the labour aristocrat's position underpinned all else, and the stratum formation would have had little relevance without it. It is not, however, a self-evident necessity that high wage-earners should form a distinct and relatively exclusive group. It is precisely that which has to be demonstrated. Differences within the working class examined in previous chapters (such as skill, earnings, craft control, relationship to employer) are not in themselves various types of status, but are different *conditions* that permitted the emergence of a particular concern for status, and a particular type of status definition.

One measure of that process is to examine through marriage registers the occupational backgrounds of bride and groom to build up a picture of social relationships, and the same material was used in the studies of

inter-generational occupational mobility. As Berent argued, 'one of the tests of the "openness" of social structure is the extent of marriage between persons of different social origins'.[19] The social backgrounds of marriage partners indicate the context in which marriage partners meet and, in the light of concern for personal and family status, are allowed to marry. The broadest and most distinct evidence of social distance is to be found in the simple division between skilled and unskilled workers. Table 6.8 reveals that for a bridegroom from a skilled working-class background, the probability of marriage into the skilled working-class or non-manual strata ranged between 60 per cent and 70 per cent in the 1850s, while the chances were generally even higher in the later period. In contrast, the chances of marrying into those strata were half for someone of labourer background (29 per cent and 36 per cent for each period), for whom the great probability was marriage into the unskilled working class.

This was not the result of a highly sectionalised occupational exclusiveness; there existed in Kentish London little of the deeply embedded craft culture that was so vital a determinant of working-class relationships where urban economies rested on traditional crafts. The milieu of the traditional craft worker in central London and certain industries in Sheffield and Edinburgh was one which centred both leisure and work on the organisation of the shop and the craft culture.[20] The dominance in Kentish London of newer industrial skills and building, less socially exclusive amongst the traditional ones, meant that the factors for occupational fragmentation rather than social stratification were far less deeply entrenched in working-class life and culture. Any tendencies towards craft differentiation *outside* the workplace were increasingly overcome by the whole pattern of social life, activities and values that unified this skilled stratum and in the long run made viable more labour-conscious politics at the end of the century.

This widening from craft to stratum is revealed in Gosling's description of London riverside society. 'The wife of a lighterman felt that she was with her equals when she went out shopping with the wife of a stevedore or the wife of a shipwright, but never with the wife of a docker or an unskilled labourer.'[21] It is to be seen at the reference group level at a meeting in Plumstead where a worker from the Royal Carriage Department cited the better pay and shorter hours of engineers and building craftsmen as an argument for the justice of improving the wheelwright's position.[22] These processes are made clear in the evidence of the marriage contacts between skilled trades revealed in the tables. A greatly disproportionate rate of marriage inside one craft is limited to

rare cases where the number of marriages between children of the same
specific occupations are far in excess of the expected figure. Most
notable though still limited are shipwrights (11.1 per cent observed,
2.4 per cent expected for 1851-3; 7.0 per cent and 1.8 per cent for
1873-5), bricklayers (7.9 per cent and 1.1 per cent; 5.8 per cent and 1.7
per cent), and most of all watermen (17.3 per cent and 1.8 per cent;
15.2 per cent and 1.3 per cent), whose high degree of contact within
the craft clearly fits their general image in this book. There was a
general breadth of social contact amongst skilled workers, and between
them and certain non-manual strata. Nevertheless, there was a sub-
stantial degree of intermarriage within the principal industries shown in
the *comparatively* high rate of intermarriage within the engineering/
metal/shipbuilding group in both periods, with the addition of skilled
building workers – and less emphatically tailors and watermen – to this
dominant stratum by the later years. The marriage tables point to a
relative lack of craft exclusiveness in the 1850s and an increasing
breadth of contact amongst the skilled working class by the later years.

This skilled elite clearly did not contain all skilled workers, nor even
all skilled men within a certain trade. The problem is to pinpoint more
precisely which skilled trades were socially superior to others, and
which had a larger proportion of members who were potentially labour
aristocrats. Hierarchies of occupations, hierarchies within occupations,
and elite groups within an industry were the commonplace of Victorian
social analysis, and of historical writing since.[23] Many of these distinc-
tions, and the differentiated experience that created them, were dis-
cussed in chapter 4.

In the absence of satisfactory earnings data or social surveys, it is
impossible to indicate what proportion of workers in each trade formed
part of this aristocracy of labour. In some trades, such as watermen,
shipbuilding craftsmen, elite engineering trades (especially pattern-
makers and the most adaptable fitters), precision metal workers and
coachbuilders, it was probably a very high proportion, perhaps the great
majority. In other engineering skills, and tailoring, it was a lower pro-
portion, and in building and shoemaking lower still. By analysing
variables such as workplace relationships, earnings, housing, occupa-
tional recruitment and marriage, a general *ranking* of trades can be con-
structed on the assumption that the evidence of broad agreement on
rankings over different variables indicates some degree of stratification
within each trade. The general picture does fit together, especially the
clear picture of a tail within each trade behind the labour aristocrats.
We cannot establish whether the tail of each trade on each variable

represents a clustering around certain grades of skilled workers, though such a conclusion seems plausible. On the basis of this evidence it is significant that the main industries of the area for skilled employment were those which repeatedly led the rankings.

Kentish London was not dependent on those traditional artisan crafts that suffered the seasonal and the technological unemployment that characterised central London and the older centres of production. It suffered fewer of the vagaries and instabilities of a small-scale employment structure in its principal industries, although building remained the exception. Skilled trades with a marked casual section were less evident.[24] Kentish London was dominated by the country's main growth industries and those producing the high-ranking skilled trades. If building is less consistent than the others, the industry's departure from the local industrial pattern must have produced a wider differentiation within each building craft.

The marriage analysis in Tables 6.6. to 6.10 makes this clearer, showing different degrees of marriage contact with unskilled groups. Contact by non-manual strata was very low, while the general hierarchy of skilled trades is fairly consistent over time. In the years 1851 to 1853 it is shipbuilding workers, watermen and lightermen, engineering and metal crafts, and tailors who had the lowest contact, all with well under 20 per cent marrying into unskilled grades; these are followed by building crafts, small metal workers and shoemakers. The figures in the period 1873 to 1875 were similar, with increasing contact between skilled groups and a decline in their intermarriage with unskilled. The top group was now engineering and metal, watermen and lightermen, tailors and shoemakers. Shipbuilding craftsmen have increased contact with unskilled, but their contact with skilled occupations also increased; the real change was their markedly lower contact with mariners.

This does not mean that there was a hierarchy of elitism that followed this pattern, for example that a fitter was superior to a mason, but that the proportions of the different trades likely to share aristocratic characteristics would probably be *ranked* in this fashion. Tables 6.9 and 6.10 present the hierarchy within a single industry where it can be analysed. Smiths stand out from other engineering and metal trades in the earlier period, with a far higher degree of contact with unskilled. The main trades called 'engineer' here, but including fitters, turners and millwrights, are the elite in this respect. Skilled shipbuilding workers do not show such features, but it is instructive from Table 6.10 to see that shipwrights are much more resistant to the challenge to the position of

Table 6.6: Marriage and Social Distance, 1851-3

Percentage where the father of the bride was:

Father of Groom	Total cases	Gentlemen, professions, finance	Retail	Farmer	White-collar	Craft engineering, metal, shipbuilding	Craft building	Wheelwrights, etc.*	Shoemakers, tailors	Misc. skilled†	Total skilled	Labourer	Misc. unskilled	Gardener	Army, navy, police	Others††
Gentlemen, large business**	184	48.8	11.9	2.7	4.8	3.8	4.3	—	3.2	6.0	17.3	1.1	2.1	—	10.4	1.1
Retail	367	8.4	24.0	8.2	0.5	7.9	10.9	2.7	9.0	8.4	38.9	4.6	5.5	3.0	1.6	5.2
White-collar	106	6.6	9.4	10.4	5.7	13.2	14.2	4.7	11.3	6.6	50.0	3.8	3.7	1.9	4.7	3.8
Engineering craftsmen	175	1.7	13.1	3.4	2.3	25.7	8.0	1.1	8.5	6.8	50.1	14.3	5.1	1.1	2.9	5.7
Shipbuilding craftsmen	109	3.7	7.3	—	4.5	21.0	6.4	6.4	7.4	9.1	50.3	5.5	5.4	3.7	—	19.2
Sawyers	36	—	8.4	5.6	—	27.9	5.6	8.4	2.8	2.8	47.5	25.0	5.6	—	—	8.4
Building craftsmen	352	1.1	12.3	6.8	1.7	14.6	11.6	0.9	4.6	7.5	39.2	11.6	6.3	6.5	4.3	9.5
Small metal craftsmen	32	9.4	18.8	—	6.2	3.1	—	—	15.7	12.6	31.4	15.6	—	9.4	3.1	6.2
Shoemakers	109	—	6.4	9.2	2.7	9.1	11.9	2.7	12.8	5.5	42.0	16.5	7.3	5.5	0.9	9.1
Tailors, clothing workers	94	1.1	12.6	2.1	4.2	18.2	3.2	3.2	10.6	9.6	44.8	11.7	9.5	—	3.2	10.7
Watermen, lightermen	75	—	9.3	2.7	1.3	10.7	10.7	5.4	8.0	20.0	54.8	12.0	1.3	—	4.0	14.7
Labourers	769	—	3.1	2.3	0.7	7.0	5.5	1.4	4.8	4.2	22.9	54.7	7.9	1.8	2.1	4.5
Gardeners	98	—	3.0	9.2	3.0	7.1	13.3	1.0	8.2	10.2	39.8	21.4	7.1	7.1	—	9.1

*includes coopers, sawyers, coachbuilders.

†includes watermen, lightermen, saddlers, printers, furniture makers, foremen.

††mainly mariners, fishermen, pensioners.

**includes professions, finance.

Source: Marriage certificates; see Appendix to this chapter.

Table 6.7: Marriage and Social Distance, 1873-5

Father of Groom	Total cases	Percentage where the father of the bride was:														
		Gentlemen, professions, finance	Retail	Farmer	White-collar	Craft engineering, metal, shipbuilding	Craft building	Wheelwrights, etc.*	Shoemakers, tailors	Misc. skilled†	Total skilled	Labourer	Misc. unskilled	Gardener	Army, navy, police	Others††
Gentlemen, large business**	171	39.8	14.0	6.4	5.3	6.5	4.7	—	1.2	6.0	18.4	0.6	3.0	1.2	5.2	6.5
Retail	428	4.0	18.5	6.6	6.1	14.5	10.3	2.1	5.1	7.0	39.0	8.6	6.5	2.6	2.6	6.1
White-collar	253	7.9	13.0	2.4	9.5	16.6	9.9	2.4	6.3	8.7	43.9	5.5	3.2	2.0	4.7	7.9
Engineering craftsmen	335	1.8	8.9	2.7	6.0	20.6	15.2	3.6	5.1	7.8	52.2	11.6	5.4	1.8	2.7	7.2
Shipbuilding craftsmen	89	—	5.5	1.1	1.1	28.1	11.2	3.4	12.3	10.1	65.1	12.4	5.5	3.4	—	5.6
Boilermakers	56	—	5.4	1.8	3.6	23.1	16.1	3.4	3.6	3.6	50.0	17.9	7.2	5.4	1.8	7.2
Sawyers	41	—	12.1	7.3	—	7.3	14.6	7.3	14.6	4.8	48.6	12.2	7.2	4.9	4.9	2.4
Building craftsmen	375	1.3	15.4	1.6	6.2	12.3	14.9	2.9	6.1	7.3	43.5	10.7	9.4	4.3	1.1	6.6
Small metal craftsmen	42	2.4	16.8	—	—	21.4	11.9	—	2.4	12.0	47.7	14.3	11.9	—	2.4	4.8
Wheelwrights	41	—	4.9	7.3	4.8	12.2	9.8	4.8	2.4	12.1	41.3	22.0	12.1	4.9	—	2.4
Shoemakers	111	—	13.5	4.5	2.7	15.3	5.4	4.5	11.7	9.9	46.8	14.4	7.2	1.8	2.7	6.3
Tailors, clothing workers	93	3.2	10.9	2.5	6.5	15.2	18.3	1.1	7.6	8.7	50.9	6.5	9.8	2.2	4.4	3.3
Watermen, lightermen	80	3.8	11.4	2.5	5.1	18.8	10.0	1.3	3.8	23.9	57.8	3.8	10.2	1.3	—	7.6
Labourers	627	0.2	5.3	1.8	1.2	7.4	6.5	2.1	5.1	6.0	27.1	47.5	7.4	4.0	1.1	4.7
Gardeners	101	—	11.0	3.0	8.0	7.0	6.9	3.0	7.0	7.0	30.9	23.8	14.0	3.0	—	7.0

*includes coopers, sawyers, coachbuilders.
†includes watermen, lightermen, saddlers, printers, furniture makers, foremen.
††mainly mariners, fishermen, pensioners.
**includes professions, finance.
Source: Marriage certificates; see Appendix to this chapter.

Table 6.8: Marriage and Social Distance: Summary Table

| Father of Groom | Percentage where the father of the bride was: | | | | | | | | | | | |
| | 1851-3 | | | | | | 1873-5 | | | | | |
	Total cases	Non-manual	Skilled workers	Unskilled and servants	Police, army, navy	Others	Total cases	Non-manual	Skilled workers	Unskilled and servants	Police, army, navy	Others
Gentlemen, large business*	184	67.8	17.3	3.2	10.4	1.1	171	65.5	18.4	4.8	5.2	6.5
Retail	367	41.1	38.9	13.1	1.6	5.2	428	34.7	39.0	17.7	2.6	6.1
White-collar	106	32.1	50.0	9.4	4.7	3.8	253	32.8	43.9	10.7	4.7	7.9
Engineering craftsmen	175	20.5	50.1	20.5	2.9	5.7	335	19.4	52.2	18.8	2.7	7.2
Shipbuilding craftsmen	109	15.5	50.3	14.6	–	19.2	89	7.7	65.1	21.3	–	5.6
Boilermakers	–	–	–	–	–	–	56	10.8	50.0	30.4	1.8	7.2
Sawyers	36	14.0	47.5	30.6	–	8.4	41	19.4	48.6	24.3	4.9	2.4
Building craftsmen	352	21.9	39.2	24.4	4.3	9.5	375	24.5	43.5	24.4	1.1	6.6
Small metal craftsmen	32	34.4	31.4	25.0	3.1	6.2	42	19.2	47.7	26.2	2.4	4.8
Wheelwrights	–	–	–	–	–	–	41	17.0	41.3	39.0	–	2.4
Shoemakers	109	18.3	42.0	29.3	0.9	9.1	111	20.7	46.8	23.4	2.7	6.3
Tailors, clothing workers	94	20.0	44.8	21.2	3.2	10.7	93	23.8	50.9	18.5	4.4	3.3
Watermen, lightermen	75	13.3	54.8	13.3	4.0	14.7	80	22.8	57.8	15.3	–	7.6
Labourers	769	6.1	22.9	64.4	2.1	4.5	627	8.5	27.1	58.9	1.1	4.7
Gardeners	98	15.2	39.8	35.6	–	9.1	101	22.0	30.9	40.8	–	7.0

*includes professions, finance.

Source: Marriage certificates; see Appendix to this chapter. There were in 1851-3 insufficient cases of boilermakers and wheelwrights.

Table 6.9: Marriage and Social Distance, 1851-3: Specific Trades

Percentage where the father of the bride was:

Father of Groom	Total cases	Gentlemen, professions, finance	Retail	Farmer	White-collar	Craft engineering, metal, shipbuilding	Craft building	Wheelwrights, etc.*	Shoemakers, tailors	Misc. skilled†	Total skilled	Labourer	Misc. unskilled	Gardener	Army, navy, police	Others††
Engineer	67	4.5	7.5	6.0	3.0	34.3	9.0	—	10.5	7.5	61.3	3.0	4.5	—	3.0	7.5
Smith	66	—	10.6	1.5	3.0	12.0	7.5	1.5	7.5	7.5	36.0	28.8	9.1	1.5	4.5	4.5
Other engineer/metal	42	—	26.2	2.4	—	35.7	7.1	2.4	7.1	4.8	57.1	9.5	—	2.4	—	2.4
Shipwright	72	4.2	9.8	—	7.0	20.8	1.4	4.2	9.8	9.8	46.0	5.6	8.4	4.2	—	15.3
Other shipbuilding	37	2.7	5.4	—	—	21.6	16.2	10.8	2.7	8.1	59.4	5.4	—	2.7	—	24.3
Builder	37	2.7	13.5	10.8	5.4	24.3	10.8	2.7	5.4	5.4	48.6	5.4	2.7	—	5.4	5.4
Bricklayer	63	—	9.5	6.3	—	16.0	11.1	—	1.6	8.0	36.7	15.9	9.5	9.5	4.8	8.0
Carpenter and joiner	158	1.3	14.5	4.4	—	12.6	13.9	1.3	4.4	8.1	40.3	13.9	9.4	5.1	3.2	7.6
Mason	29	—	6.9	20.7	—	13.7	10.3	—	6.8	13.8	44.6	3.4	3.4	13.8	—	10.3
Painter	36	2.8	5.6	5.6	5.6	8.4	5.6	—	8.4	5.6	28.0	11.1	5.6	2.8	11.1	22.2

*includes coopers, sawyers, coachbuilders.
†includes watermen, lightermen, saddlers, printers, furniture makers, foremen.
††mainly mariners, fishermen, pensioners.
Source: Marriage certificates; see Appendix to this chapter.

Table 6.10: Marriage and Social Distance, 1873-5: Specific Trades

Father of Groom	Total cases	Gentlemen, professions, finance	Retail	Farmer	White-collar	Craft engineering, metal, shipbuilding	Craft building	Wheelwrights, etc.*	Shoemakers, tailors	Misc. skilled†	Total skilled	Labourer	Misc. unskilled	Gardener	Army, navy, police	Others††
						Percentage where father of the bride was:										
Engineer	166	2.4	7.8	3.0	9.0	24.0	13.2	3.0	3.6	7.8	51.6	8.4	6.6	2.4	1.8	6.6
Smith	100	1.0	8.0	3.0	4.0	15.0	17.0	5.0	6.0	7.0	50.0	14.0	4.0	2.0	5.0	9.0
Other engineer/metal	69	1.4	11.6	1.4	1.4	20.3	17.4	2.9	7.2	8.7	56.5	15.9	4.3	–	1.4	5.8
Shipwright	57	–	5.4	1.8	1.8	24.7	14.0	3.5	12.3	14.0	68.5	8.8	5.4	1.8	–	7.0
Other shipbuilding	32	–	9.4	–	–	31.3	6.3	3.1	12.5	3.1	56.3	18.8	6.3	6.3	–	3.1
Builder	43	4.7	20.9	2.3	11.6	4.6	11.6	–	4.7	20.9	41.8	2.3	4.6	–	–	11.6
Bricklayer	52	–	17.3	1.9	5.7	13.3	15.4	1.9	3.8	3.8	38.2	19.2	11.5	1.9	–	3.8
Carpenter and joiner	140	1.4	12.1	1.4	7.1	13.5	16.3	4.9	4.3	6.4	45.4	12.1	6.4	5.0	1.4	7.0
Mason	29	–	17.1	3.4	3.4	13.6	20.6	–	10.3	3.4	47.9	–	17.1	6.9	–	3.4
Painter	71	1.4	16.9	–	2.8	11.2	14.1	–	9.8	5.6	40.7	11.3	8.4	5.6	2.8	9.8
Plumber	28	–	7.2	–	3.6	21.5	10.7	10.7	10.7	3.6	57.3	10.7	14.3	3.6	–	3.6

*includes coopers, sawyers, coachbuilders.
†includes watermen, lightermen, saddlers, printers, furniture makers, foremen.
††mainly mariners, fishermen, pensioners.
Source: Marriage certificates; see Appendix to this chapter.

shipbuilding workers in the 1870s. The smaller shipbuilding crafts reveal what might be the first signs of social decline. Amongst building craftsmen, the 'builder' is clearly the most elitist, supporting the view that they are largely a small master group. In the earlier period, masons and painters are the other trades with lower than average contact with unskilled, with carpenters and joiners and bricklayers above average. By 1873-5 only bricklayers are left with a fairly high contact with unskilled. Differences have evened out for other skilled building workers. This deviation is, of course, around a mean for building craftsmen that is still a fairly exclusive one, with only 22 per cent marrying into unskilled grades and 68 per cent into skilled and non-manual. The decline in differences amongst building and engineering craftsmen suggests a levelling-out process amongst skilled occupations, especially within a single industry. The particular case of boilermakers ought to be noted, for in both occupational recruitment and marriage contact the links of boilermakers to unskilled workers is higher than for other trades. This obliquely confirms the supposition that it was easier for labourers and unskilled workers to move into a new craft such as boilermaking than into such older ones as engineering and wooden shipbuilding. Neither measure actually observes this process, but both indicate the wider social repercussions that stemmed from it. The broad conclusion from the marriage analysis both confirms and adds detail to the picture of artisan stratification. The decline in unskilled inter-marriage mirrors trends noted elsewhere — occupational recruitment, friendly society membership and so on. The direction may be of long-term importance, but the decline is still on a limited scale. The data have also helped indicate the place of different skilled trades within the labour aristocracy. Skilled workers were certainly no undifferentiated mass, not even within a single industry or trade.

The concept of a labour aristocracy was at the centre of most mid-Victorian social analysis, 'almost a commonplace of mid-Victorian socio-economic literature'.[25] The Austrian J.M. Baernreither, visiting England in the early 1880s, was impressed by what he called 'an aristo-cracy of workmen', which 'consists of the members of these working men's associations'.[26] Robert Lowe reported current fears that Disraeli's franchise reform went 'so much lower in the scale of property and intelligence, that the aristocracy of labour will be entirely swamped'.[27] The existence of an elite of relatively prosperous, secure and respons-ible working men was central to middle-class attitudes to franchise extension at the time Lowe was speaking — Robert Jolly told a Wool-wich reform meeting that there was a specific stratum of working men

that could safely be enfranchised.[28] The depiction of such an elite allowed the middle classes to construct an interpretation of the social structure that was moralistic and normative rather than sociological and class-based. Nevertheless, its reality was no illusion.

The nature of the labour aristocracy as a concept, as well as the inadequacies of surviving data, render unattainable a precise quantitative assessment of its size.[29] Its existence as a social stratum, however, can be demonstrated, as can its character. This book sees the labour aristocracy as a section of the skilled working class, but one that did not include all skilled workers, and which took up a greater proportion in some trades than in others. Its members showed a degree of social stratification that developed around and generated a cluster of distinctive activities and values. If it depended fundamentally on its economic position, it constructed its social situation upon an additional complex of diffuse and normative characteristics. The line below the stratum was a fluctuating one, leading into other sections of the skilled working class, but a firm division separated it from the mass of the unskilled. For most labour aristocrats these defining characteristics were not temporary but long-term. Finally, during the mid-Victorian decades it came to assume a position of particular importance in organised working-class activities.

How rigid were the lines that divided labour aristocrats from those beneath and above them? There must have been a large number of this elite about whom no one would have had any doubt, but at the lower end of the stratum the boundaries seemed precise neither to contemporaries nor to us. Not all skilled workers were labour aristocrats, and with stratification built upon the accumulation of situations, attitudes, social contacts and social activities, the lines of demarcation could never have been clear. This does not imply a featureless social continuum; for any social stratum the centre is hard but the edges will blur. The relationship below with other skilled workers and some unskilled, was indeed of great importance in terms of aspirations. The pervasiveness and the influence of the labour aristocracy grew from the more uncertain aspirations and activities to emulate the elite on the part of less secure and less well-placed artisans. The labour aristocracy was able to define the ambitions of a section of working men unable for many reasons to achieve its security and stability, but none the less striving intermittently to do so. Other skilled workers were the main force here, but the aspirations could and did spread further, as was observed above in connection with Ellen Chase's housing work in Deptford. By the criterion of housing quality her respectable labourers were moving

down by leaving, but the values of independence and residential segregation had filtered down to a section of even the unskilled. The line was thus a fluid one where aspirations were involved, yet they spread unevenly from a base that was narrow but successful.

The diffusion of these aspirations does not imply a genuine social mixing. The general exclusiveness prevailed, particularly between the better skilled men and the unskilled. 'There is no place', wrote an anonymous 'Workingman' of his fellow London workers, 'in which class distinctions are more sharply defined, or strongly, or, if need be, violently maintained than in the workshop . . . Evil would certainly befall' any labourer who tried to assume equality with an artisan. For example, 'if . . . he added himself unbidden to a group of the skilled hands of the shop who were just chatting about things in general, or even "put his oar in" to a conversation that they might be carrying on in his full hearing.'[30] This firm social separation spilled over into many areas beyond those discussed here. Booth learned that the division between artisan and labourer meant that in the Hatcham Park area of Deptford, 'owing to the cleavage in the population, most of the social agencies have to be duplicated, and we find, for instance, two mothers' meetings, two Bands of Hope, and even two libraries'.[31] This was not a gulf between two homogeneous blocks, skilled and unskilled. Both contained a myriad of status distinctions. Nevertheless, especially in the absence of a middling group of semi-skilled, it was a gulf which was socially very real. The Riverside Visitor had formerly been a skilled engineer and he regularly visited a part of riverside Deptford that was densely populated with unskilled workers. His description is illuminating for what it tells us about the writer. It is, for the Riverside Visitor, a foreign land, which he cannot understand. He expresses his feelings of total alienation from the population, even declaring that he could not always understand what they said.[32]

It is worth considering how these labour aristocrats saw the mass of unskilled workers, especially the very poor. The meagre evidence allows little more than general consideration, but the attitudes were complex and probably ambiguous. There were those factors which ought to have led to understanding: labour aristocrats rejected much of middle-class style and values, were proud of the manual character of their work, and shared both awareness and experience of the precarious position of all working men in that society. They would not have accepted the simple middle-class view that poverty was caused by personal inadequacy. The impossibility of respectability on twelve shillings a week must have been as evident to them as it was to a sympathetic observer like

Mayhew.[33] Yet their income, the labour market and the bargaining power of the unskilled could not have been simply *cause*, but must in some way have been the *result* of character, effort and organisation. Labour aristocrats needed to feel superior, for their quest for status was directed at coping with the more fundamental inequalities in Victorian society. For this reason, they worked ambiguously with elements from middle-class moralising. They saw their provident associations as simultaneously the cause of good character and a reward for it and this encapsulates the ambiguity well. The security and the character that came from the labour aristocrat's life style had to be a sign of more than economic superiority; likewise the failure of the unskilled. The whole picture was further clouded by relationships at work. Most skilled workers required their trade union to prevent the encroachment of labourers when employers were often keen to dilute craft control. The active support of skilled unions for the agricultural labourers' movement[34] was inspired by traditional radical critiques of the landed classes, but it was eased by the physical distance of these labourers. Their cause threatened neither the craft control nor the status of the skilled workers. There was at this time far less artisan support for union-isation of their own helpers and labourers.

The contact upwards appears to have been more fluid. Through the evidence of the institutions and political activities examined below, and through the marriage analysis, a degree of social contact is evident between skilled artisans and occupational groups later known as the lower middle class. Artisan involvement with small shopkeepers, and to a lesser extent managerial and clerical workers, is a commonplace of political and social movements from the early nineteenth century. Such relationships were limited yet significant in Kentish London, and they partially drew in that small master stratum which remained firmly em-bedded within artisan culture and manual work. Working-class marriage contact with non-manual occupations was overwhelmingly by skilled workers, and there was no great differentiation in this amongst different skilled groups, although engineering, building and tailors generally had a higher degree of contact and shipbuilding workers lower. The non-manual occupations into which they married were principally retailers and white-collar workers, with the former principally food retailers, and dealers in goods such as coal, timber, cattle and building supplies.[35] The contact with the last-named trade was mainly by building workers, suggesting either a social network that had developed out of a business relationship or recruitment of dealers from the ranks of craftsmen. The overall involvement was with a category of retail trades that included a

wide range of shops, with differing clientele, prosperity and capital-isation. The skilled working class presumably made its social contact primarily with one section of this shopocracy.

Here was a social contact with an imprecise stratum of small shop-keepers and white-collar workers whose stance towards manual workers became more independent as the century drew to a close. In the absence of a large and coherent non-manual stratum such relationships posed few general threats to labour aristocrats, though specific clashes with aspirant clerks might occur, as in mechanics' institutes. Distinct white-collar residential areas emerged later in the century, and it was then that a lower-middle class could threaten the aspirations of labour aristocrats by despising their manual labour.[36] The evidence for the mid-Victorian period shows that the limited size of such non-manual groups and their failure to coalesce into a distinct stratum, permitted the degree of social contact that took place. The social distinctions between them and the better skilled workers were limited, especially amongst the small shopkeepers and small masters who were often recruited from the skilled working class, and who would have retained or absorbed much of the artisan culture of their milieu. Furthermore, as Gray has correctly stressed, those non-manual groups with whom the labour aristocracy had social contact held a highly marginal position within the middle class.[37] He finds in Edinburgh that this social contact by labour aristocrats with white-collar workers was less with an aspirant layer of clerks, and more with a heterogeneous collection of teachers, managers, minor officials and so on.[38] The Kentish London evidence points in the same direction, but far less emphatically. In the 1851 to 1853 analysis, 33 per cent of all brides from clerical families married into skilled working-class families, and 32 per cent in 1873 to 1875. Compare this with the 43 per cent figure for the more heterogeneous white-collar group in both periods.

The next chapter turns to the ideology of this labour aristocracy, while subsequent chapters look at the institutions and the politics that they dominated. The structural factors that enabled an artisan elite to emerge received reinforcement from the life style that they encouraged. The institutions shared an overlapping membership, as well as many leaders in common. For the first we have only general contem-porary views such as that with which this chapter opened, pointing to a clustering of values and institutional activity around members of this stratum. We shall see the same names recur amongst the leaders of different thrift organisations, political activities and trade unions. It is important to establish at the personal and not just the ideological level

the interdependence of these activities. The institutions related to each other especially closely in Woolwich where efforts to found a dispensary and a co-operative hall, for example, brought together skilled trade unions, working-class clubs, benefit societies, and co-operative societies in meetings and committees.[39] These contacts were most important, however, at the personal rather than the institutional level. There was a fundamental clustering of a pattern of institutional and ideological characteristics around members of an artisan elite. The distinctiveness of this upper stratum of the working class is not that its members joined thrift and voluntary institutions, for so to an extent did lesser skilled and unskilled workers. The real point is that they joined so many that at one level it materially affected their life chances and experiences, as discussed in this chapter; while at another level, which is the subject of the chapter that follows, it helped determine their values and their culture.

Appendix: Marriage Registers Analysis

The purpose of the analysis was to use the information recorded in marriage registers to examine occupational change between generations; the social and status relationships between occupational groups; and the denomination of the churches in which people married.

All entries in the marriage registers for Kentish London parishes were examined for two periods of three years: 1851 to 1853 and 1873 to 1875. The actual registers used are named in the list of sources. A total of 3,886 marriages were examined for the first period and 4,310 for the second.

The information in the registers was coded and punched into machine-readable form, and then analysed on the IBM 370/165 computer at the Cambridge Computer Laboratory, using the statistical subprogramme routines of the SPSS (G) package.

For *marriage and social distance* it was decided to use the occupations of the fathers of the bride and groom, on the grounds that the status considerations that affected choice of marriage partner are more generally derived from the family situation. In this I have followed others who have investigated the issue either in contemporary sociological research or historical analysis.[1] Exceptions, where the occupations of the groom or bride were taken, were where the bride was a widow, where the groom was a widower, where the groom was stated to be over 25 years of age, and where the groom was a soldier, for his place in the local social structure was as a soldier. In the analysis of *inter-generational occupational change* the actual occupations of both

groom and father of groom were used.

A problem arose with the large number of Roman Catholic marriages where fathers were listed as 'farmer'. This would seriously have distorted a category which in the English social structure was a position of some status. The status difference between Catholic and non-Catholic farmers was clearly shown by the differences in the occupations of the fathers of the marriage partner. I have assumed that the reference in the Catholic marriages was to small agriculturalists in Ireland, better classified as agricultural workers for this purpose. All Catholic farmers were thus coded.

The data set for this analysis has been deposited with the SSRC Survey Archive at the University of Essex (Number 90001 C, *Marriages in Mid-Victorian Kentish London*). It is available for use in accordance with certain limitations.

7 THE ARTISAN ELITE: II IDEOLOGY AND VALUES

The organisations and activities analysed in this book both expressed and developed an artisan ideology, and gave it the degree of cultural cohesion which broadened it from a mere craft consciousness while at the same time making it narrower than a generalised proletarian ideology. This chapter will concentrate upon the main component of those values and ideology, for it is within this framework that the subsequent specific studies fall into place.

The ideology was essentially concerned with status, respectability and independence, and with an accommodation with many of the main features of the society in which they lived. This bald statement needs refining, for presented in that form it is reminiscent of the embourgeoisement thesis developed by some sociologists to explain skilled working-class behaviour in recent decades.[1] Historians have tended to read into the mid-Victorian artisan ideology a version of just that process, arguing that an elite of skilled workers, in response to relatively higher incomes and living standards, assumed aspirations and values that were characteristically middle-class.[2]

The argument and the evidence of this study point to a different if more ambiguous conclusion.[3] The process of ideological hegemony by which the mid-Victorian ruling elite successfully contained a section of the working class was a far more subtle and ambiguous process than would be allowed by the orthodoxy of a labour aristocracy being indoctrinated with, or persuaded to accept, middle-class values and ideals. The values proclaimed by the labour aristocracy take on a very different significance when understood within a specific working-class socioeconomic situation. It is only in this context that the political militancy, the trade-union solidarity, the continuing class tensions and the subsequent labour consciousness can even be interpreted. This chapter in effect calls for a readjustment of the way in which historians of the period traditionally interpret cultural and ideological diffusion. The distinctiveness of 'meaning-systems'[4] and their relationship to structurally different situations are fundamental to the understanding of any values and ideology. There has been a tendency to neglect the fact that similar concepts can have different meanings, and that such meanings depend upon the situation and values of the speaker or participant, and

are frequently misunderstood by outside observers.

In Kentish London, the artisan value system was a complex and necessarily ambiguous one. At its centre was a concern for 'rising in the world', but not all aspirations for mobility involved occupational change. The ambition could encompass leaving the working class economically and socially, but at other more pervasive levels it involved obtaining improvement within the working class, or simply obtaining a higher status and regard in the eyes of those deemed appropriate. If Victorians were muddled about the distinctions, there is no need for us to impose an unreal typology, but an awareness of these various strands is important. Occupational change that took a man out of the working class was not the general aim. Such an aspiration could not substantially have co-existed with the strong pride in their craft and its culture that so characterised these labour aristocrats. Even if craft pride and involvement in traditional working-class culture had not intervened, aspirations built upon a mobility that would take a worker out of his manual working-class position would have foundered on the grounds that it too rarely occurred. The feasible mobility was concerned with status rather than occupation, for status achievement could make sense of their ambitions in a way in which the Smilesian paradigm of genuine economic progress could never have done.

The status sought was expressed in one of the most pervasive of mid-Victorian social concepts: respectability. With the broad mass of the working class regarded as inferior, ignorant and generally immoral, the assertion of self-respect was a way for an increasingly secure elite of skilled workers to assert their superiority and achieve a degree of separation. The idea of respectability was fundamentally Victorian in its concern for style and appearance as well as personal morality. It provided an alternative to wealth as a criterion for social judgement in a more fluid and insecure society in which traditional rank was ever less helpful for that purpose. Respectability was in this way a means of living with inequality for the middle class and for the petty bourgeoisie as well as for skilled artisans. The content might differ from one stratum to another, perhaps from one place to another, but the nature of the idea prevailed. The double edge to respectability provided its continuing satisfaction, being as much concerned with an individual's sense of self-respect as with any external recognition of his respectability. At the centre of the skilled artisan's concern for rising in the world was the achievement by this elite of a wider recognition of its value and respectability within Victorian society — as individuals and as a group through their institutions. This is what the Arsenal wheelwright,

Henry Knell, meant when he wrote that 'by attention to the rules of
good breeding . . . the poorest man will be entitled to the character of
a gentleman'.[5] The striving for self-respect and the need for external
recognition dovetailed in political liberalism. It was not a complaisant
search for respectability, but often a radical and aggressive one,
entrenched by the binding of dignity and independence from earlier
artisan traditions into the meaning of self-respect. In this context,
however, to identify oneself as a liberal was to make statements about
one's place in local society, one's independence, moral equality, dis-
regard of privilege and rejection of patronage. The story of working-
class liberalism contains within it many of those facets of artisan
respectability that gave it bite and aggression.

Many different layers of meaning were embraced by the word
'respectability', yet if it had a core it was in a notion of independence
that contained a moral imperative. There were many things that a
respectable man might not do, and many of the tensions in Victorian
social relations stemmed from disagreements as to what these prohibi-
tions were. Yet one condition to which a respectable man could not
descend was that of dependence. At its most basic level, this meant
dependence on the poor law and charity. He might be confused with
the unrespectable. 'The artisans (of Newington) would not come near
us,' said the representative of a local Charity Organisation Society, 'but
as time went on, and as the application of the rules became more
rigorous and more careful, a better class of men did come.'[6]

Independence of the will and dictates of others was equally
important. This need not conflict with wage-employment, for many of
the subtleties of status rested upon degrees of craft control in the
workplace. Yet it could never co-exist, for example, with the dock
labourers' undignified scramble for employment at the dock gates. As
an anonymous London working man observed of skilled workers in the
1870s, 'their unions exercise a wise discretion in not calling upon them
to seek for work in any manner that would grate upon their self-
respect'.[7] The subtleties of respectability might change from one social
stratum to another, but independence was at its heart. A working man
had to assert it by demonstrating that he could overcome some of the
most basic problems of poverty, intemperance and lack of industry that
were imposed by his economic and social situation. The will to seek
this independence, and the moral qualities needed to achieve it, were
proof of respectability. The institutions of thrift were to assist in this
process.

Independence was not just the negative freedom from charity and

want, but the positive self-confidence (as well as capacity) that would allow a man to make real choices about his life style; choices about which voluntary associations he would join, choices about the district in which he lived, choices about the veneer of respectable culture that he was now able to seek. Mechanics' institutes illustrate this. Repeated crises followed artisan resentment at domination by lower middle-class elements and management by gentlemen. The artisans were subject to the patronising attitudes of clerks and shop assistants that both irritated them and challenged their sense of self-respect, while management by members of the local social elite constituted a clear threat to independence. Henry Knell explained the first problem when he wrote of

> a class of fast young fellows who rejoice in the nomenclature of shopmen and clerks, who keep up a strict line of demarcation and not only monopolize the daily journals, but likewise the conversation. And if a labouring man ventures a sentiment, he is met with either a universal grin or a personal taunt, and therefore he soon becomes disgusted with that society that fails to reward him for the trouble and expense of attending.[8]

The Greenwich Society for the Diffusion of Useful Knowledge had been set up in 1836, and soon became one of the largest institutions in London, though predominantly concerned with lectures and amusement rather than classes. It was at that time artisan-dominated.[9] By 1852 growing non-manual membership provoked the establishment of a rival East Greenwich Institution, on the grounds that artisans had been driven out by middle-class members, 'among whom the working men do not feel themselves so much at home'.[10] Yet the process was repeated there, for in 1857 a Greenwich Mutual Improvement Society was set up within the East Greenwich Institute in order to counter non-working class domination.[11] One 'working man' saw these tensions as a prime cause of the Institute's decline in Deptford. 'It appears to me', he wrote, 'to be of too exclusive a character, just calculated to keep away those for whose especial benefit Mechanics Institutes were established.' He also indicated the other cause of resentment. The Institute was set up and run by prominent local gentlemen, and 'the apathy, I think, results from the fact that the working man is virtually excluded from all share in its management'.[12]

These issues, rather than the content of lectures and activities, were the real subject of resentment. When artisan secessions took place, the subject matter of meetings changed little. This was still principally

entertainment, general knowledge, and a superficial and eclectic 'culture'. The Greenwich Mutual Improvement Society, a working-class secession from the East Greenwich Institute, held its first meeting not on some subject more relevant to working men, but on 'Mohammedism'.[13] A member of the lower middle-class-dominated Deptford Mechanics' Institute, used to lectures on Scott and the Philosophy of Punch, and classes on elocution, would not have found the programme of the new Greenwich organisation very different.[14]

The rejection of patronage was an essential part of respectability, yet linked to it was a denial of a narrow and individualistic conception of independence. The friendly societies in Kentish London were organised and managed entirely by working men. Societies run by higher classes for the benefit of lower classes that were so prominent in rural areas did not exist. Patronage and patronising treatment would have removed one of the main props on which artisan respectability rested. Charles Bosanquet saw this as a distinguishing feature of London skilled workers, especially engineering and building craftsmen. 'There is strong class feeling amongst them, and the better sort of them are very independent, and look for little help from those above them.'[15] This will be seen most emphatically in Kentish London friendly societies, where the independence sought was not from fellow working men but from those who might regard themselves as moral superiors on the basis of economic and social position. The rejection of an individualism characteristic of middle-class Victorian values is a vital dimension of artisan ideology.

The other side of the coin from the exclusion of patronage was a search for social approval. If the aspiration to respectability sought success within a wider status system, then confirmation had to be added to self-description. Recognition had to come from those capable of right judgement. There is always the dual problem of status description, the ease of self-ascription and the diffuseness and difficulty of recognition. The problem was especially severe if the status of which recognition was sought was not a totally closed one, where acceptance by peers sufficed, but one that related to a wider framework. For this reason, although the notion of respectability held by the local social elite did not always coincide with that held by these artisans, it was from that stratum of local notables that approval had to be obtained.

It was difficult for working men as individuals to obtain personal confirmation of respectability, but approval of their life style, organisations and values could be obtained through their institutions in ways already indicated in chapter 5. These ranged from visits to social

gatherings, dinners and fetes organised by friendly societies and other institutions, through generalised descriptions of the working class that drew careful distinctions between different strata, to specific speeches of approval at meetings and social events, and agreement to becoming honorary members. Specific tensions were not absent, whether over trade unions or important issues such as the conviviality of drink. The essential point here is that the terms for this social approval were set by the artisans, and involved no interference in the running of their organisations.

Status recognition can be denied as much as granted. This was the cause of political tensions, where artisan requirements of recognition began with the vote but extended to a creative role in the local liberal organisations. The local reform debate in the 1860s was not about the criteria for awarding the vote, but about who, on the basis of these criteria, might be deemed worthy of it. The movement received considerable middle-class support, and with the apparent assistance of the language of Gladstonian liberalism, recognition through enfranchising respectable working men became not a favour but a right, and as such was imbued with a traditional language of morality and of justice. The middle classes of Kentish London might make the right speeches when guests of honour at artisan functions, but in local politics after 1867 working-class liberal demands met with all-too-frequent rejections. The repeated efforts of working men to obtain an equal place in the Greenwich Liberal Party were spurned, and this joined with the specific slight of Gladstone ignoring his once-enthusiastic electors to constitute at one level an apparent denial of worthiness.

Methods were therefore available by which status confirmation might be obtained (or denied) directly for the group, and only by implication for the individual. Attempts by individuals to obtain that confirmation directly became more problematic, partly because of the dangers of patronising treatment, or even of personal rejection without the reassurance of collective support. Nevertheless, for some individuals religious affiliation might have served this purpose. Religion receives no greater discussion, because of its relative unimportance for the majority of the English workers in the area. According to the religious census of 1851, east and south London had the lowest church attendance in the country, with the single exception of Preston.[16] In other places religion performed functions of social cement and ideological penetration, but in Kentish London it was never a continuing focus of social activity, relating the working class to — or dividing them from — other sections of the community. The absence of distinctively working-

class sects removed an element of social conflict that existed elsewhere.

Nonconformity was particularly weak in London, and that which existed was predominantly the old middle-class dissent of independents, Baptists and Presbyterians.[17] There were no strong working-class sects, such as the Primitive Methodists[18] or even working-class Wesleyans,[19] able to counter the respectable middle-class domination of religious activities with a social position entrenched within a distinctive working-class culture. Only the eighty or so unskilled labourers of Plumstead who maintained a devoted congregation of the elect and highly sectarian Peculiar People, disdaining proselytising and rejecting medical attention, maintained any special working-class religious presence.[20] With the Anglican Church making little impact on the working class of the area, it is instructive to examine what working-class nonconformity existed. Nonconformity can be more interesting as an indicator of social perspectives. As has been observed, one joined a chapel but merely went to church.[21] Chapel membership was a more positive and exclusive act.

The nonconformist churches in the area relied heavily on the local middle classes, and what working-class support they obtained was drawn principally from artisans. The best-known case was John Wilson's Baptist congregation in Woolwich, where the radical preacher built up a large personal following from the 1870s, mainly amongst the secure skilled workers of the Arsenal, amongst them the leading radicals.[22] In many towns religious dissent, blurring the ideological consequences of a class society, was the central thread in local liberalism through the chapel society and the movements that sprang from it, but this thread of political nonconformity was not generally a strong one in Kentish London. Attacks on the established church were the stock-in-trade of traditional radicalism, and not necessarily drawn from a particular theology. Most working men were indifferent to religion, and it was said that the skilled engineers and other artisans of Deptford 'thank Cobden and Bright and everybody but God for their prosperity'.[23]

Table 7.1 analyses the social composition of marriages on the basis of the confessional character of the church in which the marriage took place. The strength of skilled workers in the few nonconformist marriages is clearly shown, but the overwhelming mass of the population was married in Anglican churches. The strongest nonconformist occupations were white-collar ones, 11 per cent of whose marriages (defined by the occupation of the father of the groom) were in nonconformist chapels in the earlier period and 13 per cent in the later. The expected frequencies would have been only 4 per cent and 5 per cent. Artisan nonconformist strength in these terms lay with the more tradi-

Table 7.1: Place of Marriage: Social Composition by Confession

Father of Groom*	1851-1853 (percentage)				1873-1875 (percentage)			
	Anglican	Nonconformist	Catholic	Registry Office	Anglican	Nonconformist	Catholic	Registry Office
Gentlemen, professions, finance	5.9	8.1	1.4	3.8	4.5	5.6	5.6	3.9
Retail, farmers	16.2	27.5	2.1	—	14.2	15.6	6.8	7.2
White-collar	3.3	9.7	—	—	6.0	16.6	5.0	11.6
Skilled workers	40.3	35.5	11.9	26.4	41.7	41.6	26.0	40.4
Engineering, metal	6.8	3.2	2.8	3.8	10.3	10.1	5.6	10.5
Shipbuilding	4.2	1.6	—	—	4.0	3.5	6.2	0.6
Building	11.7	6.5	4.6	—	10.1	12.6	5.6	11.0
Shoemakers, tailors	6.2	14.5	2.1	7.5	5.5	5.0	3.7	6.6
Others	11.4	9.7	2.4	15.1	11.8	10.4	4.9	11.7
Semi- and unskilled	31.1	17.5	83.9	66.0	30.0	17.5	54.1	31.8
Servants	2.7	1.7	0.7	3.8	2.8	2.1	—	4.5
Police	0.5	—	—	—	0.8	1.0	2.5	0.6
Total marriages (= 100%)	2,830	124	286	53	3,194	199	162	181

Army and navy grooms have been excluded.

*The general picture was similar when run for father of the bride.

Source: Marriage certificates analysis.

tional crafts such as tailors (11 per cent) and shoemakers (7 per cent) in
the earlier period. These distinctions amongst skilled workers had faded
by the 1870s.[24]

Artisan participation in dissenting congregations is shown in the
analysis of available church membership records presented in Table 7.2.
Some congregations were clearly dominated by skilled workers (Green-
wich Road Congregational Church). In others they mixed fairly evenly
with shopkeepers of various types and white-collar workers (the Con-
gregational churches at Rectory Place, Woolwich and High Street,
Deptford). In St Mark's Presbyterian Church in Greenwich they were
clearly participating in a middle-class dominated congregation, and the
same seems to be true of the small Brockley Congregational Church,
whose records are too patchy for systematic presentation, but suggest a
high-status membership led by professional and financial men of local
and City importance, with a smattering of skilled workers.[25] In all the
cases examined unskilled workers were very rare.

The upward mixing of artisans in such dissenting congregations
needs explanation. McLeod has argued for late-Victorian London that
'a man's church was a means of identifying his position in the status
hierarchy — sometimes even a conscious statement of that position'.[26]
If this was true for the middle and lower-middle classes of Kentish
London, it applied to only a very small number of workers. In Kentish
London, some aspirant skilled workers did use membership of a specific
dissenting congregation as a method of status identification. The host of
social activities and sub-organisations that surrounded these churches,
together with the participatory religious ideals, offered opportunities
for working men and women to lead and not simply be led. Admission
to the congregations was not easily obtained. Brockley Congregational
Church decided that 'extreme care must be taken in admitting new
members', and applications were examined rigorously by elders and
deacons, generally by visiting the applicant's home twice to ascertain
the family's respectability, sincerity and sobriety.[27] In this way status
recognition could become operational.

Yet it is hardly surprising that religion functioned in this way for
only a small number of workers. The problems were the same as those
posed by mechanics' institutes, with patronising treatment a danger,
and a social mixing outside working-class circles that seems not to have
attracted a large number of skilled workers. The intense individualism
of old dissent clashed with features of artisan life style, and there were
no alternatives in the form of a more distinctively working-class non-
conformity. Religious affiliation could have functioned as a source of

Table 7.2: Social Composition of Nonconformist Congregations

1. Rectory Place Congregational Church, Woolwich (Male Members)
2. Greenwich Road Congregational Chapel, Greenwich (Fathers of Baptisms)
3. St Mark's Presbyterian Church, Greenwich (Communicants)
4. High Street, Deptford, Congregational Church (Male Members)

	Rectory Place 1852-64 per cent	1871-79 per cent	Greenwich Road 1857-77 per cent	St Mark's 1862 male per cent	1862 female† per cent	High Street 1873 per cent
Gentlemen, professions	3.7	5.5	1.9	3.4	13.8	6.8
Finance, commerce	0.7	1.4	3.9	11.9	3.4	2.3
Large employers	–	–	1.0	–	–	–
Retailers	27.6	16.4	5.8	23.7	3.4	25.0
White-collar	8.2	16.4	10.7	28.8	12.1	18.2
Shop assistants	6.0	2.7	6.8	1.7	1.7	4.5
Skilled workers*	39.6	46.6	57.3	20.3	10.3	40.9
Engineering, metal	9.7	16.4	20.4	10.2	5.2	11.4
Shipbuilding	3.7	1.4	5.8	1.7	–	9.1
Boilermakers	–	–	2.9	–	–	–
Building	9.0	6.8	8.7	5.1	1.7	4.5
Shoemakers	6.0	8.2	6.8	–	–	6.8
Tailors	3.0	4.1	1.9	1.7	–	–
Watermen	–	–	–	–	1.7	4.5
Coopers, wheelwrights	1.5	4.1	–	–	–	–
Others	6.7	5.5	10.7	1.7	1.7	4.5
Semi- and unskilled	3.7	2.7	8.7	1.7	1.7	2.3
Servants	–	–	–	3.4	50.0	–
Army, navy, police	10.4	8.2	3.9	5.1	3.4	–
Total (= 100 per cent)	134	73	103	59	58	44
Unidentified	6	9	–	15	17	9

*Including small masters.

†Only female members joining without their husbands were counted, to avoid double enumeration.
The occupation of the head of the household was taken, except for servants.

Sources: Rectory Place – Roll of Church Members 1852-93; Greenwich Rd – Baptismal Register 1857-1918: each father was counted only once;
St Mark's – Communion Roll 1842-64; High St – Records Book 1873-1910.

status confirmation, and for some it clearly did, but it countered too much of the values and social life of artisans to be of general satisfaction. It could appear as an attempt to escape one's workmates and neighbours. A Congregationalist in Woolwich told Booth that in the Arsenal a religious man was a marked man, for setting up to be better than others.[28] The search for social approval was far more safely obtained through the group, the stratum or the organisation, than through the perils of individual confrontation.

If the rejection of patronage did not preclude a desire for social approval, nor did a concern for independence require isolation. For many working-class institutions earlier in the century, independence involved some rejection of existing society. Political groups, friendly societies and self-education institutions turned in on themselves within the structure of an artisan culture that asserted its own worth and built up a self-enclosed security in an unstable world.[29] For Kentish London artisans, independence had become by the mid-Victorian decades a necessary condition that involved no isolation; an independence that was within local society, not away from it. Friendly society functions were an established part of the social life of their towns, as local newspapers and social leaders repeatedly confirmed. The societies saw themselves as an expression of the attitudes and social position of their members. There were celebrations in the town on local occasions, and invitations of notables to their functions, all launched by a march of members in their regalia through the town, often led by their own band. Their own band and their own methods of celebration symbolised their independence. The ritual and the secrecy now functioned without a widespread sense of isolation; they no longer symbolised retreat and self-protection, merely exclusiveness. All this only made sense, of course, in the context of a local middle class whose general stance towards artisan politics and trade unionism lacked self-conscious aggression. Even the occasional food riots gave rise to no editorial attacks on the mass of the towns' working classes. In fact, local newspapers specifically ascribed them to the work of outsiders.[30] Similarly, and incomprehensibly in the context of an atmosphere of class conflict, the mainstream liberal newspaper, the *Kentish Mercury,* proposed arming the local artisan volunteers.[31]

Housing and house purchase illuminate further dimensions of independence and respectability, and the means by which they were achieved. From the 1850s, with the emergence of a relatively prosperous elite of workers capable of the necessary expenditure, the growth of specifically artisan housing areas began, and with it a process of residential segregation. In Deptford they moved to the New Town and

Hatcham, in Greenwich to streets in the Maze Hill and Greenwich Park areas, in Woolwich to Plumstead New Town and Burrage Town.

Moving to a status-defined residential area intensified social attitudes, for it added a spatial dimension to social separation.[32] Housing came to be a matter for status-oriented choice in a way that has become familiar to modern sociologists.[33] The issue is in many ways an essentially urban one, both because of the potential fluidity of urban residential patterns, and because of the social designation of housing areas that develops within an urban context. In Kentish London it was regular high earnings and the construction of new artisan housing that enabled some skilled workers to exercise a choice based on social prestige. Living in the poorer areas of the town, among the mass of the working class, was distasteful to many artisans for normative as well as practical reasons. One can sense this with Thomas Wright, the Journeyman Engineer, who had to live for a time in a poor working-class area, and could not understand how a man who was a 'first-class mechanic' should be 'compelled to live in such a place'.[34] The new houses to which artisans moved were often badly built, but located in socially acceptable areas and with flourishes of architectural respectability. Housing was thus directly influenced by values that were concerned with neighbours, status identification and the powerful attractions of house ownership. It did not always mean leaving appalling housing conditions, but socially unacceptable neighbours.[35]

Factors such as these explain the unpopularity of model dwellings in Kentish London. Blocks of industrial dwellings in Woolwich and Plumstead were deemed 'utter failures', and remained unoccupied because skilled workers who could afford the rents preferred separate houses.[36] The Improved Industrial Dwellings Company had great difficulty in letting its flats in Deptford. The block was half empty at the time that its secretary reported to the Select Committee on Artisan Dwellings. The general difficulty of finding suitable tenants, who had to be 'respectable and of the artisan class', able to pay the rents and willing to live according to the rules of the company, was made worse by the development of small housing in the town. Such people who could afford the rents clearly preferred the attraction of even poorly built houses. If the situation was easier in the Company's block at Greenwich, this was because the rents there were low and presumably attracted those unable to afford more prestigious accommodation.[37] Respectability was always an independent matter, not one to be enjoyed as a result of the institutional living and middle-class condescension and coercion that characterised model dwellings such as these.

Another dimension of this can be seen through the example of the Evelyn Estate in Deptford, indicating the way in which privatised and family-centred values were partially being absorbed by these artisans by the end of the period. The estate contained 2,900 small cottage-type houses covering 170 acres, and was solidly working-class.[38] It was dominated by shipwrights and skilled engineering workers employed in such places as Penn's, Humphrey's and Maudsley's. Residence was stable and families did not move much. In fact, 'if they shift, it is only from one house to another'.[39] The houses had 'nice gardens', and there were frequent disputes with neighbours concerning gates, fences, walls and other such matters.[40] The majority of the houses were held by tenants, for the values and relevance of residential segregation did not relate only to house ownership. Nevertheless, a good minority of men on the estate had bought their houses through a building society. This suggests the relevance of new housing to the development of elitist values, for these values were reinforced by segregation. Without building societies, few working men could have advanced from the benefits of segregation to the added advantages of home ownership.

Evidence of artisan house ownership is uneven, but it was clearly rising through the period, especially amongst government workers. In 1867 one Arsenal workman claimed that as many as 500 of his fellow workers were on the county register (Plumstead being outside the Borough of Greenwich) through owning their own houses.[41] Twenty years later, one-third of all houses in Plumstead were occupied by lease-holders — principally artisans, clerks and shopkeepers, with the occasional established labourer.[42] Skilled workers in the Dockyard were no different, according to Jane Connolly's recollections. 'The men were steady and thrifty, paying into building societies until they own their own homes, educating their children well, and giving them the benefit of good home influence.'[43] As the tone of her comments suggests, building societies received a great deal of middle-class approval. Of all institutional means of advance for individual working men, they received more support from local elites than any other. When the West Kent Freehold Land Society was established in Woolwich in 1850 to enable working men to buy freehold land for building and investment, the local notables who formed the committee argued that its main beneficial purpose was to instil property consciousness in working men.[44] David Bass, a prosperous Greenwich butcher, argued that the People's Co-operative Benefit Building Society was founded by local businessmen to benefit the working class of the area.[45] The clearest statement linking house ownership to support of the mid-Victorian

liberal ideal came from the prominent Woolwich businessman, Robert Jolly, who argued at a meeting over parliamentary boundaries in 1867 that many artisans in the Arsenal had obtained their Plumstead houses through building societies, and that these were just the people to enfranchise.[46]

The development of new middle-class suburban areas spawned its own type of building societies' clientele, but in the accretion to existing settlements for much of the period it was artisans and clerks who made the most use of the societies. These societies rarely built their own houses in these years, especially in Kentish London, although an exception was the Co-operative Building Society that erected small houses in East Greenwich in 1847.[47] More important were terminating societies for house purchase alone. They had a fixed number of members who paid contributions for an agreed period (perhaps ten years) until all the members had taken loans and paid them off. The society was then terminated. The limited size and the personal element involved in the combination of investor and borrower in the same person, meant that the social element present in many such artisan institutions can be seen here. Social activities were not uncommon in Kentish London, especially in such forms as the annual dinner held by members of the Friendly Co-operative Building Society in Greenwich,[48] or more generally turning the monthly or quarterly allocation of loans, whether by lots, bidding or rotation, into a social occasion. The working-class members of such societies (and each tended to be socially homogeneous) had to be earners of good and regular wages. Regularity was particularly important. As Chapman has demonstrated, and evidence from different parts of the country supports him, the subscription rates clearly excluded those without a regular margin above subsistence.[49] In 1844 the Deptford Provident Society required a 9½d per week subscription for each £62 share, plus the repayment of the loan over a ten-year period,[50] while the Second Woolwich Freehold Building Society demanded a similar financial commitment.[51] One shilling per week regular membership subscription entitled a member of the People's Co-operative Benefit Building Society to ballot for £100 advances which would then be repaid at four shillings per week in addition to the subscription.[52] The financial commitment, and the sense of security needed to make it, was thus substantial.

Permanent societies, which differed from these earlier forms by separating borrowers from investors, developed from the 1840s. Their emergence, linked to the building of suburban estates, brought a long-term trend away from working-class dominance of the movement. It

certainly reduced the working-class control that had existed. Terminating societies did not instantly succumb to their new rivals, however, and retained their popularity with working-class borrowers through much of the period. In spite of an evident decline as the century progressed, a new terminating society was founded in Deptford as late as 1890.[53] Yet even the permanent societies lent on artisan housing. At least, some of them did. The Borough of Greenwich Building Society was not one, for in July 1852 all its advances were on lots of more than one house, and some were to builders.[54] On the other hand, its general successor, the Industrial Permanent Building Society, certainly catered for the artisan, at first in Greenwich and then elsewhere. It was established in 1852, and by June 1853 had advanced some £6,000.[55] If a few of the early loans were large, they settled at a lower level, with 21 of the 34 that were made in 1853 being for less than £200, and none of them apparently to builders.[56]

The People's Co-operative Benefit Building Society, established by Greenwich businessmen in 1848, actively campaigned for working-class support at packed public meetings throughout Kentish London.[57] At the annual meeting in 1860 a good number of working men spoke as borrowers, including an Arsenal worker, William McCubry, who advanced to become a third-class clerk.[58] In the years between 1849 and 1860 a total of 130 houses in Woolwich had been bought by members, at an average cost of only £139.[59] The society was praised by one member in particular at the meeting at which McCubry spoke. Alfred Matthews, a dockyard artisan who was also active in local radical liberal politics, explained that, having belonged to all sorts of societies, bidding, Bowkett, and now the People's Co-operative, he was convinced that this was the best.[60]

All this evidence leads to the question of why house ownership (as opposed to mere residential segregation) was sought. The motives were complex, but in the same way as segregation they lead us back into the concern of this chapter with norms and ideology. There was the desire to avoid having to pay rent to a landlord with nothing to show at the end of it; but even the belief that weekly payments might lead to a distant reward, rather than simply to the search for next week's rent, was itself an experience not readily available to less stable sections of the working class. In any case, repayments to a building society generally exceeded the rent that an artisan would pay.[61] Other factors were at work, bound up with a desire to own one's own property, to escape from the syndrome of rentals and removals, to escape lodgings or the need to share a home with changing tenants. As the Oddfellows saw it,

'these (building) societies . . . were originally founded to enable
industrious and prudent men to build or purchase houses for them-
selves and families, not only for the exercise of thrift attendant thereon,
but on account of the improved social status which such possession
unquestionably confers'.[62] It was such considerations which led
friendly societies in Kentish London to launch house-purchase facilities
for their members, as with the Woolwich and Plumstead Foresters
Permanent Mutual Benefit Building Society,[63] and the loans for house
buying made available to members by the Foresters Court 'Pride of
Woolwich'.[64] These were aimed at more than practical assistance: they
contributed to the improvement of their members, and enabled them to
achieve aspirations as much moral as material. The leaseholder enfran-
chisement movement was strong in Kentish London, especially in
Plumstead where Arsenal working men led the campaign. Its aims
embodied a Cobden-Bright type of ethical radicalism, advocating that
the working class should own their homes for moral as well as political
reasons.[65]

The aspirations to residential segregation and to house ownership
thus interlocked with the artisan ideology presented in this chapter.
When John Green, a fitter in the Arsenal and prominent in both the
co-operative and building society movements, argued that Arsenal
workers wanting their own house were 'a very superior class of work-
men indeed',[66] he was illustrating the reinforcing nature of economic
capability and personal values, for the desire for home ownership was
itself seen as a criterion for being a respectable and superior working
man. He went further. House purchase was beneficial to a working man
even if it entailed a financial loss, for 'the fact of the working man
obtaining a house makes them more thoughtful and more law-abiding
citizens, in every form and shape'.[67]

House purchase was emphasised in local co-operative propaganda,
for Kentish London co-operation shared many of the values of the drive
for house ownership. The rejection of food adulteration and of buying
on credit are further reasons for fixing co-operation within an inter-
pretation of improved living standards which enmeshed with concepts
of respectability. The need to accept adulterated goods from the small
shopkeepers who sold to the mass of the working class, and the struc-
ture of necessary credit that deepened this dependence for so many
families, provided both practical and status incentives for artisans to
use co-operation to reject those constraints. Credit took on its norma-
tive perspective when seen as the cause and not just the consequence of
working men and women failing to develop habits of thrift and econ-

omy. Respectability that distinguished one from less prosperous and less secure, and also less morally upright, sections of the working class could thus be asserted by trading at stores that ostensibly gave no credit.

Co-operation preached a morality that yielded material benefits, but it also offered more. The attainment of these rewards required a commitment to basic Victorian principles of moral behaviour and character, the morality of sobriety, industry and thrift; and artisan institutions, most notably friendly societies, displayed a concern for these principles. Chapter 9 will emphasise the concern for behaviour, character and procedure that appears in these friendly societies, especially in their rule books. That concern often developed into a consistent policy on the social criteria for admissions. The fact that they resembled so many Victorian middle-class preoccupations does not necessarily imply that they meant the same thing, for the concern amongst artisan organisations about procedure and self-discipline was an old one. Yet, as will be argued in the chapters that follow, the changing context within which these traditional concerns were expressed could only signify a change in their effective meaning.

The ability to join the appropriate institutions required a whole conjuncture of economic and social factors, including level and regularity of earnings, residential stability, differentials within the workforce based upon craft and job control, and the relationship with the employer. The ability to benefit from these institutions was understood to derive from a cluster of personal qualities of regularity, industry and thrift that allowed a man to join, to be accepted and to sustain his membership. There were two sides to this. One was a practical exclusion that required some genuine security for membership to be viable. The other was an attitude to thrift and planning for the future that we shall notice various writers finding so absent from the lower working class. Yet joining these institutions increased both a man's sense of security and, by practice and ideals, his sense of superiority over other workers. The security given by a friendly society, building society or trade union reinforced an existing situation. The differentials of social experience became mutually reinforcing in Victorian working-class life, and that intensification took place on an ideological as well as a material level. The societies and organisations thus did more than simply reflect the status concerns and values of a working-class elite; they embedded them ever more deeply. Henry Knell, an Arsenal wheelwright, implied this when he argued that 'it would be difficult to over-estimate the importance of a little private hoard to a working man; it not only proves a

source of assistance in a time of misfortune, but it tends to improve his whole moral nature'.[68] If a variant of this saw friendly society benefits as a reward for a moral character, rather than a means to it, it is an important element of the ideology that the achievement was thus traced back into the individual as a matter for moral choice.

Was all this simply a filtering down of middle-class values, the process of embourgeoisement referred to above? The concentration on values and political movements, and the failure to examine the social and economic situation, has led to an over-simplistic definition of these norms as 'middle-class'. The distinctiveness of the working-class *situation* pervades and shapes the inherent distinctiveness of the skilled working-class *culture*. This was not a totally separate value system, what Parkin calls a 'class differentiated model of the moral order'.[69] Elements in the value system were subscribed to by both sides of a middle-class and labour-aristocrat consensus. That was fundamental to the genuine calming of class relations during the mid-Victorian decades. Yet the meaning of these beliefs could differ in varying degrees, leading merely to confusion, or sometimes to conflict.[70] The behaviour of these artisans and their articulated values diverged from the established middle-class normative system too much to be called simply 'bourgeois'.

In a situation of relaxing class relations, where a section of the working class was more willing to accept the broad outlines of the existing economic and social order, the availability of normative concepts was clearly vital. Middle-class propaganda, social contact, reading material and so on could all make these available. As Parkin has observed, 'individuals do not construct their social worlds in terms of a wholly personal vision, and without drawing heavily upon the organising concepts which are part of a public meaning system'.[71] The sources of that public meaning system for the skilled elite were varied. They included both contemporary middle-class ideas of respectability and independence, and a working-class tradition of greater richness and vitality, whose language was able ambiguously to touch this newer set of concepts; to make the resulting values and behaviour so distinctive and at times complex and fragile. The downward flow of language and values was transformed by the realities of the working-class situation, and by the long tradition of working-class culture with which it made contact, especially the traditions of mutuality, collective strength, dignity and freedom. It was this process of mixing that made the labour-aristocrat value system viable.

The persuasiveness of these values rested upon their ability to make sense of the experiences of those who held them. No value system can

long survive a situation where it fails to do that. Any working-class
aspirations to join a higher class or stratum could not have survived the
challenges offered by daily experience. Artisans might have sought and
received approval in various ways from the middle class of the towns,
but they were not being accepted as social equals. Nor did they want to
be, at least not in terms of social intercourse, as we saw with mechanics'
institutes. They aspired to a set of attributes summarised in the ideas of
independence and respectability, but the words were given meanings
distinctively different from those of the middle class.

 Discussions of self-help institutions too frequently assume that their
purposes were precisely those ascribed to them in middle-class ideology.
One is often left wondering what grounds there could have been for the
class tensions and later hostilities that existed during these years.[72] The
most public of these conflicts was over trade unionism, seen on the one
hand as unreasonable coercion within a market economy, and on the
other as an essential and legitimate means of collective bargaining and
defending the craft rights that were so central to the artisan's position.
As Samuel Brown, vice-president of the Institute of Actuaries, made
clear, trade unions belonged to a different world from other working-
class institutions. 'These attempts to combine the relief of the members
in sickness or old age with the interference with the natural adjustment
of the rate of wages between masters and workmen, are evidently
abuses of the admirable system of self-help, and contrary to the spirit
and object of Friendly Societies.'[73] In the same vein the *Kentish Inde-
pendent* praised other artisan institutions but, when arguing that the
respectability of Arsenal artisans entitled them to the vote, it pointed
out (incorrectly) that there was no 'rattening or trade combination'.[74]
It was not just trade unions that came under attack, for there was a
widespread middle-class incomprehension of the social life of artisan
organisations. The institutions of thrift developed out of the more
informal methods of insurance and assistance that characterised early
nineteenth-century working-class life, and which linked the practical
ends with a form of mutual reassurance through social identification.
This was not a layer of social activities added to the material aims, but
totally intertwined with them.[75] Considerable friction with outside
observers was caused by the survival of this social activity. The social
functions of friendly societies, in particular, reflected their role in
artisan life. The public-house meetings and the annual festivities all
attracted a large proportion of the membership and were essential to
the societies' success. The meaning of the ritual and secrecy of these
societies might have changed from earlier decades,[76] but they still

symbolised cohesion and the ideals of mutual support. This intertwining of insurance protection and social unity was alien to middle-class experience, with its stress on a type of individualism that had little meaning for most artisans.

Social drinking is a good example, for in middle-class eyes it had no part in a respectable, thrifty way of life. Kentish London friendly societies resisted the propaganda and clung to the public-house venue. Nor did artisans turn to the temperance movement in any numbers. Local temperance activity was weak and fragmented, often descending to that sectarian squabbling that thrives on failure.[77] It was an example of that species of middle-class attempt to reform local working-class behaviour, whose failure inevitably followed its lack of understanding of the situation it worked upon.[78] The failure of the 'ordinary societies', essentially insurance societies with no local branches, is also relevant here. For them to achieve popularity with the working class required the rejection of traditions of mutuality and working-class control of their own institutions.

The two themes, drink and working-class control, are vital ones for they provide a link with the artisan's assertive independence. In the English working men's club movement the struggle to allow alcohol in the clubs went hand in hand with the demands for self-management.[79] For middle-class philanthropists the refusal of alcohol to the clubs reflected their doubts as to the ability of working men to control themselves and make the correct moral choices. They saw drink as an impossible temptation for working men, because it was not taken within the context of a soundly based and trustworthy character. For converse reasons, the upright middle classes could be trusted not to drink to excess. This fundamental double standard, based on a view of the failure of the working-class family as a force for moral education, was a persistent theme of social reforming and philanthropic efforts from the 1830s. In this context the aggressive self-respect of the artisan would reject the appeals of the temperance and teetotal movements. Social drinking was central to working-class culture, as also was a faith in the benefits of drink to health.[80] Artisans, in any case, recognised no necessary decline from drinking to drunkenness such as was implicit in middle-class prescriptions. Its harmful effects were due not to the drink itself but to personal moral failure. Artisans could feel sure that they would not decline in this way, for their respectability and self-control were to be relied upon. In one sense it became essential to continue drinking rather than to admit one's own moral inadequacy by seeking to eliminate all temptation. The argument of middle-class reformers

against the alcohol and the social activities of friendly societies was
irrelevant, for it grew out of a different characterisation of the respect-
able working man.

There were presumably skilled workers who rejected this and sought
a more personal removal from the working class. Thomas Wright distin-
guished between this small group and the wider 'intelligent artisan of
the popular phrase'. He said of the former that 'their individual object
is, as a rule, to improve themselves *out* of the working classes'. They
join trade unions, friendly societies and so on, but 'they are seldom
what we called good members', by which he meant that they did not
participate in the social life of the organisations.[81] They would have
found attractive the 'ordinary benefit societies' which held no meetings,
but collected subscriptions through agents. The reform movement
amongst the Kentish London members of one such society, the Hearts
of Oak, is instructive, for it grew out of a declared desire of members in
the area for local control and a degree of social mixing. Not all of
Thomas Wright's minority of 'intelligent artisans' found the life style to
which they aspired either satisfying or relevant.

In such cases the distinction between middle-class individualistic and
working-class collective self-help becomes clear. The instrumental use of
most of these institutions was not a primarily individualistic instrument-
ality of a typical Victorian middle-class style, concerned simply with
personal or family benefit and advance. The instrumentality of the
skilled elite who dominated these institutions was a more obscure one,
involving mutuality and collective strength, and an identification with
craft or stratum. Material and social aspirations need not mean an
attempt to climb a broadly accepted status ladder and leave behind
one's peers. The aspiration was rather to achieve a certain status that
combined economic position with identification with a set of respect-
able values. The achievement did not have to be experienced as indivi-
duals, but as part of a wider social group through their institutions. The
persistence of social life and collective solidarity in these institutions is
inexplicable in terms of a purely individualistic status striving. This was
a working-class self-help whose origins differed from those of the
middle-class version.

If Samuel Smiles preached to a receptive section of the working class,
there were few in Kentish London who seemed to notice. If his books
and his prescriptions were popular in the area, one might have expected
some sign of it, for he was a distinguished local resident. Upon taking
up his appointment with the South Eastern Railway Company in 1854,
he moved to Glenmohr Terrace, Blackheath. He lived over twenty years

in Blackheath, at Glenmohr Terrace, Granville Park, and eventually in a house which he had built in Westbank.[82] Yet not one occasion has been found upon which any working-class institution in the area sent him an invitation to dinners or festivals, or asked him to give addresses or speeches at meetings. Samuel Smiles might never have existed, let alone lived on their doorstep, for all the notice that the artisans of Kentish London appear to have taken of him.

The final general area that distinguished the values and institutional activity of these artisans was the peculiar idealism that persisted through the apparent watering-down of objectives. It is too easy to see the mid-Victorian artisans as mundane and materialistic, a view which rests most heavily on the transformation of the co-operative movement. 'Co-operation, which had been a system of social justice, was reduced to a few saws worthy of any scrupulous grocer.'[83] Royden Harrison's judgement is a common one, yet it is difficult to accept it when studying the local movement. The ideals of local co-operation will be examined below, and if they seem less heroic than those of their pre-decessors, and somewhat less precise, there was a faith which main-tained the repeated efforts of the movement's activists in the face of many failures. Collective hopes and the awareness of an ability to make society a better and more just place for working men to live in pervades so many of these movements. It is not enough to indicate the paltry scope of the ideals in comparison with what had passed. The working men who led these various movements carried with them so many tradi-tions and hopes from their past, and transformed them to meet the needs of a changing situation. They produced an idealism that was as concerned with justice, freedom, vision, collective enterprise and mutual trust as that of their predecessors. It was the meaning of that idealism which had altered as it was turned to new ends, of which the most important required no rejection of the existing economic and political order.

A guiding force behind these ideals was a genuine belief in progress. The chairman of the Blackheath Painters' Union spoke of 'the many improvements that had taken place of late years . . . as a people, and as a nation, they had advanced in literary, political and commercial greatness'.[84] Not all would have taken the view of Henry Knell, the Arsenal wheelwright, for whom progress was a fundamental feature of the universe,[85] but the assumption that all could progress in an econ-omic and social sense was fundamental to the political views of local working-class radicals. The great appeal of Gladstonian liberalism to these men was that it sought to remove those obstacles which hindered

the progress of society in all its aspects. Corruption, privilege and unfair rule were barriers to progress, not to class power. The deep rationalism that pervaded these politics, expressed most explicitly in the secularist movement, found its intellectual persuasion in just this faith in a society that could deliver the goods. Artisan ideology expressed the belief that independence, self-government and self-reliance were theoretically attainable by all. Yet this progress had to seem feasible. Thrift, house purchase, educating one's children[86] and so on all involve a degree of planning for the future, which was impossible for many of the unskilled and casual workers so numerous in riverside Kentish London. Thomas Wright noted its absence amongst such workers in Deptford. 'Generally speaking,' he wrote, 'they do not look forward to any improvement in the condition of their class. It has always been thus with the poor, they argue, and "ever will be till the world shall end".'[87] Contrast this with the artisan's faith in the ability of working men to make the world for themselves and his belief in the justice and fairness that brings rewards to those who deserve them. The institutions were aimed at just this positive manipulation of their world, while the political endeavour sought to remove the obstacles to these just rewards. As John Pearce, secretary of the Woolwich Amalgamated Society of Engineers, argued, they could take some control over their lives. He wrote this poem for a branch occasion.

> We cannot expect to be mowers,
> To reap up the golden ears,
> Until we have first been sowers,
> And watered the furrows with tears.
> It is not just as we take it,
> This mystical world of ours,
> Life's field is just as we make it,
> A harvest of thorn or of flowers.[88]

The final part of this chapter will turn to a recurring theme, the role and attitudes of trade unionism in the area. It is, after all, the sphere in which overt conflict necessarily occurs, though in different social and political contexts the meaning of that conflict and the intentions behind it may vary. What were the functions of trade unions for artisans in Kentish London? They amounted over all to defending and advancing the interests of their members in specific areas: pay and hours, work conditions, craft rights, social and other benefits, and the defence of the union itself. The methods were those associated with

skilled unions through the century — the strength of the well-organised artisans that rested partly on their quality (it was generally the better men who were in the union and some, notably the Steam Engine Makers, aimed at them exclusively), and partly on their solidarity and the varying reluctance with which non-members would break a strike. Unskilled unionisation was rare and weak in Kentish London, bursting occasionally into life during particularly booming periods, notably the early 1870s when the Labour Protection League set up short-lived branches in the area organising dock workers and porters. On the whole, however, Kentish London trade unionism was a movement of the better skilled workers.

Maintaining and improving pay, hours and general conditions of work frequently caused conflict between workers and employer, though the relative stability of skilled wage levels in the area (in contrast to those of the unskilled) depended largely upon the threat posed by the very existence of the union or a more general craft solidarity. The set-piece movements over wages or hours were not the most common local disputes, though there are examples of these such as the massive 1866 movement of Woolwich building workers for a one o'clock Saturday[89] and the 1879 strikes to resist the 7½ per cent reduction in engineering wages.[90] Far more frequent were the shop by shop defence of established pay and hours,[91] generally won without much struggle during a period of good trade, and then vigorously defended against all attempts at encroachment. The same applied to agreed working rules, sometimes formally negotiated and at others developed and clung to over time. The introduction of fines for defective workmanship brought out 150 engineering workers at Bunnett and Corpe in New Cross,[92] while 250 came out at a nearby factory to resist newly introduced rules that altered their conditions of work.[93] Masons at one Woolwich yard struck successfully against an attempt 'to infringe on our established custom', by expecting workers to be inside the yard five minutes before they officially began work.[94] It was this eternal vigilance and preparedness to strike if the union was strong enough in a shop, or leave employment if it was not, which was the basis of the improving position in terms of rates, hours and work conditions of the skilled workers in the main industries.

The defence of the craft was a matter that depended even more on shop by shop local control. The complex factors that gave skilled workers their bargaining power here dovetailed, and it is hardly relevant to enquire whether it was the union that gave them their strength, or their strength that gave them their union. Both grew out of the craft

culture, solidarity and pride of so many skilled industrial workers in nineteenth-century Britain. Defending craft rights partly concerned status — most commonly in objections to 'tyrannical foremen'. The ways in which the craftsman was treated by foreman and boss helped mark out his position in the workplace. More directly involved in bargaining power was the need to control entry to the trade, and prevent the dilution of that skill which was at base the craftsmen's only claim to differential treatment. The growth of a poorly paid sector of indifferent skill could be the first step to casualisation, as it was with the painters. Encroachments on craft rights were generally settled quickly, often within hours; the mere threat of trade union action was probably enough in many more cases. Dilution of the craft could take many forms. The turner who left the Woolwich Arsenal with the full support of his union, the Steam Engine Makers, did so because he had been asked to work two lathes — something no self-respecting craftsman would do, for it treated him as a unit of production rather than a craftsman wedded to his work. Nor could any trade unionist agree, for that way craft unemployment lay. He had another grievance, that he had been asked to instruct a labourer, and this was the most urgent problem facing skilled workers in the area.[95] The artisan's helper or mate must not be allowed to pick up the skill over the years and succeed in passing himself off as capable of doing the work. This was the cause of much jealousy on the job, and is a persuasive explanation for the cliquishness of the craftsman in the workplace. It was a continuation at work of the necessary social relationship with the semi-skilled and labourers. Woolwich bricklayers on a job in the town struck against the attempt to get labourers to do brickies' work.[96] Employment of too many boys, generally to train up to some unspecific skill, would also produce protests.[97] In the same way demarcation disputes abound, and were usually settled satisfactorily, as when Woolwich masons struck against a bricklayer who had fixed masonry.[98] It all amounts to the role of trade union strength in maintaining the basis of the craftsman's economic position. As Woolwich bricklayers rightly observed, 'a few earnest men will, at all seasons, do a large amount of good [here], when with uncontrolled and inexperienced men, in the rights of trade'.[99] The customs of the craft and the means of protecting them of necessity went hand in hand. As control by the craft, narrowly defined, weakened, so the need for trade union vigilance and organisation increased; the clearest case is that of building workers.

Defence of the union thus became increasingly important, as its role in industrial protection grew. Masons on a job at Deptford refused to

work with two blacklegs who had not paid the fines imposed by the
union, and the two men were discharged by the foreman.[100] On occa-
sions the employer would turn against a union at his works. This was
less common in the heavy goods industries of the area, where industrial
and trade union organisation and management techniques were at a
fairly sophisticated level. At small building sites, however, such disputes
were common. Dismissals of members of the bricklayers' union were
only withdrawn by strike action,[101] while members of a new masons'
branch at Greenwich were sacked on a job at Blackheath, and their
strike seems to have failed.[102] The building trades had to fight harder
than the other main local unions to establish themselves. They were the
victims of the less rigid control over entry to the trade, and the petty
scale of the employment structure.

The benefits that the union provided were not all in defence of the
craft and its members' positions. Individual benefits would also be
provided. Most unions gave death benefits, but the stronger gave more
– generally unemployment pay for a period, often sick benefit as well,
though as most men would also be in a friendly society this would be
optional. The Amalgamated Society of Engineers also added a tool in-
surance scheme for the millwrights, machine joiners and patternmakers
who owned their own tools.[103] All in the long run helped solidify the
union, but also served broader purposes. Union members were generally
the better workers in the trade, and the union structure could therefore
be used as a means of obtaining work for unemployed members. At one
level the tramping system did the job, but in the engineering trades
secretaries with no unemployed members in their branch would
inform each other of vacancies in their own area. The news from Wool-
wich that various trades were required at the Dockyard brought in
members of the Steam Engine Makers from Nottingham and Newton-le-
Willows, as well as the more predictable Greenwich.[104] Where unions
could give a guarantee of a worker's qualities, the branch secretary's
recommendation would be persuasive with an employer. The high
quality of men required in marine engineering work would have inten-
sified this, and most of the engineering unions could guarantee that
quality locally. The Woolwich Steam Engine Makers wanted Richard
Chadwick suspended, on account of his failure to command the general
wage,[105] for such members could either undercut others or too fre-
quently be unemployed.

Finally, there were the benefits that were aimed at the individual's
self-improvement, though with it went the development of craft skills.
Technical education became popular among trade unionists in the

1860s and 1870s, significantly making its greatest local impact amongst building craftsmen – the trade most in need of maintaining craft standards in the London area. In 1869 both Greenwich and Woolwich branches of the Amalgamated Carpenters and Joiners set up classes for members.[106] In 1876 John Jeffery, local bricklayers' leader and a prominent working-class Liberal, established technical classes in Greenwich. He encouraged members to attend and improve themselves in their trade.[107]

These benefits apart, the main areas of trade union activity – pay, hours, conditions, craft protection and the defence of the union – could all lead to struggles and often to lengthy strikes. Only when the whole town, or most of the main works there, struck together would the strike take on its most bitter form. In smaller disputes, if the strike persisted men might drift off to jobs elsewhere, leaving the shop in question blacked. It is interesting to note a creeping professionalism, one aspect of the gradually learned understanding of how to play the system,[108] in the use of the law courts to achieve ends that might more usually be sought through industrial action. The policy might be interpreted as evidence of a trust in legal processes that would have surprised earlier generations of trade unionists. From the 1860s, Woolwich bricklayers repeatedly took employers to court to obtain the correct wage rate for members,[109] while the Greenwich carpenters took similar action over dismissal with insufficient notice.[110] Most disputes, particularly those over general wage advances or reductions, were in no way amenable to such measures. For them, strike action or the threat of it were the main weapons. The strikes embodied conflict between employer and workers, they often engendered deep feelings and bitterness, and would occasionally spill over into violence. Yet, and here we return to the ideological concerns of this chapter, what did this conflict *mean*?

The very scale of the disputes encouraged the circumscribed perspective in which they were placed. The ASE lock-out of 1852, which took in the area's larger private engineering establishments, was the only national action that drew in Kentish London branches. Even at the metropolitan level, few strikes extended to Kentish London. The building disputes of 1859-61 only intervened through London contractors on jobs at the government yards,[111] while the 1872 nine-hours movement in the engineering trades precipitated no disputes in Kentish London, being generally accepted by all firms.[112] It was the employers' offensive of 1879 in the larger engineering firms that for the first time drew union branches in the area firmly into a major London strike. All

local metal unions united in the long struggle behind the Deptford Committee's motto, 'Defence not defiance'.[113] Most disputes were at the level of the town, even the shop. Wages and hours movements, defensive battles, and other conflicts all took place within a decidedly local framework, rarely enmeshed with national or metropolitan struggles. This might be one explanation for the limited perspective of local trade unionism, but it cannot itself provide a satisfactory explanation. It is difficult to examine that perspective in depth for Kentish London trade unionism did not have the internal coherence to produce its own archives, and the language, sentiments and perspectives of trade unionism at the local level are difficult to penetrate. Trade union reports to the national circulars were bureaucratic and formal. The subtleties of language cannot be probed, nor are ideas and ideals exposed in that setting. In comparison with the other institutions of working-class life, trade union meetings received only cursory attention in the pages of the local newspapers. An understanding of trade unionism in the area must therefore derive from the statements and actions of which we can obtain evidence, and from an interpretation of the wider setting that the whole of this study seeks to establish.

A degree of middle-class doubt and incomprehension concerning trade unions has already been noted. Yet far more important was the absence of a framework of local class conflict in which trade union activity would be located. Trade union sentiments must not, of course, be seen simply as feeding off wider social relationships, yet it is still valid to emphasise the absence of local social and class tension as a vital determinant of the circumscribed framework within which trade union struggles occurred. The local middle classes were certainly not favourable to trade unions, yet there is no evidence of aggressive anti-union feelings. They were probably not liked, almost certainly not understood,[114] but they do not seem to have been feared.[115] In a different social climate, the embattled bitterness of industrial conflict could certainly spill over into reinforcing the more general social climate, but this did not happen in Kentish London. It is difficult to see how the vicar of Plumstead could in any other circumstances have supported the Woolwich workers involved in the 1859 building dispute,[116] for he had no record of support for working-class causes. The trade union laws issue of the early 1870s made little local impact. As with politics, the ability to fragment areas of experience was a vital determinant of artisan behaviour and ideology. Politics would be split from economic issues. Trade union struggles would be divorced from a wider social meaning. There is, in any case, some evidence not only of the separation

of trade unionism from social conflict, but also of a growing tolerance of efficient workers' organisations. This tolerance fed off the prevailing local social quiescence. In 1861 Traill, the Greenwich magistrate, was able to demonstrate this growing acceptance of the valid strike in his castigation of a dozen unruly, stone-throwing young strikers at a blue manufactory in New Cross. He refused to treat them as men on strike — 'their conduct being more calculated to bring strikes into disrepute than anything else'.[117]

In this way conflict and at times bitterness could persist, but not spill over into social relationships in more than an unavoidable temporary fashion. There was an essential defensiveness to trade unions during these years. Not over wages and hours, certainly not over strikes, but over what they were fighting about, which was a place to be defended and advanced for a section of the working class within a broadly acceptable social framework. The classic statement of this at a national union level comes from the Ironfounders in 1865, who argued that 'our only object is to retain what we already possess and do battle with oppression in self-defence'. The report then listed the disputes that year, which included some in Kentish London. They were to resist piecework, refuse to work with non-society men, prevent labourers encroaching, reduce the number of unapprenticed boys, resist extra work, prevent masters stopping men for bad castings, and shorten hours.[118] Only the last was an issue initiated by the men. The others were struggles within terms set by the actions of employers. It is in this sense that the main drift of mid-Victorian craft unionism may be called defensive. Conflict and struggle were not seen in Kentish London as fundamental to the prevailing social and economic relationships. As in politics, so in trade unionism, the need to fight was in order to establish effective methods of rationally proceeding. The system into which that rationality fitted was rarely challenged. This explains the fervent support of a local trade union leader and radical for arbitration and conciliation. 'I believe,' said John Jeffery,

> when we have Courts of Arbitration throughout the Kingdom in every district firmly established and in good working order, strikes, turn-outs, and lock-outs will be things of the past. It will be a blessing, when there is a grievance, and six working men and six employers, all representative men, meet together, discuss the matter, and arrive at an amicable settlement . . . The employers have thought the men were uniting together to work against them, which is an absurdity.[119]

This capacity for setting trade union struggles within a narrow focus repeatedly appears in the lack of vision and broader aspirations, whether social or political, of the trade union movement. Organised trade union support for candidates in the Greenwich School Board elections may be seen as the first signs of the weakening of this position. The trend throughout the period was counter to the wider social consciousness that was to be crucial to the formation of local labour movements at the end of the century. Kentish London branches resisted political involvements as not the concern of trade unions. The secretary of the Greenwich bricklayers wrote that 'it is nothing to us, as trade unions, what our members are, be they Tory, Liberal, or, like myself, Republican'.[120] The Carpenters in Greenwich even rejected a levy for the Plimsoll Funds, because it was for 'a political purpose'.[121] Our knowledge of these men's politics reassures us that it was not their personal political views that were in conflict with radical liberalism, but the place that they ascribed to their trade unions within their politics. The two were separate spheres. For this reason, Woolwich Carpenters voted almost unanimously against branches joining their respective trades councils. Their Greenwich brothers produced a firm resolution advocating a withdrawal from trades councils in general, and that the metropolitan unions 'withdraw our delegate from the London Trades' Council'.[122] Neither in politics nor in other areas would the local trade union branches develop any alternative vision of society or of their work. Co-operative production was an occasional resort in strikes[123] or in massive unemployment,[124] but it was no part of a continuing local debate, and at other times it was never an issue.[125]

Trade unionism in Kentish London was one viable form of collective organisation for advance. It would be idle to suggest that their conflict situations did not often create severe clashes and tensions that no other artisan institution expressed. Yet the narrow vision within which that conflict was interpreted is important. Trade unionists aspired to being the secure and stable workers in their trade, and they probably succeeded. The secretary of Woolwich Steam Engine Makers was upset that a member left a job there without cause, because it 'is likely to damage our interest in that quarter'.[126] Trade unionists were only part of the working class, and aspired to no more. In this way they reinforced the elitist image that they created for themselves in other institutions. They shared with other artisan organisations a commitment to collective struggle for benefits and successes within the framework of the economic polity as it stood. Brother Watkins, vice-chairman of Greenwich boilermakers, was now a small employer, and

when he told his members of how the working class was gaining things because it struggled in unity, he was echoing so much of the value system that this chapter has presented.[127] In aspirations, in values and in personnel the various institutions of artisan life interlocked. The chapters that follow will point out the overlap of personnel at the leadership level. Fred Johnson, a painter, took the chair at a meeting of Woolwich building workers to campaign for the one o'clock Saturday in 1866. His reference to heartening developments among working men in the area referred to the new meat co-operative society recently set up. For Johnson these limited retail operations were encouraging signs of a 'spirit of co-operation' which he felt related directly to their building dispute.[128] So many trade union activities place them within the framework of Kentish London artisan institutions during these years. They would parade around their town with banners and bands, to make their importance and unity known;[129] they met in public houses;[130] they held regular anniversary dinners; they gave presentations and soirees, arranged educational activities and some social life for their members. They were exclusive and chose to be so. The good economic reasons for that in terms of bargaining by skilled men must not be allowed to hide the ways in which the life of trade union branches could confirm the other forces that shaped artisan life styles. Local militant action in the workplace could have altered this, but did not. Partly because of the inherent difficulties about a class consciousness developing out of a trade union consciousness, more specifically because the conjuncture of social, economic and ideological factors in mid-Victorian Kentish London encouraged a fragmentation of consciousness. That fragmentation operated both in terms of the way in which skilled artisans saw their own social and class position, but also in the way in which different spheres of a man's life could fail to connect. Politics, economic structure and trade unionism were divorced from each other into separate spheres with their own rules, their own legitimacy, their own rationality. The failure of trade union action at a local level, with its tendency to conflict situations, to break out into a wider and more total social consciousness, is a theme that runs persistently if intermittently through British working-class history. In Kentish London during the particular period under study it enabled trade unions to play an ambiguous role in local society, but one which never challenged that society or the wider one of which it was a part.

8 THE CO-OPERATIVE MOVEMENT

'Perhaps the most pleasing feature of the whole, is the fact that there now remains to be distributed among the members the sum of £11 13s 6d as interest on shares, and £58 15s 5d as dividends on consumption.' The 1858 report of the Woolwich Baking Society indicated its criteria of success. Five years later the same society contentedly observed that 'members are making a profit on their small investment'.[1] The rules of the Birmingham Co-operative Society in 1828 seem to reflect a different movement. 'Nothing in the way of profit of trade, or any part of the capital, shall ever be divided among the members, as Community of Property in Lands and Goods|is the great object of this society.'[2] The distribution of profits to shareholders was common to almost all societies in Kentish London, and the West Kent Supply Association was a rare exception, channelling its surplus into a guarantee fund for the rent and into the reduction of prices.[3] A major change had taken place between the stage of co-operation whose ideals were embodied in the rule of the Birmingham society and that represented by the later societies in Kentish London. The original character of shopkeeping as a means to the achievement of a visionary ideal had all but disappeared. Sidney Pollard has characterised the early co-operators as 'community builders', and to Holyoake 'all the fervour and earnestness of the early co-operative societies was not . . . about Co-operation, as it is now known, but about communistic life'.[4] This may be loosely designated the Owenite phase, when co-operation was an integral part of a strategy to transform society. The decline of that visionary element was gradual, but one decision above all symbolises it. In 1844 the Rochdale Pioneers decided to pay dividends on purchases and implicitly asserted that the profits belonged not to the society but to individuals.

The co-operative movement that grew from the 1850s in Kentish London represents this new style of the movement. This instrumental co-operation that centred on the individual was not based merely on the ideas of the leaders, but derived from the needs and aspirations of the sections of society from which the movement drew its strength. These people are not easy to identify. The leaders can sometimes be placed, the members far less often, except for the most important society in Kentish London, the Royal Arsenal Co-operative Society in Woolwich and Plumstead.[5] An examination of the entry books of the Society for

the period gives a very clear picture of the occupational structure of the male membership, and the results are presented in Table 8.1.[6] The figures for 1872-74 give a breakdown of all male members in those years, while those for 1875-80 give only new members. The final column gives an overall picture for the period. The substantial proportion of metal workers and wheelwrights amongst early members reveals the Society's origins in the Arsenal, and diversification among other skilled trades took place slowly and never very significantly. The most important overall feature is the predominance of skilled workers, and the very low proportion of unskilled and semi-skilled. It was not this latter group that made up for the declining proportion of skilled workers, but clerks and army and police personnel.

The only source available for further occupational analysis is the list of trustees, committee members and secretaries in the rule books that the societies deposited after registration. Table 8.2 lists the occupations of fifty-three of the activists in the nine co-operative societies that actually recorded the occupations of their officers. The societies are from all parts of Kentish London between the 1850s and the 1870s.[7]

The RACS evidence, together with this further sketchy material, point to the role of skilled workers and lower middle-class occupations in the societies. Joseph Prior felt that the members of his Woolwich Co-operative Provident Society were 'what most people would imagine to be as good a specimen of the working classes as can be found anywhere – men connected with shipbuilding and steam machinery'.[8] These were the men who used and ran the societies, and it was their needs and aspirations that prevailed. It has become the rule to portray these aspirations as limited and lacking in idealism, and in many ways this is correct, yet there must have been more than this to the movement in its post-Owenite, post-visionary phase. It is not easy to identify what ideal in mid-Victorian co-operation motivated its leaders in Kentish London, but some ideal there must have been. At the very least there must have been some genuine faith in the movement, for the same names occur in connection with a number of schemes over a period of years. As one enterprise collapsed, these men would turn to another. Joseph Baker was a founder of the Woolwich Co-operative Provident Society in 1854. The next year he became secretary of the Woolwich Coal Society, a post he held until 1863, when he also became a trustee of the Woolwich Baking Society. He was not alone, for Robert Brown, the patternmaker James Piper and the joiner Robert Ward followed him actively through all these enterprises.[9] James Dell, a fitter, was a trustee of the Plumstead Industrial and Provident Society in 1861;

Table 8.1: Membership of the Royal Arsenal Co-operative Society: Occupational Analysis (Percentage)

	All members 1872-74	New members 1875-80	All members 1872-80
Gentlemen, professions, clergy	0.3	1.5	1.3
Finance, commerce	—	0.2	0.1
Retailers, tradesmen	0.3	0.8	0.7
Clerks, white-collar	2.5	8.3	7.3
Shop assistants	0.7	0.8	0.8
Skilled workers	79.4	63.0	65.8
Engineering, metals	51.4	38.9	41.1
Shipbuilding	1.1	0.9	0.9
Boilermakers	2.1	1.2	1.3
Building	6.3	8.8	8.4
Shoemakers	1.1	1.1	1.1
Tailors	1.1	1.3	1.3
Watermen, lightermen	0.3	0.5	0.5
Coopers, wheelwrights, coachbuilders	11.9	4.4	5.7
Bakers	—	0.4	0.4
Others	4.2	5.3	5.1
Semi-skilled, unskilled	12.6	12.3	12.4
Servants	0.7	1.2	1.1
Army, navy, police	1.8	6.0	5.3
Not specified, illegible	1.8	6.1	5.3
Total	100	100	100
N =	286	1,369	1,655

Source: Royal Arsenal Co-operative Society Declaration Book 1872-1882.

Table 8.2: Occupations of Officers of Selected Co-operative Societies

Non-manual
 Bookseller (1), grocer (1), undertaker (1)
 Bookkeeper (1), writer (1)

Skilled manual
 Foreman (3), leading man (1)
 Engineer (5), ironfounder (1), smith (3), patternmaker (3)
 Wheelwright (4), cooper (2), coachbuilder (2), sawyer (1)
 Bricklayer (1), carpenter and joiner (9)
 Shipwright (3), ship joiner (1)
 Tailor (1), dyer (1)

Unskilled and miscellaneous
 Messenger (2), school porter (1)
 Labourer (2)
 Marine sergeant (1), naval officer (1)

Source: Co-operative rule books, see note 7.

when he moved to Greenwich he became active in the Industrial Bread and Flour Association there.[10] These men, and others, provided a thread of continuity in local co-operation — an especially strong thread in Woolwich and Plumstead.

There were clearly benefits to be derived from co-operation beyond the material advantages to individuals. Charles Rubery could never have persevered for fifteen years in both industrial and retail co-operation in Deptford without some sense of vision. The real problem lies in identifying what that vision was, for it is not immediately apparent in the statements of local co-operators, whose emphases are largely individualistic and instrumental. The dividend itself was an important benefit, but not the only one. The members of the RACS applauded Holyoake when he told them that the aim of co-operation was to obtain 'a profit impossible to be procured separately. When this profit was obtained it was an essential principle of this co-operation that it should be fairly and equitably distributed among the persons concerned in creating it'.[11] John Green, the RACS chairman in 1876 and a fitter in the Arsenal, was explicit. 'If the working classes of Woolwich would take a greater interest in co-operation, the society would soon number 5,000, instead of 500, and they would be able to declare a higher dividend.'[12]

The dividend however was not the only attraction for the workers who joined a co-operative society. The retailer who sold to the mass of the working class indulged in two practices that were both unacceptable to secure skilled workers: the adulteration of produce and the provision of credit. The addition of alum to flour, the sale of dried used tea leaves

purporting to be fresh, and the substitution of inferior goods for better grades, were all common practices, especially among the small local food dealers to whom the working classes were tied by their need for small-scale purchases and credit.[13] Adulteration was not only unacceptable in terms of value and quality. It also challenged the self-respect of a skilled worker or clerk to be forced to accept such goods. It is for these reasons that the first object of the Deptford Working Man's Co-operative Provision Association was 'to purchase unadulterated food',[14] and most subsequent societies saw this as a main task. Co-operatives likewise rejected the system of credit, the means by which shopkeepers tied working-class customers to their shops and thus made blatant adulteration more feasible. Credit was also the cause of working men and women failing to develop habits of thrift and economy. Here was the location of the argument in the ideological framework of the skilled elite of the Kentish London working class. Only by trading at stores that did not give credit could respectability be asserted, for credit was vital to the family economy of less prosperous and less secure sections of the working class. Inscribed on the title page of the rule book of the Blackheath, Charlton and East Greenwich Co-operative Society were the words 'All purchases to be paid for on delivery', and such rules were general.[15] Occasional societies allowed credit for one week, but this was more a system of slightly delayed payment than one of genuine long-term credit; these societies were, in any case, very rare. Cash payments were essential to mid-Victorian co-operation. They were a crucial part of Henry Pitman's 'Co-operator's Catechism'. 'I believe in good weight and measure, in unadulterated articles, in cash payments, and in small profits and quick returns.'[16]

The function of co-operation in enabling working men to rise in the world, whether in economic terms or through social recognition, was a constant theme of local propagandists. It is here that the argument is at its most convincing that the co-operative movement of these decades was one of men who had come to accept the fundamental beliefs and values of the society in which they lived. John Arnold, the most important figure in Woolwich co-operation of the 1870s, indicated the precise function of cash payments when he wrote, 'We have, through the agency of the store, learned the value of thrift — learned to live and thrive on the ready-money system. Not one pennyworth of goods is taken without payment.'[17] Here is the dynamic role of the values and institutions of this working-class elite. The institutions did not simply embody the attained values of those who joined them, but expressed a faith in the ability of those institutions to spread both the values and

people's capacity to follow them. The morality that co-operation taught produced tangible benefits. According to one frequent speaker to the RACS, it taught men that 'by a slight daily present sacrifice men could achieve great blessings in the future'. It was a morality whose rewards were in this world, not in the next. It was the Victorian morality of success. 'He knew of no movement which would enable men to save so easily, to make the most of their savings, and procure them so much benefit from a mutual point of view as the co-operative movement.' He concluded that it 'should enable every man to have his own house'.[18] House ownership is emphasised repeatedly in co-operative propaganda in Kentish London. John Arnold claimed that 'we have become capitalists by consuming. We are eating our way into a future; many have already eaten their way into a house'.[19]

This limited approach was perhaps not surprising when it dominated the single-product societies that were being established throughout the period. Woolwich Dockyard workers joined with Arsenal artisans to found a baking society in 1842, because the price of bread was still high in the town in spite of the falling cost of flour.[20] In response to a similar situation in Greenwich five years later, John Penn's engineers set up a society on the same principles.[21] The New Charlton Economical Baking Society was established because 'the operative classes of Woolwich and its vicinity have felt heavily the pressure of the exorbitant prices of the most essential necessaries of life during the last twelve months'.[22] The absence of an idealistic framework in societies such as these is not surprising. Even they reflect, however, a positive awareness of collective strength and capacity for collective action, an awareness that was a vital dimension of continuing oppositional strands within many such working-class organisations.

There were, however, societies launched with a wider range of goods, more substantial premises and a policy for expansion, amongst which the experience of earlier co-operative societies might have led one to anticipate a broader perspective. The largest of these, the RACS, grew out of the many single-product societies thrown up by the Arsenal and Dockyard. It was a proud body as it expanded through the 1870s. By 1882, with 2,375 members and many departments, the Society was able to spend £200 on a massive symbol of status, permanence and civic respectability — a clock tower at the Plumstead branch.[23] If little can be discovered about the ideas of Alex McLeod, a 35-year-old Scottish turner in the Arsenal when he helped to set up the society, we do know about the other moving force, William Rose, an engineering worker who had travelled around after his apprenticeship in the Steam Engine

Factory at the Dockyard, and returned to work in the Arsenal. It seems
that he was a Baptist until he read Tom Paine. The infidel republican
converted him to agnosticism, and he launched himself on a reading
programme that took in Tyndall, Huxley and Darwin. With a new
idealism, he set out to help his fellow men. His scheme is a fascinating
one for what it tells us about the man. He turned not to any concep-
tion of a reformed society, but to minor improvements that would
allow men to achieve more, as individuals, in the existing one. It seems
unlikely that Rose's extremely limited aims were shared by many, but
the contrast with the leaders of earlier co-operation is immense. Rose's
main project was for a pension fund for workers which would
encourage them to leave their jobs earlier and make way for younger
men. The role of the co-operative movement was to finance this.[24]

An individualistic view of the role of co-operation has consistently
emerged from this picture. It is a view that must be located within a
tradition of self-help and effort, but it is the working-class conception
of self-help that is the clue, not the Smilesian one. It is impossible,
without an appreciation of this distinction, to place the statement by
Joseph Prior, secretary of the Woolwich Co-operative Provident Society,
that he desired 'the elevation of [his] class'.[25] The definition that he
would have given of his 'class' is unobtainable; it would certainly have
been a very ambiguous one. It is through the word 'elevation' that we
must link Prior's words to the individualistic statements reproduced
above. Prior is not writing about a victory in which there are both
winners and losers. He is describing a process, seen by him as feasible,
by which individual working men could learn the practices, amass the
savings, and enjoy the benefits which would elevate them to a level of
independence and respectability at present held by few of the class.
Some might be fortunate, and use their savings and skills to become
their own masters, but Prior knew perfectly well that not all could do
that. All those who were potentially independent, however, could use
co-operation as a lever. This is a long way from the genuinely anti-
capitalist vision that pervaded the London co-operation of the 1820s
and 1830s.[26] The distance was a long one, but it did not mean that the
two ideals were totally distinct, for what divided middle-class concep-
tions of achievement from those of working men was the role of collec-
tive strength. The reports of the local co-operative societies, where they
have survived, are mundane and dull. One finds in them only a limited
idealism, but a genuine sense of a joint venture to be worked for, a
feeling that men are aware of a collective enterprise that rests upon
their collective abilities and commitment. Those who led the movement

in Kentish London were well aware that they were doing something that working men could rarely achieve alone. John Green's description of the motives that led to the founding of the RACS might well embody a corporate ideology, a response to threats rather than a creative force for social change, but there is nevertheless a spirit of some collective idealism. He told the Select Committee on Town Holdings, 'Had we not been trampled upon, we should not have started the society. We started the co-operative society to work our own redemption.'[27]

John Arnold of the RACS went further, and described co-operation as the 'cause that is destined . . . to be the supreme social power in the land'.[28] Yet this real idealism had little point of contact with the practice of co-operation in the area. It was a propagandist idealism that clearly moved many individuals to a lifelong devotion, yet it never seems materially to have informed the activities of the societies, which were overwhelmingly practical. The argument that the vision was held by the few, while the many concentrated on their dividend, pure food and respectability, is a partial but insufficient explanation. The vision of the few and the practicality of the many were not entirely divorced; they were united by an ideological thread, by the view of society that this study attempts to understand.

The visionary aspect of co-operation was articulated by a few, but John Arnold himself had to admit that until January 1873, when Mr Butcher of Banbury came to speak in Woolwich as part of the belated educational campaign launched by the RACS committee, the men of Woolwich knew little of the movement. 'Many, like myself at that meeting,' he wrote, 'learned for the first time the alphabet of this great social movement.'[29] The collective aspect of co-operation and the sense of a national movement was particularly strong in the north of England, particularly weak in the London area. An article in the *Co-operator* journal in 1864 complained that there was no common object 'save the securing of dividends to their members'.[30] The societies in Kentish London sent little news to the national organs of the movement in the 1870s, and only a handful of them would attend the co-operative congresses. Some local leaders were aware of this problem. Joseph Prior, a writer in the Arsenal, and secretary of the Woolwich Co-op in the 1850s and 1860s, protested on one occasion that in spite of there being 260 members in his society, and three other societies in the town with over 1,000 members, he could sell only twelve copies of the *Co-operator* each month. He dwelt specifically on the failure of any wider view of co-operation to develop amongst most of the members, even amongst most of the leaders.[31] His correspondence to the same journal two years

later gives weight to his case. One letter contained a heartfelt complaint.

> You men in the North must certainly be of different organisation to us in this part, for though, as a rule, the societies which are in existence here are composed of men mostly in a good position as well-paid mechanics, still it is a fact that the co-operative movement here seems to lack all the energy which is so prominent and so successful elsewhere. I suppose we are all to blame in the matter, somehow; the very few have at different times endeavoured to get permission to form an educational fund, library or reading room, but we always get thoroughly outvoted.[32]

Henry Pitman responded with an immediate and predictable generosity by sending a package of books with which the men of Woolwich could start a library. Prior replies with the thanks of his committee. Such things, it seems, were not for Woolwich — the books were passed on to a society on the other side of the Thames.

These are the complexities of Kentish London co-operation. If a social and political consciousness was fostered there — and in particular in Woolwich — by the co-operative movement, it was, during the 1860s and 1870s, a consciousness of a very imprecise kind. Woolwich was always a strong town for co-operative enterprises, and it is not surprising that it shared with Stratford the reputation of being London's only strongholds of co-operation, for each was a closely-knit town dominated by a single workplace. Care must be taken before reading back the political activities of the 1890s into the development of a labour consciousness in the preceding decades, and the role of local co-operation within it.[33] In the 1860s and the 1870s, the Arsenal workers still looked occasionally to senior officers to support their ventures.[34] If the potential for change was always present within the co-operative framework, as has been suggested above, the political development of the RACS after the end of our period must be related more to the social and industrial factors that affected its members than to the specific results of a co-operative consciousness. Co-operation in the mid-Victorian decades was not merely a consumer activity. Activities rarely exist in an isolated instrumentality, and this chapter has attempted to indicate the real and ambiguous values that informed the pioneers and the followers of co-operation in Kentish London. The growth of the movement must be seen both as a reflection of the needs and values of a section of the working population, and as a factor that further separated the life style and experience of that section from the rest of the working class.

9 FRIENDLY SOCIETIES

Friendly societies have been strangely neglected by historians of Victorian England. They were the largest of all the working-class organisations that developed during the period, and they were of the greatest importance to those fortunate or thrifty enough to be able to join them, yet historians have taken them for granted. As a result, we know all too little about such central issues as membership patterns, their role in working-class life, and their ideological functions — all matters that are largely neglected in Gosden's history of the movement.[1] As will emerge in this chapter, a partial explanation of this neglect is the major difficulty in finding source material on these issues, but an examination of the development of the movement in Kentish London can illuminate wider questions about friendly societies in general, as well as contributing to the argument of this study.

Insurance against the catastrophes of working-class life was essential to all families, although that does not mean that all could or did afford it. A working man's life was so much closer then to a border line that separated survival from disaster. The proximity might have been a permanent one, experienced in the day-to-day struggle for survival of a casual labourer or an unskilled worker with large family and unreliable employment. Regular wages might soften that apprehension, but disaster was always a real possibility for even the most secure of artisans. Prolonged or chronic illness, injury at work, the loss of a limb, an early and unexpected death — all of these could destroy the fragile security that Victorian working men attempted to construct for themselves and their families. Leaving aside unemployment, for which no insurance could be available other than that provided by trade unions to those least in need of it, it was sickness and death that presented the greatest personal and financial crises to working-class families. A prolonged illness would soon exhaust any savings that might have been accumulated, and without some form of regular income during sickness, a man's earning capacity could be permanently ruined. Without sick pay a man would continue at work when rest and medical attention were needed; if work became impossible, then he would rest until recovery was under way, and then return as soon as possible, leading often to a recurrence of illness, and a syndrome of perpetuating ill health that could drag a family down within a year or two.[2]

Until the rise in real wages in the closing decades of the century, the majority of the working class was severely restricted in its efforts to provide for financial difficulties. Only societies that demanded regular and adequate contributions could really cope with a wide range of personal crises. Much of the working class was excluded by lack of a continuing adequate income, and their efforts were limited and often unstable. Those who could not afford to join friendly societies, or objected to the fact that they only gave a return on the investment in times of distress, turned to expedients such as tontines and dividing societies that developed out of informal neighbourhood and workplace practices. These provided limited insurance but coupled it with regular divisions of the surplus capital. In even the best of such societies, the members aged and the surplus disappeared, so that new members could no longer be attracted and the society would collapse at just the time when its members needed it most. The main form of insurance for the low-paid were burial societies, and throughout the country it was the unskilled and labourers who dominated them.[3] There were few who could not afford the halfpenny or penny a week that such clubs demanded, and the Charity Organisation Society did not recognise burial society membership as disproving its belief that many poor London workers demonstrated a 'singular want of evidence of thrift'.[4] A decent funeral was a basic need for Victorian workers; a pauper funeral was the ultimate disgrace. A further dimension was added with the growth of those massive societies like the Royal Liver which offered insurance against the deaths of children as well as husband or wife, thus securing a strangely ambiguous compensation against family tragedy. Totally misunderstood by those who suspected it of being an incentive to infanticide, the money was generally splashed on a funeral and attendant feast, as if to use the money in a frugal and beneficial way would be to derive a too general benefit from a tragedy.

Burial societies grew out of the custom of passing round the hat in the workplace, and many local clubs in Kentish London perpetuated that approach. The Dockyard Impartial Burial Societies at Deptford and Woolwich each demanded an entrance fee, a small quarterly admission fee, and a levy of members at each death.[5] Other societies would take a regular subscription of about one penny a week together with a small entrance fee. This was the practice of most substantial societies, such as the Friendly Burial Society at Deptford and the William 4th Burial Society at Greenwich.[6]

For the substantial minority of workers who could afford to join them, however, there were friendly societies. These varied in quality

and reliability, but amongst the plethora of benefit organisations established by the working class, they alone offered anything that approached adequate cover against the costs of sickness, accident and death. As trade unions developed their benefit side, in order to strengthen the union and to restrict the supply of sick and injured men as a drag on the market, many unionised skilled workers could rely on this in addition to their friendly society benefits. The ironfounders were particularly generous, although a high subscription was needed to finance that generosity.[7] Unemployment benefit was the most important, for it was unobtainable elsewhere. There is little evidence that trade unionists took their lesser union sickness benefits as an alternative to friendly society membership; contemporary opinion judged both trade union and friendly society to be the marks of the labour aristocrat.[8] In any case, the introduction of benefits was neither early nor general amongst craft unions; not until the 1860s did the General Union of Carpenters and Joiners establish such funds.[9]

Friendly societies relied upon regular subscriptions from members, which were absorbed into a common fund, and only distributed according to need. With no accumulation of personal savings, this was genuinely insurance. Weekly contributions in Kentish London in the 1860s ranged between 5¼d and 7½d.[10] It was not until the 1870s that the actuarially more satisfactory principle of graduating contributions according to age at entry began in the area, although the entrance fee was generally graduated on that principle, with a normal scale rising from 5s to £1. The benefits varied in size but rarely in scope. The most important was sick pay, which varied in the sums paid and in their duration. Most paid about 10s or 14s a week, itself a massive fall in living standards for a skilled craftsman at just the time when a good diet was most needed, and continued at this rate for a period of six months, then reduced to half rate for another three or six months. Most then stopped, but some went on to a quarter rate, occasionally for an unlimited period. This would become a low form of pension. A member of the Royal Albert Lodge of the Ancient Order of Britons, for example, would receive, in return for a contribution of 6d a week, sick pay of 10s a week for the first six months, 5s a week for the next three months, and 3s a week for a further year.[11] More generous was Court Albions Pride of the Foresters, which offered, in return for 7d a week, weekly sick pay of 14s for six months, 7s for a further six months, and then 3s 6d for the remainder of the period of sickness.[12] Lower contributions usually meant either benefits that were lower or which reduced more quickly, but some local societies accepted lower contributions

than branches of the affiliated orders without lowering the benefits.[13] They were presumably more careful about membership, refusing those thought liable to come too often on to the funds.

All Kentish London societies offered death benefits. Nelson's Pride Court of the Foresters, for example, was in 1854 paying £12 on the death of a member, £6 for the death of his wife, and £1 6s for the death of a child.[14] Many societies also offered medical attention. Whatever the quality of the treatment received, and the types of doctors willing to contract themselves to a friendly society varied greatly from one place to another, free medical attention was an extremely important benefit. The New Charlton United Brothers increased the contribution by one penny a week in 1868 to cover the cost of a surgeon, while the Greenwich United Brothers, founded in 1836, decided eighteen years later to appoint a surgeon.[15]

The absence of good tables of sickness and life expectation in different sections of the working population meant that most societies planned their long-term finances in the dark. The results were sometimes disastrous, as a shortage of funds led to a reduction of benefits or an increase in contributions, with a resultant shortage of new young members upon whose health the actuarial soundness of friendly societies was theoretically based. Collapse sometimes ensued. The Shipwrights Provident Benefit Society ran into just these problems, and was dissolved in November 1864 because of the state of the funds. There were forty-eight members left unprotected — probably at ages when they could no longer join other societies.[16] More often, a society would survive at the expense of extra burdens on members. Band of Hope Lodge, Woolwich, of the Kent Unity of Oddfellows, experienced serious difficulties with its sick fund in the 1870s, and the situation was only saved by a burdensome levy on members of 2½d a week each for a full year.[17] The problem was that friendly societies were generally more than just insurance organisations. They were also an important part of the social life of their members. One result was the objection to a high lodge size that was actuarially necessary but socially undesirable. Another was the unwillingness to abandon elderly members, living for years off a low sick pay in a way that was never anticipated when the society was established. Friendly societies emphasised responsibility and social brotherhood, and, as an aged population survived, many went through financial crises at the end of the century.

The social life of the societies was central to their role in artisan life. The establishment by the NCOs and gunners of the Royal Artillery of an Oddfellows lodge in Woolwich in order 'to cause still further good

feeling and unanimity amongst their body'[18] eloquently indicates the image that the society presented to the local community. The social unity was given symbolic confirmation by the mythology, regalia, rituals and secrecy that had survived a very different purpose half a century earlier. The activities ranged from the conviviality and drink of the monthly or fortnightly public house meeting, to the annual dinners and festivities on other occasions. Insurance assistance grew out of the element of mutual social help within early nineteenth-century working-class culture. The dinners and monthly meetings succeeded because they affirmed the mutual trust and brotherhood that was ideally the basis of the protection. The seventy members of the Lord Bloomfield Lodge of Oddfellows in Woolwich who attended one monthly meeting represented over three-quarters of the total membership.[19] When the Old Friends Friendly Society held an annual festival at the 'Three Crowns' in Greenwich, 120 members sat down to dine,[20] while almost the entire membership of Foresters Court Star of the West appears to have attended the annual dinner in 1859.[21]

This social cohesion would sometimes break down, for what reason we cannot tell, though the fact that complaints of lack of member participation came most often from the very large societies suggests one explanation. A grossly oversized Deptford lodge of the Ancient Order of Comical Fellows had 370 members in 1879, yet only forty attended the anniversary dinner.[22] On the whole, however, the social life of the societies thrived to an extent that brought middle-class disapproval. The specific objection was that the money for the drink and festivities came from the society's funds, but this barely concealed a far more fundamental unease about the activities themselves, which were not seen as part of a thrifty and industrious way of life. The Royal Commission was perplexed by the incompatibility between respectability and public-house drinking within the middle-class view of the world. It noted that ' . . . the objections to the (registration) law being too strict, especially with reference to public-house meetings and liquor payments in lieu of rent, is urged by many societies of a respectable and improving character'.[23]

The complaints about public-house meetings and the expense of the festivities went unheeded in Kentish London. Of eighty-five registered societies in Kentish London between 1855 and 1870, all but one met in a public house, the sole exception being the works-based Benefit Society of Engineers which met in the General Steam Navigation Company's yard at Deptford.[24] At one level this merely emphasises the centrality of the public house to early and mid-Victorian working-class

life, but it also indicates the distance that separated outside observers from a comprehension of the nature of working-class social life. Any attempt to remove drink, and the conviviality that was seen to go with it, from the insurance activities of friendly societies had little chance of success. Indeed, it was not unknown for the 'medical' provision of alcohol to be a function of the society. The East Peckham Amicable Society paid 8s a week sick pay, plus what ale, beer or porter the medical attendant recommended.[25]

As all this might lead one to expect, temperance friendly societies achieved little success in Kentish London. They experienced difficulties in many areas because they were often launched to support the local temperance cause when the numbers could not support a benefit society for any length of time.[26] London itself was a weak enough area for the Sons of Temperance Friendly Society, as it was for the temperance movement as a whole, but the Kentish London branches were weak even within the metropolis.[27] The Sons of the Phoenix seem to have made even less of an impact; the subscriptions were high and the benefits low, so that only the dedicated would be likely to join the occasional lodges that were opened. The dedicated were few, according to the memory of one resident.[28]

If such temperance friendly societies rejecting beer were spurned, a little more support was given to another form of insurance that rejected the traditional approach. The non-social orders, known by the Royal Commission as 'ordinary societies', operated without any form of local organisation beyond collectors and agents. The Mutual Providence Alliance, the Royal London Friendly Society, the Hearts of Oak and others were insurance organisations and nothing more. They were expensive, paid higher benefits than usual, and were generally extremely selective. The Prudential Assurance Company would accept no Irish-born, and in certain streets of all the major cities they would take no members at all.[29] They felt superior in rejecting the social paraphernalia of most friendly societies. Members of a new branch of the Ancient Order of Shepherds, Ashton Unity in Deptford, were proud of the fact that it did not waste money on 'useless regalia' and feasts.[30]

It is not easy to identify the membership of these societies, but the secretary of the largest of them, the Hearts of Oak, felt that it was composed of artisans from 'carefully selected trades', together with small shopkeepers, clerks, surgeons, chemists and similar groups.[31] The desire to join such a society required more than an ability to pay the contributions and a select enough occupation, it also needed a rejection of many of the traditions of mutuality and social activity that had long

dominated Victorian working-class life. Skilled workers in Kentish London did not, on the whole, reject these traditions, but transformed them in the differing social climate of the mid-Victorian decades. Those who turned to the 'ordinary' societies were a tiny minority. The little evidence that we have indicates not the popularity of the style of these impersonal societies, but quite the contrary, for in 1864 Woolwich members of the Hearts of Oak became particularly unhappy about the absence of a social life in the order. A local reform movement was begun, which took as its main aim that the members 'should in some measure conduct their own affairs locally, and know one another'.[32]

The core of the friendly society movement in the area was formed round two types of society, local ones with a single branch and no external organisational links, and the local courts and lodges of the national or regional affiliated orders. Local societies predominated throughout the earlier decades of the century, and yielded only slowly to the affiliated orders. The oldest society of all was the Amicable Benefit Society, established in Woolwich in 1775, which still had a membership 104 strong in 1855. Numerous societies of this kind were launched around the beginning of the nineteenth century, such as the New United Brotherly in Greenwich in 1808, and the United Friends in Deptford in 1805, and many of them remained strong throughout the period.[33] It was upon the solid foundation of such societies that the movement grew in Kentish London, with the slow emergence from the 1840s of branches of the affiliated orders, which linked numerous local branches into a national or regional unity. The orders that overshadowed all others on a national scale, the Independent Order of Oddfellows (Manchester Unity), and the Ancient Order of Foresters, became the leading orders in Kentish London.

The Oddfellows obtained the first foothold in the area, and by 1844 had seven lodges with 726 members.[34] Once established, their lodges grew fast — Lord Bloomfield Lodge in Woolwich recruited 109 members in its first year, and outstripped many existing local societies.[35] Developments between 1840 and the mid-1850s seem to have been evenly distributed between local societies and the two main orders, but there then followed an explosion of Foresters' Courts between 1856 and 1862, when thirty registered courts were set up. It is also from about 1860 that other affiliated orders got under way in the area. Four lodges of the Kent Unity of Oddfellows, for example, started in Plumstead and Woolwich between 1859 and 1861; thriving on defections from the Manchester Unity. The founding of new unities was common all over the country as the older orders, especially the Manchester Unity,

attempting to enforce some consistent actuarial and admissions policy, faced local lodges resisting centralisation. The very high instability of membership of Kent Unity lodges between 1860 and 1865 suggests that a refusal to accept sound central guidance could well have been one cause of their defections.[36]

We have little direct evidence about the occupations of friendly society members. The affiliated orders originated among the better-paid working-class occupations, and the demands and rewards were aimed at their financial situation.[37] The attempts to integrate the orders into the tramping structure confirms their basically artisan orientation. The Foresters, for example, gave grants and hospitality to members tramping in search of work, and boasted of a welcome in every town.[38] Sir George Young's report on the southern and eastern counties, which he prepared for the Royal Commission on Friendly Societies, confirms this impression. He concluded that craftsmen formed the majority of members of the affiliated societies. 'With few exceptions the lodges of a society like the Manchester Unity were practically closed against agricultural and other unskilled labourers by the high rate of contributions demanded.' The Foresters, he suggested, were possibly less exclusive, with rather dangerous actuarial implications.[39] If such assessments are correct, we would expect the membership of the societies to form a substantial but restricted proportion of the total population of adult males, and this seems to be the case in Kentish London.

Friendly society membership has been exaggerated by an unquestioning acceptance of the appendix to the Fourth Report of the Royal Commission, which produced a national calculation of four million friendly society members. The Royal Commission, if it was to obtain a national total, required some multiplier by which to increase the membership total of registered societies to a full total that would include unregistered ones. A case study of Lancashire produced the multiplier, whose results were then extrapolated to the rest of the country. There are two problems with this calculation. In the first place, the limited but ubiquitous burial societies were included in these calculations, and hence in the four million total. Further, the multiplier was derived from the county where burial societies were at their very strongest, and where they were underpresented in the registered returns to a greater degree than were genuine friendly societies. The famous and much-used four million figure is thus, as a membership of true friendly societies, a nonsense: they were far more restricted.[40]

If we now focus upon Kentish London again, calculations based upon the annual returns for 1864 and 1872[41] suggest that the propor-

tion of the adult male occupied population of Kentish London which was in *registered* friendly societies was in the region of 23 per cent for both these years. An allowance for unregistered societies produces the conclusion that the proportion of adult occupied males in some form of friendly society proper in Kentish London in these years was between 35 per cent and 40 per cent.[42] These figures represent proportions in friendly society membership at any one time. When we include the substantial turnover rate in many societies discussed below, it is clear that these percentages must be further reduced to produce a substantially smaller *de facto* elite of permanent members. However general they may be these figures do point clearly both to the importance of friendly society membership in Kentish London, and to its relatively restricted nature.[43]

In the absence of detailed membership records, efforts to establish some social principles of friendly society membership in Kentish London have necessarily to take an oblique form. Only for the Woolwich and Plumstead lodges of the Ancient Order of Foresters have such records been located. The results, important as they are, must be treated with care, for they represent only one order in only one of the three towns. Nevertheless, certain clear conclusions emerge. A summary of the total intake over the period as a whole can be found in the final column of Table 9.1, indicating the dominance of skilled workers and those in lower middle-class occupations, but also a proportion of unskilled workers and servants higher than one might have expected, and certainly higher than in the Royal Arsenal Co-operative Society in the same area. The more detailed chronological breakdown in that table of *new* members admitted indicates a firm division in the period 1858 to 1862. Between 1845, when the first court was founded, and 1857, skilled workers were overwhelmingly dominant, but in 1858 the years of massive expansion of the Woolwich and district Foresters began, and it was in that year that the proportion of unskilled among new members first exceeded 30 per cent. The large-scale army intake into existing courts began around 1868, and centred upon Court Bold Robin Hood and Court Little John, both courts with a fairly high proportion of unskilled workers amongst the membership before the soldiers were admitted.

This picture of intense artisan domination in the establishment and development of the Woolwich Foresters followed by an expansion in the period around 1860, and a related social widening of the intake to unskilled workers and then to soldiers, is clearly of importance. Great care must be taken, though, in attempting to generalise too far from it.

Table 9.1: Ancient Order of Foresters, Woolwich: Occupations of New Members (percentages)

Occupation	1845-1857	1858-1867	1868-1876	Total 1845-1876
Professional, clergy, finance	0.1	0.1	0.1	0.1
Retail	5.9	3.3	4.9	4.2
Clerks, white-collar	2.0	2.2	3.6	2.6
Shop assistants	0.3	0.5	1.1	0.7
Skilled workers	73.8	54.5	40.5	53.2
Engineering, metal	26.6	25.0	18.2	23.2
Shipbuilding	9.5	4.2	1.0	4.1
Boilermakers	6.4	2.2	1.3	2.5
Building	14.3	11.4	7.5	10.5
Shoemakers	2.7	1.7	0.9	1.6
Tailors	2.0	0.9	0.4	0.9
Bakers	2.3	1.3	2.1	1.7
Watermen, lightermen	0.1	1.9	1.6	1.5
Wheelwrights, coopers	5.1	1.8	0.2	1.8
Others	4.8	4.2	7.4	5.3
Unskilled	16.0	34.9	28.2	30.0
Servants	0.7	1.6	1.7	1.5
Army, police, navy	–	2.6	19.8	7.5
Unidentified	1.0	0.3	0.1	0.3
Total (%)	100	100	100	100
Total (number)	692	2,507	1,393	4,592

NB Entirely army courts have been excluded.

Source: Ancient Order of Foresters, South London District, 'Quarterly Returns from Courts 1845-1876'.

The Ancient Order of Foresters was only one order in the town. Against its 1,564 members in 1868, must be set the membership of two orders of Oddfellows, 1,812 in the Manchester Unity and 1,553 in the Kent Unity.[44] These, together with the local societies and smaller orders, competed with the Foresters for membership, and there is no evidence as to how the composition of membership of the various societies differed, except that the period of major growth for the Foresters was a period of particularly high instability of membership — far higher than the Manchester Unity experienced at a time when they, too, were expanding. This may point to the effect of different degrees of discrimination in admissions policies upon the occupational composition of the intake.[45]

The peculiarity of Woolwich, in comparison with Deptford and Greenwich, must lead also to caution in generalising from these data. The town's friendly societies were more unstable than those in either of the other towns between 1860 and 1875. If we accumulate the total membership of all societies recorded in the 1880 Abstract[46] and compare it with the number of men whose membership was discontinued for reason of non-payment (excluding death), we find a discontinuation rate in Woolwich of 22.3 per cent, compared with 18.3 per cent and 19.7 per cent in Greenwich and Deptford respectively. A not entirely unexpected result, for a place where a section of labourers had an unusual degree of job security, however low their pay, was one likely to make membership of friendly societies more widespread.

An interesting reaction by older membership groups against a dilution of membership may be seen in the growth of an Ancient Order of Shepherds within the Foresters' movement. A set of 'sanctuaries', one within each court, would offer extra benefits in return for extra subscriptions. One result was a tendency for those who joined the Shepherds to form an exclusive group, termed 'a clique within the larger society'.[47] This may reflect some retreat into exclusiveness by those who resented the expansion of membership, as well as a search for higher benefits. It is significant that the order was launched and became popular during the period of greatest expansion.[48]

The evidence from the Woolwich Foresters is thus instructive but not conclusive. It is certainly true that more semi-skilled and unskilled workers joined friendly societies than the other principal organisations of working-class thrift. This is hardly surprising — more skilled workers did so as well — for the status and ideological issues were less exclusively compelling factors in the areas of sickness and death benefits than in other spheres of thrift, and friendly society membership was in many

ways more accessible, if only temporarily. If any of these types of organisation could be seen as a human rather than a social necessity, it was friendly societies.

Of equal importance is the fact that both the ideology and the form of the movement that they joined were shaped by its origins and its leadership. The overall artisan domination, broadly based if weakening from the 1860s, is one vital continuing aspect of this. The persistent artisan leadership is another. Most significant of all are the patterns of social consistency and exclusiveness that characterised much of the movement, in particular the older, larger and most stable societies, and the specific ideological characteristics that informed the movement and tied it firmly within the context of the skilled working-class social ideology analysed in other chapters.

The persistent artisan leadership of the movement is reflected in the occupations of trustees. These officers were responsible for the activities and behaviour of the local lodge or society, and they provided an essential basis of experience and leadership. Twenty-nine Kentish London societies submitted full trustee details to the Registrar-General, and all but two of these societies made their returns after 1860 when the major expansion had commenced. Sixteen of the societies were lodges and courts of affiliated orders, the rest being local societies. The complete leadership dominance by skilled workers, particularly those in the principal industries of engineering, shipbuilding and building, and by lower middle-class occupations, is evident from Table 9.2.

From leadership we turn to membership. It was clearly essential for any friendly society to pursue some form of reasonably consistent policy on admitting members. Limits on age at admission were actuarially mandatory for even the least experienced, and were usually set at around thirty-five years, but most went further and excluded a body of so-called 'dangerous trades', which were thought especially liable to sickness or injury. Deptford Mechanics Local Benefit Society specifically excluded plumbers, painters, glaziers, drug and colour grinders, water gilders, workers in white lead, quicksilver or gunpowder, firework makers, and manufacturers of vitriol, turpentine and aquafortis.[49] The policies on admission that went beyond these provisions lead us into a more complex world where liability to put excessive demands on the funds of the society becomes intertwined with attitudes of social exclusiveness. The regular character clause could mean a great deal in practice, or it could mean nothing more than the rejection of habitual drunkards; thus the Grand Provision Society of Deptford demanded that an applicant 'bear a sober, honest, industrious character'.[50]

Table 9.2: Occupations of Trustees of 29 Registered Friendly Societies
in Kentish London, Principally 1860-1875

Occupational group	Number		%	
Professional, clergy, finance	2		1.1	
Retail	15		8.0	
Clerks	12		6.4	
Shop assistants	2		1.1	
Skilled workers	129		68.6	
Engineering, metal		33		17.6
Shipbuilding		16		8.5
Boilermakers		8		4.3
Building		31		16.5
Shoemakers		8		4.3
Tailors		3		1.6
Bakers		1		0.5
Watermen, lightermen		10		5.3
Wheelwrights, coopers		7		3.7
Others		12		6.4
Unskilled	28		14.9	
Servants	—		—	
Army, police, navy	—		—	
Unidentified	—		—	
Total	188		100	

Source: Returns of trustees in the PRO at FS1, FS3 and FS5.

Financial prudence and social prejudice most openly operated when the
members of the William the Fourth Society, Deptford, decided to
exclude all Irish. This was the only Kentish London society formally to
institute such a rule (although many operated it in practice), and it had
a leadership who were all unskilled labourers.[51] If the composition of
the membership was similar, are we observing the assertion of status
consciousness by that section of the English working class that could at
least pride itself on not being Irish?

The most important exclusion of all was that enforced by the wage
minimum. A large proportion of societies specified a minimum wage for
members, aimed at excluding most unskilled workers, or at the very
least all but the most regularly employed of them. The Grand Provision
Society required at least 18s per week.[52] The demand by the St Alphage
Benefit Society in 1849 that 'no person be admitted member of this
society if his average income or wages does not amount to fifteen
shillings per week, one week with the other throughout the year' would
exclude all but the most regularly employed of unskilled workers,[53]
while even they would be excluded from the Brotherly Love Friendly

Society, which required members to earn at least a pound a week.[54]

These provisions indicate a pattern of restrictions on entry that went beyond the narrow issue of preservation of funds. Efforts were made to enforce them. One society in neighbouring Bermondsey carried out active enquiries 'in regard to the health, moral character, earnings and so forth of the proposed member'.[55] The committee of the Provident Reliance Friendly Society was specifically asked as late as 1886 whether or not it would object to receiving as members men employed in the East Laboratory, a part of the Arsenal almost totally staffed by unskilled labourers.[56] It is perhaps necessary to reconsider the role of the paraphernalia of ritual in the societies in the context of this pattern of intended, if limited, social exclusiveness. By the mid-Victorian period the secretiveness, the distinctive costumes, regalia and titles, and the secret initiation ceremonies had all taken a more ambiguous role from their earlier nineteenth-century function of creating an environment of self-enclosed security in a hostile world.[57] The older meanings were less relevant to those who now participated. Relevant least of all, perhaps, to the most active members who enthusiastically perpetuated the rituals. They had become a reassurance of exclusiveness at the same time as a symbolic confirmation of brotherhood.

One specific way in which this intended restrictiveness on admissions could in theory operate was through craft exclusiveness, but friendly societies established for single trades were not common in Kentish London. The Shipwrights' Provident Benefit Society was the most prominent, and maintained the craft and workplace distinctions defended by its members, for the 1859 rule book specified that an apprentice might join in his last year, but he was 'not allowed to remain in the club room until he has served his time'.[58] Most societies tied to specific trades or workplaces tended to be of the limited burial club variety. The main conclusion from the Foresters' data must be that there was more craft mixing in individual courts than craft exclusiveness. Rarely does the place of a single occupation within a court suggest craft exclusiveness, although there is a great deal of evidence of what might be called workplace recruitment. The domination exercised by shipwrights in Court Star of Kent — between 1846 and 1866 one-third of the 279 new members were of that trade — is an isolated case. A sudden substantial intake of members in one trade into a court was not infrequent, and this presumably indicates a principal form of recruitment through personal contact in the workplace or the trade society. Thus, Court Star of Kent had only one caulker amongst its members between 1845 and 1860, but in the latter year ten caulkers joined. The

twenty painters who joined Court Queen of the Forest in 1859, and the substantial intake of smiths by Court Foresters' Hope between 1854 and 1856, are similar cases.[59] These various patterns of occupational intake and exclusiveness are hardly surprising, but far more significant is the broad mixing of trades within friendly societies. It was from activities such as these that developed the behavioural patterns which overcame a mere craft exclusiveness amongst skilled workers.

Other indirect evidence confirms that the older base of friendly societies and the social core of the movement in the area maintained a social selectivity and exclusiveness throughout the period. Table 9.3 reveals that the older courts and societies were both consistently larger and more stable than the newer foundations. As there was no accumulation of individual savings in friendly societies, merely investment in a common fund, nothing could be salvaged if a member lapsed and gave up his membership. Only necessity, generally financial necessity or lack of commitment, can explain most discontinuation. Table 9.3 thus

Table 9.3: Rates of Discontinuation and Mean Size of Kentish London Friendly Societies in 1880 Abstract

Year of establishment	Number of societies	Rate of discont. 1855-75 %	Mean size 1855-75
1775-1840	14	15.2	122
1841-1855	26	18.2	136
1856-1862	38	27.9	60
1863-1875	6	31.1	76

Source: Abstract of Quinquennial Returns by Friendly Societies 1855-1875. *Parliamentary Papers,* 1880,LXVIII. The method of calculating the Rate of Discontinuation is described above, p. 184

indicates some policy of selectivity amongst older societies. The large number of new foundations after 1856 might have greatly increased the number of societies and lodges, but they failed to attain a numerical dominance of members. The friendly society movement, throughout the period, was dominated by the older base of societies, and these maintained policies of social selectivity which later societies seem to have relaxed.

This is confirmed if we turn to the Woolwich Foresters. There, too, the older courts were always substantially larger. In 1872 the total membership of all courts founded up to 1858 was 991, whereas only 676 members were in courts founded after that date. In the same year,

the mean size of the older courts was 165, that of the newer ones
founded between 1859 and 1865 was only 61. Records of suspension
and expulsion for non-payment of contributions between 1865 and
1869 provide further evidence as to the factors behind court
instability.[60] The main issue was not social composition, pure and
simple. The most important rank correlation is the fairly high one
between lowness of suspension rate and order of establishment[61] and
this returns us to the argument of social selectivity and the effect of the
growth of new courts during the Foresters' expansion in Woolwich. The
most important factor in determining the stability of a court's member-
ship relates to the period of establishment of the court; those set up
during the period of high artisan domination were those which main-
tained the pattern of social selectivity that went with it. It is also
interesting to note that the two later foundations which have unexpec-
tedly low suspension rates, Courts Good Intent and Royal Albert, both
contained an extremely high proportion of artisan and lower middle-
class members.

All this points to some form of consistent policy of admissions of
new members. The 1880 Return provides a further indirect means of
testing this. The Registrar-General asked secretaries each quinquennium
to divide their membership into one of four categories, according to
their type of employment. These were light labour and heavy labour,
each with or without exposure to the weather. The division was created
to test theories about sickness and types of employment, but it is of
little use to us except in as far as we can determine some further
consistency of intake by looking for the extent to which societies main-
tained a constant proportion of members in each of the four categories
over time, and in spite of a fairly substantial turnover of members. With
a substantial turnover, it would have to be due to some consistent policy
of intake that favoured certain types of trades, certain industries,
certain crafts. The method used here is to calculate the percentage of
members in the four categories for each society in a quinquennium, and
then to examine the variation in these figures between one quin-
quennium and another. The results are striking. If one looks first of all
at the societies making returns for the quinquennia ending in 1860,
1865 and 1870, that is, the older pre-expansion foundations, we find
that the mean variation in the percentages in each category for each
society between 1860 and 1865 was 2.7 per cent, between 1865 and
1870 2.6 per cent.[62] The figures for societies making their first returns
in 1865 — that is, the newer foundations — are markedly higher. The
mean variation between 1865 and 1870 was 7.8 per cent, between 1870

and 1875 6.9 per cent.[63] In other words, the social consistency of membership on the basis of this fourfold categorisation was far greater in the older and larger societies than in the newer ones. This is confirmed by making similar calculations for all societies making returns in both 1865 and 1875. The mean variation for those founded before 1857 was 4.1 per cent, whereas the figure for the later foundations was over double at 8.4 per cent.

It is therefore clear that the older and larger societies maintained their consistent admissions policies throughout the period. A fairly explicit social pattern is also apparent in Woolwich Foresters' courts, some examples of which are presented in Table 9.4. The growing intake of unskilled workers was generally either into courts such as Mount Pleasant that already had an unusually high proportion of such workers, or into new foundations such as Pride of the Mill. The nine courts with a high proportion of skilled working-class and lower middle-class members (over 65 per cent) in the initial five years after foundation are all remarkably resistant to dilution over the period as a whole. Star of Kent and Foresters' Hope are examples of such courts, and it is also interesting to note the strength of shipbuilders in the one and engineering workers in the other. As far as the Woolwich Foresters were concerned, a basic social character tended to inform a court throughout its life.[64] Amongst the key engineering, shipbuilding and boilermaking craftsmen, there was a further tendency to exclusiveness in relation to unskilled and semi-skilled workers in these courts. The tendency was that where unskilled participation was especially high, the place of these key crafts amongst skilled workers in that court tended to be low; and the reverse held where unskilled membership was unusually low. Pride of the Mill was a rare exception to this rule.[65]

The friendly society movement in Kentish London thus experienced a particular pattern of development. Large, fairly stable and socially selective societies were joined from around 1860 by a mushroom growth of new societies, which turned out to be smaller, less stable and less selective in their intake.[66] The older societies dominated the movement, and it was the ideology and the approach that they had developed which was to persist throughout the period. The developments around 1860 were of organisation not ideology, and the leadership of the movement was in the hands of the artisan stratum which had dominated it throughout the earlier period.

Mary Cull, wife of an army officer, and a long-resident member of Woolwich middle-class circles, addressed one of the poems, in a collection that she published, to 'The Officers and Brethren of the Woolwich

Table 9.4: Ancient Order of Foresters, Woolwich: Occupational Composition of Selected Courts

	Star of Kent		Mount Pleasant		Forester's Hope		Pride of the Mill	
	1845-49	1845-76	1845-49	1845-76	1850-54	1850-76	1860-64	1860-76
Prof., clergy, finance	5.9	3.8	8.5	6.0	7.2	5.3	5.2	5.3
Retail		5.0		2.4	2.9	1.4	1.3	1.2
Clerks, white-collar		0.3		1.2		0.4	1.3	0.6
Shop assistants								
Skilled workers	88.2	83.3	51.1	38.0	87.0	75.0	29.9	26.3
Engineering, metal	17.6	19.9	17.0	18.8	37.7	35.6	18.2	15.8
Shipbuilding	45.1	36.9		0.4		1.6	1.3	1.2
Boilermakers	3.9	5.0		5.6		0.4		
Building	5.9	9.8	8.5	4.0	33.3	17.4	9.1	4.7
Shoemakers		0.6	8.5	2.0	1.4	1.4	1.3	1.2
Tailors	2.0	0.9	10.6	1.6	1.4	0.8		0.6
Bakers	7.8	1.9		0.8	5.8	4.7		
Watermen, lightermen		4.1		1.6		1.2		
Wheelwrights, coopers	2.0	0.3	4.3	3.2	2.9	7.1		0.6
Others	3.9	3.8	2.1		4.3	4.9		2.3
Unskilled	5.9	6.9	34.0	49.2	1.4	16.0	57.1	64.3
Servants			4.3	2.8		0.2		
Army, police, navy		0.6					5.2	2.3
Unidentified			2.1	0.4	1.4	1.8		
Total (%)	100	100	100	100	100	100	100	100
Total (number)	51	317	47	250	69	510	77	171

Source: Ancient Order of Foresters, South London District. 'Quarterly Returns from Courts, 1845-76.'

District Manchester Unity of Oddfellows'. The poem expresses great approval of the Unity, but embodies an arid repetition of sentiments about unity and thrift that characterises so much of middle-class views of the friendly society movement.[67] The Charity Organisation Society certainly saw membership of a society as a clear indication of respectability,[68] and this was the common view, shared by many of the societies' members. Yet in the same way that the ideology of the Kentish London friendly societies relates to that body of attitudes established elsewhere in this study, so the gap between middle-class ideals and working-class practice must be reiterated here. The clearest statement on a national scale of the middle-class view of the role of friendly societies in developing characteristics of thrift, self-control, self-help and social unity is by John Wilkinson.[69] Yet missing from his picture, from Mary Cull's poems, and from most other outside studies is a comprehension of the role of the social life of a society in creating a pattern of activities that related to the insurance benefits in a way that was far more indistinct than was generally recognised.

The social cohesion grew out of aspects of working-class tradition that had survived the growing artisan concern for the home. It was not just Mary Cull's 'blessed combination' for instrumental purposes, it was also a fundamental social and cultural force. Emphasis must once again be laid upon that gap in understanding that was reflected in middle-class incomprehension of the social festivities and drinking sessions that were such an important part of most friendly societies. Samuel Smiles did not understand the phenomenon, but in an interesting anonymous article in the *Quarterly Review* he at least recognised that there were reasons for the social activities that lay beyond his comprehension.[70]

Nevertheless, many aspects of friendly societies which attracted outside approval were intended to be so received. A concern for the Victorian principles of moral behaviour and character development find repeated expression in the rule books and, more widely, in the speeches and local activities.[71] The concern for moral character has already been noted, and it was usually expressed in terms of sobriety, honesty and industry. Some societies spelt out the qualities required at great length. The Kent Unity of Oddfellows would have no one as a member 'who bears a bad character, or leads a dissolute life, or frequents bad company, or who is guilty of habitual intoxication, or of quarrelsome behaviour'.[72] Most rule books then turned to dress and behaviour within meetings. The United Brothers in Greenwich expected 'every member to attend his lodge cleanly and decently attired'.[73] The rules of a Charlton lodge had sections headed 'Immoral Conduct' and 'Order

and Decorum'.[74] The Grand Provision Society were concerned 'to keep good order and decent carriage among the members',[75] and it was common to object to gambling and swearing. The elements common to most are best summarised by Rule 22 of Court Royal Albert of the Ancient Order of Foresters.

> That every member is expected to attend his court cleanly and decently attired; address the chief ranger in a proper and respectful manner, and observe due kindness and decorum to all present; during discussion only one member to address the chief ranger at a time, and shall be standing; the speaker shall utter his sentiments in a cool and dispassionate manner, the chief ranger shall call him to order if he digress; and if a member by intemperate conduct or behaviour interrupt a speaker who is in order, or retard the business of the court in any way, the chief ranger may inflict a fine of 6d upon him.[76]

The concern for decorum, for lack of passion, for formal discipline, for what may be regarded as respectable manners is unmistakable; what is especially interesting is that societies should feel the need so frequently to enshrine these principles with such prominence in their rule books.

These examples almost all come from the 1860s and 1870s. They relate both to the types of members that the societies wanted, and to the types of behaviour that were deemed proper. Their resemblance to the preoccupations of the mid-Victorian middle class does not mean that they relate either necessarily or exclusively to those concerns. The emphasis upon procedure and self-discipline has an ancestry that can be traced back into the eighteenth century,[77] to the self-respecting artisan's aggressive search for dignity. Yet in just the same way that the desire for self-education had in many ways changed by the mid-Victorian period from a fundamental concern with personal transformation into a narrower instrumentality, so the assertive dignity could be transformed into a desire for respectability within a wider status system. As with so many aspects of behaviour, the context could change while the words remained similar. The concerns impinged far less upon the place of working men as working men, far more upon their role in the home or in a wider system of status recognition. A member's toast at the Plumstead dinner to celebrate the tenth anniversary of the Ancient Order of Britons there, hoped that 'the Order would continue to extend its influence of making men provident and happy, better husbands and better fathers'.[78] According to the founders

of a new society in Deptford, it was 'calculated for the most extensive moral good . . . it is a credit to itself and an ornament to the country'.[79]

It is the context of thrift, working-class self-help and respectability that makes sense of these Kentish London friendly societies. Their role was more complicated than a narrow instrumentality would allow. Leaving aside the whole issue of the social functions of the societies, it is essential to see the dual-sided purchase of the respectability that attached itself to friendly society membership. The benefits provided by the society allowed the independence from charity and poor relief that was essential to the notion of respectability. The point was made clearly by a member at the annual dinner of Foresters' Court Nelson's Pride, Deptford, when he argued that 'nothing so much enhanced the feeling of self-respect in the working man as to feel himself independent', and stressed that joining a friendly society was the best way to achieve this.[80] Yet the other side of this coin is a repeated argument that the benefits are a *reward* for character and moral propriety, rather than simply a way of achieving them. As one local society phrased it, 'Industry and Sobriety are now called into action, and will be rewarded as they ought to be by a comfortable independence which those who labour for the supply of their own necessities procure for themselves'.[81] A short story in the *Oddfellows Magazine* told of a man's conversion from moral failure to Oddfellowship, and this act of joining the order was seen as a clear *indication* that he had become a 'steady, thoughtful man'.[82] The ability to benefit from a friendly society was seen as deriving from a cluster of personal qualities of regularity, industry and thrift that allowed a man to join, be accepted and sustain his membership.[83] There were two sides to this. One was a practical exclusion that required some genuine sense of security for friendly society membership to be viable. The other was an attitude to thrift that was often a cultural matter, for it was frequently observed that only regular wages fostered an attitude of planning for the future.[84] This need for personal security to make friendly society membership viable went beyond the demands of regular weekly contributions. Stability of residential area, employment and income were needed to prevent falling into arrears and non-entitlement to benefit. In this sphere, as in so many others, the security given by a friendly society perpetuated and reinforced existing degrees of relative security.

The potential conflict between patronage and independence was an important one for friendly societies, for one of the greatest strengths was their exclusively working-class structure of control and organisation. Patronage and outside interference were adamantly rejected at the

same time as external links were sought. James Larkin, a mechanic in Woolwich Dockyard, was firm in his refusal to contemplate patronage in his discussion of the Oddfellows. The Order made 'working men depend upon themselves . . . They possess resources of their own, sufficient to protect them in their emergencies, without calling in the aid of other classes'.[85] It is important to note that the resources have to be collectively provided. It is not the support of other persons that Larkin is rejecting, but the support of other classes. There was a significant absence in Kentish London of those types of society run by honorary members, by the local middle class or gentry. The Loyal Britons in Deptford were a rare exception, for they solicited donations for their pension fund from 'the more wealthy portions of the community' in 1845.[86] The Royal Commission called such organisations 'county societies', and they were rarely found in urban industrial areas, where working-class autonomy was deemed essential.

The rejection of government control was equally emphatic. Any attempts to give the Registrar-General real powers were always resisted. Simmonds Sweetlove, a prominent Greenwich Chartist, protested to the *Northern Star* in 1849 at government efforts to control friendly societies. He explained that the new United Brotherly Society, at the Fishermen's Arms in Greenwich, with 240 members, had been holding public meetings as part of a fierce campaign against government involvement. They claimed that friendly societies could look after their own affairs, and would do so.[87] This rejection of government interference was clearly not limited to the Chartists in the locality, who would have had political suspicions. It was far more general, as the case of the United Brotherly suggests, and it persisted. Societies prided themselves on their self-sufficiency. When New Cross members of the Ancient Order of Foresters proceeded through the town in celebration of their anniversary, they were led by their own band.[88] This was in no way unusual – throughout the country, trade unions and friendly societies prided themselves on their own local bands. Their significance was in the way that they symbolised an independent, self-contained method of celebration and festivity that related closely to the societies' own provision for ritual, their own terminology, their own traditions.

This internal self-control also meant that friendly societies, again like trade unions but in this case more embellished with pomp, supplied an important and attractive framework within which working men could achieve honour and office. One harmful consequence was a reluctance to accept necessary amalgamations and submission to central actuarial guidance within the order.[89] The ability of individuals to rise through a

carefully structured hierarchy of individual honour and achievement
was not an essential part of self-government, for it went far beyond
committees and trustees. The Foresters had Rangers, Chief Rangers,
Sub-Chief Rangers, Senior Woodwards, Junior Woodwards and so on.
Both the spurious ladder and the genuine capacity provided for
working men to take office and govern themselves were an essential
part of the friendly society ideal. As the lecture on the constitution of
the Foresters, written in 1879, commented, achievement was dependent
upon individual character development.

> The path of distinction and honour is open to all . . . No office is
> too high for the poorest to aspire to; no duty too humble for the
> richest to stoop to. Intelligence to govern, ability to exercise auth-
> ority with becoming humility, yet with the requisite firmness, and
> personal demeanour to ensure respect, are all the qualifications for
> office required; and these are in the power of every member to
> acquire.[90]

It was a central tenet of friendly society exclusiveness that this inde-
pendence and this capacity for self-government must theoretically be
attainable by all. This was, perhaps, the artisan conception of progress.
As James Larkin argued, 'The great aim of the members of the Order is
to do good to each other, and to improve the character of the human
race, by inculcating the doctrine of self-reliance.'[91] In practice, however,
there were many who were permanently dependent, as was recognised
by Charles Hardwick of the Manchester Unity of Oddfellows.

> There are, undoubtedly, many sections of society which yet require
> helping onward to their own good by leading strings, gently held,
> and, in some instances, tightly drawn, by the hands of their wealthy
> philanthropic friends and neighbours; but such is not the case with
> the intelligent, self-reliant, industrious artizans — the founders and
> managers of their own provident institutions.[92]

During the mid-Victorian period Kentish London friendly societies
coupled a rejection of patronage with a search for social approval, an
emphasis on independence with a denial of isolation. It was a fundamen-
tal part of the quest for respectability that recognition of its achieve-
ment must come from those thought capable of right judgement. While
the notions of respectability held by the local social elites and aspirant
workers did not always coincide, it was from the former that approval

had to be obtained. The main way of obtaining this was by seeking
honorary members from amongst the towns' leaders. 'They see the
working of such an institution, and by their example show their sanc-
tion and approval of its principles.'[93] Just eight months after its
establishment, the Provident Reliance Friendly Society was looking for
honorary members amongst 'gentlemen of position'.[94] The regular
election of such men to honorary membership of Kentish London
societies has already been discussed, and the approval was readily
obtained. William Angerstein, a member of one of Greenwich's most
wealthy families, presided at a meeting to elect the committee of man-
agement of the Foresters' Benevolent Fund,[95] and Francis Keddell, a
Deptford solicitor, explained that he had become an honorary member
of Court Foresters' Delight because he was 'so impressed with the
society'.[96] The *Oddfellows Magazine,* presumably on receipt of the
newspaper cutting from Kentish London members, quoted with pride
the reference in the *Greenwich and Deptford Chronicle* to the local
Oddfellows as 'a respectable body of men'.[97]

The Kentish London friendly societies were thus an institution of
working-class independence, not separation. The independence was not
from local society, but *within* it. Enmeshed in skilled working-class life,
they were at the same time an established part of the social life of their
towns. This the *Kentish Mercury* formally observed in 1858,[98] and its
columns recorded the fact week by week. In their external activities,
the societies saw themselves as a broad expression of the social attitudes
and position of their members. The anniversaries of the coronation
would be celebrated by the courts of the Foresters and lodges of the
Oddfellows marching through Woolwich together.[99] In the same way,
Kentish London Foresters sought their own distinct company within
the volunteer movement in the 1860s.[100] Local political and parlia-
mentary candidates were given approval by invitations to meetings or
by honorary membership, as when Court Blossom of Kent held a
meeting of 300 persons to confer that distinction on Colonel Sleigh in
1857.[101] The marches through the towns and the public festivities were
the most frequent expression of this outward involvement. Annual
dinners, public gatherings, festivals, at all of which local social leaders
would attend — all of these were launched by a march of members, in
appropriate regalia, through their town. The secretiveness, the
symbolism, the ceremonial of friendly societies were becoming more of
an expression of exclusiveness within a context of social involvement,
far less of a retreat into isolated mutuality in a hostile and insecure
world. The ethos of mutuality so fundamental to working-class life did

not disappear. Its informal survival amongst the less prosperous and less stable section of the working class may be guessed at, although evidence is sparse. Amongst the skilled workers, and scattering of lower middle-class occupations, who built the friendly society movement in Kentish London, dominated it as it expanded, whose ideals and vision provided its ideology and its social exclusiveness, that ethos became transformed. It made its impact upon the developing conceptions of independence and respectability. The structure and the organisations persisted, the ceremonies and the ritual continued, but the involvement in the social life of the town and the search for social approval by its leaders indicate the changing context.

10 POLITICAL IDEOLOGY AND ACTION

Popular political behaviour can too readily be presented as a national phenomenon with local deviations. For so many districts the reality was instead local movements with some national themes. National events, movements and rhetoric were all fundamental in Kentish London working-class politics, but to understand that politics we must see how the experience of their own communities and their own lives within them coloured the behaviour and ideology of the politically-conscious working class. The most important influence of all was the absence of any continuing sense of class hostility. The consequences will become evident: the lack of direction to Chartist activity; the working-class willingness to work with middle-class liberals; the open-ness and lack of aggression of that formal liberalism; the channelling of working-class political demands into a broad and unspecific radicalism that was rarely about local struggles. Without the aggressive and class-conscious bourgeoisie that developed in many provincial towns, especially those where a new nonconformist wealth challenged an old corrupt Anglican corporation, working-class radicals did not need to define themselves against any forceful alternative positions. The reforming liberal leadership that emerged from the community's social elite was rarely challenged as illegitimate or unacceptable. In fact, the working-class political identity that emerged after Chartism took the form of responses to specific challenges, rather than a continuous thread in local politics. The threat of independent working-class political action that remained was of an organisational rather than an ideological kind. There was a genuine if uneven community politics, unified by loose organisation and vague sentiment. Here, as in so many spheres, the working-class presence was distinctive but not isolationist.

Radical politics in these years were dominated by the artisans, independent craftsmen and small shopkeepers who increasingly mobilised both the skilled workers in the main industries and the older craftsmen. The viable working-class liberalism of these groups in Kentish London was a political expression of their social ideology of respectability and independence, of justice and progress. At the centre of that political ideology was a traditional radical position that during this period failed to advance beyond its basic stances. A class-conscious, a labour-conscious, and at times a socialist politics appears in many parts of

199

England, even elsewhere in London, during the 1840s and the 1870s.
Yet this never materialised in Kentish London, where the growing
political integration of the working-class elite mirrored their increasing
social accommodation. Their radicalism was drawn from that English
political tradition derived from Thelwall, Paine and the radical organisa-
tions of those years. Elsewhere that main strand yielded to a politics
that sought a critique of the urban industrial capitalist society in which
an ever-increasing proportion of the population lived. In Kentish
London, however, the response to the difficulties experienced by
working men was an onslaught on the traditional ruling elite. It was a
radicalism of the small man rather than the worker, and sought to dis-
mantle the traditional political structure and the landed privilege that
sustained it. Propaganda attacks centred on the Tory Party, the
established church, the landed aristocracy and large landowners, and
the old professions, while the prime strategy was to achieve the political
democracy that would itself break those corrupt and selfish forces.
Little attention was given to interfering with industrial wealth, for the
issue was not the poor against the rich, or employees against employer,
but the people versus the parasitic elite. The evidence of business and
industrial wealth may not have been relished by those who did not
share it, but it had been earned in a legitimate fashion.

This obsession with the land was not a yearning for a golden rural
age, but the consequence in a changing situation for the most active
sections of the working class of an analysis that was specifically, almost
exclusively, political. If working-class politics in Kentish London was
complacent, this does not mean that it was not radical and at times
aggressive; but it was not concerned with fundamental social change.
The same radical themes could imply a social levelling, even a challenge
to the sanctity of property, in the context of class conflict and intense
social and economic dislocation, and in many places this occurred after
the Napoleonic Wars and during the height of Chartist activity. Yet that
levelling content, that basic challenge to not only the supposedly out-
moded and corrupt elite but also the new social system that it
apparently manipulated, inevitably challenged the coherence of the
ideology and required it to move on to a more satisfying social critique.
This was never necessary in Kentish London where, in the more stable
climate of the third quarter of the century, the traditional radicalism
could be subtly and distinctively developed into a brand of liberalism.
The concerns were comparable — justice, dignity, political equality, the
ending of privilege and corruption and the achievement of political
democracy. They were now expressed through a liberal commitment

that revealed a new degree of acquiescence and accommodation, and
a setting of goals that made sense in the local community, even if by the
1870s the meaning of these goals was being disputed. Equality and
justice were still filled with a narrowly political and constitutional
meaning. As Kentish London working-class politics moved from a
wavering Chartist commitment into a long involvement with liberalism,
it reflected the needs of politically-active working men in just the same
way as did the other institutions examined in this study.

Chartism

Chartism in Kentish London was no indigenous development, but the
result of persistent prodding from outside. There seems to have been
no continuing radical tradition in the area that might maintain political
relationships and an intellectual continuity, in marked contrast to the
central London districts. By April 1841 London boasted thirteen
Chartist localities, but none was in Kentish London, whose initiation
into the movement only came with that second wave of London expan-
sion that saw the establishment of thirty-four metropolitan localities by
May 1842.[1] The chief strengths were always in the City, Soho, Maryle-
bone and the East End.

Kentish London lacked a clear tradition of radical organisation,[2] and
this must explain the slow response in the area to the visits of delegates
to the National Convention. The police, it would seem, were genuinely
unconcerned.[3] The first local branch did not appear until May 1841 in
Deptford,[4] and it grew through that summer to become a joint Dept-
ford and Greenwich Association.[5] Woolwich lagged behind, as always in
such matters. It was in July 1842 that the movement was emphatically
established, with a massive open-air demonstration in Deptford Broad-
way following a Chartist take-over of a public meeting on the distress in
the north.[6] Only then would it be realistic to talk of a serious Chartist
presence in Kentish London. A brief chronology of the local movement
reveals a general inactivity in 1843 and 1844, when simply maintaining
organisation seemed a full-time political task. Only grand political
meetings might temporarily reinvigorate the cause, as when new enrol-
ments followed O'Connor's meeting in Greenwich in December 1843,[7]
but fresh headway was only made in 1845 with a revival built around
the Land Company. By June 1845 that organisation was providing most
of the news that came from Deptford and Greenwich,[8] as it did again
after a brief revival of general Chartist activity in 1846. The final stage
was the new Chartist campaign launched in October 1847,[9] which
continued up to the march from Kennington Common. The inconclu-

siveness of that demonstration, and the arrest of national leaders, marked the effective end of the movement in Kentish London. Reorganisation in June 1848 provided no real basis for activity, and the police noted that 'the Chartists (in Greenwich) appear, since the apprehension of the Chartist leaders, to be becoming gradually more lukewarm in the cause'.[10] Subsequent enquiries elicited even less evidence of concern amongst the Greenwich police force.[11] Sporadic attempts at local reorganisation over the subsequent eight years met with little success.

Even within a heterogeneous London Chartism, the movement in Kentish London appears distinctive. One-third of all localities in London in the period 1841-3 were tied to a single craft or trade,[12] but there were no such groups in Kentish London. There, the residential community was close enough for a satisfying social and political life to be sustained, in contrast with those constraints of size and anonymity in the central areas that made the trade the only community that could provide a realistic basis for Chartist organisation. The relative weakness of Kentish London Chartism may be due to the absence of this trade structure in a situation where local class conflict could not provide a sufficient basis for political momentum. The dominant trades were not those such as cabinet-makers, silk-weavers, shoemakers and tailors, that lay at the centre of working-class organisation elsewhere in the metropolis, trades threatened by the growth of specialisation and mechanisation, and changes in organisation.[13] It was significant that the National Association of United Trades, an important example of the type of organisation based on these occupational groups, made little impact in Kentish London.[14] On the other hand, however weak it may have been, Chartism in Deptford and Greenwich did create a positive political presence and mobilising force in the 1840s. The small core of committed activists who maintained the thread of Chartism through the decade were none the less able to mobilise considerable support on the great occasions. Around two thousand were in Deptford Broadway in July 1842, and over twice that number on Blackheath the next day to greet Dr McDowall.[15] There were regular audiences of around one thousand for Chartist public lectures and meetings.[16]

It was not great meetings but continuity of organisation and wider geographical links that made Chartism a significant stage of working-class political development, even in an area of such limited success as Deptford and Greenwich. For most of the 1840s, the Chartist cause was given an identity and a solidity by the permanent existence of a district of the National Charter Association. The district was organised,

funds were regularly collected, officers appointed and members recruited. Whenever a revived agitation was possible, it was under the Chartist banner that it was formed. Through the *Northern Star* and, less effectively, *The People's Paper*, a sense of a national political movement developed that was to be vitally important in the national formulation of political activity from the 1860s. Reports were regularly sent to those papers, contributions made to funds for political exiles or foreign causes, representatives elected to metropolitan and national conferences. The importance of all this must not be lost sight of in the general picture of instability and weakness, for the continuity was provided by more than just leadership. Indeed, there seems a striking absence of continuity among Chartist leaders in Kentish London.

Three men dominated Chartism in the area throughout its existence.[17] Joseph Morgan, a young tallow chandler, was the first treasurer of the Deptford Charter Association in 1841, and prominent in all spheres of local Chartist activity. George Floyd, a Deptford baker about the same age as Morgan, was a leading member of most Chartist bodies in the area, and subsequently took a lead in the Reform League and the Advanced Liberal Association. The third principal figure was Thomas Paris, an elderly Scottish smith who had come south in 1819, and who contributed immense political experience. As one political activist observed of him, 'Castlereagh has done much good for men unknowingly. He persecuted a few noble spirits and forced them to scatter abroad and their minds have acted on the minds of others.'[18] If no others were active over such a long period, there were many whose involvement was briefer but equally vigorous. Such men were the Scottish engine-fitter Walter Friar, the shoemaker James Bligh, and the plasterer Charles Firth, who left in 1847 on winning a Land Company site. The occupations have been established of only one-third of the 111 Chartist activists[19] in Kentish London. Of those thirty-four, there were five small retailers, eleven small craftsmen, thirteen skilled workers in the engineering and building trades, three gardeners, a labourer and a coachman. There are no grounds however for regarding the sample as in any way representative. More certain, perhaps, is the limited nature of the continuity amongst those leaders. Individuals might well have moved from a low-level involvement in one period to activism in another, but it is still notable that of the thirty-six activists in the initial period from 1840 to 1842, only five were active in the next principal upsurge between 1846 and 1848. Similarly, of the twenty-eight activists in that latter period, only eight led the attempted reconstruction from 1849 to 1852.

Kentish London Chartism, a faltering and intermittent movement lacking a wide continuous leadership, seems to have lacked drive and direction when compared with many other areas, particularly the northern and midlands industrial districts. More specifically, it lacked local targets. Recent Chartist historiography has stressed the extent to which the movement's dynamic rested on local social and economic conflicts, notably hostility in the north and some midlands towns to the manufacturing bourgeoisie.

The studies in Asa Briggs's collection illustrate the close relationship between technological change, struggles over economic conditions and over issues such as factory reform and the new poor law on the one hand, and the nature of Chartist activity and ideas on the other.[20] Social and economic relations in Kentish London gave few local issues with which to invigorate the national Chartist demands. Phrases about independent and class action were not given their meaning by a series of local conflicts. This is not to deny the existence of a genuine and determined radicalism, but it was of a traditional kind that could inform mid-Victorian popular liberalism as easily as Chartism. Central London associations moved from such a traditional radical position towards a more class-conscious Chartism after 1840, responding to a withdrawal of non-working-class radicals, militant strike action, economic distress and embittered class feelings, all of which affected most strongly the declining London trades.[21] In the different conditions of Kentish London there was little sign of these trends. Even the stonemasons' strike penetrated the area only through its extension to men at work at Woolwich Dockyard. Demonstrations that led to clashes with the police were fundamental to the radicalisation of inner London Chartism during 1842, but there were no such conflicts with local authorities in Kentish London beyond the isolated affair in Deptford Broadway.[22] The indignation of Greenwich Chartists on being refused the use of a room they had booked in October 1850 suggests that such occurrences were rare. Their threat of legal action in the county court — a revealing response — was stoically taken by the lecturer, Bronterre O'Brien, who announced that he was used to such treatment.[23]

Far from the relationship between the Deptford and Greenwich middle class and the Chartists being one of hostility, there were in fact many points of contact within the overall framework of working-class independence. The efforts made by middle-class reformers were significant, for these men were dominant figures in the community and in its liberal politics. The prosperous draper, John Wade, Deptford's leading liberal for many years, was active in the Metropolitan Parliamentary

Reform Association, whose aim was to moderate Chartist demands and launch a joint agitation.[24] A Greenwich Reform Association was formed in 1840 to campaign for a measure of parliamentary reform as well as the repeal of the Corn Laws. Its leaders — the magistrate and retired naval officer Captain Fead, George Borrett, Joshua Hargrave, the prosperous grocer Joseph Peppercorn, and others — were figures prominent in the social elites of the community.[25] The repeal of the Corn Laws was linked in these associations with a demand for more extensive parliamentary reform. In many areas, there was a vigorous conflict between repealers and Chartists that derived not from theoretical positions but from local antagonisms which had often been fuelled by agitations, over the poor law and factory reform, that were absent from Kentish London. More significant in explaining the weakness of such class hostility was the absence of a strong manufacturing and commercial interest whose aggressive self-confidence was spurred by religious and civic developments.[26] Working-class consciousness in these years fed richly off the extent of middle-class consciousness. In Kentish London, however, where branches of the Anti-Corn Law League held occasional meetings but failed to maintain any continuous organisation,[27] the Chartists agreed with the free traders that it was the privileged landed classes who deserved the principal onslaught. The suspicion of middle-class political groups that persisted was thus based more on a political mistrust than on a locally-generated social and economic hostility.

The identity of Kentish London Chartism must not be lost. The movement never actually called for Corn Law repeal — although in May 1846 it demanded firm opposition to the Protectionists.[28] It always opposed formal class collaboration in politics. These firm positions of national Chartism were essential to its coherence, and comprehensible in the context of the national politics of those years. Yet with no local class conflict manifesting itself socially and politically, there was a lack of direction to Chartism in the area. Deptford Chartists might feel that they ended a long discussion with 'two gentlemen corn law repealers' with the latter's 'complete discomfiture', but they were willing to admit such men to their meetings and carry on a long dialogue with them.[29] This carried over into a willingness to work with middle-class liberals, themselves dominant figures in the local community, on issues that did not encompass franchise reform, as when Deptford and Greenwich Chartists gave their support to the local liberal campaign over church rates, and congratulated them on their work.[30] David Wire, Liberal candidate in the 1847 election, thought that

'though there were some good things in the People's Charter, I am not
at present prepared to say that I can support it as a whole'. On suffrage
he would go no further than a great extension, and he rejected annual
parliaments.[31] Yet local Chartists, on such compromising grounds,
decided to give him support. Samuel Kydd, a national Chartist figure,
appeared on the hustings as a candidate although there seemed to have
been no local deliberations.[32] His position was firm, rejecting all
liberals alike — 'Barnard is an old Whig, Salamons a younger' — but the
local Chartists were less forthright. They were proud that Dundas and
Salamons approved of Kydd personally, and they reported in the
Northern Star that 'despite of interest and faction, even Admiral
Dundas honoured our candidate . . . and the committee of the opposi-
tion candidates who were on the hustings, unanimously praised Mr
Kydd's address. It was cool, temperate and logical'.[33]

Kentish London Chartism thus developed out of the local society of
whose politics it was a part, while using the position of a national
politics towards which it was reaching out. The national contacts were
very important, yet it is fascinating to note the way in which the ideo-
logy of the movement in the area remained fixed within that tradi-
tional radicalism which sought its targets not amongst the capitalist and
the employer who formed an increasingly important part of Chartist
consciousness in many other areas, but amongst the landed classes, the
privileged aristocracy, the church and the monopolist. Justice and fair-
ness within a traditional radical framework was the demand, and it was
later to dictate the attitudes of the Reform League and the Advanced
Liberals in the area. The Greenwich smith, Thomas Paris, gave his view
of Chartism. 'I do not know whether I am a Chartist, but I want equal
justice, and I don't know whether this is being a Chartist.'[34]

Joseph Morgan outlined their targets in 1848. Talking about the
parliamentary representation of the Borough, he asserted vigorously,

> . . . if you desire the aristocracy to be represented, return a lordling;
> if you wish the army to be represented, return generals; if you want
> the government and navy to have a monopoly of your representation,
> why, continue to return Admiral Dundas; if you wish the Church to
> be represented, find a Sir Robert Inglis; if you wish the people to be
> represented . . . return Samuel Kydd.

At the same meeting, another Chartist 'believed that their greatest
enemies were the parsons'.[35] The traditional bases of the privileged
ruling elite came under fire, and the argument was primarily neither

economic nor even social, but concerned with politics and justice. The analysis of oppression never went beyond 'class legislation', for it was political deprivation that was central for the Chartists of Deptford and Greenwich. As Joseph Morgan argued, 'class antagonism, gross anomalies, and monstrous inequalities, are the results of the present system of legislation'.[36] Class legislation depended upon aristocratic domination, the power of the church and the monopolistic control over the land. This was a traditional critique that can be traced back to Paine and Thelwall, although specific sources need hardly be established for that current of popular radicalism that emerged from the 1790s as a central element in English lower-class politics. Nevertheless, Paine himself was regularly lauded by Kentish London Chartists, with public celebrations of his birthday. The traditional radical gallery of saints were their mentors. 'We desire to promulgate the great political truths handed down to us by those immortal philosophers and patriots — Jefferson, Franklin, Paine, Cobbett, Cartwright and Hunt, contained in the document called the People's Charter, by lectures, public discussion, reading, etc. . . . '[37] This repeated concern of Deptford and Greenwich Chartists for education and lectures of both a political and non-political character[38] points to the rationalist approach that underpins one strand of English popular radicalism, a faith that knowledge and understanding must constitute the downfall of political oppression. Walter Cooper illustrated the targets and the rationalism. He said that it was 'not that the working classes wished by physical force to raze to the ground the altar and the throne; because they would prefer by the spread of knowledge to remove its basis; and when they fell, depend upon it, they never would be built again'.[39] Another local Chartist expressed his faith in public meetings and education 'raising up and concentrating the mind that will, by and by, be too strong to be assassinated by priests or successfully conspired against by kings and princes'.[40]

The Kentish London Chartists rarely tied the six points and their vision into any conception of the local communities and the local economic structure in which they lived their lives. The landed elite, the church and privilege were under attack, because in traditional radical analysis they stood for the sources of oppression from which political inequalities stemmed. An intriguing address in 1850 from the Greenwich Charter Association based the justice of their case on working men's industry, hard work and service to the nation; absent was the aggression of the 'fruits of one's labour' argument being mobilised elsewhere. The association demanded national and unsectarian education, manhood suffrage and the payment of MPs, no taxation without representation,

no union of church and state, opposition to the National Debt, to the present poor laws, the game laws, primogeniture and entail, and the demand for fair wages and full employment.[41] It is interesting to note the similarity with Advanced Liberal demands in a document twenty years later.[42] This continuity of themes is as important as the different degrees of political integration that lay behind the movements that produced them.

The anti-capitalist theme, basically absent from Chartist rhetoric in Kentish London, does appear occasionally after 1850, at times when Ernest Jones's influence was strong. The best expression is by Joseph Morgan — 'What are the capitalists for the workmen: they knew that the greater was the competition for work the greater was the profit derived'[43] — yet he himself ignored such an analysis on most other occasions. In any case, local Chartists were by now few and had little impact. Before the 1848-9 disintegration, John Gathard told a story far more representative of the recurring themes of Kentish London Chartism.

> The musician said did we not perform that piece of music well. 'Yes', responded the organ blower, 'we did.' 'You,' said the musician, 'what had you to do with it.' On the next occasion when a fine and magnificent piece of music was performed, all at once the organ ceased in a most difficult portion of the music. The musician shouted out most lustily. The organ blower coolly put out his head, and very quaintly said, 'Then shall it be we?' Now, he thought, they had been organ blowers to the aristocracy long enough. The time had arrived when we should let them know that the industrious portion of the population are somebody.[44]

It was this popular radical concern over landholding, rather than any utopian rural communitarianism that explains the Kentish London enthusiasm for the Land Plan. Even to O'Connor, the originator of the scheme, there was no really coherent political content, 'merely a rather muddled feeling that there was a connection between landholding and political power'.[45] The Land Plan generated the Kentish London Chartist revival in 1845, the focus of most activity at a time when the scheme was still only gradually spreading to the south of England.[46] It is clear from the chronology and the personnel that the land was a central issue, rather than the concern of fringe Chartists. Regular meetings went beyond the collection of subscriptions to the discussion of Chartist politics. By June 1845 Joseph Morgan was calling for 'the

repeal of the enclosure of common acts and the reconstitution of the
land to the people'.[47] The motivation behind individual involvement in
the Land Plan is almost impossible to penetrate, but its importance to
Deptford and Greenwich Chartists suggests a genuine commitment to
the peasant smallholding ideal. This 'small proprietary class'[48] rather
than any more communitarian conception was the aim of O'Connor
and it was part of those traditional radical concerns dominant in
Kentish London Chartism. Local success was fostered by members
winning sites in the ballots, among whom was one leading activist, John
Gathard.[49]

The general peacefulness of Deptford and Greenwich Chartism is
hardly unexpected. Without local issues or hostilities to inflame
opinion, there prevailed a vague constitutionalism that was only coloured
by a traditional language of popular self-protection.[50] At a massive
Deptford meeting at the Lord Duncan in 1842, Dr M. Drury, an Irish
radical, argued that the Charter could only be obtained 'at the point of
a bayonet'. He was ridiculed by the audience and sat down amidst
'derisive laughter'. He was told that the Reform Bill and Catholic
Emancipation had both been carried out without resort to force; the
audience affirmed their faith in constitutionalism.[51] The basic assump-
tion of the use of 'every legal and peaceable means'[52] prevailed. It was
the involvement of George Davis, a self-appointed police spy,[53] that
introduced talk of violence and arming of a limited kind. The middle
months of 1848 were a period of arrests and disruption in the national
Chartist movement and this atmosphere was aggravated by Davis's entry
into the Wat Tyler Brigade in Greenwich as an *agent provocateur*. He
offered to sell weapons, recruited fresh members and opposed the
dissolution of the local association.[54] It is clear from Davis's evidence
that some local Chartists had bought weapons from him in response to
his encouragement of fears of repression. The act was out of character
for local Chartists and very few were involved — notably Paris and
Pinegar. The Old Bailey trial of the central London Chartists and Green-
wich police memoranda suggest that an atmosphere of fear and isolation
amongst Greenwich Chartists led some into this defensive response.
Davis himself commented that 'Bligh is in great trepidation at
present'.[55] Their concern was to defend themselves against what they
were encouraged to believe were to be attacks by the authorities. June
1848 was no time to think of taking power through violence.

The local movement thus disintegrated in some confusion. Neverthe-
less, the numerous Chartists who reappeared in later movements of one
sort or another strengthen the argument that the experience of Chartist

organising was, in spite of its specific limitations and diffuseness, an important one for working men in Deptford and Greenwich. The experience of organisation, self-expression, and self-confidence was a formative one for those involved and it is perhaps the most important continuity of all in many parts of the country, including Kentish London. E.W. Belbin was to be secretary of the Greenwich Reform League, an Advanced Liberal and a leading local secularist. George Floyd, the baker, was as active in the Reform League and Advanced Liberals, and ultimately in parish government, as he had been in the Charter Association. As political activity declined in the 1850s, some turned to other forms of organisation. Walter Friar, the Scottish fitter, was on the committee of the Deptford Mechanics' Institute, and then returned to political work with the Reform League and Advanced Liberals. Charles Rubery, a Deptford boilermaker, first appears in the Chartist movement, but between then and his involvement in liberal radical politics, we find him leading the Deptford Working Men's Co-operative Provision Association, the Perseverance Boilermakers, and the Deptford and Greenwich Co-operative Shipbuilders. John Longmaid, a Greenwich tailor, went on from Chartism to the Advanced Liberals, the Reform League, secularism and the Deptford Radical Association and, in trade unionism, the Greenwich Labour Protection League. E. Robinson was in 1862 a trustee of a Deptford temperance friendly society, while a fellow Chartist, George Witherby, had been secretary of a Deptford lodge of the Loyal Briton Friendly Society. This list could continue. Although there can be no statistics of continuity, for the evidence is totally unsystematic, it is clear that for many working men in Kentish London the initial experience of Chartist organisation and activity was a vital part of their involvement in artisan associations, whether political or otherwise, in later years. The continuity of political tradition that will be noted must not be allowed to hide this additional organisational continuity.

Electoral Politics

The Borough of Greenwich received its parliamentary status as part of the 1832 redistribution, and from then until the 1870s it was consistently Liberal to a greater extent than even the metropolis as a whole. The fifteen elections and by-elections from 1832 until 1873 returned twenty-five members, of whom only three were Tories —M.W. Attwood in 1837, Peter Rolt in 1852, and T.W. Boord, whose 1873 by-election victory over a deeply divided local Liberal Party initiated a long Conservative domination of the borough. The real arguments in the area

took place within the Liberal camp, and this is reflected in the fact that between the two Reform Bills thirty-one Liberals stood in elections compared with only eight Conservatives. Only in Woolwich did the Conservative vote ever seriously challenge that of the Liberals, and there, after Palmerston's death, it was the Liberal identification with a weak foreign policy that most harmed them. On the whole, particularly in Deptford and Greenwich, the working-class organisation and vote were firmly Liberal.

Contemporaries thought that government influence in the borough was considerable,[56] but the Greenwich experience supports Gash's view that 'even on a preliminary analysis that influence (in "Government boroughs") tends to shrink to much smaller proportions than was commonly allowed in this period.'[57] It is true that government candidates were often successful, but there was far less difficulty in the choice for Greenwich was a two-member constituency. At many elections the voters would return a government nominee alongside a more radical Liberal. Through the 1830s and 1840s the representation was principally shared between Sir James Dundas, who rather inadequately commanded the naval operation in the Crimea during 1854, and the Liberal-Whig landowner and shipbuilder, E.G. Barnard. When Barnard died, there was no government nominee to oppose the Jewish banker, David Salamons, a far more radical reformer than Barnard,[58] but on Dundas's resignation Sir Houston Stewart, a Lord of the Admiralty, successfully defeated the reforming Liberal Montagu Chambers in a by-election. This pattern continues until the second Reform Act, with Dundas, Stewart, Codrington, and probably the weak Liberals Angerstein and Bright, identifiable as either directly or indirectly government MPs.

It is difficult to decide how far specific influence was mobilised, and how far it was perfectly reasonable for electors to vote for a candidate (one of two to be elected) who would be extremely useful to a borough so dependent upon government decisions. There was direct manipulation, but the *Kentish Independent* thought that government nominees could only succeed when there was a Liberal government.[59] Certainly, neither Derby in 1859 nor Disraeli in 1868 could get their candidate returned. The allegations of corruption in 1852 led to fiercely resisted and unsuccessful attempts to disfranchise government workmen in the following year.[60] Five years later Joseph Blow wrote to the chairman of the committee for Sleigh, Codrington's radical opponent, that Codrington had called on him and promised that, in return for his vote, Codrington would 'pay me a visit to my satisfaction after the election'.[61]

Yet such examples can be found in many mid-Victorian constituencies, and there is little evidence to support the view that Greenwich was a nomination borough. It was not difficult for a Liberal government to get its candidates elected, far more difficult for the Conservatives, and the seat would be shared with a more radical MP. If the electors of Greenwich had it both ways, who can blame them?

The regularity with which Greenwich elected Liberals was no result of party organisation, for it was renowned as a loosely organised borough for both parties,[62] until in the 1870s the Conservatives markedly improved their organisation, especially over registration, with important results. The Liberals were extremely lax over these matters, taking for granted the borough's political complexion. Organisation was almost anathema to Greenwich Liberals in the 1850s and 1860s. They were no coherent party, but a conglomeration of local sentiments and a flux of committees. In election after election more Liberals stood than could be elected – in six, the only contest was between rival Liberals of one shade or another. If it failed once, in 1852, when the Conservative Rolt won on a minority vote, there was generally no need to organise the borough. Greenwich Liberalism traditionally depended on informal contacts. Only in the 1870s, under the pressure of Conservative organisation and success, the evident need for registration activity, and open tensions within the Liberal movement, were more formal organisations set up.

Organisational inadequacy, more than anything else, explains the Conservative successes of that decade. T.W. Boord, the Tory distiller, won a seat in a by-election occasioned by the death of Salomons, sharing the representation with Gladstone from the 1874 election. Gladstone's distress at the 1874 result was based on aesthetic rather than political considerations. 'My own election for Greenwich after Boord the distiller', he wrote, 'is more like a defeat than a victory, though it places me in Parliament again.'[63] In 1880 Gladstone departed and Boord was joined by a second Tory, Baron de Worms. The local legend of a secret alliance between Boord and local publicans sounds an improbable explanation of lasting success in such a large electorate.[64] The initial explanation must lie in the organisational failings of the Liberal party. The wrangles that led to the gradual defection of the essential working-class activists will be examined later, but it is important to note that it was the Advanced Liberals who made the only real attempts at registration. In 1873, the local press complained loudly about the state of the party's organisation in the borough, arguing that the 1873 register was a disgrace to the local Liberals. Only forty-seven lodgers were on

the whole register.[65] Worse difficulties in 1876 led to efforts to reshape Liberal organisation, consciously imitating the Birmingham system.[66] The general disunity and apathy, a broad failure to recognise that Greenwich could ever be anything but Liberal, led to more laxity in registration, a key factor in the 1880 double defeat.[67] It would seem that the Greenwich electoral register between 1870 and 1900 was largely a creation of the Conservative Party.[68] The general trend of prosperous middle-class Liberals towards Conservatism in the closing decades of the century can only have increased the broad difficulties of the Liberal Party in Greenwich.[69]

The Liberal Party in Kentish London

Politically active workers became progressively integrated into the electoral politics of the borough. The very informality of Greenwich liberalism made this easier, as did the existence of one stream of borough MPs whose reforming tendencies made contact with traditional popular radical concerns, and gave them some expression in formal politics. They ranged from Salomons and Chambers to the more outspoken John Townsend and David Wire. The last-named missed election mainly because he advocated reductions in public establishments and thus alienated the Woolwich vote.[70] Equally important was the reforming stance of the local Liberal leadership. The occupations have been identified of thirty-three out of fifty-two leading middle-class Liberals of the period. Fourteen were retailers, like the draper John Wade, the grocer Joseph Peppercorn or the corn-dealer Bowditch; seven professional men, like solicitors Barwis, Keddell and Jones; six small industrial employers like the hatter Tanner, the shoemaker George Carpenter or the builder Robert Jolly. Most were members of the social elite of their communities, and their liberalism embraced reforming ideas that gave it an additional point of contact with the stable artisans of the area.

Greenwich earned its reputation as the most radical borough in Kent.[71] The Borough of Greenwich Parliamentary and Financial Reform Association was established in 1849 and, under the leadership of prominent Liberals, it soon had 300 members,[72] demanding household suffrage, the ballot, triennial parliaments, equal electoral districts and the abolition of the property qualifications for MPs.[73] In other towns the Association generally represented the radical middle-class interest against entrenched Whig positions,[74] but although Greenwich did contain older, often landed Whigs, like William Angerstein, the conflict was not serious. The forefront of Liberal politics in Kentish London was

generally occupied by such men as those in the Greenwich Association. The reforming activities of leading Liberals continued into a period when the drive to achieve class reconciliation was less urgent. The Woolwich, Plumstead and Charlton Reform Association, for example, was established in January 1853 and united leading Liberal tradesmen and Arsenal artisans.[75] At an 1858 reform meeting in Woolwich Town Hall the platform was taken by prominent Liberals, among them Robert Jolly and Rev. Tuffield, together with Fordham and Armstrong, two Arsenal artisans and future Advanced Liberals. This predominantly working-class meeting demanded household suffrage, the ballot, triennial parliaments and the abolition of the property qualification for MPs.[76] The alliance became closer during the agitation the next year which grew out of the clause in Derby's Reform Bill to disfranchise government workers. Prominent Liberal reformers took the lead, notably the draper John Wade and solicitors Francis Keddell and William Jones; they called the meetings and organised the campaigns, supported by an active working class that attended and spoke at meetings, yet never took the initiative.[77]

The viable political accommodation achieved between working-class political interests and the mainstream of the borough's Liberals was helped by the weakness of Liberal organisation, for it made less likely a conflict between rival leaderships over the direction of policies or activities. The general incoherence of mid-Victorian liberalism was well reflected in Greenwich, with an essential openness and informality paradoxically encouraging the integration of working-class politics while allowing the growth of a cliquishness that was later to fragment the movement.

This integration was helped by the size of the Greenwich electorate, rising from 6,907 in 1854 to 9,765 on the eve of reform and 14,034 on the first post-reform register.[78] With 52.7 per cent of the electorate classified as working-class in 1866, all qualifying as £10 occupiers, it was one of only eight boroughs to boast a majority of working-class voters.[79] Doubts might be cast on the definition of working class employed in compiling these figures, but the comparative significance is clear. A feeling of political exclusion was less likely to develop, even before the 1867 Reform Act, and this is confirmed by the extraordinarily high turn-out at elections by those better-off workers qualified to vote. Between 1832 and 1859, 70 per cent of all Greenwich electors voted at elections, compared with a metropolitan average of 53 per cent.[80]

Yet beyond these preconditions for a fuller political involvement lies

the nature of Gladstonian liberalism as understood by the politically
active working class in the area. John Vincent touches on the heart of
the matter. 'For the nineteenth century man', he writes, 'the mark or
note of being fully human was that he should provide for his own
family, have his own religion and politics, and call no man master. It is
as a mode of entry into this full humanity that the Gladstonian Liberal
Party most claims our respect.'[81] These are the very qualities of respect-
ability and of dignity that colour so much of the ideology of Kentish
London skilled workers. Working men had been voting Liberal for
many years, but what is important is not so much the rare and often
peripheral act of voting, but the political campaigning, pressurising and
organising that signified from the 1850s a relationship with Liberalism
that was real if often tense. By the middle of that decade, working-class
radicals were seeking links with middle-class Liberal reformers. Amongst
the former were men like Joseph Morgan, Charles Jeffries and John
Longmaid who joined the Chartist separatism of the previous decade to
the radical Liberalism of the Reform League and the Advanced
Liberals. Longmaid called for moderate compromise in activity
providing that purity of principle was maintained. 'What do we gain, he
asked, from opposing middle-class movements that do not go all the
way with us?

> Would it not be better for us to endeavour to enlist the sympathy of
> all classes to act together in the obtainment of the largest measure of
> Reform possible under the circumstances, by throwing our weight,
> influence and intelligence, with a courteous bearing, without
> pandering, and without sacrificing a single point of principle?

He argued that they would not succeed without middle-class liberal
reformers, and a wider body of working men.[82] He was soon joined by
the rest of the Chartists in Greenwich and Deptford. 'Seeing the present
position of the middle classes standing in need of great reform, we are
willing to co-operate with them in any Reform movement that would be
beneficial to the whole people.'[83] A year later a Greenwich branch of
the Political Reform League was established as a joint campaign of
middle-class and working-class reformers.[84] This co-operation, which
reached a peak with the enthusiastic election of Gladstone himself as
Member of Parliament for the borough in 1868, derived from that de-
pendence on sentiments and feelings rather than programmes which was
the key to the Liberal Party's viability in the country. Vincent has
rightly observed in this connection that 'the possibility that, propaganda

apart, the working class was genuinely liberal in the same way . . . as the middle class has not been sufficiently considered'.[85] The plans to elect Gladstone grew with active working-class support when his failure in south-west Lancashire seemed probable. With Sir David Salamons he won a resounding victory over the Conservatives in the first election on the enlarged register.

Yet the reality became clearer, the myth receded and the enthusiasm for Gladstone in the borough was to wane. While the myth lasted — and the illusion of Gladstonian liberalism lasted longer than that of its titular head — its power was undeniable. The reason for the success was less Gladstone himself, and more the wider role of a liberalism that stood for justice and fairness, dignity and respectability, independence and reform. The words are vague, yet were filled with meaning. More correctly, with meanings, for it was disagreement as to what they meant that lay at the core of the disputes in the 1870s. Kentish London Liberalism drew working-class radicalism into the formal politics of the area. Yet it is not a discrete political sphere that we are examining, but one that enmeshed with the social life of the community and the ideological traditions of its working-class politics. What underpinned this accommodation was not so much the negotiation of political demands, but a developing involvement of a section of the Kentish London working class with the social life of the area, with its elites and aspects of their values. If the Liberal Party revealed a lack of policies and a concentration on sentiment and posture, that was precisely what appealed to these working-class Liberals. A large part of their radical demands were, after all, mainly that — especially those dominant themes relating to questions of the land and privilege. It was a search for rational solutions to social problems, the release of individual initiative and energy and the ending of privilege and monopoly that characterised Liberalism and its appeal to the mid-Victorian artisans in Kentish London.

The 1857 Elections

Several strands of this working-class liberalism are illustrated in the elections of 1857 and it is therefore worth while to examine those events in detail. In February 1857 Peter Rolt resigned his seat on accepting a government contract. In the ensuing by-election the government nominee, Sir William Codrington, defeated a radical Liberal, Colonel Sleigh, by a vote of 2,893 to 1,579. Only a month later came the general election, at which Codrington was again returned. The second sitting member, Montagu Chambers, was forced into third place

by another radical Liberal, John Townsend, a local auctioneer who had been Sleigh's agent. There was even more enthusiastic working-class support for Townsend than for Sleigh, partly because he was a local candidate, but also because it was now possible to elect a radical Liberal without the damaging ejection of a government nominee.

Sleigh's campaign took as one of its main themes the need for the people of Greenwich to show that they were not subservient to the government.[86] Independence and the free integrity of the responsible citizen were fundamentals of the liberal creed, but the case could be dangerously overstated, for working men were not willing to see their respectability threatened by the suggestion that they had actually become slaves. One government artisan, John Climock, demanded at a public meeting that Sleigh reject a letter that had appeared in his newspaper speaking of 'dockyard and Arsenal slaves'. Sleigh responded adeptly and explained that he referred to clerks and government officers, not artisans and workmen. Loud cheers.[87] Nevertheless, they went on to elect Codrington. The local Liberals were divided, for although Sleigh's politics were more acceptable, the government candidate was useful. John Townsend was really pitted against Chambers, not Codrington. Chambers was a reformer but he had not looked after the Liberals of the borough well enough. They felt that this ambitious lawyer-politician was devaluing the electors. The London correspondent of the *Newcastle Chronicle* explained that 'the working men of the locality got it into their heads that they were made mere tools of by Mr Montagu Chambers'.[88]

The political stand upon which Sleigh and Townsend obtained widespread support connects with the traditional targets of working-class radicalism identified throughout the chapter. Both advocated the ballot, franchise extension, abolition of church rates, abolition of income tax, religious freedom and attacks on aristocratic government.[89] They gave special attention to aristocratic rule, for the privileges of the landed class depended upon the pernicious income tax levied upon the non-parasitic elements in society. Sleigh argued that, after the ballot had been introduced,

> it is true that you may not have men for your representatives who are professed scions of aristocracy, with their emblazonments, but you will have men who will be really your representatives in the House of Commons, who will zealously vindicate your cause, and who will resist the gross injustice of one class of society being crushed to the earth by a tax from which the other class is compara-

tively exempt.

This attack could be neatly widened into an onslaught on that structure of aristocratic leadership exposed so painfully during the Crimean War, for Sir William Codrington had been Commander-in-Chief in the Crimea. 'The valour of the troops was not to be questioned; but it was made painfully apparent that it had been commanded by fools.' The radical assault on privilege, corruption and injustice was thus mobilised. Army leaders, as all others, must be selected on merit not patronage.[90]

These were the political positions to which the working-class voters and non-voters of Kentish London responded. Their enthusiasm stretched to the refusal of the artisan band at Deptford Dockyard to play for Codrington, in spite of the benefits they might expect from his election.[91] Yet both Sleigh and Townsend attracted widespread support outside the working class. Sleigh had been invited to stand by many influential Liberals, including John Wade, Peppercorn, David Bass, Clemmison and Carter Moore,[92] and although these divided at the general election between Townsend and Chambers, the former's success indicates the extent of his middle-class support. The large Liberal building contractor, Eugene Murray, was one of Townsend's most important supporters, particularly in the trying period that followed his election. Only seven months after his success he came close to bankruptcy, but was saved by a subscription raised by local radical Liberals, mainly artisans and tradesmen.[93] Local committees organised support for him that seems largely to have come from artisans in the major industries.[94] The relief was only temporary, and a year later he resigned his seat, owing £5,901 − a fair amount of it expenses incurred on behalf of Sleigh.[95] After his resignation he took to the stage with his family, and toured London playing Shakespeare. At one performance in the Greenwich Lecture Hall he recited from memory the whole of *Richard III*.[96] He was no more successful in dramatic novelty than in business, and emigrated to Canada.

Serious working-class activity was thus a response to specific political challenges to their position in local politics. It was not exclusively working-class, however, for it attracted a much wider range of Liberal supporters. The movement, like that of the Reform League and the Advanced Liberals later, was firmly within the liberal radical tradition, aiming at throwing off patronage by government or by political opportunists, and at obtaining a far greater degree of popular control over the selection of candidates. Radical candidates with strong working-class backing stood in many constituencies in the 1857 general election.

Yet, elsewhere, a labour consciousness often emerged from local indus-trial conflicts and coloured working-class radicalism, making it part of a local *social* conflict as well as a political one.[97] These were not the origins of the Greenwich movement which, although asserting a strong working-class political dignity and independence, never isolated itself from a wider local network of liberal opinion. If the struggle was a refusal by politically conscious working men to accept political domin-ation by others, it was also one stage in that continuing tension between involvement with local liberalism and protest against its ultimate failure to grant them full political status.

Reform League

Kentish London was penetrated early by the Reform League,[98] and from its outset the agitation reflected both the emerging co-operation with middle-class Liberals and the liberal radicalism of working-class activists. Here, too, there was considerable overlap between the leaders of political, social and trade union organisations. Most Reform League activists were to be at the forefront of the Advanced Liberal movement, while at least six had been leading Chartists, and this leadership came from the same stratum of skilled workers and small shopkeepers. The most active were two fitters, a bricklayer, a shipwright, two bakers, a clerk in the Arsenal, a shoemaker and a licensed victualler. If these men frequently appear in other artisan institutions, the relationship of ideas within the structure of artisan ideology was as relevant as that of personnel.

If the various reasons for demanding an extension of the franchise are polarised as a concern with either power or equality, the reality may be distorted but the distinction is clear. A concern for freedom and justice was central to Chartist arguments, especially in Kentish London, but in many parts of the country these more indeterminate formulations yielded to a concern with popular power; at times and in places with class power. This gradually yielded to a language of reform that talked of civic equality and justice in bringing working men within the pale of the constitution. Each member of the Reform League carried on his membership card the words of Gladstone, 'Every man who is not pre-sumably incapacitated by some considerations of personal unfitness or of political danger, is morally entitled to come within the pale of the Constitution.'[99] Kentish London working men spoke in just these terms. George Floyd moved at a Reform League meeting at Blackheath 'that in the opinion of this meeting the time has arrived when the industrious classes of the country should be entrusted with the franchise'.[100] It is a

language of trust and recognition, a demand that the manifest injustice of denying the vote to upright tax-paying citizens should be undone, and that the working class be recognised for what it was. The demand was for all working men to be enfranchised, but the activists in Kentish London were prepared to accept less. The Woolwich delegate to the Reform League Council in 1866 spoke against the general spirit of the discussion when he told Council that 'the Reformers of that town, though in favour of manhood suffrage, were against rejecting any good measure of reform'.[101] Similarly in Deptford, where Charles Yarham, the shipwright and Reform League secretary, argued that although manhood suffrage was needed he was willing to accept the compounder and lodger franchise.[102] The Liberal Representation of the People Bill introduced in March 1866 was an extremely limited measure, carefully devised so as not to alter the balance of voting power towards the working class in most boroughs, and the Reform League gave it only provisional support while pressing for manhood suffrage.[103] Yet a public meeting on Blackheath, 'chiefly comprised of the working classes from Greenwich, Woolwich, Deptford and Plumstead', gave the Bill emphatic support, with no qualifying resolutions.[104]

These Reform Leaguers demanded recognition of the value of working men as men, who possessed rights and recognised duties within a democracy concerned with political equality and justice. There was no concern with any wider social reconstruction. When E.S. Fludger, Advanced Liberal and Reform Leaguer, addressed the Woolwich branch of the League, his argument was couched in terms of the justice of widening the franchise. He talked of votes for all men, not about votes for the working class. It was assumed that women were excluded from the political nation, so they amounted to the same thing, but it is the language that is important, not the demand. Fludger stressed that the mode of campaigning must be respectable. 'Their operations have met with the approval and sympathy of all, irrespective of difference of opinion, for the very creditable manner in which everything has been done, also for having partially removed that slur which has been cast upon Woolwich, that of having no public spirit.'[105]

J. Baxter Langley long nursed the Greenwich working-class radicals for their support between 1865 and 1875, and knew exactly the language to which they would respond.

> He felt no hesitancy whatever as to the fitness of working men gener-
> ally being admitted within the pale of the constitution. Their general
> intelligence, love of law and order, and respect for the rights of

others; their unswerving patriotism, industry and sobriety fully entitle them to the rights of citizenship.[106]

Baxter Langley obtained such a strong following, and these phrases are matched by so many statements from working-class Liberals, that we can be sure that the ideas were important to them. The rhetoric could become more militant, and this distinguished popular radicals from middle-class reformers like Baxter Langley. After the defeat of Baines's Borough Franchise Reform Bill, E.W. Belbin, a former Chartist, secretary of the Greenwich Reform League, secularist and later Advanced Liberal, wrote to the *Beehive* that

> the ground has now been broken. The working classes see now who are their enemies . . . It is the old battle between freedom and despotism over again . . . Electors of the class who send fraudulent bankers and share-dabbling speculators to make laws for England's loyal and honest workmen are put out of court, I rather think, when throwing mouthing taunts broadcast at her law-respecting working class.

This fascinating mixture is about justice and honesty, the unfairness of the speculators and bankers who produce naught, and the respectability of the working class. The parasitism of financial speculation has now been added to that of land ownership, but the struggle between freedom and despotism is not an economic one; barely a social one; it is about politics. Belbin argues for the 'principle founded by all rational and reasonable reformers, from Hampden downwards, on that grand doctrine of equal duties, equal rights, and vice versa, a doctrine Magna Charta first proclaimed to England's sons in 1615 (*sic*)'.[107] This conception of political reform seeks to remove specifically political abuses, of which the disfranchisement of the working man was the greatest, for it denied his rights as a citizen. Most irritating was the language used by the opponents of reform, castigating working men as unreliable and unrespectable. As Belbin argued, agreeing to accept less than manhood suffrage,

> Let it be proved, I say, that the majority of the class stigmatised as scum are embryo levellers, destructive anarchists, forgers, robbers of their richer neighbours' property . . . before you presume to treat that majority as having no moral stamina in their composition. Poll England tomorrow, and find out how many of its working class

desire to lay hands on the soil, how many would care to put down their pipes, and their cups of ale, to even listen to a stump speech from any violent declaimer against the proprietors of England's soil.[108]

If this emerging radical movement was not concerned with class power, and if it did not grow from class conflict, it does represent an important awakening of local working-class organisation. In terms of self-confidence and expertise the relationship between different types of contemporaneous organisation, political and non-political, is as important as that between various political movements at different times. Further, its assertion of the rights of working men may have been couched in terms of social recognition, and may have been the language of men who had come to terms with the basic structure of their society, but they did not doubt that it was working men who were the victims of the injustice and the privilege. At no stage, however, were politics expressed as being about class power. Working men certainly had interests – the efforts in the next decade to return working-class MPs was partly to represent them – but they were seen only as sectional. The local Reform League branches virtually ignored the redistribution issue in the reform agitation. Yet the Chartist movement understood that the franchise without a redistribution of seats would mean massive accumulations of working-class votes in some areas, without any commensurate increase in working-class power. So they demanded equal electoral districts. The passion for the franchise indulged by mid-Victorian working men, to the exclusion of the constituency boundaries and allocation that obsessed the cabinets of the day, reflects the nature of their political vision.

Advanced Liberalism

The Greenwich Advanced Liberal Association, with many Reform League leaders among its activists, was founded in May 1869 at a large public meeting attended by over 500 people, most of whom were working men. The chairman, Henry Berry, announced objects for the association, which encompassed the ballot, franchise extension and the abolition of primogeniture, mortmain and entail. Baxter Langley emphasised the game laws and currency reform. The association was unmistakably the product of the working-class radical liberalism that had been finding firmer local expression in the 1860s.

The Advanced Liberals pressed for reforms concerning political democracy and the ending of privilege and aristocratic domination. They

saw such reform as Gladstonian in spirit, yet Gladstone was no anti-aristocratic campaigner. Both his choice of cabinets and his expressed political views indicated that, yet it is a clear indication of the ambiguity with which Gladstone attracted political devotion that his name was so enthusiastically cheered at that inaugural meeting.[109] Two months later three thousand people gathered on Blackheath at an Advanced Liberal meeting to support Gladstone's Irish Church Bill, and protest against the Lords' amendments. The chair was taken by James Matthews, shipwright, co-operator, secretary of the Greenwich National Education League and leading Advanced Liberal.[110] There is one indication of the range of activities in which artisan radicals were involved. Its early years saw the Advanced Liberals supporting the Gladstone government in all that it did, for they placed themselves firmly within the Liberal movement. That identification led to tensions, however, as they responded to the assertion of artisan respectability implicit in the franchise extension by seeking a part in local affairs and in the choice of election candidates, commensurate with their strength in the borough. The differences between the Advanced Liberals and middle-class Liberals were not initially serious, however, and the struggle over trade union law after 1867 did not embitter class relations in the way it did elsewhere. Yet if the middle-class reforming Liberals were willing to approve of much of working-class Liberals' life and institutions, they would do little beyond that. Local tensions then dovetailed with national dissatisfaction over the Gladstone government, and local feelings of rejection by the Prime Minister who was their MP, to generate a battle that worsened through the decade.

The history of the Greenwich Advanced Liberals is of repeated attempts to forge a satisfactory relationship with the established Liberal elites of the area. When the Deptford branch of the National Education League, dominated by Advanced Liberals, proposed putting up a working man's candidate in the 1870 School Board elections, they complained about their repeated and unsuccessful attempts to involve the local Liberal middle class.[111] After a succession of conflicts with this Liberal elite, the Advanced Liberals refused in 1876 to merge with the Borough of Greenwich Liberal Association. Thomas Bookham made it clear on behalf of the Advanced Liberals that they wanted party unity, but with two separate organisations under one umbrella. They were different, but both liberal.[112] Liberalism was the creed of the mid-Victorian artisan in Kentish London, and it takes a great deal of conflict between ideology and experience before the former yields.

From around 1870 dissatisfaction grew within the Association,

partly over the legislative policy of the Liberal administration, and the demand that it follow a more radical course. As early as November 1869, John Longmaid was attacking the aristocratic privilege which was crushing the progressive demands of the people.[113] This almost populist cry of the people versus the aristocracy was a persistent element in Kentish London radicalism. More sustained criticism was evident in the hostile questioning of Sir David Salamons when he addressed his constituents a year later. The issues raised included the ballot and suffrage, the monarchy, the education bill, Salamons' failure to fulfil his promises to the nonconformists of the borough, especially over education and the University Test, and working men's share in the representation of the borough.[114]

An eleven-point list of measures to restore working-class support to Gladstone offers the fullest statement of the Advanced Liberal position. Some proposals were concerned with political democracy and its extension by the ballot and payment of MPs, while others sought to reduce unemployment and its consequences, by colonising waste lands and reorganising the poor laws. All the other demands reflect a continuing concern with privilege and the power of the large landowners. They sought to abolish the purchase system in the army, and all sinecure offices; other demands included the institution of a land tax, abrogation of the game laws, abolition of primogeniture and entail, and the simplification of land transfer laws so that large estates could be broken up.[115] This is a programme for political democracy derived from an analysis that saw the monopolistic holding of landed property, and the privilege which went with it, as the greatest obstacle to political progress. The similarity with the demands of the Kentish London Chartists is striking.

Familiar in the same way are the demands of the Deptford Radical Association founded in 1873 by a number of Advanced Liberals 'to teach the best principles of civil government amongst mankind'.[116] The movement was dominated by artisans and small tradesmen, and its position by 1881 was within this context a highly radical one.[117] The Association grew out of the local agitation in support of the agricultural labourers,[118] and it was still concerned primarily with privilege and land. It is instructive to observe, and not only in Kentish London, the support for the rural labourers organised by skilled workers who did little to encourage trade unionism among their own unskilled. The sheer distance of the former, and the fact that it was the landowners and agricultural interest who opposed them, made the cause an attractive one for working-class radicals.

The Gladstonian myth had to suffer once vague phrases could be turned into legislative reality, and organisational tensions only hastened its breakdown. The basis of the criticisms directed at the local MPs and party leaders was that artisan ideology described in other chapters – a concern for working-class dignity, respectability, independence and recognition. This can be clearly seen in the response to Gladstone as MP for the borough, for early enthusiasm soon gave way to disillusion. His aloofness suggested that he was using his constituents for his own ends. The working men of Greenwich had returned him, and now he spurned them. Advanced Liberal hostility to Gladstone rested on that resentment as much as on political disagreements. For three years after his election he never spoke publicly in his constituency. By September 1871, a packed meeting of the Advanced Liberal Association expressed confidence in Gladstone only by means of the chairman's casting vote.[119]

The Prime Minister bowed to local advice and on 23 October 1871 he addressed a massive crowd on Blackheath, and seemed to understand their dissatisfaction. 'At least, gentlemen, this I can say, that if I have not been able to render to you the tokens of respect which are your due, I have never gone off my path for the purpose of visiting any other place.'[120] This was on the whole true, though he had managed the journey to Aberdeen, Whitby and Wakefield before he travelled down the river to Greenwich. The speech that followed concentrated on the important task of restoring good relations with the working-class voters of his constituency. After defending the closure of the Dockyards, he moved on to the attack, deploying the issues that had given him his national stature, and to which the working classes of Kentish London responded. He attacked sinecures and privileges, stressed the economies that he had made in public expenditure, praised the Education Act while being aware of its deficiencies, applauded the ballot and made great play of the abolition of purchase in the army. 'We are assailing class interest in its favourite and most formidable stronghold.'[121]

Local squabbles and discontent with Cabinet policy meant that the restoration of Gladstone's popularity could only be temporary. In August 1873, when he succeeded Lowe as Chancellor of the Exchequer, he controversially declined to offer himself for re-election because there was no certainty of success in Greenwich, where working-class dissatisfaction ran high.[122] The election of Boord in the same month exposed the weakness of Liberal registration. Gladstone was returned in 1874, but the days of his popularity in the borough were over. Excluding the three meetings in the 1874 election campaign, the sum total of Glad-

stone's speeches in the borough during twelve years as its MP was five —
two of these on the same day in November 1878.[123] As the Gladstonian
Liberal Party was driven geographically from the centre to the periphery
in its search for support, it is fitting that Gladstone in 1880 should
abandon 'his ungrateful constituency at Greenwich'[124] and flee to
Midlothian.

Gradual rejection of Gladstone was but one facet of a new Advanced
Liberal independence. Equally important was their treatment by the
local Liberal Party. A franchise extension demanded as an acknowledge-
ment of equality could not have been satisfying, for its real content was
so illusory. If it brought them within the pale of the constitution, it
gave them little to do there. In this way the assertive dignity, the
collective strength and the pervasive independence of the Kentish
London artisans spilled over from their social institutions to their
politics. William McCubry was a good man to voice their demands —
active in the Reform League, the Advanced Liberal movement,
secularism and the Liberal Party; he was also a director of the People's
Co-operative Benefit Building Society. 'The time had arrived', he
claimed, 'when the working classes of the borough should have a fair
share of the representation. The middle classes had been over-
represented.'[125] The Advanced Liberals were doing all the registration
work, and getting none of the decision making — particularly in the
selection of candidates. With more formal organisations and a Liberal
government the vagueness of involvement in a liberal movement was
sure to be exposed. Recognition of their worth required both the
following of their radical programme and a place in the councils of the
local Liberal Party. They required this because they were working men,
but not because they had specific political or social demands to make as
working men. The distinction is a subtle one, but it makes sense of the
difficult period of the 1870s and 1880s as Greenwich workers moved
falteringly towards a labour consciousness.

The Advanced Liberals refused an invitation to talk to the new
Liberal Electoral Association in 1873 on the grounds that there was no
organisational provision for working-class involvement. They would
concentrate on returning an Advanced Liberal.[126] Middle-class Liberals
needed the Advanced Liberals to help mobilise working-class support,
but they were unwilling to reject the traditional candidates. Yet the
working-class vote was too important to be alienated in this way. Even
the middle-class Woolwich Liberal Association was reluctant to support
Salamons because the Woolwich working-class voters felt that Baxter
Langley had done a great deal for them, and it was the opinion of the

Woolwich Liberals that the Arsenal men and the trade unions in
Woolwich would support him.[127]

In fact, Salamons died before the next general election. In the by-
election Baxter Langley stood, together with William Angerstein for the
moderate Liberals and Sir John Bennett, another radical. Boord's vote
exceeded these three together, but the surprisingly low vote for
Angerstein was seen locally as a protest against Gladstone, whose cam-
paign chairman he had been in 1868.[128] In spite of the bad feeling
aroused, a public meeting of the Advanced Liberals after the defeat
responded well to Baxter Langley's call for continued work with the
middle-class liberals, and agreed to support their candidate at the next
election if they would return the compliment.[129] The pact held for
1874, but attempts at reunification failed in 1876. The division
seriously harmed Liberal electoral prospects in the borough.

These dissatisfactions coalesced into a demand for a greater working-
class voice in the selection of candidates. In July 1872 Greenwich
Advanced Liberals set up a Borough of Greenwich Representation
Committee 'pledged to support the return of the candidate at the
approaching election who will be most likely to carry out the views of
the industrial classes'.[130] J. Baxter Langley, their hero throughout these
years, was no working man, and no supporter of anything but a formal
liberal politics, albeit a radical one. By 1878, when he was no longer
available, the Advanced Liberals sought no more than the right to be
consulted over the selection of candidates. When the Greenwich 500
came up with two men, the Advanced Liberals agreed to support one of
them, J.E. Saunders, after a long interview with him to establish his
political views.[131]

The detailed and varied strands of these pages have been important,
for they have shown working-class Liberalism feeling uncertainly for
some as yet unclear position within the local Liberal Party, and for a
clearer relationship to Liberal doctrine. It was still explicitly a radical
liberalism, and those who have seen it as a sign of independent labour
or socialist consciousness are mistaken.[132] The concerns of J. Baxter
Langley leave no doubt of that. Baxter Langley, doctor, trained at
Kings College London and Leeds School of Medicine, factory reformer
in the 1840s, scientist and owner of radical papers, began seriously to
nurse the Greenwich radical interest in the 1860s.[133] He continued to
pay them great attention, to address their meetings and to accept their
nominations for candidacy, until his resignation from the borough's
affairs when a major fraud charge was brought against him in 1877.[134]
Throughout the period of his great popularity, he argued a static liberal

position, declaring allegiance to 'Thompson, Fox, Cobden and other noble men' at one time, Herbert Spencer and J.S. Mill at another. The radicalism was not far from that of the working-class activists of the area, opposing the House of Lords and more generally the privileges of the landed interest, with repeated emphasis on the game laws, primogeniture and entail, and Irish land reform. His other constant themes were national unsectarian education, and that where working-class voters were numerically important they were entitled to a say in the choice of candidates. The Advanced Liberal movement fully endorsed his views and pressed him no further. The nearest he came to supporting the interests of labour as labour, rather than the rights of all men to social and political justice, was his support for trade union co-operation to prevent strike-breakers being brought across international frontiers.[135]

William McCubry told the Woolwich Advanced Liberals in 1873 that 'it was now time for the working classes to think for themselves and manage their own affairs'.[136] Within the developing ideology of the organised working class of Kentish London, political conflict led to a specific response — the move to independence within the Liberal tradition. This was the beginning of changes whose significance grew in the last two decades of the century. The hesitant independent radicalism in Kentish London from the late 1860s was clearly important in creating the framework for more clearly independent political organisation in these years, and one important part of it was the increasing involvement in local affairs. Yet popular liberalism in Kentish London seemed so rarely to show concern for local social and economic issues. The traditional obsession with the land, church and privilege was ritually inappropriate, but it took on a meaning in the context both of their experience and their ideology of radical independence. The enfranchisement of 1867 had failed to affect the local political strength of Kentish London working men, and this challenged both their political equality and social dignity. This was enhanced by the increasing failure of local politics after 1868 to provide the satisfactions for working men that they had once offered. The conflict with the established elites of the town who dominated its local government, its politics and its social life became more frequent. From a position of commitment to their locality and involvement in it, the radical working-class Liberals began to take part in local government affairs. The Advanced Liberals discussed the establishment of a voluntary fire brigade, union workhouse contracts, the quality of tea in the workhouse and the possible corrupt tendering involved, and they began to take firm positions on vestry elections.[137]

Local government was perhaps the most important field for labour and socialist groups in the country in the 1890s, but then the programme and personnel were distinct. In the Kentish London of the 1870s, however, it manifested itself principally in terms of supporting orthodox candidates of whose general views on local affairs they approved, although an Advanced Liberal would occasionally stand. Some success was achieved, but there does not seem to have been a great deal of enthusiasm on the part of working-class ratepayers.[138] Nevertheless, this particular attention to local affairs indicates a sense both of involvement in the local community and of its susceptibility to influence, all within a still accepted framework of political assumptions.

Political Radicalism: some general observations

Some threads might be drawn together at this point. The most important concerns the absence of continuing class — as opposed to political — hostility informing local politics. True even of the Chartist period, this became especially valid from the 1850s, when the radical tradition continued within a predominantly *political* critique of the position of working men. It was the radicalism of men who had come to terms with the bases of the society in which they lived, and aimed now at reforming it. The movement was dominated by skilled artisans in the main manufacturing and service industries, together with some small tradesmen. They were in 1867 unusually acquiescent in a compromise to enfranchise the householding artisan alone, and it was they who had formed the large working-class electorate even before reform. The foundations for all this were a particular set of communities, a particular industrial and economic structure, and a particular type of workforce. These produced a particular type of middle-class politics which made political accommodation for long a feasible strategy. Working-class radicals of course used the threat of independent action, but only rarely, and within a context that accepted the orthodox political structure.

If the political perspective was concerned with political and not social equality; if the objection to capitalists when expressed was not that their wealth was based on exploitation but that it was misused for obtaining political privilege; if the type of society in which they lived was broadly accepted by the politically active working class of Kentish London — this does not mean that they were politically conservative. Henry Pelling has wrongly argued that the theory of the labour aristocracy requires that it be conservative in politics, imposing its conservatism upon working-class institutions.[139] The labour aristocracy in mid-

Victorian Britain was far more actively radical than any other section of the working class. Yet this radicalism was circumscribed by a broad social acquiescence; an acquiescence not in this law or that law, not in this employer or that employer, not in this level of wages or that level of wages, but in the existing system of law, in the existence of employers, in the methods of wage determination. The oppositional efforts of working-class radicals in Kentish London during this period were based on an analysis of social ills that placed political inequality at its heart.

If traditional radicalism had softened in its social criticism and merged with a liberal critique that made political involvement with other strata possible, the rhetoric of the Chartist orators could continue. For Chartism had left its mark, partly in organisational experience and self-confidence, but also in the memory. John Longmaid addressed the Advanced Liberals on 'past excitements', and spent much time on Chartism, in whose local activities he was involved. The sense of radical political history is important, but the way in which he indiscriminately linked O'Connell, O'Connor and Lovett shows how unimportant the debate about personalities and policies were to the Chartists of the area, and how far Chartism had retreated into an exciting memory.[140] Rhetorical phrases in a socially acquiescent context are most apparent in a letter from E.W. Belbin, secretary of the Deptford Reform League. He was writing about the ironworkers, locked out in the north.

> Numbers of slaves (slaves to capital) and hungry bellies are the millionaire's joy, and I am surprised that any one claiming to be considered as the working man's friend can be so barefacedly a 'political turncoat' to his order . . . as to withhold his support to plans for emigration from a land much too oligarchic in its social and political constitution for its much belied and politically-helpless working population. 'Go ahead', I say, Sir, to the thousands of locked-out men of the iron districts — make what you can of what you have — ship it off 'with your little ones', and the Fates above grant you a speedy passage to a land where everyone might find good masters, good wages, and have a good house of his own, with ten acres of virgin soil he may (being less taxed and better fed) have to call his own at a cheap rate.[141]

This radical position dovetailed with the social values of its adherents. Their liberalism concerned independence and respectability, acknow-

ledgement of moral worth and value as citizens, and concern for justice
and the ending of privilege. These were important strands of Chartism
throughout the country, but the criteria for the evaluation were not
those of the dominant social ideology. Chartism proclaimed a concern
with power and oppression, working-class liberalism with position and
equality. If the distinction was less marked in Kentish London, there
remains a significant divergence within the continuing tradition of the
vote as a right. The denial of that right could be a sign or cause of
oppression, as it was in the earlier decades of the century in Britain, or
the broader denial of social worth that is signified in mid-Victorian
Kentish London. The political position of working-class activists in the
area from the 1840s to the 1870s was not to do with such pejorative
terms as capitulation or collaboration, but was about what seemed
relevant to them, placed between their own local context and a wider
national politics.

If there was a dominant theme, it was of a traditional radical crit-
ique that in English popular politics could trace back to Paine. It com-
bined a particular diagnosis of the ills of the lower classes with a funda-
mentally rationalist optimism in progress and the capacity for change.
Social and economic relationships in Kentish London encouraged the
persistence of this traditional radicalism. Its central concerns can be
summarised as universal suffrage, excessive taxation, opposition to the
privileged establishment — especially the Church of England — and an
opposition to landed privilege and the power of the great landowners
that produced demands for reform of land law and the ending of the
national debt. To these must be added a Painite anti-authoritarianism
built upon a traditional conception of an Englishman's liberties. The
culture that emerged through the early nineteenth-century movements
derived from the impact of eighteenth-century rationalism upon the
English radical tradition. This culture fragmented as the Victorian
decades passed. A real continuity can nevertheless be traced in the
activities of the Reform League, the Sunday Trading Riots,[142] working-
class liberalism, the land reform movement, working-class secularism in
the 1860s and 1870s, and many other movements. Much of its drive
and coherence had gone, but it survived in the radical debating clubs of
central London, to be gradually transformed into a class-conscious
socialism. In Kentish London, however, the strands which persisted
were those which could be woven into an ideology of social accommo-
dation concerned with justice and independence. It was a radicalism of
the traditional rational and anti-aristocratic kind, but less forceful and
less culturally united, less part of a satisfying alternative life style of the

sort that many central London artisans had constructed for themselves.[143] This wider political integration lay behind the failure of Kentish London workers to develop a distinctive political ideology during the 1870s at the time when the pressures upon them grew. Their politics were not basically about power, whether local or national. Nor, from the 1850s, do we hear of oppression or class legislation, as even the rhetoric of an aggressive politics concerned with power receded. It was replaced by a pervasive optimism apparent elsewhere in the artisan ideology. The national Chartist movement felt no confidence in the outcome of economic progress in the existing class society, as is indicated by their refusal to separate the repeal of the Corn Laws from the adoption of the Charter. By later decades this had in many places been reduced to a belief that if obstacles were removed — corruption, privilege, protection — the inherent movement towards economic and political progress would benefit the whole of society.

T.S.D. Floyd, Advanced Liberal member of an artisan-dominated branch of the National Education League, expressed this rationalism in his belief in the power of education over ignorance. Education would be one of the greatest boons to the working classes, giving them the power of working out the great problems which impeded the progress of the country. He went on to argue that the foundations of a true and solid religion would follow. Finally, it would be the means of bringing about more unanimity between classes, because one of the things that had kept them apart was ignorance of one and the intelligence of the other.[144]

The class hostility that was perpetuated by artisan radicals in Kentish London was not that between employer and employee, but between the industrious, productive classes as a whole, and the lazy and privileged. The latter category was flexible, but the division generally amounted to the people versus the landowners and aristocracy, for it was the latter who symbolised the constitution that was steadily and successfully being purged. The attack was not on private property in land, but on its monopolistic ownership. This denied the working man the ability to hold land himself, and at the same time created the power of the landed classes.

The involvement of local Advanced Liberals in the Tichborne Affair is instructive. There was large-scale interest in the Claimant as spectacle. Over a thousand persons paid between 6d and 2s to hear him speak briefly in Woolwich in August 1873, and they loudly cheered him.[145] There were huge demonstrations in Greenwich and local contingents to the Hyde Park protest.[146] More significant, however, are the public

lectures on the affair organised by the local Tichborne Association. Little evidence remains about the group, but at the meetings in question there were Advanced Liberals present, with George Floyd, Deptford's most prominent working-class radical, in the chair at one, and J. Baxter Langley at the other.[147] A local Magna Charta Association grew out of these meetings to press for free and popular justice.[148]

The response of some local working-class radicals to the Tichborne case is revealing. A number of themes underpinned popular support for the Claimant. The State was seen as supporting the strength of aristocratic wealth by unfair justice; anti-aristocratic feeling was stirred by the apparent sight of the aristocracy rejecting its own merely because he had become common; the Tichbornes were an old English Catholic family, and this allowed anti-Catholic feeling to develop; finally it appeared that the strong, supported by privilege and the courts, were oppressing the weak. The Tichborne affair was one of those cases that, quite unexpectedly, sparked off widespread national feelings on a quite unwarranted scale. Yet its pecular features of attraction struck a chord with some at least of the Deptford and Greenwich Advanced Liberals. It should by now be no surprise that an issue with these elements so appealed to them. It went beyond the issues of justice, the aristocracy and the worth of the common man's manners, to attacks on the wider structure of the old privileged elite. A resolution in a Greenwich meeting attacked the Gray's Inn, that bastion of legal exclusiveness, for disbarring Kenealy.[149] A working-class speaker at another meeting rose to argue that the electors must 'turn out the noodles who laughed Dr Kenealy down in the House of Commons. They wanted the working men represented in that assembly'.[150]

Secularism

If the Tichborne affair offers only intriguing links, Kentish London secularism can tell us significantly more about working-class radicalism, for it drew its support not only from similar occupational strata, but also from many of the same people. Secularism was not a major characteristic of working-class radicalism in the area, and the issue of free-thinking against religion caused no visible conflict within political movements. Nevertheless, a number of local leaders were involved in secularist groups, and in them they professed many attitudes that informed the wider radical movement in Kentish London. In the decade following 1864, ten of the most active secularists were important local radicals, amongst them Joseph Morgan, E.W. Belbin, John Longmaid, George Floyd and George Mulchinock who was Reform League secre-

tary in Deptford. The narrowly religious interests of the Woolwich group reflected the absence of such strong political links, but it still contained men like Caines, local Reform League secretary, Hand, a former Chartist and member of the Reform League, and William McCubry, who was in the same organisation and also a leading local co-operator.

The first secular society in the area was founded in Woolwich in 1854 by a young ropemaker, Augustus Dinmore, who was later to support the Polish cause and the Advanced Liberals.[151] There was little activity though over the next fifteen years, and the explanation offered by one member was that 'our friends are of the intelligent portion of the workmen of the Arsenal and Dockyard, whose actions must be guarded, advancement and employment depending more on favour than ability'.[152] Only after 1870 did the group become very active. Its narrowly religious obsession may be either an explanation or a conse-quence of this general failure. The Deptford and Greenwich group, founded by the French Republican, Le Lubez, in 1862,[153] was far more active and better organised. It faltered in 1866 and through the following year, perhaps due to a diversion of energy into the political reform movement, but was restored to vigorous life in April 1868.[154]

Tom Paine was the greatest force in popular freethinking in England.[155] In 1865 the Plumstead and Woolwich society held a tea meeting and soiree to celebrate the birth of 'the immortal Paine, the great liberator of mind and body, the enemy of tyranny, and friend of freedom and humanity'.[156] Faith in rational thinking and education as the force to end superstition moved the Woolwich secularists, rather than the issue of political and social injustice. *Age of Reason* spoke to them more than *The Rights of Man*. While they discussed 'Have we a Sabbath by Divine Appointment?', the Deptford and Greenwich society was debating the American Civil War.[157] Woolwich meetings concen-trated on dismissing Christianity and superstition, and debating ration-alist philosophers.[158] The rationalist strand in freethought led in Wool-wich to an emphasis on the denial of religion.

While this was important in Deptford and Greenwich, the presence of many political activists allowed the social criticism implicit in Painite rationalism to emerge. A faith in the progress that would allow for improvement was central to that criticism. There was no despair in that secularist group, no sense of a lost cause, for what they then sought was broad social improvement and the growth of political equality (in much the same vein as the Advanced Liberals) rather than the mere destruc-tion of religious belief. 'Our veteran friend', the old Chartist Joseph

Morgan, urged the young secularists to acquire general information, for 'the progress of civilisation depended upon the improvement of the experience of those who have preceded us, and that the ideas he has always entertained of the perfectibility of men required the abolition of the terrors of priestcraft and the brutality of despotic rulers',[159] From that point of political and social faith stems the relationship between local secularists and radical political issues. They supported the cause of Poland, and at a Blackheath meeting called upon the Liberals of the area 'to keep alive the sacred fire by holding frequent meetings in favour of political and religious freedom'.[160]

Land was a central concern. A meeting in 1863 asked 'Is hereditary property, as it is at present, a just and equitable thing?' and concluded by condemning primogeniture and entail. It objected to the fact that many people were destined from birth to be rich or poor. They were not questioning riches themselves, but their distribution on the basis of birth and privilege rather than industry and worth.[161] The same analysis with a religious emphasis accounted for poverty. The majority of those at a meeting thought 'that the cause lay in the unequal distribution of the soil . . . The mass of the people were kept systematically poor, half-starved, and ignorant by their Christian brethren, in order to be used as cattle or machines, for the enriching of already rich proprietors and farmers.'[162] In this lack of interest in any explanation of urban poverty that was based on urban industrial conditions they mirror local radicalism.

In 1867 and 1868 the society became more narrowly anti-religious,[163] but the political concern reappeared with the re-engagement of the politically active secularists. John Longmaid chaired a meeting at which they discussed the Liberal Party, and 'the good that can be secured for the people by the people, through organisation, education, and the proper use of the power they now have through the extended franchise'. On other occasions they discussed Princess Louise's dowry, French politics, Bradlaugh, and monarchy and republicanism.[164]

They went no further. It is difficult to penetrate into the meaning of secularist ideas for rank and file members, but in Kentish London their secularist interests and their political and social concerns were immersed in the context of the radical liberalism discussed above, and Royle has correctly stressed the importance of a notion of freedom akin to that of Mill, concerned with freedom from government interference and all restrictions on the expression of ideas.[165] For the minority of Kentish London working-class radicals who became involved in secularism, their commitment grew on the one hand from a belief in Painite rationalism,

and a social progress that depended upon the removal of ignorance, and on the other from an analysis that held the old privileged elite of established church, landed aristocracy and unreformed parliamentary system[166] responsible for the political inequality and widespread superstition that were the main obstacles to that progress.

Kentish London secularists lacked the clubland artisan traditions and culture of the societies north of the river examined by Shipley.[167] Its moderate support came from those involved in other activities that made firm contact — however critical — with the life of their community. It never took the form of a counter-culture, except in those years when it became most narrowly anti-Christian, shook off its political and social interests and carried a hysterical anti-religious campaign into the streets of Deptford. By then it was a tiny and socially irrelevant group, whose politically concerned membership had fallen away.[168] On the other side of the Thames, club secularism really took off in those years as an intensive cultural politics developing a socialist commitment. At just that point it was at its weakest and most narrowly anti-Christian in Kentish London.

The socialist and revolutionary ideas circulating in clubs north of the river were coolly received in Deptford and Greenwich, where radicalism was too committed to the Liberal tradition. The First International, the Land and Labour League and the Manhood Suffrage League made no headway. In March 1870 Mr Babbs delivered to the Deptford and Greenwich Secular Society an aggressive political speech, specifically anti-capitalist, and inviting members to join the Land and Labour League.[169] A branch was actually listed in Deptford once, more in hope than reality, and it was never mentioned again.[170] Another attempt the following August met with a cool reception.[171] By concentrating on certain clubs, Shipley distorts the picture of the London secularist groups. In the context of a class-conscious and revolutionary meeting at the Franklin Hall he argues that 'Metropolitan Clubland may have contained the mealy-mouthed, but they are not much in evidence . . . '[172] The nature of working-class political integration is thus caricatured. Kentish London secularists were not mealy-mouthed. They held firm and deeply felt radical opinions. These were, however, still located centrally within a tradition of liberal radicalism that Shipley's clubs were abandoning.

Internationalism

The *Weekly Dispatch* found it incongruous that there should be any real feeling for Italy among 'men who were never out of Wapping and Brick

Lane'.[173] Yet English working-class movements in the nineteenth cen-
tury persistently responded enthusiastically if superficially to inter-
national causes. Poland in 1847, Italy and Poland again in the 1860s,
the American Civil War, the French Republic in 1870, all provoked keen
interest among radical working men in Kentish London. Their appeal
was the struggle for liberty, democracy and self-determination. The fact
that they used arms and often resisted established rulers did not jeopar-
dise the constitutionalism of the Kentish London groups, for the differ-
ence between England and other countries were taken for granted. The
traditions of freedom and the progress of that century indicated how
limited were the abuses at home in comparison with those abroad.

The concern for Poland that had briefly involved local Chartists[174]
was to revive during the Crimean War, and blossom after the insurrec-
tion in January 1863. Labour political and trade union groups
demanded British intervention if necessary, to secure Polish liberty.[175]
Kentish London radicals rallied to the cause. A Deptford Friends of
Poland organisation was formed by men later to be active in the Reform
League and Advanced Liberals,[176] and a Woolwich branch had large
crowds at meetings on Plumstead Common and Blackheath, mostly
working men in the Arsenal and Dockyard. The cause was presented
there as a narrowly liberal one – nationalism and resistance to the
spread of Northern Barbarians. David Booth appealed to the working
men of the district to support the Poles on the grounds of humanity
and love of liberty, justice and truth. A Plumstead wheelwright
demanded that Britain go to war on the issue; moral support was not
enough.[177]

Large working-class meetings supported the cause of Garibaldi and
the Italians in 1860,[178] and a number of members of the Arsenal
volunteer force served with Garibaldi's British Legion.[179] Enthusiastic
meetings of several thousand in 1867 were encouraged by anti-Papal
feeling, but the real issue was the working-class liberal enthusiasm for
the cause of political liberty and self-determination that Garibaldi
represented.[180] The overall interest in the fates of Italy, Poland and
France – the Advanced Liberals sent an address of support to the new
republican government there in September 1870[181] – never went
beyond the demand for freedom from political oppression. The greater
level of that oppression abroad required a greater effort to overthrow it.
The social content of this republicanism never intruded.

This internationalist theme led to no real interest in the First Inter-
national, although there was a short-lived Greenwich branch in 1865.[182]
In 1873 a new branch in Woolwich was given temporary impetus by the

use of the organisation to prevent strike-breaking, but the main lesson from that episode is the lack of local response to political ideas that went beyond a radical liberalism. When engineers at Siemens Telegraph Works struck over night rates, the company brought eight to ten Germans from Berlin to fill their places. H. Maddox, secretary of a dormant Woolwich branch of the International, intervened, halted further dispatches of Germans from Berlin[183] and persuaded the German workers at Siemens to leave, and also sent word to Berlin to deter others. The English strikers and the Germans had a joint celebration. 'One fact deserves mention', Maddox wrote to Samuel Vickery. 'We each had to sing (illegible) National Anthem. The Watch by the Rhine was sung by our friends en masse but when it came to our turn no man in the room knew the words, thank God, so we gave them "Britain never shall be slaves".'[184] The British Federal Council now expected their Woolwich branch to grow, but Maddox discouraged them. ' . . . there is in reality none existing here. We muster 2 members, myself and a German.' There was plenty of activity in the town, he said – a Liberal Association, a branch of the Advanced Liberal Association, and a flourishing co-operative store. There was neither political nor social inertia, but 'in this town of Government hacks, anything in advance of what is termed Liberalism has no favour here'.[185]

Agitation over international liberal issues helped shape the liberal-radical politics of the period, yet in Kentish London this rarely extended to Irish affairs. The area had a substantial Irish population, but contact was rare between working-class radicals and Irish political groups. There was also little Irish participation in English movements. The inward-looking Irish communities around the river bank and railway yards were culturally somewhat isolated, discouraged by priests and social hostility from any serious degree of integration. For the English radical artisans, repeal or Home Rule might have been acceptable propositions, but many of the unruly and unacceptable poor Irish families of the neighbourhood were no part of their social milieu, and they had no desire to make them so. In any case, the politics of the local Irish tended to be uninterested in English affairs and conducted in a quite alien fashion.

It could be that the very quiescent character of the Kentish London Chartists deterred any potential Irish commitment.[186] They clashed with Drury of the Deptford Repeal Association, who told them that they were aiming at goods that could only be obtained by violence.[187] He was not advocating violence, but declaring his lack of faith in their constitutionalism. This was the distance between them. The traditional

view that O'Connell was responsible for lack of co-operation between Chartists and Repealers is inadequate. Fundamental problems of relations and political assumptions were at the root of the failure.

The Irish Confederates were one of a number of groups to the left of the Repeal Association that challenged its position from the middle of the decade, and in March 1848 a club was set up in Greenwich.[188] Seventy Irishmen attended their weekly meetings: boilermakers, engineers, tailors, bricklayers and labourers. The police, unworried by the Chartists, felt that 'these are violent men'.[189] Police spy George Davis alleged talk of arming and violence.[190] Davis cannot be trusted, but the Confederates were certainly well to the left of the Repealers, and willing to countenance unconstitutional tactics. It may be significant that it was at just this time that the Deptford and Greenwich Chartists chose to hold fraternal meetings with the local Repeal Association.[191]

The working-class radical liberals of the following decades supported the slogans of liberal Irish policy, but made only occasional efforts to contact Irish political groups. Advanced Liberals attended public meetings of the Irish Home Rule Association, and the shipwright Alfred Matthews hoped that one such meeting 'would have the effect of uniting the English and Irish working classes'.[192] The local Irish, however, seem to have been divided between priest-dominated organisations like the London and Provincial Home Rule Association, more independent groups like the Deptford Home Rule Association and minority organisations like the Home Rule Confederation.[193] None showed much interest in any wider radical politics. The division was only deepened by the Fenian scares. The declaration of support from the Deptford United Irishmen, and the march by Deptford Irish in support of the Fenians,[194] struck a chord out of tune with English radical politics. Reports from local authorities about support for Fenians are at times hysterical and overstated. Yet, exaggerated as it may have been, there were clearly grounds for the letter from Superintendent Wilmot to the Admiralty in December 1867 asking for special constables.

We know that nearly all the Irish here are Fenians, they have been heard to say so, and I am sorry to inform their Lordships that parties in this Yard have been heard to make use of the most outrageous language against the Queen's Government, and expressed the determination of the Fenian Brotherhood to destroy all public buildings and property.[195]

The Arsenal and Dockyard artisans readily became special constables to protect both government and private property in the area. The handful of Arsenal workers who declined to be sworn in were mostly Irishmen.[196] The Anti-Fenian feeling reached hysterical levels. Thomas Daly was arrested in Woolwich as a suspected Fenian on the grounds that he had money in spite of doing no work.[197] The mobilisation over Fenian scares did not produce any counterpropaganda by working-class radical groups where some degree of sympathy for the Irish cause might have been expected. In fact, the Woolwich branch of the Reform League temporarily severed its links with the Central Council over supposed support for Fenianism by some Council members.[198] The whole climate of Irish politics, from Repealers to Fenians, made no serious contact with working-class radicalism in Kentish London. The conditions, assumptions and traditions that generated the one had little to say to the other.[199]

Conclusion

The purpose of this chapter has not been to document all political activity by the Kentish London working class, but to isolate the main characteristics of that politics. A form of politics has emerged that relates very clearly to the type of society that existed in Kentish London, and an ideology that is clearly part of the broader pattern of attitudes outlined in this study. Working-class politics in Kentish London did not, of course, move unrelated to national or metropolitan developments, but the elements that have been concentrated upon are those which distinguish Kentish London politics. These were deeply coloured by the social experience of the participants. The lack of a class-conscious politics, the devotion to a traditional radical analysis that saw privilege and political inequality as the root of social ills, the targets for political attack, the high degree of political integration within a wider structure of formal politics — all derive from the way in which national political issues and movements took shape within a specific set of communities. This explains a great deal that is negative about local Chartism, and much that is positive and aggressive in mid-Victorian liberalism. An anti-capitalist consciousness that emerged in some towns during the Chartist period; a political analysis that during the 1870s tackled the implications of urban poverty in the context of the urban social and economic structure; a vigorously independent working-class politics; a clarification of the involvement with liberalism — none of these developments made any immediate sense to the political activists in Kentish London.

This is not a matter of direct economic or structural determinism. Those structures were mediated through the experience of the local communities, and an ideology that was developed to comprehend it. In that context, a working-class politics of militant independence was neither satisfying nor necessary. Its slow emergence was not due to specific structural change but to the complicated implications of the ideology of respectable independence. The relative economic insecurity of the 1870s in the area clearly had some effect, but the evidence is not apparent. Neither trade conditions nor industrial relations in the area explain periods of greatest independent action, in 1857 and the early 1870s. Political and industrial militancy in the country at large clearly affected attitudes in Kentish London, but it is generally possible to explain local developments through local dissatisfactions understood in terms of the assumptions of political activists. The more independent labour consciousness in the following decades is beyond the scope of this chapter, but the early signs of its appearance in the 1870s must be treated with caution. The dissatisfactions that they fed upon needed other developments to push them in the direction of labour independence and ultimately separate labour political consciousness. The final chapter will reflect on this issue. One of the most significant indications of what was to come was perhaps the small issue of the decision in November 1870 by both the Boilermakers and the Carpenters and Joiners in Deptford to pledge their union support for T.S.D. Floyd, the Advanced Liberal candidate in the 1870 School Board election.[200] From these origins a local labour movement drew together.

The optimism and the sense of progress that pervade so much of the politics that we have examined, the faith in the ability of working men to make for themselves an improved position in their society, and the integration within the formal electoral and liberal politics of the area, derived from local experience as well as a wider ideology. It would be wrong to claim that all the forms of behaviour examined in this study were common to the strata concentrated upon, or that they were all mutually consistent. Yet it is valid to see them all as responses that grew out of common roots and a range of common understandings. Beyond this, however, lay personal continuities. The links of local Chartists with non-political activities and with later politics have already been noted. Similar cases can be found for the later years. All the Advanced Liberal or Reform League activists whose names follow were prominent in some other working-class institutions, whether friendly society, trade union or co-operative society. It is in no way a complete list. All were active Advanced Liberals.

The Deptford shipwright, Alfred Matthews, was also a member of the Radical Association, secretary of the Deptford and Greenwich Co-operative Shipbuilders in 1869, and active in the People's Co-operative Benefit Building Society throughout the 1860s. Another shipwright, Charles Yarham, a member of the Reform League as well as of the Advanced Liberals, was a trustee of the Deptford Dockyard Impartial Burial Society. The boilermaker, Charles Rubery, was a trustee of the Deptford Working Man's Co-operative Provision Association and of the Perseverance Boilermakers, and a leading member of the Deptford and Greenwich Co-operative Shipbuilders. Other Advanced Liberals were leading trade unionists. Edward Woods was secretary of the Greenwich Ironfounders;[201] A.L. Fordham was prominent in Arsenal disputes in 1872; C.H. Green was president of the Greenwich Labour Protection League. The career of John Jeffery takes in many of these areas and more. He opened the Woolwich branch of the Bricklayers' Union in 1863. A leader of the Greenwich Reform League, he helped organise 1,000 London bricklayers for the great reform demonstration in December 1866. Ten years later he launched technical classes for bricklayers at Greenwich.[202] Finally, William McCubry, an Arsenal clerk who had risen from being a manual worker, was President of the People's Co-operative Benefit Building Society.

It is through such men that we can understand how the activities and ideology presented in this study must be seen as a whole, in spite of an apparent institutional fragmentation. As with other spheres of activity, politics did not take shape as a challenge to a view of society or of social relationships, not even in its most assertive moments in the 1870s, certainly not in the agitation for reform. It was less a challenge to values, far more an assertion of them — in a specifically working-class context. This character it shared with many working-class institutions, and with them it must be seen. The social and political security felt by the middle classes of Kentish London was based not just on observing local working-class politics, but on a whole experience of their institutions and informal behaviour. As early as 1860, after all, the *Kentish Mercury*, arguing that 'our labouring population are now contented, and to a great extent well-informed', proposed arming the local artisan volunteer corps, and teaching them to use their guns.[203]

11 CONCLUSION

The overall intention of this book has been to examine an aspect of the stabilisation of Victorian society that has until recently received more general comment than detailed analysis. At the level of generalised national argument the role of the labour aristocracy has often been presented as necessary to an understanding of the period. The existence and the ideology of that stratum, however, have often lacked definition that derived from the local contexts within which national developments ultimately impose themselves upon individuals. This is the justification for a study of specific communities. It is unreal to ask whether the communities in question were typical or representative, for that issue is in the last resort unresolvable. The real task must be to locate the towns in question within a wider national context or within some typology of urban development, and the early chapters were in part constructed with that end in view. They emphasised the way in which the towns of Kentish London grew from a broad social base. The towns existed with industrial elements of some size well before the major expansion of the period studied here. An additional feature that distinguished the area from many others was that its broad social composition, although altered during the early Victorian period, remained similar in its broad outlines. In terms of elites and the composition of the towns' controlling stratum there were no great changes. They differed in this respect both from the communities of other parts of London that suffered early from the suburban pressures that narrowed their own social composition, and also from those provincial towns where struggles took place between old-established and new social elites. Whether the conflict was open and clear between the rulers of a pre-industrial regional centre and the new elites of industrial and commercial entrepreneurs as in Manchester, or a more blurred dispute between different sections of a similar business community as in Liverpool or Leicester, the domination of the town involved social and political conflict within the propertied elite of a kind absent from Kentish London.[1]

The existence of a labour aristocracy in mid-Victorian Britain has been at the centre of this study. The striking dimension is not the meaning of an economically elitist position to working men as individuals, but the fact that the economic and social developments of the period provided the context for the emergence of a genuine social

243

stratum. Artisan institutions played a key role in overcoming the potentially fragmenting influence of earlier craft cultures. This was made easier by the nature of the dominant industries of Kentish London and their rapid growth within the Victorian economy. Nevertheless the broader social stratification that grew out of a craft sectionalism was a vital stage in laying the foundations for a still wider labour consciousness at the end of the century.

This study has concentrated upon identifying the labour aristocracy, and has tried to identify its activities and its values, its relationship to the rest of the working class, and its emerging ideology. That ideology showed a concern for status whose visibility rested upon a particular configuration of local and national developments, and whose function was to allow the labour aristocrats to come to terms with the broader economic inequalities. As was argued in chapter 7, the concern for status throughout Victorian society was a process of accommodation to structured inequality. Its viability for the labour aristocrats in Kentish London depended upon specific economic prosperity and the particular characteristics of local society, in terms both of the internal composition of the working class and of the broader social structure of the towns. Within this context some of the general views concerning labour aristocrat ideology have been questioned, particularly those that relate to the twentieth-century embourgeoisement debate. I have tried to go beyond that, and show the continuities and the flexibility of the social and political radical tradition which enabled a section of the working class to adapt itself to a changing situation.

This has been the broad purpose of the book — to define these developments, refine our understanding of them and attempt to explain them. Instead of attempting to summarise the argument and its conclusions, the remainder of this concluding chapter will raise two issues that have grown out of the work as a whole. The first concerns the labour consciousness that seems to have emerged in Britain in the years between the end of the period covered here and the First World War. The other issue is the process by which a dominant ideology was established in mid-Victorian Britain, and the wider implications of the historical development analysed in this book.

Between 1880 and 1914 some kind of independent labour movement appeared in many parts of the country. At the national level it took the form of the Labour Representation Committee and nominally independent labour representation in Parliament. Socialist parties of various kinds set up branches in many towns. The other important local formation was of labour movements, in which what was historically sig-

nificant was not national allegiance nor even a socialist commitment, but a drawing together of working-class organisations into closer co-operation and a sense of identity. These could include trade union branches and trades councils, labour political committees, working men's clubs and societies, co-operative societies, friendly society branches, socialist groups and so on. Hesitant contact over limited issues such as school board elections would herald the beginnings of some local co-operation. These developments, far more than national Labour Party politics, were signs of an emerging labour consciousness, a greater drawing together of different sections and organisations of the working class.

Detailed research would be needed far beyond the period of the present book to establish such developments in Kentish London.[2] Yet we do know a certain amount about the political successes and failures of an independent labour politics in the area. Woolwich was the best-known of the towns in this respect. Initial socialist and labour skir-mishing in local affairs in the 1890s was developed by propaganda work by the Woolwich Radical Club, the local Independent Labour Party branch and the Royal Arsenal Co-operative Society, together with cam-paigns of political significance over the eight-hour day in the Arsenal and the great engineering dispute of 1897-8. The result was victories by independent trades council candidates in two borough council elections in 1901 and 1902, followed by the greatest success when Will Crooks won Woolwich for Labour in a famous parliamentary by-election in 1903. Crooks held the seat for virtually all the period between then and the First World War, and from 1903 to 1906 the Woolwich Labour Party won a majority on the borough council.[3]

Labour was less successful in the other two towns. Deptford had a Social Democratic Federation branch from 1886 and an ILP one from 1892, but most working-class political activity was contained within the Liberal/Progressive framework. Deptford Labour Party's successes after the turn of the century were less notable than those in Woolwich and firmly tied to an ideological liberalism — at times also to an organisa-tional one. Greenwich was weaker in terms of socialist politics in the 1890s and although a Labour Party was founded in 1905 it made little headway. In this it was typical of other London boroughs with a large middle-class population.[4]

For the purpose of these comments the precise details of local politics, trades councils, candidates and so on are far less important than the broad facts of a heterogeneous local labour politics aspiring to some independence from existing formations. In all these places, what-

ever other sections of the working class were actively involved, it is clear that the politically conscious artisans were at the forefront. In Woolwich especially, we can see the prominence of the Arsenal workers, who were progressively agitated and mobilised through the 1890s, within the local labour movement.[5] In the years after 1904 nearly 60 per cent of the shareholders in the *Woolwich Pioneer* were skilled manual workers – 42 per cent of them in engineering.[6]

How may this shift to an independent labour politics be explained? The possible explanations are various, but it is disturbing that in general terms, and this applies more widely than Kentish London alone, we have too unclear a picture of exactly what it is that we are trying to explain. In what ways was the move from an essentially accommodationist liberal-radicalism to an independent labourism a major ideological one? How substantial was the reversal of political and social philosophy, or was it principally a tactical change? Until we are clear as to the precise nature of the shift –and it clearly took on greatly varying characteristics – it is dangerous to attempt too careful an explanation.

There is a clear contrast between Woolwich and Deptford. Liberalism never took the firm hold with Woolwich labour aristocrats that it did elsewhere in Kentish London. The emancipation from liberalism was more difficult in Deptford than in Woolwich, confirming a suspicion that the labour movement and independent labour politics grew easiest where there was no long-standing working-class liberalism to overcome. Labour also had the specific advantage for Woolwich of having none of the Liberals' anti-imperialist reputation. After 1900 the Woolwich Labour Party was the only one in London to absorb both the Lib-Lab and the socialist wings of the movement. That was the basis of its strength. Will Crooks's old-fashioned radicalism really ill-fitted his constituency party which was, according to Paul Thompson, 'a movement essentially based on the recognition that liberalism was an outdated philosophy of "old exploded fallacies", and that the Labour Party must put forward a new concept of society'.[7]

Deptford was very different. No broadly based socialism here, it was a trade union party scorning the socialist groups. It adopted a liberal-radical position within a strategy of independence, yet became increasingly dependent on the local Liberals.[8] The Deptford artisans were the most deeply wedded to liberalism in the mid-Victorian years and their move towards an independent political consciousness in the 1870s had never challenged the outlines of a deeply-held traditional radicalism. The strong Deptford SDF branch of the 1880s was, according to Annie Besant, 'mostly of the very poor'.[9] This was not typical

of the SDF elsewhere in London, and socialists in Deptford tended to fight the Progressives, possibly showing their alienation from a liberal-oriented and labour aristocrat-dominated movement.

The emergence of an independent labour movement built up in the 1890s and came to fruition after the turn of the century. Developments in the two decades after 1880 were therefore crucial in the uneven transition. It was a period of tensions and conflicts at many levels for labour aristocrats, and these problems of a political, economic and social kind must all contribute to an explanation of their changing political consciousness. Nevertheless, the very different experiences in Woolwich and Deptford must be emphasised. The independent labour consciousness involved two elements which need not go together, though often they did. One was a tactical decision to struggle and organise outside the existing party framework, the other an ideological rejection of liberal-radicalism that sometimes embraced a specific adoption of a socialist perspective. These elements inevitably fed off each other, but the ability of the former to exist without the latter, as in Deptford, is important for our understanding of the process as a whole. It could allow a continuation of radical liberal ideology if not of tactics. More studies of local labour movements as they emerged in this period would help clarify the issue.

These changes touch upon various interests of this book, of which only one is the resilience of the liberal-radical tradition. The rise of labour movements in so many towns also represented a shift in the orientation of the labour aristocracy towards the rest of the working class. There was some degree of turning back into the manual working class by that elitist stratum which had previously maintained an exclusiveness. In contrast to the picture of fragmentation presented in this study, the labour movement that emerged between the late 1880s and the First World War represents a growing, though by no means full, identification by the politically active working class of their political interests with those of the working class as a whole.

It was stressed in chapter 7 that the process of stratification which produced a fragmented social consciousness had to be linked to the wider labour consciousness of the end of the century. The emergence of a labour aristocracy was in itself a vital broadening away from a narrow craft sectionalism. A basis for this was the shift of the centre of highly paid skilled workers away from narrowly based and culturally somewhat isolated crafts such as coachbuilders, bookbinders and gold beaters towards the less traditionally oriented skilled trades that expanded in the mid-Victorian economy. Also important were the organisations,

clubs and less formal institutions whose leisure activities generated a wider social unity. In this way the paradoxical effect of the elitist stratification of the mid-Victorian period was to effect a development within the working class without which the participation of the labour aristocrats in a more general labour movement at the end of the century would have been far more difficult.

Why did this shift take place after the end of our period? If the viability of the mid-Victorian labour aristocracy depended on its structural position, then so too must changes in its behaviour. It is on this basis that four suggestions may be offered as contributions towards an explanation of the change. These are the situations at work, in its widest sense; the emergence of a non-manual lower-middle class; a continuing process of residential segregation; and increasing tactical conflicts with organised Liberalism.

The economic developments of the Great Depression and the period of the imperialist economy that grew out of it put increasing pressures upon many skilled workers, but especially those in metals and engineering. Here lies its specific significance for Kentish London. The factors that put pressure on skilled workers in the heavy goods industries especially were numerous but closely interrelated. The least effective response of industrialists to the economic difficulties was the increasing concentration of capital which still lagged well behind developments in Germany and the United States. Yet the extent to which it did develop restricted further the mobility prospects of skilled workers moving out of wage employment. It also increased the highly capitalised and bureaucratic nature of the industries. More important was the technological response. The introduction of more labour-saving machinery in engineering is the clearest example, with skilled labour substitution and the emergence of new semi-skilled grades between the older polarities of craftsman and labourer. In order to make the most effective use of the capital inputs, and more generally in order to produce more cheaply and effectively to counter foreign competition, there were efforts to speed up skilled work. One result was a far more intensive supervision of the craftsman's production which hurt him in two ways. It increased the extent to which he felt the impact of management and employer, but also challenged his craft pride and sense of control over the job. Trade union defence followed, and the bitter struggles in the metal trades in the 1890s derived directly from these issues. The final workplace context is the rise of employers' associations in many industries, and a general employer counter-offensive that was partly a response to the unionisation of 1889-90, but also aimed at

establishing authority in the workplace. In this way the new methods and new machines could be used most effectively. It was this cluster of developments that put growing pressure on the labour aristocrats, not so much in financial terms[10] but in their pride, independence and self-assurance. The struggle against the employer became one of much wider importance and aggression.

The economic expansion of a service sector in a growing international economy, with financial and commercial institutions on a new scale, together with the bureaucratisation of manufacturing industry, led to the emergence in numbers of managerial, technical and white-collar grades and with it the rise of a lower-middle class.[11] Socially they created the new shapeless suburbia in the major cities, especially London, and presented particular problems to the labour aristocrat. Clerks and other non-manual employees had been sufficiently few to lack cohesion or any great consciousness of status. They were certainly unable to threaten the confident place of the labour aristocrat within the local community, though specific skirmishes over mechanics' institutes occurred in Kentish London. The emergence of a distinctive white-collar stratum, earning little if any more than the better-paid worker but priding itself on its salaried and non-manual status, was an explicit threat to labour aristocrats. The status of the latter was being challenged not on the grounds of their failure to achieve some possible qualities, but on the inescapable fact that they worked with their hands. The new stratum that separated the labour aristocracy from the established middle classes, and rejoiced in its fiercely maintained but tenuous superiority, distinguished itself further by a process of residential segregation. This could take white-collar workers into new residential areas separate from artisans[12] but it often simply meant the separation of specific streets with the superior flourishes that regular earnings made possible.[13] This argument can be pushed no further without detailed research, but the rejection of these artisans by an increasingly numerous and self-conscious lower-middle class may be seen as a further factor pushing them back into the working class.

The residential sorting that speeded up in London at this time went beyond this differentiation. Areas such as Kentish London which had maintained some social breadth during the Victorian period began to lose it towards the end of the century. Local social elites of the older kind began to desert the area,[14] and with them went those relationships between labour aristocrats and local social leaders that had characterised the mid-Victorian community. The degree of social mixing that had occurred through nonconformity was reduced yet further, but

more important was a decline in the viability of local liberalism. From the 1880s, London constituency Liberal parties were based on a working-class numerical majority and a declining middle-class religious minority. The need to rouse the energies of the one without losing the money of the other was a dilemma that could be paralysing.[15] Growing class segregation and religious indifference among a large proportion of working-class liberals served only to exacerbate the problem. The growth of a more labour-conscious politics was a possible result of this increasing social isolation.

This leads to the fourth factor affecting labour aristocrat relationships with the working class as a whole — the growing organisational difficulties experienced by working-class liberals from the 1880s. These merely intensified the tensions within the Greenwich Liberal movement of the previous decade. That conflict between artisan liberals and the constituency Liberal leadership had tended to lack an ideological base, concentrating at one level on policies within a traditional radical framework, and on another upon organisational problems revolving around a place in the party's decision-making process. Rejection by middle-class liberals thus led initially to frustration and anger within the existing political assumptions. It was these tendencies that were driven much further under the pressure of essentially non-political forces towards the end of the century. To these must be added the 1883 Corrupt Practices Act, the 1885 redistribution and the democratic reforms of local government, none of which necessitated an independent labour politics, but which all inserted new factors into an already strained community liberalism that was fast losing its political and social viability.

These are some of the factors responsible for the late Victorian and Edwardian process by which the labour aristocracy shifted its relationship to a potentially wider labour movement. The problem is a difficult one. In the same way that we know too little of the meaning and orientation of labour aristocratic ideology in the mid-Victorian period, a gap that this book is intended partially to fill, so we understand even less about the real nature of the working-class political and social perspectives in the decades that followed. Labour history has done a great service in giving popular movements and experience their proper place in historical analysis, but it has also clouded understanding in many areas. Whether its tendencies are a Whiggish depiction of the progress of the working-class movement, or an analysis that concentrates on leadership as the vital force in labour politics, it has produced too few penetrating studies of the realities of working-class political and social

ideology during the crucial period of transition to an independent politics. The discussion above of some of the issues involved is only speculative, but if the argument of this book is correct, these kinds of factors would need to be drawn firmly into any explanation of the growth of independent labour.

The other issue that I want to raise in this concluding chapter is concerned with articulating some of the possible consequences of the book's argument for the mid-Victorian period itself. The way in which an ideology is formed, in particular the way in which a dominant ideology becomes convincing outside the social class or group whose clear interests it represents, is one that has long concerned both historians and sociologists of knowledge, and this is not the place to tackle the theoretical complexities of that debate. Yet certain points of interest to that discussion, certainly in its historical dimensions, seem worth raising in a more general form at this stage.

The significance of the development of a more accommodationist political and social position amongst the organised sections of mid-Victorian workers has long been recognised. The labour aristocracy adopted enough of the features of the dominant ideology of mid-Victorian England to contribute to the stabilisation of society as a whole. This is certainly not to say that what might be called bourgeois ideology, recognising that the term itself avoids many questions about ideological diversity in Victorian England, was fully accepted by the working class during the period. It was not even accepted by the labour aristocrats whose increased willingness to operate within the economic and social framework as they found it has so impressed historians. This study has emphasised how distinctively working-class was the artisan value system, yet it was one which absorbed some of the general assumptions of that dominant ideology. It is true that however great the distinction that marked out the working-class character of those values, their historical significance was to serve to maintain the prevailing economic and social arrangements of a particular society. Talk of a dominant ideology in effect means just that.

It is easier to discuss in national terms the broad problem of how the ideology was constructed, but far more difficult to analyse it at a local level, where what we are enquiring about is not some generally significant development where the results are of more interest than the process, but the realities of ideological change which involve the way in which individual artisans came to see the world. This problem arises over John Foster's description of the transition to working-class fragmentation and liberalisation in Oldham.[16] His argument that the town's

bourgeoisie felt the need to resume broader cultural control from the 1840s is convincing,[17] for an awareness of the need to assert a new social control is the key to understanding the responses of the propertied urban classes in various towns from the 1830s. Where Foster's analysis is unsatisfying is his explanation of how that process actually occurred. By presenting a too vivid contrast between class-conscious Oldham and its later liberal form, he needs to show us an equally dramatic process by which that ideological transition was effected. When he explains the mechanisms involved he is forced by his argument to rely on formal methods of social control and ideological dissemination, mechanisms that ultimately *imposed* values upon labour aristocrats. Both class-conscious Oldham and liberal Oldham are in an important sense too unambiguous. Neither the traditional components of the one nor the radical continuities that persisted in the other are drawn out. My doubts rest not just on a general view of working-class political ideas during the nineteenth century, but also on an unwillingness to accept his mechanisms of ideological transition.

Two themes emerge from this study which point in interesting directions. The first is that ideology was indeed constructed in Kentish London by the local social elites, but in a way which was neither aggressive nor, of course, conspiratorial. The other point is that the labour aristocracy's political and social values in the period were not some external imposition, but rather the drawing out in a changed situation of strands within the working-class tradition. It is this construction of an ideology serving different interests from within the working-class culture that is so interesting.

It is important to keep sight of the fact that however much this process drew upon indigenous working-class traditions, it also involved the actual construction of a dominant ideology; someone was winning the ambiguous consent of these labour aristocrats and it was achieved by an active process. It is this process which can be neglected when attention focuses at the national level. The values of respectability and independence were enmeshed in a popular liberalism created by social contact in Kentish London. The emergence of a particular accommodationist ideology could not have been a result of a direct and static causation linking economic and social structure to ideological consequences. Within that configuration there appeared the active efforts of the local social elite, and the ambivalent but ultimately receptive attitude of labour aristocrats to them.

There are various ways in which ideological diffusion can be achieved. A common feature, one that Foster for example shows as

important in Oldham after 1848, was the role of a small master and shopkeeper stratum as an intermediary between the skilled workers and the substantial bourgeoisie of the towns. Their role in self-help and political organisations could have been crucial in easing the downward diffusion of the values. Until the people involved are identified more closely, however, doubt must remain as to just how distinct from the working class were the members of this stratum. It could well emerge that their marginality, their insecure position even within the petty bourgeoisie, and their identification with a personal working-class background, all made them less plausible as an agent of ideological transmission.

In Kentish London the process was, in any case, one of more direct contact between local social elites and labour aristocrats. The absence of a dominant employing bourgeoisie made this feasible. The attendance at working-class meetings, the speeches and encouragement offered there and so on were all essential to the developments that I have analysed. These were not the classic and well-known methods of ideological control, such as mechanics' institutes, religious persuasion, temperance and education. These activities were indeed attempted, but their patronising and aggressive nature ensured failure. Where the active role of local social leaders was important was not in imposing a new set of values through these institutions, but rather in encouraging those strands in artisan ideology of which they approved, strengthening and reinforcing them, and binding them into a new unifying social force — liberalism. The visits to societies by prominent members of the local middle class, speeches there, attendance at festivals and celebrations, sharing of social and political platforms — all these activities were vital in actively aiding the diffusion of a particular framework of values that served to make class relations more stable. Most important of all was liberalism, where the relationship was visible and continuing, capable for a long time of absorbing all kinds of tensions, because what was essential was not agreement over all matters of detail but an acceptance of certain common assumptions. This must not be seen as a necessarily self-conscious process, but it was an effective one none the less. Its success rested upon the economic and social development of the period, the activities of members of the social elite of the towns, and the existence of independent artisan traditions capable of adaptation.

This last point is of striking importance in explaining the overall process. One emphasis of this study has been that ideology only moves and survives if it is capable of making apparent sense of the world in which those who share it live. In that light, it is difficult to see how externally

imposed ideas can in the long run be successful. The process by which ideological dominance is achieved is both more complex and more internal than the classic notion of social control would allow. This emerges most clearly in the discussion of political ideas and activities. The ideology that came to prevail amongst labour aristocrats in Kentish London was one that now served the stability of existing economic and social relationships in a way in which artisan ideas had not done earlier in the century. The aspect of middle-class ideology that they most actively came into contact with was that of middle-class radical liberalism. Yet the reality of their own economic and social situation strikingly differed from that of the social group which had generated that political and social philosophy. As should be clear from chapter 10, what occurred was not an acceptance by artisan liberals of ideas from outside, no infiltration or indoctrination, but the self-generation from within the working-class radical tradition of an ideology still based upon a vigorous assertion of independence, self-respect, justice and the rejection of privilege. This position could make contact with an element in middle-class ideology that was notably present in Kentish London. It was in addition socially accommodationist in the mid-Victorian context. All this is not the same as saying that this labour aristocracy accepted middle-class ideology. The tensions and conflicts outlined in the preceding chapters, both political and social in nature and often vigorous in form, did not destroy the broad effectiveness of the process, though their existence does strengthen further this argument.

It is here that the two main points developed in this conclusion tie together. The labour aristocracy in mid-Victorian Kentish London represented through its values and its activities an element in what nationally was a recently achieved social stability. Yet it was also, through its radicalism, its collective organising, and its rejection of a narrow individualism, strengthening potentially oppositional elements within working-class tradition and culture. It was from that dual function that there developed the ambiguities and the tensions of its relationship to the world around it.

LIST OF SOURCES

Books and articles used are referred to in the footnotes. The abbreviations used in this list for the main record collections are as follows:

Bishopsgate Bishopsgate Institute Library
BTHR British Transport Historical Records Department
GLRO Greater London Record Office
LSE British Library of Political and Economic Science
 (London School of Economics)
PRO Public Record Office

Government Works

List of effective workmen in the Woolwich Arsenal 1841 (WO 44/294) (PRO)
Efficiency of workmen in the Royal Arsenal 1844-52 (WO 44/523) (PRO)
Introduction of paying men by ticket 1846-47 (WO 44/297) (PRO)
Arsenal Volunteer Corps 1846-47 (WO 44/523) (PRO)
Return of persons employed in the Royal Carriage Department on 1st April 1854 (WO 44/524) (PRO)
Reorganisation of the clerical establishments in the Royal Carriage Department and the Royal Laboratory 1854 (WO 44/297) (PRO)
List of officers employed in the War Department June 1st 1857 (SUPPLY 5/59) (PRO)
Petitions for appointments (WO 54/888 and 930) (PRO)
Miscellaneous papers on establishments (ADM 7/595-596) (PRO)

Building Industry

District Surveyors' Monthly Returns — 1849-52 (MBO 48-52) (GLRO)
District Surveyors' Monthly Returns — 1877-80 (MBW 1665-1698) (GLRO)
District Surveyors' Annual Abstracts 1856-79 (MBW 1772-1776) (GLRO)
Return of District Surveyors as to houses surveyed 1848-52 (MBO vol. 306) (GLRO)

Employment

General Steam Navigation Company: Deptford Works Entry Book
1877-87 (Company office)

London Brighton and South Coast Railway Company: Staff Records
(LBS 15/14) (BTHR)

South Eastern Railway Company: Staff Records (SER 15/6) (BTHR)

Trade Unions

Webb Trade Union Collection — manuscript notebooks on building
workers (A/X-XIII), engineering workers (A/XV-XVII), shipbuilding
workers (A/XXXII-XXXIII), river workers (A/XLI), labourers and
dock workers (A/XLII), coopers (A/XLIV) (LSE)

Operative Bricklayers' Society: *Trade Circular* 1861-80, *Quarterly
Reports* 1862-66, *Annual Reports* 1863-81 (Amalgamated Union of
Building Trade Workers Head Office)

Operative Stonemasons' Society: *Fortnightly Returns* 1840-80,
Financial Reports 1843-50, *Annual Audit* 1863-82 (Amalgamated
Union of Building Trade Workers Head Office)

National Association of Operative Plasterers: Executive Minutes
1862-75 (Union Office)

United Operative Plumbers' Association: *Quarterly Reports* 1878-87
(Plumbers' Union Head Office)

Amalgamated Society of Carpenters and Joiners: *Monthly Reports*
1863-80, *Annual Reports* 1860-80, *Financial Report* 1860 (Amalga-
mated Society of Woodworkers Head Office)

General Union of Carpenters and Joiners: *Monthly Reports* 1863-68,
1877-80, *Annual Reports* 1849-50, 1867-80 (Amalgamated Society
of Woodworkers Head Office)

Amalgamated Society of Engineers: *Annual Reports* 1851-80, *Monthly
Reports* 1851-80, *List of Shops in London* (no date), General
Information Schedule — Returns from Branches 1876 (Amalgamated
Union of Engineering Workers Head Office)

United Kingdom Patternmakers' Association: *Annual Reports* 1872-80,
Monthly Reports 1877-80 (United Patternmakers' Association Head
Office)

United Society of Boilermakers: *Annual Reports* 1877-82 (Bishopsgate)

Friendly Society of Ironfounders: *Reports* 1865-80 (Bishopsgate)

Steam Engine Makers' Society: *Trade Reports* 1848-80, *Annual Reports*
1837-80 (Bishopsgate)

Amalgamated Society of House Decorators and Painters: *Quarterly
Reports* 1873-81, *Annual Reports* 1873-81 (Bishopsgate)

General Amalgamated Labourers' Union: *Report* 1872 (Bishopsgate)
*Balance Sheet of the 1859-60 Strike and Lock-Out of the London
 Building Trades* (1860) (Bishopsgate)
Miscellaneous rule books, etc. (FSI and FS7) (PRO)

Friendly Societies

Ancient Order of Foresters, South London District: Quarterly Returns
 from Courts 1846-76, various rule books (AOF South London Office)
Independent Order of Oddfellows – Manchester Unity: *South London
 District Reports* 1844-80, *Quarterly Reports* 1839-80 (IOOF
 South London District Office)
Sons of Temperance, London Grand Division: *Reports* 1868-80
 (Division Office)
Provident Reliance Friendly Society: Minute Books 1881-87, First Half-
 Yearly Report 1881 (Head Office)
Many rule books (FS1, FS3, FS5) (PRO)

Co-operative Societies

Royal Arsenal Co-operative Society Declaration Book 1872-1882
 (Head Office)
Woolwich Baking Society: *Reports* 1858-63 (Royal Arsenal Co-
 operative Society Head Office)
New Charlton Economical Baking Society: *Rules* 1853 (Royal Arsenal
 Co-operative Society Head Office)
Rule books (FS1, FS8, FS17) (PRO)

Building Societies

Industrial Building Society: Annual Reports 1853-75, Minute Books
 1852-54 (Greenwich Building Society Head Office)
Borough of Greenwich Building Society: Minute Book 1852-55
 (Greenwich Building Society Head Office)
Rule books (FS6) (PRO)

Religion

Records of Christchurch, East Greenwich, Building Committee 1847-52
 (P78/LTC/56/1-63) (GLRO)
St Paul's, Greenwich, Building Committee 1866 (P78/PAU 1/20)
 (GLRO)
Greenwich Road Congregational Chapel: Baptismal Register 1857-1918
 (N/C/49) (GLRO)
Deptford High Street Congregational Church: Records 1873-1910,

Records and Cash Accounts 1853-71 (Church)

Rectory Place Congregational Church, Woolwich: Roll of Members
1852-93 (Church)

St Mark's Presbyterian Church, Greenwich: Communion Roll 1842-64
(Presbyterian Historical Association Office)

Brockley Congregational Church: Minutes and Members Rolls 1854-61,
1861-80 (Manor House Public Library, Lee)

Items from *Methodist Recorder* and *Methodist Magazine* (Methodist
Archives Centre)

Marriage Registers

For 1851-53: General Register; St Alphege; St Nicholas, Deptford;
St Luke's, Charlton; St Thomas; St Mary's; St Margaret's (Woolwich
Registry)

For 1873-75: All the above, together with St John's, Blackheath;
St Paul's, Greenwich; Holy Trinity; Christchurch, Greenwich;
St Peter's, Greenwich; St James, Kidbrooke; St Paul's, Charlton;
St John's, Woolwich; Christchurch, Shooter's Hill; St Nicholas,
Plumstead (Woolwich Registry)

For 1851-53: St Paul's, Deptford (Lewisham Registry)

For 1873-75: St Paul's, Deptford; St Luke's, Deptford; St James,
Hatcham; All Saints; St John's, Deptford; St Peter's, Deptford;
Christchurch, Deptford (Lewisham Registry)

Politics

Papers on Chartism (HO 44/52, 45/102, 45/2410 London, 45/2410B)
(PRO)

Meetings and Demonstrations 1830-67 (MEPOL 2/59) (PRO)

Papers on Fenianism (HO 45/7799) (PRO)

Plumstead Common Riots (HO 45/9413/56640) (PRO)

Metropolitan Parliamentary Reform Association 1842 (British Museum
Additional Manuscripts 27810)

Metropolitan Anti-Corn Law Association (British Museum Additional
Manuscripts 35147)

Minute Book of the Central Garibaldi Committee 1860-61 (Bishopsgate)

Reform League Papers 1865-67 (Bishopsgate)

Liberal Association pamphlets (Bishopsgate)

Colonel Sleigh File (Greenwich Local History Centre)

Martin Collection (Greenwich Local History Centre)

Miscellaneous pamphlets and posters (Greenwich Local History Centre)

Letters from Maddox to Federal Council of First International

(Internationaal Instituut vour Sociale Geschiedenis, Amsterdam.
Made available as photocopies)

Miscellaneous

Census Enumerators' Schedules: 1841 (HO 107), 1851 (HO 107), 1861
(RG 9), 1871 (RG 10) (PRO)
Greenwich Hospital Works Department, General Entry Book (ADM
73/153) (PRO)
Greenwich Workhouse Admission Register 1854-72 (GLRO)

Directories

Pigot's Directory of London and Six Counties, 1840; *Post Office
Directory of Six Home Counties*, 1845, 1851, 1855, 1870; *Post
Office Directory of London and Nine Counties*, 1846; *Post Office
London Directory* 1850, 1851, 1853, 1858, 1865, 1870, 1878; *Post
Office London Suburban Directory*, 1860, 1865, 1868, 1876;
Bagshaw's Directory of Kent, 1847; *Melville's Directory of Kent*,
1858; *Post Office Directory of Kent*, 1878.
Woolwich, Plumstead and Eltham Directory, 1848; *Jackson's Woolwich
Directory*, 1850, 1861, 1864, 1868; *Archdeacon's Greenwich and
Woolwich Directory*, 1852; *Mason's Greenwich and Blackheath
Shilling Directory*, 1852; *Deptford Directory for 1853; Blackheath,
Lee and Lewisham Directory*, 1879-80; *Chapman's Directory for
Woolwich*, 1884
Marchant's Building Trade Directory, 1857; *Post Office Directory of
Engineering Trades*, 1870
London and Provincial Medical Directory, 1848, 1854, 1860; *Medical
Directory*, 1870

Official Publications

The year and volume numbers all refer to *Parliamentary Papers*.

Censuses of Population, 1801-1881
Return of assessed taxes 1847-1848, XXXIX, 233
Select Committee on Small Arms 1854, XVIII
Select Committee on the Elective Franchise 1860, XII
Employment at Dockyards, etc. 1860, XLII, 49
Annual Reports of the Registrar-General of Friendly Societies 1862, XXIX;
1863, XXIX; 1864, XXXII; 1872, LIV; 1873, LXI; 1874, LXII.
Officers, Foremen, Artificers and Labourers at Royal Arsenal 1863,
XXXIII, 531

Dockyard Officers and Workmen, March 1863. 1863, XXXI, 163

Admiralty Order on Promotion of Officers and Artificers in Dockyards, 1861.1863, XXXV, 169

Returns Relating to Government Employee Voters 1866, LVII, 45

Return of Working-Class Electors in Parliamentary Cities and Boroughs, 1866.1866, LVII, 47

Royal Commission on Trade Unions 1867, XXXII; 1867-68, XXXIX; 1868-69, XXI

Royal Commission on Friendly and Benefit Building Societies 1871, XXV; 1872, XXVI; 1873, XXII; 1874, XXIII

London School Board (Inspectors' Reports), August 1875.1876, LIX

Abstract of the Quinquennial Returns of Sickness and Mortality experienced by Friendly Societies, 1855-1875.1880, LXVIII

Select Committee on Artisan and Labourers' Dwellings Improvements 1881, VII; 1882, VII

Workmen Employed and Overtime, Royal Arsenal, 1886-1890.1886, XL, 879; 1887, LI, 733; 1888, LXVII, 921; 1890, XLIII, 617

Select Committee on Town Holdings 1887, XIII

Condition of the Working Classes 1887, LXXI

Committee on the Army Manufacturing Departments 1887, XIV

General Report on the Wages of the Manual Labour Classes in the United Kingdom, 1893-94, LXXXIII. ii

Newspapers and Periodicals

Kentish Mercury 1840-1880

West Kent Guardian 1840-1850

Kentish Standard 1842

Kentish Independent 1843-1880

Greenwich and West Kent Observer 1853

Greenwich Free Press 1855-1865

South London News 1857

Pryce's Monthly Journal 1868

Greenwich and Deptford Chronicle 1869-1880

Greenwich Good Templar 1875-1876

Newcastle Chronicle 1858

Northern Star 1838-1852

Morning Star 1865

People's Paper 1852-1858

Working Man 1861-1862

Workman's Advocate 1865-1866

Beehive 1862-1872
Commonwealth 1866-1867
Oddfellows' Magazine 1857-1880
The Reasoner 1846-1854
National Reformer 1860-1876
The Co-operator 1860-1871
Co-operative News 1871-1872

Unpublished Theses and Papers

Andrews, J.H., 'Political issues in Kent, 1820-46' (Univ. of London
 M. Phil thesis, 1967)
Cross, Sheila, 'Elections in Greenwich' (typescript in Greenwich Local
 History Centre)
Crossick, Geoffrey, 'Social structure and working class behaviour:
 Kentish London, 1840-1880' (Univ. of London PhD thesis, 1976)
Dyos, H.J., 'The suburban development of Greater London south of
 the Thames, 1826-1914' (Univ. of London PhD thesis, 1952)
Hartridge, R.J., 'The development of industries in London south of the
 Thames, 1750-1850' (Univ. of London MSc thesis, 1955)
Hickman, G.M., 'The origins and changing functions of settlement in
 south-east London' (Univ. of London PhD thesis, 1951)
Lees, Lynn, 'Social change and social stability among the London Irish,
 1830-1870' (Harvard Univ. PhD thesis, 1969)
Ludlow, Barbara, 'Greenwich Marsh and Westcombe Park, 1837-1901'
 (thesis for Diploma of Local History, 1964: in Greenwich Local
 History Centre)
McLaine, W., 'The early trade union organisation among engineering
 workers' (Univ. of London PhD thesis, 1939)
Matsumura, T., 'The flint glassmakers in the classic age of the labour
 aristocracy, 1850-1880' (Univ. of Warwick PhD thesis, 1976)
Pollard, S., 'The economic history of British shipbuilding, 1870-1914'
 (Univ. of London PhD thesis, 1951)
Prothero, I.J., 'London working-class movements 1825-48' (Univ. of
 Cambridge PhD thesis, 1967)
Roebuck, J., 'Local government and some aspects of social change in
 the parishes of Lambeth, Battersea and Wandsworth, 1838-1888
 (Univ. of London PhD thesis, 1968)
Rolfe, E., 'The growth of south-east London with special reference to
 the development of communications' (Univ. of London PhD thesis,
 1968)
Royle, E., 'George Jacob Holyoake and the secularist movement in

Britain 1841-1861' (Univ. of Cambridge PhD thesis, 1968)

Viles, D.B., 'The building trade workers of London 1835-1860' (Univ. of London M.Phil thesis, 1975)

Wheble, C.L., 'The London lighterage trade' (Univ. of London MSc thesis, 1939)

NOTES

Chapter 1

1. F. Gillespie, *Labor and Politics in England 1850-1867*, London, 1966 edition.
2. R. Harrison, *Before the Socialists. Studies in Labour and Politics 1861-1881*, London 1965. See esp. pp. 1-39.
3. S. Pollard, 'Nineteenth-century co-operation: from community building to shopkeeping', in A. Briggs and J. Saville (eds.), *Essays in Labour History*, London 1960, pp. 74-112.
4. F.M. Leventhal, *Respectable Radical: George Howell and Victorian Working Class Politics*, London 1971, p. xiv.
5. F.B. Smith, *The Making of the Second Reform Bill*, Cambridge 1966, pp. 8-14.
6. E.J. Hobsbawm, 'The labour aristocracy in nineteenth-century Britain', in *Labouring Men*, London 1964, pp. 272-315.
7. T. Tholfsen, *Working Class Radicalism in Mid-Victorian England*, London 1976.
8. T. Tholfsen, 'The transition to democracy in Victorian England', in *International Review of Social History*, 6, 1961, pp. 226-48.
9. J. Foster, *Class Struggle and the Industrial Revolution. Early industrial capitalism in three English towns*, London 1974, esp. ch. 7, pp. 203-50.
10. R.Q. Gray, *The Labour Aristocracy in Victorian Edinburgh*, Oxford 1976.
11. Ibid., p. 1.
12. W. Ashworth, *An Economic History of England 1870-1939*, London 1960, pp. 6-7.
13. E.J. Hobsbawm, *Industry and Empire. An Economic History of Britain since 1750*, London 1968, pp. 88-97; S.G. Checkland, *The Rise of Industrial Society in England 1815-1885*, London 1964, pp. 35-51; J.R.T. Hughes, *Fluctuations in Trade, Industry and Finance. A Study of British Economic Development 1850-1860*, Oxford 1960, pp. 3-10, 285-9.
14. R.A. Church, *The Great Victorian Boom, 1850-1873*, London 1975, p. 25.
15. R. Harrison, op. cit., p. 23.
16. Checkland, op. cit., p. 39.
17. Hughes, op. cit., p. 4.
18. Ashworth, op. cit., p. 14.
19. Church, op. cit., p. 57.
20. Ibid., p. 76.
21. Ibid., p. 37.
22. F.B. Smith, op. cit., p. 8.
23. Cf. G.J. Barnsby in the *Bulletin of the Society for the Study of Labour History*, no. 27, 1973, p. 36.
24. Though see the excellent contribution by G. Stedman Jones, *Outcast London. A Study in the Relationship between Classes in Victorian Society*, Oxford 1971, pp. 19-155.

Chapter 2

1. G. Stedman Jones, *Outcast London: a study in the relationship between*

classes in Victorian Society, Oxford 1971, pp. 257-8.

2. Janet Roebuck, 'Local government and some aspects of social change in the parishes of Lambeth, Battersea and Wandsworth 1838-1888' (Univ. of London PhD thesis, 1968), *passim.*

3. *Kentish Mercury*, 27 February 1858.

4. J.H. Andrews, 'Political Issues in Kent 1820-46' (Univ. of London M Phil thesis, 1967), p. 102.

5. *Victoria History of the County of Kent*, vol. 2, London 1926, p. 337.

6. J. Arnold et al., *Handbook for the 1896 Co-operative Congress*, Woolwich 1896, p. 247.

7. *Victoria County History of Kent*, op. cit., p. 339.

8. Daniel Defoe, *A Tour thro' the whole island of Great Britain*, reprinted London 1927, p. 97.

9. Ibid., p. 94.

10. Ibid., p. 95.

11. E.J. Hobsbawm, 'The nineteenth-century London labour market', in Ruth Glass (ed.), *London: Aspects of Change*, London 1964, pp. 3-28.

12. For a fuller discussion of this issue see Geoffrey Crossick, 'Social structure and working class behaviour: Kentish London 1840-1880' (Univ. of London PhD thesis, 1976), pp. 38-42.

13. Ellen Chase, *Tenant Friends in Old Deptford*, London 1929, p. 31.

14. Frederick Willis, *London General*, London 1953, pp.29-30.

15. G.M. Hickman, 'The Origins and Changing Functions of Settlement in South-East London' (Univ. of London PhD thesis, 1951), p. 96.

16. H.J. Dyos, 'The Suburban Development of Greater London South of the Thames 1826-1914' (Univ. of London PhD thesis,1952), p. 205.

17. *Kentish Mercury*, 8 February 1851; 28 May 1859.

18. PRO, HO 61/25.

19. Barbara Ludlow, 'Greenwich Marshes and Westcombe Park 1837-1901' (Thesis for Diploma of Local History, 1964. Copy in Greenwich Library), *passim.*

20. A.R.B. Bennett, *London and Londoners in the 1850s and 60s*, London, 1924, p. 198.

21. Dyos, op. cit., *passim*; Eileen Rolfe, 'The Growth of South-East London 1836-1914, with special reference to the development of communications' (Univ. of London PhD thesis,1968), *passim*; H. Pollins, 'Transport lines and social divisions', in Ruth Glass, op. cit., pp. 29-61.

22. F. Sheppard, *London 1808-1870: The Infernal Wen*, London 1971, pp. 107-8.

23. Dyos, op. cit., p. 240.

24. Sheppard, op. cit., p. 123.

25. Dyos, op. cit., p. 230.

26. Ibid., pp. 251-62.

27. E. Course, *London Railways*, London 1962, pp. 19-31.

28. See the diagram 'Railways Opened 1836-1914' in Rolfe, op. cit.; also Sheppard, op. cit., p. 140.

29. Course, op. cit., p. 205.

30. *Greenwich and Deptford Chronicle*, 19 February 1870.

31. For evidence on these matters see numerous guide books and directories, the separation of local political and social organisations, and the evidence of Booth in his Religious Influences series, Charles Booth, *Life and Labour of the People in London*, London 1902, third series, vol. 5.

32. *Kentish Mercury*,15 January 1859.

33. R.W. Pepper, 'The Urban Development of Lewisham – a Geographical

Interpretation' (London Univ. MA thesis, 1965), p. 127.

34. Ibid., p. 207.
35. Charity Organisation Society, *On the Best Means of Dealing with Exceptional Distress: the Report of a Special Committee*, London 1886, Q. 382.
36. *Kentish Independent*, 30 November 1867.
37. J. Arnold *et al.*, op. cit., p. 248.
38. *Kentish Independent*, 30 November 1867.
39. Ibid., 12 October 1867.
40. *Kentish Mercury*, 16 November 1866.
41. Booth, op. cit., third series, vol. 5, p. 7.
42. *Kentish Mercury*, 17 January 1852; 8 October 1853; also see Booth, op. cit., third series, vol. 5, pp. 3 and 9.
43. Ibid., third series, vol. 5, p. 10.
44. *Greenwich and Deptford Chronicle*, 5 March 1870.
45. Rochester Diocesan Society, *A Short Account of the Spiritual Needs of the Ten Metropolitan Boroughs in South London*, London 1902.
46. C.E. Buckley, 'Memoir of old Deptford', in *Transactions of the Greenwich and Lewisham Antiquarian Society*, 5, 1961, p. 88.
47. Booth, op. cit., first series, vol. 2, appendix pp. 53-4.
48. This does not preclude specific segregation within the area. For example, the streets alongside the Park were generally inhabited by artisans and clerks.
49. Booth, op. cit., third series, vol. 5, p. 50.
50. A problem in drawing too firm conclusions is the unsystematic nature of the evidence upon which this discussion is based. It rests upon the local press, Booth's subsequent observations and his references to past development, and an impressionistic picture built up in the course of the research. Ideally, a systematic and statistical study would involve the use of census schedules, but the time-consuming nature of that work made it impossible for this project.
51. Aileen Smiles, *Samuel Smiles and his Surroundings*, London 1956, p. 81.
52. Quoted by M. St J. Packe, *The Life of John Stuart Mill*, London 1954, p. 357.
53. *Report of a preliminary inquiry into . . . the sanitary condition . . . of Woolwich*, General Board of Health, London 1851, p. 56.
54. *Kentish Independent*, 14 October 1848.
55. Booth, op. cit., first series, vol. 2, appendix p. 56.
56. *Kentish Independent*, 8 September 1866.
57. *Kentish Mercury*, 18 February 1854.
58. *Kentish Independent*, 2 October 1869.
59. W.T. Vincent, *The Records of the Woolwich District*, London 1887, p. 59.
60. *Kentish Mercury*, 4 May 1861.

Chapter 3

1. In this way the nineteenth-century census differs from the present-day categories of the Registrar-General, and it is for this reason that I seriously doubt whether Stedman Jones can make valid inferences from his attempt to recalculate the 1861 census in terms of an amended version of the Registrar-General's categories. Although he explains the procedure in Appendix 1, he does not tackle the objections raised here. Gareth Stedman Jones, *Outcast London: a study in the relationship between classes in Victorian society*, Oxford 1971, pp. 387-93.

Henceforth in this chapter, Greenwich and Lewisham will refer to the boroughs of those names, unless otherwise stated.

3. *West Kent Guardian*, 4 January 1840.
4. *Greenwich and Deptford Chronicle*, 9 April 1870.
5. *Kentish Mercury*, 27 June 1857.
6. *Kentish Independent*, 7 November 1867; *Kentish Mercury*, 7 January 1860.
7. *Kentish Mercury*, 18 December 1858. The works were visited by Thomas Wright – see his pseudonymous article under the name Riverside Visitor, 'Bundle-wood work and workers', in *Good Words*, 1883, pp. 542-5.
8. The large number of proprietary and endowed schools in the area makes this classification appropriate.
9. The comparison between Greenwich and London as a whole needs qualification, lest it be thought to contradict the assertion of an important professional and non-industrial middle class in the area. The London figure is a mean with wide variation between the different boroughs. The relative size of the non-industrial middle class in any one borough changes as much with the size of the occupied population as a whole as with its own dimensions. The result is a figure for Greenwich lower than London as a whole which had many areas with far less working-class population than Greenwich. The fact that Greenwich was not a dormitory for City clerks at this time is indicated in the commerce total. In addition, Lewisham contained some areas that were socially part of the riverside town.
10. *Kentish Mercury*, 19 December 1840.
11. F. Bédarida, 'Londres au milieu du XIXe siècle: une analyse de structure sociale', in *Annales*, 23, 1968, p. 274.
12. Ibid., pp. 277-8.
13. E.P. Thompson and Eileen Yeo (eds.), *The Unknown Mayhew. Selections from the 'Morning Chronicle' 1849-1850*, London 1971, *passim*.
14. P.G. Hall, *The Industries of London since 1861*, London 1952, p. 70, Hall's Greenwich included Lewisham.
15. Sheppard, in his recent history of Victorian London, inexplicably ignores the engineering and shipbuilding works of Kentish London in his discussion of those industries. F. Sheppard, *London 1808-1870: The Infernal Wen*, London 1971, pp. 174-80.
16. E.J. Hobsbawm, 'The Labour Aristocracy in Nineteenth-Century Britain', in his *Labouring Men*, London 1964, pp. 272-315.
17. *Kentish Mercury*, 1 May 1858; 27 March 1858.
18. Ibid., 1 May 1858.
19. Ibid., 8 August 1840.
20. Ibid., 2 June 1860.
21. Ibid., 5 June 1852.
22. *Kentish Independent*, 24 February 1866.
23. J. Arnold, *Our Duty as Co-operators*, Woolwich 1880, p. 7.
24. The following directories were used (see list of sources): Pigot 1840; Kelly 1846; Bagshaw 1847; Post Office London 1851, 1853, 1858, 1865, 1870, 1878; Deptford 1853; Melville 1858; Marchant 1857; Post Office Suburban 1865; Post Office 6 Counties 1870; Post Office Engineering 1870; Post Office Kent 1878. Wherever possible, other directories were used for cross-checking and correction.
25. S. Pollard, 'The decline of shipbuilding on the Thames', in *Economic History Review*, 3, 1950-51, *passim*; Philip Banbury, *Shipbuilders of the Thames and Medway*, Newton Abbot 1971, p. 70.
26. P. Barry, *Dockyard Economy and Naval Power*, London 1863, p. 294
27. *Kentish Mercury*, 2 March 1867.

28. *Greenwich and Deptford Chronicle*, 20 February 1875.

29. *Kentish Mercury*, 9 August 1856; 8 November 1856.

30. Barbara Ludlow, 'Greenwich Marshes and Westcombe Park 1837-1901' (Thesis for the Diploma of Local History, 1964. Copy in Greenwich Library), p. 8; Banbury, op. cit., p. 202.

31. L.C. Cornford, *A Century of Sea Trading 1824-1924*, London 1924, pp. 38 and 145.

32. *Greenwich and Deptford Chronicle*, 7 June 1863.

33. Ibid., 30 January 1875.

34. *Kentish Mercury*, 4 April 1846.

35. For both this and the Deptford estimate see W.T. Vincent, *The Records of the Woolwich District*, London 1887, p. 289; *Parliamentary Papers*, 1860, XLII, pp. 49 and 279.

36. *Kentish Independent*, 12 December 1846.

37. Ibid., 18 April 1868.

38. Employment data for the Arsenal are surprisingly difficult to find. This summary is based on Vincent, op. cit., p. 373; O.F.G. Hogg, *The Royal Arsenal*, London 1963, pp. 1289-91; and local newspapers.

39. *Kentish Mercury*, 6 October 1855.

40. Hogg, op. cit., p. 828.

41. *Kentish Mercury*, 17 February 1849.

42. Keith Burgess, 'Technological change and the 1852 lock-out in the British engineering industry', in *International Review of Social History*, 14, 1969, p. 221; R.J. Hartridge, 'The Development of Industries in London South of the Thames 1826-1914' (Univ. of London MSc thesis, 1955), p. 153.

43. On this whole process see Burgess, op. cit., *passim*.

44. Edgar C. Smith, *History of Naval and Marine Engineering*, Cambridge 1938, p. 60; Barry, op. cit., pp. 267-9; *Kentish Mercury*, 2 September 1854.

45. *Kentish Mercury*, 11 April 1846; 30 August 1862; *Greenwich and Deptford Chronicle*, 19 July 1873.

46. *Kentish Mercury*, 8 October 1853.

47. The works closed with the death of England in the mid-1860s. C.H. Dickson, 'George England and Co.' in *Journal of the Stephenson Locomotive Society*, 32, 1961, pp. 138-43.

48. South Eastern Railway, 'Staff Registers: Loco Department', British Transport Historical Records (BTHR): SER 15/6; London, Brighton and South Coast Railway, 'List of Staff, December 1871', BTHR: LBS 15/14.

49. *Kentish Mercury*, 7 July 1860.

50. W.V. Bartlett, 'The industrial development of Deptford', in *Transactions of the Greenwich and Lewisham Antiquarian Society*, 7, 1966, p. 79.

51. Ibid., p. 72.

52. *Kentish Mercury*, 16 June 1855.

53. David Alexander, *Retailing in England during the Industrial Revolution*, London 1970, pp. 150-3.

54. John Lovell, *Stevedores and Dockers. A Study of Trade Unionism in the Port of London, 1870-1914*, London 1969, p. 24.

55. Henry Mayhew, *London Labour and the London Poor*, London 1861-1862, vol. 3, p. 288.

56. Charles Booth, *Life and Labour of the People in London*, London 1902, second series, vol. 3, p. 410.

57. C.L. Wheble, 'The London Lighterage Trade' (London Univ. MSc thesis, 1939).

58. G.T. Jones, *Increasing Returns*, London 1933, part 2.
59. *Kentish Independent*, 17 February 1866; 10 March 1866.
60. *Kentish Mercury*, 28 March 1857.
61. 7 & 8 Victoria 1844, Cap LXXXIV. For a description of the working of the Act see Ida Darlington, 'The Metropolitan Buildings Office', in *The Builder*, 191, 1956, pp. 628-32.
62. Greater London Records Office, MBO 48-52; MBW 1665-1698. The areas covered were Deptford, Greenwich, Charlton, Woolwich, Plumstead, Eltham, Blackheath, Lee, Lewisham, Sydenham, Rotherhithe, Peckham and East Camberwell.
63. H.J. Dyos, 'The speculative builder and developer of Victorian London', in *Victorian Studies*, 11, 1968, p. 652.
64. On jobbing builders, see Geoffrey Crossick, 'Social Structure and Working-Class Behaviour: Kentish London 1840-1880' (Univ. of London PhD thesis, 1976), pp. 84-5.
65. Ibid., p. 84.
66. Dyos, 'The speculative builder', p. 651.
67. Greenwich Hospital Works Department, General Register, PRO, Adm 73/153.
68. Dyos, 'The speculative builder', pp. 661-9.
69. Select Committee on Town Holdings, *Parliamentary Papers*, 1887, XIII, Q. 10, 537.
70. E.W. Cooney, 'Origins of the Victorian Master Builders', in *Economic History Review*, 8, 1955, pp. 167-76.
71. Dyos, 'The speculative builder', *passim*; G.T. Jones, op. cit., p. 59; G.S. Lefevre and T.R. Bennett, *Account of the Strike and Lock-Out in the Building Trades of London in 1859-60*, London 1860, p. 12.
72. These cases emerge from an examination of the directories listed in n. 24.

Chapter 4

1. J. Foster, *Class Struggle and the Industrial Revolution. Early Industrial Capitalism in Three English Towns*, London 1974, passim.
2. *Greenwich and Deptford Chronicle*, 1 April 1876.
3. Compare Matsumura's superb data on the earnings of flint glassmakers in T. Matsumura, 'The flint glassmakers in the classic age of the labour aristocracy, 1850-80' (Univ. of Warwick PhD thesis, 1976), pp. 80-109; and the company wage records used to good effect by R.Q. Gray, *The Labour Aristocracy in Victorian Edinburgh*, Oxford 1976, pp. 72-83.
4. E.J. Hobsbawm, 'Custom, wages and workload in nineteenth-century industry' in *Labouring Men*, London 1964, pp. 344-70.
5. See the excellent discussion of seasonality in G. Stedman Jones, *Outcast London. A Study in the Relationship between Classes in Victorian Society*, Oxford 1971, pp. 33-51.
6. Workingman, *Working Men and Women*, London 1879, p. 62.
7. E.J. Hobsbawm, 'The labour aristocracy in nineteenth-century Britain' in *Labouring Men*, op. cit., p. 280.
8. On the distinction between bureaucratic and craft control see A. Stinchcombe, 'Bureaucratic and craft administration of production', in *Administrative Science Quarterly*, 4, 1959, pp. 168-87.
9. H. Gosling, *Up and Down Stream*, London 1927, pp. 7-8.
10. Riverside Visitor, 'A rookery district' in *Good Words*, 1883, pp. 542-5. I am grateful to Dr Joyce Bellamy for the information about Thomas Wright

who was almost certainly the Riverside Visitor as well as writing more prominently as Journeyman Engineer. There is considerable other evidence to suggest this, but the fact that Wright was a school board visitor for Deptford, and that the area discussed in this article clearly resembles the riverside part of Deptford, must be taken as added confirmation.

11. 'Most thrifty and enterprising lightermen could have sanguine hopes of starting on their own account.' C.L. Wheble, 'The London lighterage trade' (Univ. of London MSc thesis, 1939), pp. 150-2.

12. Webb Trade Union Collection, A/XLI ff. 182-5.

13. *Kentish Mercury*, 13 April 1867; 11 and 18 February 1871; *Greenwich and Deptford Chronicle*, 24 September 1870.

14. Wheble, op. cit., p. 147. See the description by H. Mayhew, *London Labour and the London Poor*, London 1861-62, vol. 3, p. 331.

15. PRO, FS3/109/505. See also the similar regulation of another Greenwich society, PRO, FS1/231.

16. *Greenwich and Deptford Chronicle,* 12 March 1870.

17. The discussion that follows owes much to the excellent examination of London dock labour by J.C. Lovell, *Stevedores and Dockers. A Study of Trade Unionism in the Port of London, 1870-1914*, London 1969, pp. 30-58.

18. H.L. Smith and V. Nash, *The Story of the Dockers' Strike*, London 1890, p. 26.

19. H.L. Smith, 'Chapters in the history of London waterside labour', in *Economic Journal*, 2, 1892, pp. 593-607.

20. The master lumpers were often publicans or connected with publicans, and men were taken on and paid in the context of a required amount of drinking. See Mayhew, op. cit., vol. 3, pp. 288-300.

21. Webb Trade Union Collection, A/XLII f. 252.

22. Smith and Nash, op. cit., p. 22.

23. Webb Trade Union Collection, A/XLII f. 239.

24. Smith and Nash, op. cit., p. 130.

25. Charles Booth, *Life and Labour of the People in London*, London 1902, second series, vol. 2, p. 279.

26. General Steam Navigation Company: Deptford Works Entry Book 1877-1887. N = 21 (shipwrights); 29 (caulkers); 152 (ship-joiners); 110 (riveters); 12 (sailmakers). Compare with the figures for labourers – 60 per cent (N = 130); holders-up – 77 per cent (N = 56); painters – 61 per cent (N = 25).

27. Leone Levi, *Wages and Earnings of the Working Classes*, London 1867, p. 63. For shipwrights this could mean an initial expense of over £10.

28. J.F. Clarke, 'The Shipwrights', in *Bulletin of the North-East Group for the Study of Labour History*, 1, 1967, p. 21.

29. Webb Trade Union Collection, A/XXXII f. 23.

30. Ibid., f. 33.

31. Ibid., f. 279.

32. London Working Men's Association, *Report of Trades Conference, March 1867*, London 1867.

33. *Kentish Mercury*, 25 June 1859.

34. W.C. Steadman in F.W. Galton (ed.), *Workers on their Industries*, London 1895, p. 56.

35. Webb Trade Union Collection, A/XXXII f. 137 and f. 279.

36. *Kentish Mercury*, 25 July 1868.

37. Booth, op. cit., second series, vol. 5, p. 325.

38. United Society of Boilermakers, *Annual Report*, 1877.

39. *Greenwich and Deptford Chronicle*, 21 August 1869.
40. Hobsbawm, 'The labour aristocracy', op. cit., p. 284.
41. A.L. Bowley and G.H. Wood, 'The statistics of wages in the U.K. during the last hundred years – Engineering and Shipbuilding', in *Journal of the Royal Statistical Society*, 68-69, 1905-6, pp. 176-7. An alternative calculation by K. Knowles and D.J. Robertson, 'Differences between the wages of skilled and unskilled workers, 1880-1950', in *Bulletin of the Oxford University Institute of Statistics*, 13, 1951, p. 111 gives the unskilled wages as percentage of the skilled wages in shipbuilding trades in 1880 as 54 per cent. In 1950 this figure was 82 per cent.
42. S. Pollard, 'The economic history of British shipbuilding, 1870-1914', (London Univ. PhD thesis, 1951), p. 40.
43. Webb Trade Union Collection, A/XXXIII f. 50.
44. Ibid., f. 221; J.B. Jefferys, *The Story of the Engineers 1800-1945*, London 1945, pp. 103-5.
45. Royal Commission on Trades Unions, *Parliamentary Papers*, 1867-68, XXXIX, Q. 16, Q. 711.
46. The best description of this system was given by Clifford Wigram in his evidence to the Royal Commission on Trades Unions, op. cit., 1867-68, XXXIX, Q. 16, 616 to Q. 16, 630.
47. *Kentish Mercury*, 16 July 1864.
48. E.J. Hobsbawm, 'General labour unions in Britain, 1889-1914', in *Labouring Men*, op. cit., p. 165.
49. *Parliamentary Papers*, 1860, XLII, p. 49.
50. PRO, ADM 7/596.
51. The ratio is admittedly an arbitrary choice, but I believe that it reflects the likely division, because (a) it was not usual to attach many labourers to the shipwrights' department, most labourers were drawn from the general pool; (b) there were frequent complaints about shortages of labourers in the shipwrights' department; (c) there were no labourers specifically attached to the shipwrights' department in 1848, and there is no evidence of changes in practice since then. Thus the ratio may, if anything, underestimate the number of skilled men.
52. This proportion is based on the structure of the department in 1848.
53. *Kentish Independent*, 4 July 1846.
54. Ibid., 4 September 1847.
55. *Kentish Mercury*, 5 August 1865.
56. Notes by James Bennett, PRO, ADM 7/596.
57. *Kentish Mercury*, 19 February 1853.
58. J. Connolly, *Old Days and Ways*, London 1912, p. 105.
59. *Kentish Mercury*, 15 June 1866.
60. *Parliamentary Papers*, 1860, XLII, p. 49 and 279.
61. *Kentish Independent*, 23 May 1846; 29 July 1848. *Kentish Mercury*, 9 April 1859.
62. *Kentish Mercury*, 2 July 1859.
63. Ibid., 17 December 1859.
64. Ibid., 23 April 1853.
65. *Kentish Independent*, 11 April 1846.
66. *Parliamentary Papers*, 1863, XXXV, p. 169.
67. Calculated from information in PRO, ADM 7/196.
68. *Kentish Mercury*, 15 February 1868.
69. Connolly, op. cit., p. 104.
70. *Kentish Mercury*, 18 January 1856.
71. Webb Trade Union Collection, A/XXXII f. 229.

72. Connolly, op. cit., p. 104-5.
73. *Kentish Independent*, 6 March 1869.
74. *Kentish Mercury*, 4 June 1859.
75. Ibid., 19 February 1853.
76. *Kentish Independent*, 24 March 1866.
77. P. Barry, *Dockyard Economy and Naval Power*, London 1863, pp. 52, 67-70.
78. *Kentish Mercury*, 30 September 1865.
79. Levi, op. cit., p. 66. In 1906 the figure had fallen only slightly, to an estimate of 59 per cent by G.T. Jones, *Increasing Return*, London 1933, p. 84.
80. N.B. Dearle, *Problems of Unemployment in the London Building Trade*, London 1908, *passim*.
81. PRO, ADM 73/153.
82. D.B. Viles, 'The building trade workers of London, 1835-60' (Univ. of London M Phil thesis, 1975), p. 103.
83. Webb Trade Union Collection, A/X f. 401.
84. Workingman, *Reminiscences of a Stonemason*, London 1908, p. 76. The latter part of that statement is illustrated many years later in the story Tawney noted in 1912 in his *Commonplace Book* (published London, 1972), p. 33. 'A man asks his labourer to hand him bricks. "Pass up those bricks, Bill, will you." The Boss, passing, "Not so much of your bloody 'will you'!"'
85. R. Harrison, *Before the Socialists*, London 1965, p. 31.
86. General Amalgamated Labourers' Union, *Report*, 1872.
87. Ibid., p. 11.
88. *Greenwich and Deptford Chronicle*, 8 April 1876.
89. Amalgamated Society of Carpenters and Joiners, *Monthly Report*, May 1874.
90. Viles, op. cit., p. 120.
91. Ibid., p. 124.
92. Dearle, op. cit., pp. 80 and 98.
93. Viles, op. cit., p. 36.
94. Operative Society of Stonemasons, *Fortnightly Returns*, 16 September 1847.
95. Levi, op. cit., p. 65.
96. Booth, op. cit., second series, vol. 1, pp. 41 and 69.
97. Royal Commission on Trades Unions, op. cit., 1867, XXXII, i, Q. 1116.
98. *Kentish Independent*, 10 March 1866.
99. Booth, op. cit., second series, vol. 1, p. 72.
100. J.O. French, *Plumbers in Unity: History of the Plumbing Trades Union 1865-1965*, London 1965, p. 29.
101. *Kentish Mercury*, 3 December 1864; Webb Trade Union Collection, A/XIII f. 21.
102. Operative Society of Stonemasons, *Annual Reports*.
103. Webb Trade Union Collection, A/XIII f. 397.
104. Operative Bricklayers' Society, *Trade Circular*, November 1862.
105. Operative Society of Stonemasons, *Fortnightly Returns*, 15 September 1859.
106. Ibid., 2 August 1860.
107. Webb Trade Union Collection, A/XIII f. 216.
108. Workingman, op. cit., p. 100.
109. Operative Bricklayers' Society, *Trade Circular*, November 1872.
110. F. Chandler, *History of the Society*, London 1910, pp. 8-11.

111. Operative Bricklayers' Society, *Trade Circular*, April 1862.
112. National Association of Operative Plasterers, Executive Committee Minutes, February 1864; *Kentish Mercury*, 15 April 1865; Amalgamated Society of Carpenters and Joiners, *Annual Report*, 1865, and *Monthly Report*, December 1867.
113. See, for example, the movement in Greenwich in 1853. *Kentish Mercury*, 8 July 1853.
114. PRO, FS7/6/274.
115. Webb Trade Union Collection, A/X f. 108.
116. K. Burgess, 'Technological change and the 1852 lock-out in the British engineering industry', in *International Review of Social History*, 14, 1969, pp. 222-32.
117. Jefferys, op. cit., p. 16.
118. Ibid., p. 15; W. McLaine, 'The early trade union organisation among engineering workers' (Univ. of London PhD thesis, 1939), chs. 1-4.
119. Webb Trade Union Collection, A/XV f. 355.
120. Steam Engine Makers' Society, *Trade Report*, July 1862.
121. J.B. Jefferys and M. Jefferys, 'The wages, hours and trade customs of skilled engineers in 1861', in *Economic History Review*, first series, 17, 1947, p. 30.
122. Royal Commission on Trades Unions, op. cit., 1867, XXXII.i, Q. 898.
123. J.B. Jefferys, *The Story of the Engineers*, op. cit., p. 55.
124. J.B. and M. Jefferys, op. cit., p. 33.
125. Steam Engine Makers' Society, *Trade Report*, April 1854.
126. Ibid., December 1863 and February 1868.
127. P. Barry, *The Dockyards and the Private Shipyards of the Kingdom*, London 1863, p. 270.
128. J.B. Jefferys, *The Story of the Engineers*, op. cit., pp. 58-62, 104-5.
129. PRO, ADM 7/596.
130. General Report on the Wages of the Manual Labour Classes in the United Kingdom, *Parliamentary Papers*, 1893-94, LXXXIII. ii.
131. McLaine, op. cit., p. 212.
132. Webb Trade Union Collection, A/XVII f. 87.
133. *Kentish Independent*, 24 October 1846.
134. Amalgamated Society of Engineers, *Monthly Reports*.
135. Ibid., August 1871.
136. Friendly Society of Ironfounders, *Reports*, December 1871 and December 1875.
137. United Society of Boilermakers, *Annual Report*, 1877.
138. *Kentish Mercury*, 2 December 1865.
139. Webb Trade Union Collection, A/XV f. 199; McLaine, op. cit., p. 330.
140. Steam Engine Makers' Society, *Trade Report*, March 1860.
141. Webb Trade Union Collection, A/XVII f. 257.
142. Circular to London patternmakers dated July 1880, bound in United Patternmakers' Association, *Monthly Reports*, 1880.
143. W. Mosses, *The History of the United Patternmakers' Association 1872-1922*, London 1922, p. 16.
144. H.J. Fyrth and H. Collins, *The Foundry Workers: a Trade Union History*, Manchester 1959, pp. 61-3.
145. Ibid., p. 54.
146. Bowley and Wood, op. cit., pp. 566-7.
147. PRO, ADM 7/596.
148. Hobsbawm, 'The labour aristocracy', op. cit., p. 294.
149. Webb Trade Union Collection, A/XVII f. 54.

150. Jefferys, *The Story of the Engineers*, op. cit., p. 103.
151. Select Committee on Small Arms, *Parliamentary Papers*, 1854, XVIII, Q. 346.
152. Anon (A. Winter), 'Woolwich Arsenal', in *Quarterly Review*, 103, 1858, p. 222.
153. N. Rosenberg (ed.), *The American System of Manufactures*, Edinburgh 1969, editor's introduction, p. 80.
154. J. Anderson, *A General Statement of the Past and Present Condition of the Several Manufacturing Branches of the War Department*, London 1856, pp. 9-12.
155. O.F.G. Hogg, *The Royal Arsenal*, London 1963, p. 671.
156. Rosenberg, op. cit., p. 81.
157. Though see some ad hoc listings for the 1840s, PRO, WO 44/294; WO 44/523.
158. Anderson, op. cit., p. 5.
159. Ibid., p. 22.
160. *Kentish Mercury*, 17 October 1857.
161. Committee on Army Manufacturing Departments, *Parliamentary Papers*, 1887, XIV, Q. 1926-Q. 1933.
162. Sir T. Hastings to Select Committee on Small Arms, op. cit., Q. 224.
163. *Report of a preliminary inquiry into . . . the sanitary condition . . . of . . . Woolwich*, London 1851, p. 45.
164. Amalgamated Society of Engineers, *Monthly Report*, May 1860.
165. *Greenwich and Deptford Chronicle*, 29 October 1870.
166. *Kentish Mercury*, 14 April 1860.
167. Steam Engine Makers' Society, *Trade Report*, January 1871.
168. PRO, WO 44/297.
169. J.B. and M. Jefferys, op. cit., p. 34.
170. Hogg, op. cit., p. 1272; *Kentish Mercury*, 18 July 1857.
171. *Kentish Mercury*, 27 March 1852.
172. PRO, Supply 5/59.
173. *Kentish Independent*, 21 March and 9 May 1868.
174. E. Chase, *Tenant Friends in Old Deptford*, London 1929, pp. 47-8.
175. PRO, WO 54/888 and 930.
176. Hogg, op. cit., p. 832.
177. *Kentish Independent*, 2 November 1867.
178. Ibid., 12 October 1867.
179. Committee on Army Manufacturing Departments, op. cit., Q. 246-Q. 250.
180. Anon, 'Our eye witness at Woolwich', in *All the Year Round*, 1, 1859, p. 372.
181. Hogg, op. cit., p. 1274.
182. *Kentish Mercury*, 26 November 1853; 24 November 1855.
183. Ibid., 6 January 1849.
184. Ibid., 16 April 1853.
185. Royal Laboratory Burial Society, *Articles*, 1820; *Rules*, 1857.
186. *Kentish Mercury*, 15 July and 25 November 1854.
187. Ibid., 30 August 1856; Hogg, op. cit., p. 751.
188. *Kentish Independent*, 24 March 1866.
189. *Greenwich and Deptford Chronicle*, 24 February, 16 March and 18 May 1872.
190. Ibid., 1 June 1872.
191. Ibid., 1 June 1872.

Chapter 5

1. *Kentish Mercury*, 13 April 1866.
2. D'Arcy Power (ed.), *Plarr's Lives of the Fellows of the Royal College of Surgeons of England*, London 1930, vol. 2, p. 291.
3. Jane Connolly, *Old Days and Ways*, 1912, p. 174.
4. See the discussion in L.C. Freeman *et al.*, 'Locating leaders in local communities: a comparison of some alternative approaches', in *American Sociological Review*, 28, 1963, pp. 792-3.
5. See especially R.O. Schulze, 'The bifurcation of power in a satellite city', in M. Janowitz (ed.), *Community Political Systems*, New York 1961, pp. 19-80.
6. E.P. Hennock, 'The social composition of borough councils in two large cities 1835-1914', in H.J. Dyos (ed.), *Studies in Urban History*, London 1968, pp. 315-36.
7. *Greenwich and Deptford Chronicle*, 17 August 1872. Emphasis added.
8. See for example W. Lillie, *The History of Middlesborough*, Middlesborough 1968, *passim*, and Robert Wood, *West Hartlepool*, Hartlepool 1969, *passim*.
9. These honorary committees were taken from the local press, except for the two church-building committees, whose records are in the Greater London Record Office (Christchurch, Greenwich at P78/CTC/56 and St Paul's, Greenwich at P78/PAU 1/20). The most difficult part of the exercise both here and for the local office-holders examined below was to establish the occupations and other relevant information about these people. This information was collected from a variety of sources, including the local newspapers, directories, and the manuscript census schedules in the Public Record Office. Of 933 persons holding local office, the occupations of only 51 (5.5 per cent) could not be established, while only twelve members of the honorary committees could not be traced.
10. W.T. Vincent, *The Records of the Woolwich District*, London 1887, p. 143. On the insecurity of savings banks see H.O. Horne, *A History of Savings Banks*, London 1947, *passim*.
11. The actual occupations of the president, vice-presidents and trustees were: chief storekeeper at the Victualling Yard; City silk manufacturer; customs officer; three clergymen; surgeon; two linen drapers; two chemists; butcher; brewer; builder; watchmaker; grocer.
12. R. Newton, 'Society and politics in Exeter 1837-1914', in Dyos (ed.), op. cit., p. 306.
13. Connolly, op. cit., pp. 88-9, 142-5.
14. Vincent, op. cit., p. 399.
15. The local office-holders whose names were selected were those holding the following positions at any time during the appropriate periods, i.e. 1840-1844, 1855-1859, 1870-1874: Churchwarden, Poor Law Guardian, member of the Local Board of Health or Local Board of Works, Town Commissioner, Commissioner of the Court of Requests, Governor and Director of the Town. An individual would only be counted once in each period, however many offices he held. The same procedure was employed for obtaining information about occupations as outlined above for elite committees.
16. G. Best, *Mid-Victorian Britain 1851-1875*, London 1971, p. 87.
17. For a useful discussion of early Victorian shopkeeping see David Alexander, *Retailing in England during the Industrial Revolution*, London 1970, pp. 110-58.
18. For a detailed analysis see Geoffrey Crossick, 'Social structure and working-

class behaviour: Kentish London 1840-1880' (Univ. of London PhD thesis, 1976), pp. 172 and 175.

19. Food retailers made up 30.9 per cent of retailers on elite committees, and 41.5 per cent, 38.5 per cent and 27.2 per cent of those amongst office-holders in each of the three periods examined.

20. Drink retailers comprised 18.4 per cent of retailers on elite committees, and 14.1 per cent, 24.2 per cent, and 22.5 per cent of those amongst office-holders in each period.

21. This was true of most of the tradesmen amongst the elite.

22. Vincent, op. cit., p. 142.

23. The information concerning medical practitioners was found in a search of Power, op. cit., the *London and Provincial Medical Directory* for 1848, 1854 and 1860, and the *Medical Directory* for 1870. Two of the twenty-three could not be traced.

24. For full details see Crossick, op. cit., p. 171.

25. *Kentish Mercury*, 31 August 1844.

26. Ibid., 20 July 1866.

27. One change in the 1870-1874 period is hidden in the 'Others' category of the Woolwich office-holders table. Four working men were elected to parish office for the first time – as vestrymen and members of the Board of Works. One was merely described as a working man, two were Arsenal foremen and the other an Arsenal engineer. All were elected as members of the Plumstead Ratepayers' Association, together with other middle-class members in an attempt to democratise local parish government. The real implications lie in the closing years of the century, and are beyond our scope here, but they relate to a possible decline in the utility of this form of data for the reconstitution of social elites in Kentish London in the last quarter of the century. However, we are fortunate to have a considerable quantity of evidence from elite committees for this period to confirm the continuation of the earlier pattern.

28. For the full story see the reports in PRO, HO 45/9413/56640, ff. 1-113; and *Greenwich and Deptford Chronicle*, 10 June to 19 August 1876.

29. *Kentish Mercury*, 22 January 1853.

30. Ibid., 24 September 1853.

31. Ibid., 15 June 1866.

32. For an excellent example of this from an American mill-town, see H.G. Gutman, 'Industrial invasion of the village green', in *Trans-Action*, 1966.

33. *Oddfellows Magazine*, October 1866, p. 492.

34. *Kentish Mercury*, 13 November 1858.

35. Ibid., 26 June 1852.

36. Ibid., 3 July 1852.

37. Ibid., 10 February 1855.

38. Ibid., 14 February 1857.

39. Ibid., 16 August 1856.

40. *Greenwich and Deptford Chronicle*, 14 December 1872.

41. An example is the Nottingham Ancient Imperial Order of Oddfellows as reported in *Kentish Mercury*, 7 November 1865.

Chapter 6

1. Workingman, *Working Men and Women*, London 1879, pp. 36-7.

2. E.J. Hobsbawm, 'Custom, wages and workload', in *Labouring Men*, London 1964, pp. 344-70.

3. *Greenwich and Deptford Chronicle*, 1 April 1876.
4. S. Pollard and D.W. Crossley, *The Wealth of Britain*, London 1968, p. 216; E.J. Hobsbawm, 'The labour aristocracy in nineteenth-century Britain', in *Labouring Men*, op. cit., pp. 290-5.
5. K. Knowles and D.J. Robertson, 'Differences between the wages of skilled and unskilled workers 1880-1950', in *Bulletin of the Oxford University Institute of Statistics*, 13, 1951, pp. 110-11. The differential has been much narrower for much of the present century.
6. The survey is called 'Conditions of the Working Classes' and is to be found in *Parliamentary Papers*, 1887, LXXI, pp. 303 ff. The districts were chosen as those 'mainly inhabited by persons who might be taken as fair representatives of the working classes'. Although the report's introduction dismisses it on the grounds of its lack of rigour in the surveying and interviewing procedures something can be obtained from the 8,364 interviews carried out in Deptford – that is, with over 40 per cent of the adult male population. Odd groupings of occupations in the tables, and high rates of non-response to certain questions, mean that the findings which are of use are limited to certain occupations and certain questions.
7. E. Chase, *Tenant Friends in Old Deptford*, London 1929, p. 76.
8. These figures for housing stratification amongst skilled and unskilled workers are strikingly similar to those calculated by Gray for Edinburgh some fifteen years later. His sample was also unavoidably biased towards the lower levels of skilled workers. R.Q. Gray, *The Labour Aristocracy in Victorian Edinburgh*, Oxford 1976, pp. 96-7.
9. This does not include those admitted for smallpox or insanity.
10. The index is as follows: $$\frac{\text{Observed percentage}}{\text{Census percentage}} \times 100$$

 The observed figure represents the proportion of those admitted to the workhouse between 1867 and 1872 who were in the trade in question. The census figure is the proportion of that named occupation amongst adult occupied males in the 1861 census tables. 1871 was unsuitable because of the classification system employed. Members of the armed services have been excluded from the census figures for this purpose. Greenwich Poor Law Union and the Borough of Greenwich census area were identical.
11. Shoemakers were more likely to enter Edinburgh County Workhouses than any other trades in 1871. Gray, op. cit., pp. 50-1. It is clear that shoemakers were a trade with great internal variation brought about by the growth of a casual section.
12. S. Thernstrom, *The Other Bostonians*, Cambridge, Mass., 1973, pp. 45-75, discusses this issue with the help of far better data.
13. Webb Trade Union Collection, A/X f. 64 (painters), ff. 152-4 (plasterers), f. 206 (bricklayers), f. 285 (carpenters and joiners), f. 397 (stonemasons). See also C. Booth, *Life and Labour of the People in London*, London 1902, second series, vol. 1, pp. 100-5.
14. There were trades where such progress was precise and structured. In flint glassmaking the leading position in each 'chair', the Workman, had progressed through the hierarchy from apprentice to Footmaker and then to Servitor, before becoming a Workman. That promotion ladder was a difficult one to climb however, with Servitors having a 2 per cent chance of promotion in any one year, according to Takao Matsumura. All this must have greatly strengthened the labour aristocratic consciousness of those who reached the top. T. Matsumura, 'The flint glassmakers in the classic age of the labour aristocracy, 1850-80' (Univ. of Warwick PhD thesis,

1976), *passim*. On promotion chances see ibid., pp. 238-9.

15. The practice was widespread but is difficult to measure. For local examples see Steam Engine Makers' Society, *Trade Report*, September 1874; *Kentish Mercury*, 18 February 1865 (a member of the ASE); *Greenwich and Deptford Chronicle*, 6 January 1872 (a member of the Boilermakers).

16. Compare these figures with the flint glassmakers examined by Matsumura, a classic example of an introverted and relatively closed traditional craft group, 61 per cent of whom were the sons of flint glassmakers. Matsumura, op. cit., p. 117.

17. G. Stedman Jones, *Outcast London. A Study in the Relationship between Classes in Victorian Society*, Oxford 1971, pp. 67-98.

18. E.J. Hobsbawm, 'The labour aristocracy in nineteenth-century Britain', in *Labouring Men*, op. cit., pp. 272-315, and esp. p. 273.

19. J. Berent, 'Social mobility and marriage: a study of trends in England and Wales', in D.V. Glass (ed.), *Social Mobility in Britain*, London 1954, p. 321. See also J.P. Chaline, 'Les contrats de mariage à Rouen au XIXe siècle', in *Revue d'Histoire Economique et Sociale*, 48, 1970, p. 258.

20. On the older established Edinburgh crafts and their occupational sub-cultures, see Gray, op. cit., p. 91.

21. H. Gosling, *Up and Down Stream*, London 1927, p. 145.

22. *Greenwich and Deptford Chronicle*, 30 November 1872.

23. Earnings between trades and within trades clearly varied in an important fashion in Victorian Edinburgh, according to wages data and living standards data in Gray, op. cit., pp. 72-88.

24. On casualisation in skilled trades see Stedman Jones, op. cit., pp. 52-66. I have already indicated my belief that he exaggerates the speed with which the south side shipbuilding workers became casualised, though the problems of that group of workers clearly accelerated towards the end of the 1870s.

25. R. Harrison, *Before the Socialists. Studies in Labour and Politics 1861-1881*, London 1965, p. 5.

26. J.M. Baernreither, *English Associations of Working Men*, London 1889, p. 20.

27. Anon (Robert Lowe), 'Trades Unions', in *Quarterly Review*, 123, 1867, p. 351.

28. *Kentish Independent*, 2 November 1867.

29. Pelling's conclusion that this lack of quantitative precision by historians means that the stratum itself clearly did not exist does not, in my view, follow. H. Pelling, "The concept of the labour aristocracy', in his *Popular Politics and Society in Late-Victorian Britain*, London 1968, pp. 37-61. For my criticisms of Pelling's views see Geoffrey Crossick, 'Social structure and working class behaviour: Kentish London 1840-1880', (Univ. of London PhD thesis, 1976), pp. 217-19.

30. Workingman, op. cit., p. 111; see also C. Bosanquet, *London: its Growth, Charitable Agencies and Wants*, London 1868, pp. 133-6.

31. Booth, op. cit., third series, vol. 5, p. 28.

32. Riverside Visitor, 'A rookery district', in *Good Words*, 1883, pp. 542-5.

33. See especially the passage cited in E.P Thompson and E. Yeo (eds.), *The Unknown Mayhew*, London 1971, pp. 46-7.

34. The three local branches of the carpenters and joiners, for example, were virtually unanimous in agreeing to their union giving the agricultural labourers' movement financial assistance. Amalgamated Society of Carpenters and Joiners, *Monthly Report*, May 1874.

35. See Crossick, op. cit., Table 7.13, p. 216.

36. Geoffrey Crossick, 'The emergence of the lower middle class in Britain: a discussion', in G. Crossick (ed.), *The Lower Middle Class in Britain 1870-1914*, pp. 48-52.
37. Gray, op. cit., p. 110.
38. Ibid., pp. 108-10.
39. *Greenwich and Deptford Chronicle*, 12 July and 25 October 1873.

Appendix

1. Berent, op. cit.; Chaline, op. cit.; J. Foster, *Class Struggle and the Industrial Revolution*, London 1974, p. 261; H.McLeod, *Class and Religion in the Late Victorian City*, London 1974, pp. 294-5.

Chapter 7

1. The more recent sociological arguments are usefully summarised in John H. Goldthorpe *et al.*, *The Affluent Worker in the Class Structure*, Cambridge 1969, ch. 1.
2. The most cogent recent statement of this interpretation is by Harold Perkin, *The Origins of Modern English Society, 1780-1880*, London 1969, pp. 340-407. Trygve Tholfsen presented the case in an important article that grew out of his work on Birmingham, 'The transition to democracy in Victorian England', in *International Review of Social History*, 6, 1961, pp. 226-48, although in his more recent book, *Working-Class Radicalism in Mid-Victorian England*, London 1976, Tholfsen has moved far closer to the position presented in this study. More pervasive are comments less central to their authors' intentions, but which express just this interpretation of mid-Victorian artisan ideology. See, for example, Sidney Pollard, *A History of Labour in Sheffield*, Liverpool 1959, pp. 122-4; and Derek Fraser, *The Evolution of the British Welfare State: A History of Social Policy since the Industrial Revolution*, London 1973, p. 100, where he specifically refers to a 'so-called embourgeoisement of working-class attitudes' in the 1860s.
3. A tendency towards this kind of redefinition seems to be growing amongst historians of the Victorian period. See the comments by G. Best, *Mid-Victorian Britain, 1851-1875*, London 1971, p. 268; T. Tholfsen in the book cited above and also in 'The intellectual origins of mid-Victorian stability', in *Political Science Quarterly*, 86, 1971, pp. 57-91; and Robert Q. Gray, 'Styles of life, the "Labour Aristocracy", and class relations in later nineteenth-century Edinburgh', in *International Review of Social History*, 18, 1973, pp. 445-52.
4. On 'meaning systems' see F. Parkin, *Class Inequality and Political Order: Social Stratification in Capitalist and Communist Societies*, London 1972.
5. H. Knell, *Chips from the Block: an Essay on Social Science*, London 1861, p. 13. 'Good breeding' are precisely the words used by the Edinburgh printers' union when describing its members' behaviour at a huge soiree. See Robert Q. Gray, *The Labour Aristocracy in Victorian Edinburgh*, Oxford 1976, p. 100.
6. Charity Organisation Society, *On the best means of dealing with exceptional distress: the report of a special committee*, London 1886, Q. 825.
7. Workingman, *Working Men and Women*, London 1879, p. 32.
8. Knell, op. cit., p. 84.

9. J.W. Hudson, *The History of Adult Education*, London, 1969 ed.,pp. 170-2; *Kentish Mercury*, 11 April 1840 and 6 June 1840.

10. *Kentish Mercury*, 6 March 1852.

11. *Greenwich Free Press*, October 1857.

12. *Kentish Mercury*, 8 September 1855. Within four years few working men members remained, *Kentish Mercury*, 19 February 1859.

13. *Greenwich Free Press*, October 1856.

14. *Kentish Mercury*, 22 May 1852 and 11 September 1852. The cultural activities of Edinburgh artisan organisations displayed precisely the same character, Gray, *The Labour Aristocracy*, op. cit., p. 101.

15. C. Bosanquet, *London: its Growth, Charitable Agencies, and Wants*, London 1868, pp. 133-4.

16. K.S. Inglis, 'Patterns of religious worship in 1851', in *Journal of Ecclesiastical History*, 11, 1960, p. 85.

17. Ibid., p. 86. On the middle-class suburban character of London congregationalism see J.H. Taylor, 'London Congregational Churches since 1850', in *Transactions of the Congregational Historical Society*, 20, 1965, pp. 22-41.

18. In 1853 there were reportedly only 91 Primitive Methodists in Kentish London. By 1876, of 84 chapels in London there were only 3 in the area. W.H. Yarrow, *The History of Primitive Methodism in London 1822-76*, London n.d., p. 141.

19. In the early years of the century Woolwich Methodism was very much working class, *Methodist Recorder*, 28 September 1905; but it had become highly respectable by the 1840s, though then and subsequently its established middle-class leadership was joined by shipwrights and Arsenal artisans. See Rev. J.E. Clegg, *History of the Plumstead Common Wesleyan Church*, London 1913, appendices 10 and 11.

20. On the Peculiar People see the local press through the early 1870s, especially the *Greenwich and Deptford Chronicle*, for descriptions of the sect, its links through Essex and the repeated and generally unsuccessful manslaughter charges that followed the deaths of children denied medical treatment.

21. S. Meacham, 'The church in the Victorian city', in *Victorian Studies*, 11, 1968, p. 367.

22. M. Williams, *John Wilson of Woolwich*, London 1937, pp. 45, 56-7; F.S. Clayton, *John Wilson of Woolwich*, London 1927, pp. 12 and 18.

23. C. Booth, *Life and Labour of the People in London*, London 1902, third series, vol. 5, p. 23.

24. For full details see Geoffrey Crossick, 'Social structure and working class behaviour: Kentish London 1840-1880' (Univ. of London PhD thesis, 1976), Table 7.15, p. 239.

25. Members roll of Brockley Congregational Church.

26. D.H. McLeod, 'Membership and Influence of the Churches in Metropolitan London 1885-1914' (Univ. of Cambridge PhD thesis, 1971), p. 31.

27. Brockley Congregational Church, *Remembering the Way*, London 1961, p. 8. A similar practice can be seen in the minute book of the Zion Baptist Church, New Cross. It was presumably common, given the small size and social closeness of these dissenting congregations.

28. Booth, op. cit., third series, vol. 5, p. 120.

29. See E.P. Thompson, *The Making of the English Working Class*, Harmondsworth 1968, ch. 12; E. Yeo, 'Robert Owen and Radical Culture', in S. Pollard and J. Salt (eds.), *Robert Owen: Prophet of the Poor*, London 1971, pp. 84-114.

30. For example, *Kentish Mercury*, 26 January 1867.
31. Ibid., 26 May 1860.
32. In this connection Gray has correctly observed that 'residential segregation, whatever its causes, had a cultural *meaning*.' Gray, *The Labour Aristocracy*, op. cit., p. 97. It is important to see the relationship of distinctive values both to the desire for separation and to its consequences.
33. B.T. Robson, *Urban Analysis*, London 1969; J.O. Wheeler, 'Residential location by occupational status', in *Urban Studies*, 5, 1968, pp. 24-32; O.D. Duncan and B. Duncan, 'Residential distribution and occupational classification', in *American Journal of Sociology*, 60, 1955, p. 493-503.
34. Thomas Wright (Journeyman Engineer), *The Great Unwashed*, London 1868, pp. 125-50.
35. Residential patterns were similarly 'bound up with the projection of a sense of social superiority' for artisans in mid-Victorian Edinburgh. Gray, *The Labour Aristocracy*, op. cit., pp. 97-9.
36. Select Committee on Town Holdings, *Parliamentary Papers*, 1887, XIII, Q. 10190-3.
37. Select Committee on Artisan Dwellings, *Parliamentary Papers*, 1881, VII, Q. 4753-80.
38. Select Committee on Town Holdings, op. cit., Q. 9029-33.
39. Ibid., Q. 9224-9.
40. Ibid., Q. 9064-72.
41. *Kentish Mercury*, 2 November 1867.
42. Select Committee on Town Holdings, op. cit., Q. 2208, Q. 10075-81.
43. Jane Connolly, *Old Days and Ways*, London 1912, pp. 104-5.
44. *Kentish Independent*, 3 August 1850; 23 November 1850.
45. *Kentish Mercury*, 12 March 1853.
46. Ibid., 27 June 1868.
47. *Kentish Independent*, 27 March 1847.
48. *Kentish Mercury*, 11 October 1851.
49. S. Chapman (ed.), *The History of Working-Class Housing. A Symposium*, Newton Abbot 1971, p. 237.
50. PRO, FS6/86/171.
51. PRO, FS6/87/206.
52. *Kentish Mercury*, 8 December 1860.
53. PRO, FS6/85/144.
54. Minute book of the Borough of Greenwich Building Society, July 1852.
55. *Kentish Mercury*, 4 June 1853.
56. Minute book of the Industrial Permanent Building Society, 1853.
57. *Kentish Independent*, 4 March 1848.
58. *Kentish Mercury*, 14 January 1860.
59. Ibid., 8 December 1860.
60. Ibid., 14 January 1860.
61. Select Committee on Town Holdings, op. cit., Q. 10505-8.
62. *Oddfellows Magazine*, July 1879.
63. Ancient Order of Foresters, *Rules of Court Pride of Woolwich*, 1880.
64. PRO, FS6/88/220.
65. Select Committee on Town Holdings, op. cit., Q. 10181-2; D.A. Reeder, 'Politics of urban leaseholds in late-Victorian England', in *International Review of Social History*, 6, 1961, pp. 413-30.
66. Select Committee on Town Holdings, op. cit., Q. 10142.
67. Ibid., Q. 10505-7.
68. Knell, op. cit., p. 59.
69. Parkin, op. cit., p. 80.

70. This distinctive meaning which labour aristocrats gave to words in broader circulation also emerges in R.Q. Gray's article 'Styles of life', op. cit., *passim*.

71. Parkin, op. cit., p. 82.

72. The early article by Tholfsen, 'The transition to democracy', op. cit., is a good example of this.

73. Annual Report of the Registrar-General of Friendly Societies, *Parliamentary Papers*, 1864, XXXII, p. 377.

74. *Kentish Independent*, 2 November 1867. Fraser exaggerates his case when he argues that respectability came to be identified with trade unionism. W.H. Fraser, *Trade Unions and Society: the Struggle for Acceptance 1850-1880*, London 1974, p. 215.

75. Cf. P.H.J. Gosden, *The Friendly Societies in England 1815-1875*, Manchester 1961, p. 115.

76. On the earlier functions of this ritual in creating an environment of self-enclosed security in a hostile world, and as 'authentic evidence of the growth of independent working-class culture' see E.P. Thompson, op. cit., pp. 456-63.

77. *Kentish Mercury*, 23 December 1871. Jane Connolly noted the lack of support for temperance in Woolwich. Connolly, op. cit., p. 241. In contrast to Kentish London, temperance or at least rejecting the atmosphere of the public house were important elements in the ideology of respectable Edinburgh artisans. Gray, *The Labour Aristocracy*, op. cit., pp. 124-5.

78. See, for example, the leaflet announcing 'The Grand Temperance Demonstration and Rural Fete' at Westcombe Park, 26 July 1869, in Greenwich Local History Library.

79. R. Price, 'The Working Men's Club movement and Victorian social reform ideology', in *Victorian Studies*, 15, 1971, pp. 117-47.

80. B. Harrison, *Drink and the Victorians. The Temperance Question in England 1815-1872*, ch. 2, pp. 37-63.

81. Thomas Wright, op. cit., pp. 11-12.

82. Aileen Smiles, *Samuel Smiles and His Surroundings*, London 1956, pp. 81-95.

83. R. Harrison, *Before the Socialists. Studies in Labour and Politics 1861-1881*, London 1965, p. 9.

84. *Beehive*, 13 July 1867.

85. For this view, which reads as a combination of Spencer and Christianity, see Knell, op. cit., p. 11.

86. Artisan Plumstead was much more ready to send its children to school than predominantly lower working-class Woolwich in 1875. Absentee rates were between 11 per cent and 16 per cent in the former area, but reached 38 per cent in the latter. London School Board (Inspectors' Reports), August 1875, *Parliamentary Papers*, 1876, LIX, p. 289.

87. Riverside Visitor, 'A rookery district', in *Good Words*, 1883, p. 545.

88. *Kentish Mercury*, 15 July 1871.

89. Operative Bricklayers' Society, *Trade Circular*, April 1866; *Kentish Independent*, 9 December 1865 to 24 March 1866.

90. Amalgamated Society of Engineers, *Monthly Reports*, 1879 *passim*.

91. Gray suggests that the fierce concern of skilled trades in Edinburgh to uphold a standard working day arose partly from a belief that a variation in working hours would lead to irregularities of employment and ultimate casualisation. Gray, *The Labour Aristocracy*, op. cit., p. 56.

92. *Kentish Mercury*, 18 November 1865.

93. *Morning Star*, 1 February 1865; *Kentish Mercury*, 4 and 11 February 1865.

94. Operative Society of Stonemasons, *Fortnightly Returns*, 4 June 1840; 11 March 1841.
95. Steam Engine Makers' Society, *Trade Reports*, October 1860.
96. Operative Bricklayers' Society, *Trade Circular*, November 1863.
97. Friendly Society of Ironfounders, *Report*, 1865.
98. Operative Society of Stonemasons, *Fortnightly Returns*, 22 January 1857.
99. Operative Bricklayers' Society, *Trade Circular*, May 1863.
100. Operative Society of Stonemasons, *Fortnightly Returns*, 13 May 1858.
101. Operative Bricklayers' Society, *Trade Circular*, August, October and November 1864.
102. Operative Society of Stonemasons, *Fortnightly Returns*, 23 September and 9 October 1852.
103. Amalgamated Society of Engineers, *Monthly Report*, March 1866.
104. Steam Engine Makers' Society, *Trade Reports*, October 1880.
105. Ibid.
106. Amalgamated Society of Carpenters and Joiners, *Annual Report*, 1869.
107. Operative Bricklayers' Society, *A Short Biographical Sketch of Brother John Jeffery, Secretary of Greenwich Branch*, London 1906, p. 5; Operative Bricklayers' Society, *Trade Circular*, April 1877.
108. E.J. Hobsbawm, 'Custom, wages and workload', in his *Labouring Men*, London 1964, pp. 344-70.
109. *Kentish Mercury*, 26 October 1861; Operative Bricklayers' Society, *Trade Circular*, September 1876.
110. Amalgamated Society of Carpenters and Joiners, *Monthly Report*, February 1878.
111. See, for example, *Kentish Mercury*, 13 August 1859.
112. *Greenwich and Deptford Chronicle*, January 1872-March 1872.
113. Ibid., 15 March 1879.
114. A plasterer at a Woolwich lock-out meeting in 1859 pointed out that the masters were great believers in political economy, but they did not like their men acting by it. *Kentish Mercury*, 20 August 1859.
115. J.R. Vincent, *The Formation of the Liberal Party*, London 1966, p. 104, notes this change in Rochdale, though he probably exaggerates it. Cf. Edinburgh where the anti-union statutes put a great strain on the alliance of working-class organisations and middle-class Liberals. Gray, *The Labour Aristocracy*, p. 152.
116. *Kentish Mercury*, 20 August 1859.
117. Ibid., 2 November 1861.
118. Friendly Society of Ironfounders, *Annual Report*, December 1865.
119. Operative Bricklayers' Society, *Trade Circular*, February 1868.
120. Ibid., June 1879.
121. Amalgamated Society of Carpenters and Joiners, *Monthly Reports*, December 1863.
122. Ibid., November 1867.
123. *Northern Star*, 17 January 1852.
124. The major local case followed the closure of Deptford Dockyard in 1869.
125. Takao Matsumura has shown a similar limited perspective for co-operative production amongst flint glassmakers in these years, in 'The flint glass-makers in the classic age of the labour aristocracy, 1850-1880' (Univ. of Warwick PhD thesis, 1976), pp. 272-84.
126. Steam Engine Makers' Society, *Trade Reports*, February 1860.
127. *Greenwich and Deptford Chronicle*, 6 January 1872.
128. *Kentish Independent*, 17 February 1866.
129. For example, Operative Bricklayers' Society, *Trade Circular*, July 1874,

for a rain-soaked bricklayers' parade in Deptford.
130. See Thomas Wright, op. cit., p. 151 ff.

Chapter 8

1. Woolwich Baking Society, *Reports* for 1858 and 1863.
2. S. Pollard, 'Nineteenth-century co-operation: from community building to shopkeeping', in A. Briggs and J. Saville (eds.), *Essays in Labour History*, London 1960, p. 96.
3. PRO, FS8/23/1013.
4. Quoted by Pollard, op. cit., p. 90.
5. Originally called the Royal Arsenal Supply Association: the name was changed in 1872. The society will hereafter be referred to as RACS.
6. There are no occupational data for the female members, who have therefore had to be excluded from the analysis. They comprised 18 per cent of all members in the years 1872-4, and 38 per cent in 1875-80.
7. Rule books, etc. of the following societies, all in the PRO. Royal Victoria Coal Society (FS1/15/433); Deptford Dockyard Impartial Coal Society (FS1/235/918 Kent); East Greenwich Coal Society (FS15/445); Greenwich Economical Bread and Flour Association (FS1/233/664); New Cross Working Men's Co-operative Industrial Society (FS8/12/361b); Plumstead Industrial and Provident Society (FS8/5/124b); Woolwich Co-operative Provident Society (FS8/4/106); Woolwich Baking Society (FS8/6/149); Woolwich Co-operative Store (FS1/234/724).
8. *Co-operator*, December 1864.
9. PRO, FS8/4/106; FS8/4/105; FS8/6/149.
10. PRO, FS8/5/124b; FS17/10.
11. *Greenwich and Deptford Chronicle*, 15 March 1879.
12. *Greenwich and Deptford Chronicle*, 25 March 1876.
13. John Burnett, *Plenty and Want: a Social History of Diet in England from 1815 to the Present Day*, Harmondsworth 1968, pp. 99-120.
14. PRO, FS1/234/777 Kent.
15. PRO, FS8/24/1094.
16. Quoted by Royden Harrison, *Before the Socialists. Studies in Labour and Politics 1861-1881*, London 1965, pp. 8-9.
17. *Greenwich and Deptford Chronicle*, 29 May 1880.
18. Hodgson Pratt, reported in *Greenwich and Deptford Chronicle*, 1 December 1877.
19. Ibid., 29 May 1880.
20. *Kentish Standard*, 17 September 1842.
21. *Kentish Independent*, 23 and 30 January 1847; PRO, FS1/233/664.
22. New Charlton Economical Baking Society, *Rules*, Woolwich 1853.
23. *The History of the Royal Arsenal Co-operative Society Ltd., 1868-1918*, London 1922, pp. 38-9.
24. Ibid., pp. 16-19.
25. *Co-operator*, December 1864.
26. I. Prothero, 'London Working-Class Movements 1825-1848' (Univ. of Cambridge PhD thesis, 1967).
27. Select Committee on Town Holdings, *Parliamentary Papers*, 1887, XIII, Q. 1205-6.
28. J. Arnold, *Our Duty as Co-operators,* Woolwich 1880, p. 2.
29. J. Arnold, *Paper at the Co-operative Conference, Woolwich 1879*, Woolwich 1879.

30. *Co-operator*, October 1864.
31. Ibid., December 1864.
32. Ibid., August 1866.
33. Paul Thompson, *Socialists, Liberals and Labour. The Struggle for London 1885-1914*, London 1967, p. 250.
34. For an example see the report in *Kentish Independent*, 24 February 1886.

Chapter 9

1. P.H. J. Gosden, *The Friendly Societies in England 1815-1875*, Manchester 1961, *passim*.
2. Lady Florence Bell, *At the Works: a study of a Manufacturing Town*, new edition; Newton Abbot 1969, p. 47.
3. Charles Booth, *Life and Labour of the People in London*, London 1902, first series, vol. 1, pp. 134-46.
4. Charity Organisation Society, *On the best means of dealing with distress: the report of a special committee*, London 1886, Q. 211.
5. PRO, FS1/234/783 Kent; FS1/235/824.
6. *Kentish Mercury*, 18 February 1854; 25 October 1862.
7. H.J. Fyrth and H. Collins, *The Foundry Workers*, London 1959, pp. 19, 55-7.
8. Workingman, *Working Men and Women*, London 1879, p. 36.
9. Webb Trade Union Collection, A/XI f. 113.
10. This statement, and much of the discussion that follows, are based upon an examination of the rule books of friendly societies in the Public Record Office.
11. PRO, FS5/127.
12. PRO, FS1/235/876 Kent.
13. Examples are the Grand Provision Society, Deptford and the United Brothers, Woolwich, PRO, FS1/225A/421 Kent; FS3/110/788.
14. *Kentish Mercury*, 7 October 1854.
15. PRO, FS1/235; FS1/229/579.
16. PRO, FS1/ 225B.
17. PRO, FS5/11.
18. *Kentish Mercury*, 15 May 1858.
19. *Kentish Independent*, 3 February 1844.
20. Ibid., 17 July 1847.
21. *Kentish Mercury*, 24 September 1859.
22. *Greenwich and Deptford Chronicle*, 4 October 1879.
23. Royal Commission on Friendly Societies, *Parliamentary Papers*, 1874, LXII, para. 72.
24. Abstract of Quinquennial Returns by Friendly Societies, 1855-1875, *Parliamentary Papers*, 1880, LXVIII.
25. PRO, FS1/224/394.
26. Royal Commission on Friendly Societies, op. cit., 1874, XXIII.2, p. 443.
27. London Grand Division of the Sons of Temperance, *Reports*, 1867-80; Brian Harrison, *Drink and the Victorians*, London 1971, p. 32.
28. Jane Connolly, *Old Days and Ways*, London 1912, p. 241. In the whole of Deptford and Greenwich there were only 170 members of temperance societies in 1872, *Greenwich and Deptford Chronicle*, 27 January 1872.
29. Royal Commission on Friendly Societies, op. cit., 1873, XXII, Q. 25; Q. 864-6.
30. *Kentish Mercury*, 29 August 1865.

31. Royal Commission on Friendly Societies, op. cit., 1873, XXII, Q. 24; Q. 391-2.
32. *Beehive*, 17 December 1864.
33. Abstract of Quinquennial Returns, op. cit., *passim*.
34. Independent Order of Oddfellows, Manchester Unity, *South London District Report*, 1844.
35. *Kentish Independent*, 3 February 1844.
36. Abstract of Quinquennial Returns, op. cit. Of the total membership of the three Kent Unity lodges returned for the period 1860-65, the proportion that discontinued their membership for reasons other than death during that quinquennium was 40.2 per cent.
37. Gosden, op. cit., pp. 76-7.
38. *Kentish Mercury*, 16 August 1856. On tramping as an artisan institution see the excellent discussion by E.J. Hobsbawm in his *Labouring Men*, London 1964, pp. 34-63.
39. Royal Commission on Friendly Societies, op. cit., 1874, XXIII. 2, p. 442.
40. For a fuller discussion of this issue, see Geoffrey Crossick, 'Social structure and working class behaviour: Kentish London, 1840-1880' (Univ. of London PhD thesis, 1976), pp. 335-8.
41. Reports of the Registrar General of Friendly Societies, *Parliamentary Papers*, 1864, XXXII; 1873, LXI.
42. Crossick, op. cit., pp. 336-8.
43. In these and all subsequent local calculations, the societies and lodges that were specifically and wholly for the military have been excluded; soldier membership of mixed societies has been retained.
44. *Pryce's Monthly Journal*, June 1868.
45. On the basis of the returns in the Abstract of Quinquennial Returns, op. cit., the rates of discontinuation in Kentish London between 1860 and 1865 were 15.0 per cent for local societies, 19.0 per cent for Oddfellows (Manchester Unity), and 30.3 per cent for Foresters. These rates are explained in the next paragraph.
46. Abstract of Quinquennial Returns, op. cit.
47. Royal Commission on Friendly Societies, op. cit., 1874, XXIII. 2, p. 442.
48. *Kentish Mercury*, 10 March 1860.
49. PRO, FS1/220.
50. PRO, FS1/225A/421 Kent.
51. PRO, FS1/235/894 Kent.
52. PRO, FS1/225A/421 Kent.
53. PRO, FS1/232/651.
54. PRO, FS3/106/280.
55. Royal Commission on Friendly Societies, op. cit., 1873, XXII, Q. 24, 649.
56. Minute book of the Provident Reliance Friendly Society, 4 January 1886.
57. E.P. Thompson, *The Making of the English Working Class*, Harmondsworth 1968, pp. 460-1.
58. PRO, FS1/225B.
59. The source for these conclusions on the Woolwich Foresters, and other unattributed statements about them, is the Quarterly Returns from Courts 1845-1876 of the Ancient Order of Foresters' South London District
60. The absence of occupational information about those suspended makes necessary the indirect approach that follows. The full results are presented in Crossick, op. cit., p. 345.
61. Spearman's coefficient of rank correlation, $r_s = 0.89$.
62. Mean court size 255; mean discontinuation rate 18.7 per cent.
63. Mean court size 127; mean discontinuation rate 28.9 per cent.

64. For a court by court analysis of all twenty-three Foresters' courts see Crossick, op. cit., pp. 339-44.

65. The proportion of the membership in the unskilled category rose above 35 per cent in seven courts, and fell below 25 per cent in six. The average of all courts was 30.1 per cent. In the seven courts with a high proportion of unskilled members, engineering and shipbuilding craftsmen formed over 60 per cent of all skilled workers in only two cases, whereas in the six courts with a low proportion of unskilled they were in a dominant position in all but one case.

66. The reason for this sudden expansion remains unclear. Employment conditions were not exceptional. Nationally, the economy was emerging from the 1858 depression, and locally the metal unions reported fluctuating trade, from moderate to good in Woolwich, but rather dull at times in Greenwich and Deptford. The government works were active, though not exceptionally so. See Steam Engine Makers, *Trade Reports*, 1858-1863; Amalgamated Society of Engineers, *Monthly Reports*, 1858-1863. A drive by the major orders is a possible explanation of the growth, but it is difficult to explain why the friendly society ideal should have become so attractive just at that time.

67. Mary Cull, *Poems*, Woolwich 1854, p. 121.

68. Charity Organisation Society, *On the best means of dealing with exceptional distress*, op. cit., Q. 884.

69. Rev. J.F. Wilkinson, *The Friendly Society Movement*, London 1886, see esp. p. 207.

70. Anon (Samuel Smiles), 'Workmen's Benefit Societies', in *Quarterly Review*, 1864, pp. 318-50.

71. For an excellent statement by a national friendly society leader on the moral role of membership, see the article by Past Grand Master Charles Hardwick in Independent Order of Oddfellows, *Quarterly Report*, 1 April 1863.

72. PRO, FS5/10.

73. PRO, FS1/237/1163.

74. PRO, FS1/237.

75. PRO, FS1/225A/421 Kent.

76. Ancient Order of Foresters, *Rules of Court Royal Albert*, 1872.

77. E.P. Thompson, op. cit., pp. 456-7.

78. *Kentish Mercury*, 21 February 1874.

79. *Beehive*, 22 April 1865.

80. *Kentish Mercury*, 7 October 1854.

81. PRO, FS1/224/394.

82. *Oddfellows Magazine*, January 1857.

83. Ibid., October 1860.

84. Lady Bell, op. cit., pp. 118-25; Booth, op. cit., first series, vol. 1, p. 46.

85. James Larkin, *Leisure Moments: a Collection of Miscellaneous Poems*, Woolwich 1849, p. 86.

86. PRO, FS1/229/575 Kent.

87. *Northern Star*, 5 May 1849.

88. *Kentish Mercury*, 18 July 1846.

89. Royal Commission on Friendly Societies, op. cit., 1874, XXIII. 1, fourth report, para. 128.

90. *Formularies and Lectures of the Ancient Order of Foresters*, London 1894, pp. 42-3.

91. Larkin, op. cit., p. 85.

92. Independent Order of Oddfellows, *Quarterly Report*, 1 April 1863.

93. *Oddfellows Magazine*, October 1866.
94. Minute book of Provident Reliance Friendly Society, 6 March 1882.
95. *Beehive*, 2 April 1864.
96. *Kentish Mercury*, 16 August 1856.
97. *Oddfellows Magazine*, October 1864.
98. *Kentish Mercury*, 13 November 1858.
99. Ibid., 2 July 1853.
100. Ibid., 8 and 29 December 1860. The rules of the volunteer service prevented them from obtaining it.
101. Letter from William Billington to Colonel Sleigh, 20 January 1857. In Greenwich Local History Centre.

Chapter 10

1. I.J. Prothero, 'London working-class movements 1825-48' (Univ. of Cambridge PhD thesis, 1967), pp. 395-402. Rowe's contention of the failure of London Chartism is seriously weakened by his neglect of years after 1840. D.J. Rowe, 'The Failure of London Chartism', in *Historical Journal*, 11, 1968, pp. 472-87.
2. Prothero, op. cit., pp. 385-429.
3. PRO, HO 45/102 Item 6.
4. *Northern Star*, 29 May 1841.
5. Ibid., 22 January 1842.
6. Ibid., 30 July 1842; 6 August 1842.
7. Ibid., 2 December 1843; 20 January 1844.
8. Ibid., 28 June 1845. Compare the similar experience of Thomas Frost in Croydon: Thomas Frost, *Forty Years' Recollections*, London 1880, pp. 10, 28 and 96.
9. *Northern Star*, 30 October 1847.
10. Ibid., 20 May 1848; 3 June 1848; PRO MEPOL 2/59, police return dated 22 June 1848.
11. PRO MEPOL 2/59.
12. I.J. Prothero, 'London chartism and the trades', in *Economic History Review*, 24, 1971, pp. 202-3.
13. I.J. Prothero, 'Chartism in London', in *Past and Present*, no. 44, 1969, p. 83.
14. But see *Northern Star*, 13 February 1847; 8 May 1847.
15. *West Kent Guardian*, 30 July 1842.
16. See, for example, *Northern Star*, 12 February 1842; 21 November 1846; 5 February 1848.
17. The information on activists is from the *Northern Star*, *People's Paper*, and local newspapers. Personal details come from the same sources, supplemented by the manuscript census schedules in the Public Record Office.
18. *Northern Star*, 28 November 1846.
19. Activists were defined as those serving on local committees, acting as delegates, chairing or otherwise participating in meetings.
20. *Local* class conflict underlay the story of Chartism in Bradford and Leeds, for example. See A.J. Peacock, *Bradford Chartism, 1838-1840*, York 1969, *passim*; also the essays in Asa Briggs (ed.), *Chartist Studies*, London 1969.
21. Prothero, 'Chartism in London', op. cit., pp. 44-5.
22. On inner London see ibid., p. 81. For an example of police ridicule of the Greenwich Chartist threat, see the letter from 'R' Division, dated 10 June 1848, PRO HO 45/2410 London.
23. *Northern Star*, 5 October 1850.

24. Minutes of the Business Committee of the Metropolitan Parliamentary Reform Association, 21 September 1842. BM. Add. MSS 27,810 f 52.
25. *Kentish Mercury*, 18 January 1840; 15 February 1840.
26. On the differing patterns of conflict between repealers and chartists see Lucy Brown, 'The Chartists and the Anti-Corn Law League', in Asa Briggs (ed.), op. cit., pp. 342-71. From her analysis, the Kentish London situation was similar to that in Sheffield and Wolverhampton where specific social structures worked against vigorous class conflict in politics.
27. Address of the Metropolitan Anti-Corn Law Association, 6 December 1841. BM. Add. MSS 35,147 ff 89-90. There was no trouble when Cobden and Peyronet Thompson addressed over 1,200 people in Greenwich. *Kentish Independent*, 27 April 1844.
28. *Northern Star*, 16 May 1846.
29. *Northern Star*, 26 March 1842.
30. Ibid., 26 October 1844.
31. Ibid., 5 June 1847.
32. Ibid., 24 July 1847.
33. Ibid., 7 August 1847.
34. Ibid., 4 November 1848.
35. Ibid., 5 February 1848.
36. Ibid., 20 April 1850.
37. Ibid., 4 December 1847.
38. See, for example, ibid., 22 and 29 January 1848.
39. Ibid., 20 April 1850.
40. Ibid., 28 November 1846.
41. Ibid., 15 June 1850.
42. *Kentish Mercury*, 4 February 1871.
43. *Northern Star*, 20 April 1850. See also the address in *People's Paper*, 8 May 1852.
44. *Northern Star*, 24 October 1846. Punctuation as in original.
45. Joy MacAskill, 'The Chartist Land Plan', in Briggs (ed.), op. cit., p. 307.
46. Ibid., pp. 318-22; *Northern Star*, 11 January 1845.
47. *Northern Star*, 28 June 1845.
48. Quoted in MacAskill, op. cit., p. 339.
49. *Northern Star*, 8 and 22 May 1847; 14 August 1847.
50. For a discussion of this rhetoric, see Dorothy Thompson (ed.), *The Early Chartists*, London 1971, pp. 18-19.
51. *Northern Star*, 12 February 1842.
52. Ibid., 19 September 1846.
53. PRO, HO 45/241-B, memo dated 16 March 1848; HO 45/2410 London, letter from 'R' Division dated 10 June 1848.
54. *Northern Star*, 30 September 1848; 4 November 1848.
55. PRO, HO 45/2410 London, memo dated only June 1848, from Inspector Marks of Greenwich Police.
56. Charles R. Dod, *Electoral Facts 1832-1853*, Brighton 1972, reprint, p. 131.
57. Norman Gash, *Politics in the Age of Peel*, London 1953, p. 339.
58. In 1858 he supported the lodger vote, a greatly extended property franchise, the ballot, and the abolition of church rates. Election Address, in the Martin Collection, Greenwich Local History Centre.
59. *Kentish Mercury*, 14 February 1852.
60. Ibid., 23 April 1853; 7, 14 and 21 May 1853.
61. Letter from Joseph Blow to the Chairman of the Sleigh Committee, dated 7 February 1857, in the Colonel Sleigh File, Greenwich Local History Centre.

62. H.J. Hanham, *Elections and Party Management in Politics in the Time of Disraeli and Gladstone*, 1967, p. 200. In the discussion of party organisation that follows I found helpful a brief typescript paper by Sheila Cross, 'Elections in Greenwich', in the Greenwich Local History Centre.

63. J. Morley, *The Life of William Ewart Gladstone*, London 1903, vol. 2, p. 490.

64. M. Benney, A. Gay and R. Pear, *How People Vote*, London 1956, p. 39. Nevertheless, the establishment of Tory success in the 1870s may have depended upon a fairly systematic tie-up between the party and the local victuallers' association.

65. *Greenwich and Deptford Chronicle*, 29 March 1873.

66. Ibid., 1 December 1877; 19 January 1878.

67. Ibid., 10 April 1880.

68. Benney, Gay and Pear, op. cit., p. 40.

69. On this wider trend see James Cornford, 'The Transformation of Conservatism in the Late Nineteenth Century', in *Victorian Studies*, 7, 1963, pp. 35-66.

70. *Kentish Mercury*, 28 June 1851; 5 July 1851.

71. Ibid., 21 January 1860.

72. *Kentish Independent*, 22 June 1850.

73. *Kentish Mercury*, 5 April 1851.

74. F. Gillespie, *Labor and Politics in England 1850-1867*, London 1966, reprint, p. 86 ff.

75. *Kentish Mercury*, 22 January 1853; 5 February 1853.

76. Ibid., 30 January 1858.

77. Ibid., 12 and 19 March 1859.

78. Ibid., 10 December 1853; 14 December 1866; *Kentish Independent*, 5 September 1868.

79. Return of Cities and Boroughs, *Parliamentary Papers*, 1866, LVII, pp. 748-9.

80. Select Committee on the Elective Franchise, *Parliamentary Papers*, 1860, XIII, pp. 348-54.

81. J.R. Vincent, *The Formation of the Liberal Party*, London 1966, p. xiii.

82. *People's Paper*, 9 May 1857.

83. Ibid., 25 July 1857.

84. *Kentish Mercury*, 7 August 1858. For a fuller discussion of this League see Gillespie, op. cit., pp. 160-7.

85. Vincent, op. cit., p. 77.

86. *Kentish Mercury*, 10 January 1857.

87. Ibid., 10 January 1857.

88. *Newcastle Chronicle*, 27 August 1858.

89. *Kentish Mercury*, 24 January 1857; *Greenwich Free Press*, 28 March 1857.

90. *Kentish Mercury*, 10 January 1857.

91. Letter from John Harding to Colonel Sleigh, dated 7 February 1857, in the Colonel Sleigh File, Greenwich Local History Centre.

92. *Kentish Mercury*, 17 January 1857.

93. Ibid., 12 and 19 September 1857; 10 October 1857.

94. *South London News*, 10 October 1857; *Kentish Mercury*, 4 September 1858.

95. Supplement to *Greenwich Free Press*, undated, in the Martin Collection, in Greenwich Local History Centre.

96. Advertising Bill in the Martin Collection.

97. This was especially true in Sunderland and Kidderminster. Gillespie, op. cit., pp. 120-8.

98. In October 1865 London as a whole boasted fifteen branches of the Reform League, of which four were in Kentish London. *Workman's Advocate*, 14 and 28 October 1865.
99. Membership Card of the Reform League, Bishopsgate Institute.
100. *Workman's Advocate*, 9 September 1865.
101. *Commonwealth*, 13 October 1866.
102. Ibid., 15 June 1867.
103. F.M. Leventhal, *Respectable Radical: George Howell and Victorian Working Class Politics*, London 1971, pp. 71-2.
104. *Commonwealth*, 12 May 1866.
105. Ibid., 22 September 1866.
106. Ibid., 17 February 1866.
107. *Beehive*, 13 May 1865.
108. Ibid., 27 May 1865.
109. *Kentish Mercury*, 15 May 1869. On the ambiguity of Gladstone's position, see Vincent, op. cit., pp. 211-35.
110. *Kentish Independent*, 24 July 1869.
111. *Greenwich and Deptford Chronicle*, 22 October 1870.
112. Ibid., 14 October 1876.
113. Ibid., 13 November 1869.
114. Ibid., 1 October 1870.
115. *Kentish Mercury*, 4 February 1871.
116. *Greenwich and Deptford Chronicle*, 10 May 1873.
117. *Objects and Rules* of the Borough of Greenwich Radical Association 1881. In Howell Collection.
118. *Greenwich and Deptford Chronicle*. 12 April 1873. See more generally Royden Harrison, *Before the Socialists. Studies in Labour and Politics 1861-1881*, 1965, pp. 210-46.
119. *Kentish Mercury*, 30 September 1871.
120. Arthur T. Bassett, *Gladstone's Speeches and Descriptive Index*, London 1916, p. 402.
121. The whole speech is reprinted in ibid., pp. 401-25.
122. For a discussion of this episode see R.R. James, 'Gladstone and the Greenwich Seat', in *History Today*, 9, 1959, pp. 344-51.
123. Bassett, op. cit., pp. 37-62.
124. The words are those of Philip Magnus, *Gladstone: a Biography*, London 1954, p. 259.
125. *Greenwich and Deptford Chronicle*, 24 May 1873.
126. Ibid., 22 February 1873.
127. Ibid., 14 June 1873.
128. Ibid., 9 August 1873. The result was Boord 4,527; Langley 2,379; Angerstein 1,063; Bennett 324.
129. Ibid., 16 August 1873.
130. Ibid., 13 July 1872. This was a branch of the Labour Representation League.
131. Leventhal, op. cit., pp. 127-8.
132. Benney, Gay and Pear, op. cit., pp. 40-1.
133. H.W. Nicholas, *A Brief Biography of J. Baxter Langley Esq.*, London 1867, passim. In 1870 he was the candidate for Josephine Butler at the 1870 Colchester by-election where the Contagious Diseases Act was a major issue.
134. *Greenwich and Deptford Chronicle*, 11 August 1877.
135. For these positions see many speeches and statements, but especially those in *Beehive*, 30 November 1867; *Greenwich and Deptford Chronicle*,

6 November 1869; 12 March 1870.

136. *Greenwich and Deptford Chronicle*, 29 March 1873.
137. Ibid., 18 September 1869; 9 October 1869; *Kentish Mercury*, 18 September 1869.
138. *Greenwich and Deptford Chronicle*, 18 June 1870.
139. H. Pelling, *Popular Politics and Society in Late Victorian Britain*, London 1968, p. 56.
140. *Greenwich and Deptford Chronicle*, 23 October 1869.
141. *Beehive*, 15 April 1865.
142. Brian Harrison, 'The Sunday Trading Riots of 1855', in *Historical Journal*, 8, 1965, p. 231.
143. On the central London clubs, see Stan Shipley, *Club Life and Socialism in Mid-Victorian London*, Oxford 1972, *passim*. In my view he greatly exaggerates the representativeness of these clubs.
144. *Greenwich and Deptford Chronicle*, 19 February 1870.
145. Ibid., 23 August 1873.
146. Ibid., 20 March 1875; 8 April 1875.
147. Ibid., 15 May 1875; *Kentish Mercury*, 20 March 1875.
148. *Kentish Mercury*, 28 August 1875.
149. Ibid., 20 March 1875.
150. *Greenwich and Deptford Chronicle*, 31 July 1875; on the whole Tichborne affair, see D. Woodruff, *The Tichborne Claimant*, London 1957, *passim*.
151. *National Reformer*, 16 July 1854.
152. Ibid., 2 May 1863.
153. Ibid., 27 December 1862.
154. Ibid., 19 April 1868.
155. Susan Budd, 'The Loss of Faith in England, 1850-1950', in *Past and Present*, no. 36, 1967, p. 110.
156. *National Reformer*, 19 March 1865.
157. Ibid., 26 November 1864; 3 December 1864.
158. Ibid., 1 November 1874; 15 November 1874.
159. Ibid., 17 December 1864.
160. Ibid., 23 May 1863; 9 July 1864.
161. Ibid., 29 August 1863.
162. Ibid., 10 October 1863.
163. Ibid., May 1868.
164. Ibid., 2 January 1870; 5 March 1871; 27 February 1870; 24 July 1870; 14 August 1870; 11 December 1870.
165. E. Royle, 'George Jacob Holyoake and the Secularist Movement in Britain 1841-1861' (Univ. of Cambridge PhD thesis, 1968), pp. 59-69.
166. The legal profession was part of that old elite. George Floyd, who chaired the meeting referred to above that condemned the Inns of Court for their role in the Tichborne Affair, was himself an active secularist.
167. Shipley, op. cit., *passim*.
168. *National Reformer*, 29 August 1875; 12 September 1875.
169. Ibid., 13 March 1870.
170. Ibid., 10 April 1870.
171. Ibid., 7 August 1870.
172. Shipley, op. cit., pp. 48-9.
173. *Weekly Dispatch*, 24 April 1864, quoted by H. Collins and C. Abramsky, *Karl Marx and the British Labour Movement*, London 1965, p. 19.
174. *Northern Star*, 28 March 1846; 7 February 1847.
175. Collins and Abramsky, op. cit., p. 22.
176. *Kentish Mercury*, 23 May 1865.

177. Ibid., 11 April 1863.
178. Ibid., 22 September 1860.
179. Ibid., 10 November 1860.
180. Ibid., 25 October 1862; 1 and 8 November 1862.
181. *Greenwich and Deptford Chronicle*, 24 September 1870.
182. Collins and Abramsky, op. cit., pp. 60, 108.
183. Letter from Maddox to Vickery dated 6 February 1873. In Internationaal Instituut voor Sociale Geschiedenis, Amsterdam (IISG). Ref: 14354b & c.
184. Letter from Maddox to Vickery dated 19 February 1873. IISG. Ref: 14362a.
185. Letter from Maddox to Vickery dated 30 March 1873. IISG, Ref: 14374a & b.
186. Cf. R. O'Higgins, 'The Irish Influence in the Chartist Movement', in *Past and Present*, no. 20, 1961, pp. 83-96.
187. *Northern Star*, 12 February 1842.
188. Ibid., 18 March 1848.
189. PRO, MEPOL 2/59, 22 June 1848.
190. PRO, HO 45/2410B, memo dated 16 March 1848.
191. *Northern Star*, 29 April 1848.
192. *Greenwich and Deptford Chronicle*, 13 September 1873.
193. Ibid., 4 March 1876; *Kentish Mercury*, 23 December 1871.
194. *Kentish Independent*, 28 December 1867; *Kentish Mercury*, 30 October 1869.
195. PRO, HO 45/057799/318, letter dated 23 December 1867.
196. *Kentish Independent*, 4 January 1868; PRO, HO 45/057799/350, letter dated 11 January 1868.
197. *Kentish Independent*, 1 February 1868.
198. *Kentish Mercury*, 9 November 1867.
199. The politics of the Irish in nineteenth-century England needs its historian. At the moment we have only the excellent discussion of Irish immigrant politics in London by Lynn Lees, in 'Social change and social stability among the London Irish 1830-1870' (Harvard Univ. PhD thesis, 1969), pp. 245-76.
200. *Greenwich and Deptford Chronicle*, 12 November 1870.
201. He was elected as the Union's Assistant Corresponding Secretary in 1868. Friendly Society of Ironfounders, *Monthly Report*, December 1868.
202. Operative Bricklayers' Society, *A Short Biographical Sketch of Brother John Jeffery, Secretary of Greenwich Branch*, 1906, *passim*.
203. *Kentish Mercury*, 26 May 1860.

Chapter 11

1. On the process in these towns, see L.S. Marshall, 'The Emergence of the First Industrial City: Manchester, 1750-1850', in C.F. Ware (ed.), *The Cultural Approach to History*, New York 1940; B.D. White, *A History of the Corporation of Liverpool, 1835-1914*, Liverpool 1951; R.W. Greaves, *The Corporation of Leicester, 1689-1836*, Oxford 1939.
2. The best information available can be found in P. Thompson, *Socialists, Liberals and Labour. The Struggle for London, 1885-1914*, London 1967, *passim*, The material on Kentish London is inevitably sketchy, apart from a closely political examination of Woolwich, ibid., pp. 250-63.
3. R.B. Stucke (ed.), *Fifty Years History of the Woolwich Labour Party 1903-1953*, Woolwich 1953, pp. 7-13; E.F.E. Jefferson, *The Woolwich*

Story 1890-1965, London 1970, pp. 50-1; P. Thompson, op. cit., pp. 250-63.

4. Ibid., pp. 240-7, 309-14.
5. Stucke, op. cit., pp. 15-17.
6. D. Hopkin, 'The Membership of the Independent Labour Party: a spatial and occupational analysis', in *International Review of Social History*, 20, 1975, pp. 192-3.
7. P. Thompson, op. cit., p. 263.
8. Ibid., pp. 244-7.
9. Quoted in ibid., p. 115.
10. There is little evidence of a narrowing of differentials before 1914, though real wages did decline of course after the turn of the century.
11. G. Crossick (ed.), *The Lower Middle Class in Britain 1870-1914*, London 1976.
12. For an example see Charles Booth, *Life and Labour of the People in London*, London 1902, third series, vol. 5, p. 77.
13. It was in these years that Blackheath and Charlton became dormitories for many City clerks, and commuting from Kentish London became far more common than it had ever been before for City workers. Ibid., pp. 77 and 82.
14. See the experience of Greenwich as observed by Booth, ibid., pp. 51 and 56.
15. P. Thompson, op. cit., p. 295.
16. J. Foster, *Class Struggle and the Industrial Revolution*, London 1974, pp. 203-50.
17. Ibid., p. 191.

INDEX

Individual members of the elite in Chapter 5 only appear in this index if their names occur elsewhere in the book.